Bard FICTION PRIZE

Bard College invites submissions for its annual Fiction Prize for young writers.

The Bard Fiction Prize is awarded annually to a promising, emerging writer who is a United States citizen aged 39 years or younger at the time of application. In addition to a monetary award of $30,000, the winner receives an appointment as writer-in-residence at Bard College for one semester without the expectation that he or she teach traditional courses. The recipient will give at least one public lecture and will meet informally with students.

To apply, candidates should write a cover letter describing the project they plan to work on while at Bard and submit a C.V., along with three copies of the published book they feel best represents their work. No manuscripts will be accepted.

Applications for the 2010 prize must be received by July 15, 2009. For further information about the Bard Fiction Prize, visit www.bard.edu/bfp or call 845-758-7087. Applicants may also request information by writing to the Bard Fiction Prize, Bard College, Annandale-on-Hudson, NY 12504-5000.

Bard College PO Box 5000, Annandale-on-Hudson, NY 12504-5000

COMING UP IN THE FALL

Conjunctions:53
NOT EVEN PAST:
HYBRID HISTORIES
Edited by Bradford Morrow

When fiction and poetry enter the supposedly objective realm of history, what sort of crossbreed or hybrid emerges? An imaginative paper mongrel falsely baying at the distant but very real moon? Or is it possible the creative narrative artist can forge a heightened vision of what was, or might have been, that becomes more compelling, more *telling*, than the historian's factual account? What is it that truly happens when a fiction writer or poet uses historical circumstance as a stepping-stone along a path ascending into full-blown fabrication? And what does it mean when historical incident solidifies into myth, and that same myth in turn influences history?

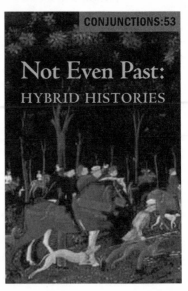

For our fall issue, *Not Even Past: Hybrid Histories*, we have gathered a portfolio of fiction, poetry, and drama by some of the most visionary writers at work today, all of whom conjure periods, moments, and people in history through the kaleidoscopic lens of imagination. Among those who are contributing to this issue are Nathaniel Mackey, Robert Coover, Can Xue, Peter Gizzi, William H. Gass, Paul West, and D. E. Steward.

Subscriptions to *Conjunctions* are only $18 for more than eight hundred pages per year of contemporary and historical literature and art. Please send your check to *Conjunctions*, Bard College, Annandale-on-Hudson, NY 12504. Subscriptions can also be ordered by calling (845) 758-1539, or by sending an e-mail to Michael Bergstein at Conjunctions@bard.edu. For more information about current and past issues, please visit our Web site at www.Conjunctions.com.

CONJUNCTIONS

Bi-Annual Volumes of New Writing

Edited by
Bradford Morrow

Contributing Editors
Walter Abish
Chinua Achebe
John Ashbery
Martine Bellen
Mei-mei Berssenbrugge
Mary Caponegro
William H. Gass
Peter Gizzi
Robert Kelly
Ann Lauterbach
Norman Manea
Rick Moody
Howard Norman
Joan Retallack
Joanna Scott
David Shields
Peter Straub
John Edgar Wideman

published by Bard College

EDITOR: Bradford Morrow
MANAGING EDITOR: Michael Bergstein
SENIOR EDITORS: Robert Antoni, Peter Constantine, Brian Evenson,
J. W. McCormack, Micaela Morrissette, Pat Sims, Alan Tinkler
WEBMASTER: Brian Evenson
ASSOCIATE EDITORS: Jedediah Berry, Eric Olson, Patrizia Villani
ART EDITOR: Norton Batkin
PUBLICITY: Mark R. Primoff
EDITORIAL ASSISTANTS: Alice Gregory, Jessica Loudis, Elias Primoff,
Jenia Ulanova

CONJUNCTIONS is published in the Spring and Fall
of each year by Bard College, Annandale-on-Hudson,
NY 12504. This issue is made possible in part with
the generous funding of the National Endowment for
the Arts, and with public funds from the New York
State Council on the Arts, a State Agency.

State of the Arts

NATIONAL ENDOWMENT FOR THE ARTS

A great nation deserves great art. NYSCA

SUBSCRIPTIONS: Send subscription orders to CONJUNCTIONS, Bard
College, Annandale-on-Hudson, NY 12504. Single year (two volumes): $18.00
for individuals; $40.00 for institutions and overseas. Two years (four volumes):
$32.00 for individuals; $80.00 for institutions and overseas. Patron sub-
scription (lifetime): $500.00. Overseas subscribers please make payment by
International Money Order. For information about subscriptions, back issues,
and advertising, call Michael Bergstein at (845) 758-1539 or fax (845) 758-2660.

Editorial communications should be sent to Bradford Morrow, *Conjunctions*,
21 East 10th Street, New York, NY 10003. Unsolicited manuscripts cannot
be returned unless accompanied by a stamped, self-addressed envelope.
Electronic and simultaneous submissions will not be considered.

Conjunctions is listed and indexed in the American Humanities Index.

Visit the *Conjunctions* Web site at www.conjunctions.com.

Cover design by Jerry Kelly, New York. Cover painting by Kenny Scharf.
Blobareeblob, 2006, oil on linen, 60 x 48 inches. Reproduced by kind permis-
sion of the artist and Paul Kasmin Gallery.

Available through D.A.P./Distributed Art Publishers, Inc., 155 Sixth Avenue,
New York, NY 10013. Telephone: (212) 627-1999. Fax: (212) 627-9484.

Printers: Edwards Brothers

Typesetter: Bill White, Typeworks

ISSN 0278-2324
ISBN 978-0-941964-68-5

Manufactured in the United States of America.

TABLE OF CONTENTS

BETWIXT THE BETWEEN
IMPOSSIBLE REALISM

Edited by Bradford Morrow and Brian Evenson

EDITORS' NOTE

TO BE HUMAN is to experience, at times, the sensation of feeling betwixt and between. To witness the relative comfort of the familiar disrupted by the unexpected, confused by some antithetical force that, however briefly, destroys the "normal." In literary terms, the crisis that necessarily evolves from such a disruption is very often the bedrock of narrative. How does the fictive character work through the betwixt-and-between nature of life toward some denouement, some resolution, or else some fresh windmill to tilt at that will once more destroy any hard-earned balance?

If the state of being betwixt and between is the stuff of realism, we wanted to travel further down an avenue begun with *Conjunctions:39, The New Wave Fabulists,* wonderfully guest-edited by Peter Straub some years ago, to explore what happens when the borderlands of the normal and absurd, the everyday and the uncanny, the real and the impossible, are breached. In other words, we thought it would be interesting to find what lies in the next possible dimension—betwixt *the* between. What we learned anew was that fantastic fiction, whatever name it goes by—New Wave Fabulism, Speculative Fiction, the New Weird, Slipstream Fiction—is a thriving, daring, imaginative literature that can never again be shunted into the ghetto of "genre."

Betwixt the Between investigates ways in which, on the one hand, works of fiction treat the impossible as if it were the solid groundwork of the real, or on the other hand how the ineffable can sometimes flash lightning-quick through the realms of the real, leaving everything the same and yet unaccountably changed. Worlds and concomitant modes of logic are offered here that reveal something about our daily existence and yet turn away from it to forge disjointed realities that strike the reader simultaneously as familiar and anything but. At one end of the spectrum, one encounters the odd characters of Stephen Wright's "Brain Jelly" as they gouge their brutal way through a world not wholly unlike our own. At the other, say in Edie Meidav's "The Golden Rule," the disruption of the real is subtle enough that if you glance the other way you might miss it.

7

After acclimating to these betwixty milieus, everything begins to feel at once real and impossible—from the classic fairy-tale setup in which the knight is supposed to slay the dragon rather than engage in intellectual repartee, to the quasi-horror narrative that reminds us once again why it's never a good idea to walk into the deep, dark woods. A complementarity takes place. Genre and literature meld as Bigfoot consorts with the Dalai Lama, and packs of wild dogs rule the neighborhood. Here the reader will find doctors who might be aliens, dreams that seep their way into the bedsheets, factories for growing meat, the slowest and deadliest animal in existence, new realities wrung out of the crumpled pages of yesterday's newspaper, and brief glints of another world glimpsed from a park bench, all acknowledged as true in and of themselves.

Every one of the twenty-five tales collected here is distinct and fully visioned and stands exactly for the world it brings into being, unique and oblivious to alternative alternatives. The result is a series of fictions each of which has its own particular, and peculiar, claim on reality—a claim, now that it has its teeth sunk in, that it's not willing to relinquish. Welcome to the impossible real.

—Bradford Morrow & Brian Evenson
April 2009
New York City & Providence

Brain Jelly
Stephen Wright

APOSTROPHE CAME FROM a country where all the cheese was blue. The cows there ate berries the whole day long. You should see their tongues.

Apostrophe liked cheese. Her refrigerator was full of forgotten chunks and shards of dried-up cheeses from around the world. Her favorite was the kind that looked like pus and smelled like vagrant armpits. She could eat that kind every day.

Ratio liked butter. Everything that went into his mouth had to have some butter on it. Including Apostrophe.

Ratio and Apostrophe were not husband and wife. They were not brother and sister. Were they even girlfriend-boyfriend? You'd have to ask them. They liked sex. They practiced it together every chance they got.

Apostrophe was rich. Ratio was rich. Their families were rich. Their friends were rich. They had so much money they didn't have to think about it anymore. They did what they wanted when they wanted to do it. When they worked, they worked at jobs they liked. When they got bored, they quit.

Here are some of Apostrophe's jobs:

Volunteer in a soup kitchen passing out crackers to disgraced business executives.

Boob wrangler to a celebrity who had difficulty keeping those particular parts inside her clothes.

Guest host of an all-night radio talk show devoted entirely to the perplexing problems of the spirit life. Ghosts: Are they real? Who are they? What do they want?

Published poet who wrote posturing poems about wanting to write a posturing poem. She never used any indefinite articles. She never used the word "epiphany." Her work was very popular. One of her books even won an award of some kind or other. After that, she gave up writing. What was the point?

Here are some of Ratio's jobs:

Assistant art restorer at the Museum of Exploded Ideas, where

he helped to restore one Mucilage, a couple Frenzies, and several Wisenheimers.

Apprentice to a world-class alchemist famous for turning trash into tinsel.

Salesclerk selling uncomfortable shoes to emaciated fashionettas who didn't need any shoes. At the time he was a regular foot man.

Visiting professor of trivia at Mistletoe College.

Professional white-water enthusiast who once sailed an inner tube to the end of the world. He looked over. There was nothing there.

In between jobs Apostrophe and Ratio went pogoing around the world. They were collectors of experiences they often promptly forgot. They both suffered from life attention deficit disorder.

Now Apostrophe and Ratio had come to be in a big, loud city in a big, loud country. Combustion engines raced up and down every street. Sirens cried. Dogs howled. Planes shook windows. Every building was either being thrown up or torn down. Every television set was always on. The people had to shout at one another in order to be heard.

"I get it," said Ratio. "You rush madly about as if in urgent need of a urinal."

"Which you can't ever find," said Apostrophe.

"Doesn't look too difficult."

"I think we can manage it."

So they rushed madly about too. It was fun. In one frantic day of frantic touristing they kissed the Keystone, devoured the complimentary Founder's Hock in Fig Sauce, strolled through the lapsed Gardens, rode a spoon over the Great Falls, gazed in wonder upon the Golden Bough through double sheets of high-impact glass. Now what?

Apostrophe and Ratio were staying in the Penitential Suite of the Hotel Cellophane. Since that first hectic day they had not gone out once. They had been eating room service and having sex.

At the moment Apostrophe was encamped in bed. She was involved. She was painting her toenails, each one a different glittery iridescence. She was reading a magazine article on the current threats to the mediocracy. She was gobbling down a waffle drenched in sidewinder syrup. She was watching television. She was multitasking.

On the television screen there was the war. There was always the war on the television screen. There was shouting, shooting, stuff blowing up. First the people liked it, then they didn't. First they did, then they didn't.

Ratio was on the floor, doing his push-ups. He liked his body. He liked it hard.

"This rug stinks," he said.

"What do you expect?" said Apostrophe. "People walk on it." She paused. "With their feet."

Ratio went up and down, huffing and puffing. He watched himself in a mirror going up and down, huffing and puffing.

"They should have shampooed it before we checked in."

"Probably," said Apostrophe, "they didn't know it was us who was coming." She leaned back. She wiggled her toes. They looked good. "You know, us, the rug-sniffing people."

Ratio jumped to his feet. "Let's go," he said.

Apostrophe smiled. She was always smiling at him. Sometimes she smiled so much at him her smiley muscles ached. "Where?" she said.

"Let's go buy something we can't buy at home."

"OK," she said.

They got ready to greet the world. It was the first time in days they had had any clothes on. Apostrophe liked to dress like a hooker. She didn't care what anybody thought. In her country there was no official costume. Everyone was on their own. This frightened some people. They picked fights with Apostrophe. She was happy to oblige. She liked to fight.

Ratio always dressed like a rapper. He didn't rap. He didn't listen to rap music. He liked how he looked as if he did.

First, they went to a crowded little store that stocked all the items the big stores didn't. Apostrophe bought a rare two-handled seidel with intricate carvings of extinct species around the rim. She bought a grigri and a cantrip and a quarrel that she especially liked because she didn't know what it was.

Then they went to a gun shop. In this country all you had to do to buy a gun was raise your right hand and swear you would never, ever intentionally shoot someone. Ratio so swore. He walked out with the ballistics-flavor-of-the-month, a Mortimer 19 semiautomatic handgun. It had unicorn grips and quartz sights and it made an insistent beeping sound when the magazine ran low.

Outside, on the sidewalk, the people scurried about like besieged bugs. Around every corner horns and jackhammers.

Apostrophe and Ratio took a cab to the movies. They saw the latest blockbuster, *Eschatology Force II: Cry Me a River*, starring Frank Abyss and Jennifer Omen. When, at the end of the movie, a little girl's doggie saves the world by turning off the evil carbon

dioxide machine with his paw, Apostrophe threw back her head and laughed.

"Ugh," said Apostrophe afterward. "Too much gore."

Ratio shrugged. "It's a movie," he said. "It's not real."

"My brain thought it was real."

"Your brain thinks you are real."

"Aren't I?"

"No."

Apostrophe and Ratio took a cab to Zoom, where everyone who was rich and well connected was supposed to go to eat. The house specialty was arranging pieces of food on the plates in alphabetical order. Roving packs of famous thin people came and went. The waiters all wore tight black waistcoats and suede gloves. Whenever someone ordered the Super Platinum Buttersteak for Two, the chef rang a little bell.

"These people," said Apostrophe. "They chew with their mouths open."

"Don't look at them," said Ratio.

"People here have more teeth than we do back home."

"The better to eat you with," said Ratio.

Back at the suite Apostrophe immediately took off all her clothes. Sometimes clothes made her skin so itchy she wanted to scream. She assumed the bed position, grabbed the remote, and began searching the television screen for something bright and sparkly. She couldn't bear to watch old movies in black and white. They reminded her too much of death.

Ratio sat at the table, polishing his Mortimer.

"I think," he said, "I'm gonna have to shoot this thing pretty soon."

"Please," said Apostrophe. "Not in the room. Remember the Brigand House."

A year earlier, at the legendary Brigand House in a faraway land noted for its creamy cream puffs and perfectly tooled bowling balls, Ratio had had one of his "intervals." Apostrophe had been off scouting locations for a nature documentary a friend of hers was producing about abnormal toad migrations. Ratio was lonely. His penis was lonely. Over the years his penis had received considerable handling by himself and others. It had gotten used to the attention. It didn't like to be ignored. Ratio decided to coat the walls of their room with frosting. Half chocolate. Half vanilla. He thought it might be Apostrophe's birthday or something. He knew she liked cake. When

Apostrophe hadn't shown up by dark, he covered every flat surface in the room with hundreds of lighted candles. Then he left and allowed the room to catch fire by itself. It did. Ratio and Apostrophe were asked never to return to the hotel again. Or the country.

"I'll shoot out the window," Ratio said.

Apostrophe looked at him.

"One shot," he said. "One tiny shot."

Ratio went to the window. He tugged on it. He tugged again.

"Damn," he said.

"All the hotel windows here are bolted shut," said Apostrophe. "To cut down on the suicides."

Ratio looked at her.

"I read that somewhere," she said.

Ratio looked around the room. As if he'd already looked around the room more times than he had ever wanted to.

"I need to get lit," he said.

"OK," said Apostrophe.

Whatever country they were in, they always made a point of sampling freely of the popular drugs of the region. Here the people's choice at the moment seemed to be something called Velocitin. It gave you the sensation that you could accomplish, or already had accomplished, everything required of you. But once the drug had been smoked, snorted, or popped, you realized you couldn't move.

What followed was a night forever sucked down the memory hole.

In the afternoon Apostrophe woke up and called room service. She ordered her customary breakfast. Two aspirins, a bowl of jelly beans, and a Nothing cola. It had no calories, no vitamins, no nutrients. It tasted real good.

Then Apostrophe went into the bathroom. When she came out she had dyed her hair the new Universal Tint. People saw what color they wanted to see.

"Let's go out," said Ratio.

"OK," said Apostrophe.

They went to the park. They saw grass. They saw people shouting at each other. They saw trees. They saw naked men in the bushes doing naked things to one another.

They found an empty bench and sat down.

"I'm going to shoot that guy over there," said Ratio.

"Where?" said Apostrophe.

"Across the pond. The one in the don't-touch-me suit and the look-at-me hair. There's some varnish that needs cracking."

13

"OK."

Ratio had a theory. It was this. If you wanted to do something you didn't want people to see you doing, just do it boldly in plain sight. Obvious, oblivious—there had to be some deep, secret connection. He was certain of it.

Ratio raised the gun. He looked through the sights. He fired.

Apostrophe cupped her hands over her ears. "So loud," she said.

"Don't worry," said Ratio. "It's lost in the tumult of the city. Everything's lost in the tumult."

Ratio looked across the pond. No one screamed. No one fell down. No one ran.

"Maybe you missed," said Apostrophe.

"You forget I was the best marksman in my firearms class at the School of Enhanced Resolutions."

Ratio raised the gun. "Check out the vanilla wafer over by the garbage can," he said. "Cartoon version of an urban operator walking his dogette."

"He's so pale," said Apostrophe. "Bet if you touched his face your hand would come away sticky."

Ratio breathed the way you were supposed to. He sighted the way you were supposed to. He squeezed the trigger the way you were supposed to.

The world went on as it was supposed to.

"Damn," said Ratio. He turned the Mortimer around. He peered down the barrel.

"Maybe the people here are impervious to bullets," said Apostrophe. "They've evolved. Developed a protective hide. From the constant exposure, you know."

Ratio took a round out of his pocket. He examined it. He pressed his thumb against the tip. "Seems hard enough," he said. "Sharp too."

"Try a girl," said Apostrophe. "They have softer skin."

Ratio looked around. "How about little miss marathon woman coming our way? Run, girly, run."

"What's with the weird jogging suit?" said Apostrophe. "It's like the colors were on their way to becoming real colors but got frightened and turned back."

Ratio pointed the barrel. He shot.

The woman ran right on past with barely a glance toward Ratio and Apostrophe.

"Damn," said Ratio.

"Maybe you should shoot yourself," said Apostrophe. "See if the stupid thing actually works."

Ratio looked at her.

"I mean, in an arm," said Apostrophe. "Or a leg. Someplace not too importantly painful."

Ratio sat there for a while. He was doing that thing with your head where you keep running one thought over and over again. Then you stop and you can't remember what you'd been thinking.

"I think we should break up," said Ratio.

"Yeah?" said Apostrophe. "Why?"

"I don't know. I feel like it."

"That's no answer."

"It's the only one I got."

"Can't we wait to do this until we get back home?"

"Why contaminate the tulips with our tears?"

"When do you have this big breakup scheduled for?"

"Right now."

Ratio got up and walked away.

Apostrophe sat and watched him go. Should I cry now? she wondered. Or wait until later? She decided to think about it for a while and then decide what to do.

She sat on the bench alone. After a while she thought about Ratio's penis. She couldn't help it. She did.

Then Apostrophe went shopping. She went to a store where all the employees had decorative bits of metal embedded in their faces. One of the sales clerks began flirting with Apostrophe. Her name was Etude. She had a tattoo of a screw on her neck. She was studying to be a certified public accountant. Apostrophe had been with girls before. She passed on the pass.

When Apostrophe left the store, she was carrying a big bag of skimpy black clothing.

Apostrophe considered getting a bit of metal embedded in her face but decided to go to a bar instead. She needed a drink. Her favorite drink was a Knucklehead. Knuckleheads always made her feel vague. As she drank, she became vaguer and vaguer. Every time she looked around the room, she was met by the same pair of dark eyes looking back at her. Finally she picked up her Knucklehead and her big bag of skimpy black clothing and simply walked over to the guy. Up close he looked even better than at a distance.

"What?" she said.

The guy looked her over, scalp to toes. "What 'what'?" he said.

15

Then he looked her over again.

"You were staring at me."

"So?" he said. "Maybe you're the only thing worth staring at in this whole shitball room."

Apostrophe promptly sat down. "Don't you love this part," she said, "where you've just met someone, but you don't really know them at all, so everything is fresh and mysterious and you feel just like an explorer landed on the shore of some thrilling, strange continent?"

"What if the continent is Antarctica?" he said.

Apostrophe smiled. "I've got warm clothes."

His name was Graveyard. His girlfriend had left him that very morning. She hadn't liked how he looked at her anymore.

"Maybe a lot of people broke up today," said Apostrophe.

"Probably it's the moon," said Graveyard. "Or something creepy like that."

"Or the chemicals in our food."

"Or the chemicals in the air."

"Something's doing it."

"We can't seem to stay together for very long."

"Even if we want to."

He had these weird unclassifiable eyes that looked like broken crystal. She could not stop peering into them. She could see herself on the other side. It made her insides go all fuzzy.

"I like grape bubblegum," said Graveyard.

"My favorite," said Apostrophe.

"I hate cell phones."

"Me too."

"Do you have one anyway?"

"Yes."

"Me too."

Graveyard was rich. She could tell. The money part of the brain that bings and bongs so loudly in most other people was sound asleep in his. It was hibernating.

"Sometimes I like to party for days on end," said Apostrophe.

"Disappear inside yourself."

"You never know what you'll find."

"I've been to the end of my ride. Know what's there?"

"Tell me."

"Sawdust and crazy-house mirrors."

They ordered the glazed weasel medallions with beet fries and freshly irradiated garden salad. They fed each other with their hands.

Apostrophe could feel his fingers on her lips. She wanted to bite them.

"I like trains," said Graveyard.

"Especially the scenic cars," said Apostrophe. "With the glass bubble on top."

"I hate to get where I'm going too quickly."

"It's unnatural."

"All destinations should be approached gradually."

"Except this one." Apostrophe leaned over and kissed him. For a moment she forgot who she was.

"I liked that," said Graveyard.

"Me too," said Apostrophe.

Graveyard also liked the sun in the morning and the moon at night.

As did Apostrophe.

They went back to Apostrophe's suite at the Hotel Cellophane and they had sex. Then they had it again.

"I've never smelled your smell before," she said.

"Is it bad?"

"No."

"What's it smell like?"

"Skin."

Apostrophe fell asleep holding Graveyard's hand. She dreamed. They were good dreams.

Sometime in the middle of the night Apostrophe woke up. She lay there for a while on the wet sheets, listening to Graveyard snore. She thought about Ratio. She wondered where he was. She wondered how he was. Then she realized she wished he were dead. She really did.

When she got up to take a pee, Apostrophe noticed that the room had somehow gotten lighter. She stepped to the window. She looked out. It was snowing. She couldn't see a thing. The blown crystals made hissing sounds against the glass. The snow looked like sugar. I want to remember this, thought Apostrophe. The city vanished beneath blowing mounds of sweet stuff. Angles and edges and solids made soft and obscure. Good enough to eat. The sight made her feel lonely and sad and happy all at once. She couldn't sort out the parts of her heart. She really didn't want to. The snow hissed. Graveyard snored. The world went away. This was not a vision. This was not an "epiphany." We know how she felt about those. It was nothing, really. Just one brief, imperishable moment, however small, however still, in the time of a big, loud country.

Hungerford Bridge
Elizabeth Hand

I HADN'T HEARD FROM Miles for several months when he wrote to ask if I wanted to get together for lunch. Of course I did, and several days later I met him at a noisy, cheerful restaurant at South Bank. It was early February, London still somewhat dazed by the heavy snowfall that had recently paralyzed the city. The Thames seemed a river of lead; a black skim of ice made the sidewalks treacherous—I'd seen another man fall as I'd walked from Waterloo Station—and I wished I'd worn something warmer than the old wool greatcoat I'd had since college.

But once settled into the seat across from Miles, all that fell away. "You're looking well, Robbie," he said, smiling.

"You too."

He smiled again, his pale eyes still locked with mine, and I felt that familiar frisson: caught between chagrin and joy that I'd been summoned. We'd met decades earlier at Cambridge; if I hadn't been a Texan, with the faint gloss of exoticism conferred by my accent and Justin boots, I doubt if he would have bothered with me at all.

But he did. Being chosen as a friend by Miles carried something of the unease of being hypnotized: Even now, I felt as I imagine a starling would, staring into the seed black eyes of a krait. It wasn't just his beauty, still remarkable enough to turn heads in the restaurant, or his attire, though these would have been enough. Miles looked and dressed as though he'd stepped from a Beardsley drawing, wearing bespoke Edwardian suits and vintage Clark shoes he found at charity shops. He still wore his graying hair longish, artfully swept back from a delicate face to showcase a mustache that, on special occasions, would be waxed and curled so precisely it resembled a tiny pair of spectacles perched above his upper lip.

On anyone else this would have looked twee. Actually, on Miles it looked twee; but his friends forgave him everything, even his drunken recitations from *Peter Pan*, in which he'd played the lead as a boy.

I knew my place in the Neverland hierarchy: I was Smee, sentimental and loyal, slightly ridiculous. I doubt that, even as an infant,

18

Miles had ever been ridiculous. His demeanor was at once aloof and good-natured, as though he'd wandered into the wrong party but was too well mannered to embarrass his host or the other guests by bringing this fact to their attention. His mother was a notorious groupie who was living out her twilight years in Exeter; his father could have been any one of a number of major or minor rock stars whose luxurious hair and petulant mouth Miles had inherited. Back at Cambridge, he'd scattered offhand anecdotes the way other students scattered cigarette ash. His great-aunt had been Diana Mitford's best friend; as a child, Miles had tea with Mitford, and upon the aunt's death he inherited a sterling lemon squeezer engraved with the initials AH. Once, camping with a friend on Dartmoor, he'd found a dead stag slung over the branches of a tree, the footprints of an enormous cat in the boggy earth beneath. A German head of state had fellated him in a public men's room in Marrakech. He'd been Jeanne Moreau's lover when he was thirteen, and had his first play produced at the Donmar Warehouse two years later.

That sort of thing. Now he gazed at me, and unexpectedly laughed in delight.

"Robbie! It really is so good to see you."

When the waiter arrived, Miles asked for a Malbec that was not on the wine list, but which appeared and was opened with a flourish several minutes later.

"We'll pour, thanks." Miles gently shooed the waiter off. "Here—"

He filled my glass, then his own. "To happy endings."

Over lunch we gossiped about old friends. Kevin Bailey had lost everything in the crash and was rumored to be living under an assumed name in Portugal. Missy Severence had some work done with a plastic surgeon Miles knew, and looked fabulous. Khalil Devan's third wife was expecting twins.

"And you've been OK?" Miles refilled my glass. "You really look great, Robbie. And happy—you even look relatively happy."

I shrugged. "I *am* happy. Happy enough, anyway. I mean, it doesn't take much. I've still got a job, at any rate. And my rent hasn't gone up."

"Mmmm."

For a minute Miles stared at me thoughtfully. I was used to these silences, which usually preceded an account of recent disturbances among some subset of sexual specialists in a town I'd never heard of.

Now, however, Miles just tapped his lower lip. Finally he tilted his head, nodded, and gave me a sharp look.

19

"Come on," he said. He removed a sheaf of notes from his wallet and shoved them under the empty wine bottle, pulled on his fawn-colored overcoat and wide-brimmed hat as he headed for the door. "Let's get out of here."

We walked across Hungerford Bridge in the intermittent rain, skirting puddles and pockets of slush. Below us the Thames reflected empty, parchment-colored sky. When I looked back across the water, the buildings on the opposite bank seemed etched upon a vast blank scroll, a barge's wake providing a single ink stroke. Gulls wheeled and screamed. The air smelled of petrol, and snow. Beside me Miles walked slowly, heedless of damp staining the tips of his oxblood shoes.

"I think I'm going away," he said at last.

"Away? Where?"

"I don't know. Australia, maybe. Or Tierra del Fuego. Someplace warm."

"Tierra del Fuego's not warm."

He laughed. "That settles it then. Australia!"

We'd reached the other side of the bridge. Miles stopped, staring down past a dank alley. On the far side of the alley, a wedge of green gleamed between grimy buildings and cars rushing past the Thames, the intricate warren of doors and tunnels that led into Embankment tube station. I always noted this bit of park as I rushed to or from work: a verdant mirage suspended between Victoria Embankment and the roil of central London, like a shard of stained-glass window that had survived the bombing of its cathedral. Depending on the season, the sidewalk leading into it might be rain washed or sifted with autumn leaves beneath a huge ivy-covered plane tree.

Now the swatch of green glowed, lamplike, in the cold drizzle.

"Let's go down there," said Miles. "I want to show you something."

We wound our way through the pedestrian tunnel and downstairs into the street. A flower stall stood outside the subway entrance, banks of Asian lilies and creamy roses, bundled green wands of daffodils that had yet to bloom. It smelled like a garden after rain, or a wedding. A black-clad girl moved slowly among her wares, rearranging delphiniums and setting up placards with prices scrawled in red marker. Miles tipped his hat to her as we passed. She smiled, and the sweet scents of damp earth and freesia trailed us into the park.

"You know, I've never been here." I drew alongside Miles. "All these years I've just seen it from up there—"

I pointed to where the bridge's span had disappeared behind a

crosshatch of brick and peeling billboards. "I don't even know what it's called."

"Victoria Embankment Park." Miles stopped and looked around, like a fox testing the air. "I haven't been here in a while myself."

For a few minutes we walked in silence. The park was much larger than I'd thought. There was an ornate water gate to one side, relic of a Tudor mansion now long gone. Several maintenance men smoked and laughed outside a brick utility building. A few other people strolled along the sidewalk, hunched against the frigid rain. Businessmen, a young woman walking a small dog. Tall rhododendrons clustered alongside the path, leaves glossy as carven jade, and box trees that smelled mysteriously of my childhood.

"This was all the tidal shore of the Thames." Miles gestured at the river. "They filled it in around 1851, thus Embankment. I always wonder what they'd find if they dug it up again."

We continued on. Signs warned us from the grass, close cropped as a golf green. A large statue of Robert Burns stared at us impassively, and I wondered if this was what Miles wanted me to see.

But we walked past Burns, past the immense plane trees shedding bark like a lizard's skin, past an outdoor café open despite the weather, and some wildly incongruous-looking palms with long spear-shaped leaves. Perhaps a hundred feet away, Cleopatra's Needle rose above the traffic, guarded by two patient sphinxes.

"Here. This is as good a spot as any."

Miles walked to a bench and sat. I settled next to him, tugging my collar against the cold. "I should've worn a hat."

He didn't even glance at me. His eyes were fixed on a small, curved patch of garden on the other side of the path, two steps away. Forlorn cowslips with limp stems and papery leaves had been recently planted at the garden's edge. The wind carried the cold scent of overturned earth, and a fainter, sweeter fragrance: lilies of the valley, though I saw none in bloom. Here too the grass was close cropped, though there were several small depressions where the roots of a great plane tree thrust through the dirt. Moles, I thought, or maybe the marks of older plantings. Behind it all ran a crumbling brick wall about six feet in height, topped by the knotty, intertwined branches of an espaliered tree growing on the other side. This, along with the ancient plane tree, made our bench feel part of a tiny enclave. The sounds of traffic grew muffled. People passing us on the main path just a few yards off seemed to lower their voices.

"It's lovely," I murmured.

21

"Hush," said Miles.

He continued to gaze fiercely at the green sward across from us. I leaned back against the bench and tried to get comfortable. The brick wall provided some shelter from the rain, but I still shivered. After a few minutes Miles moved so that he pressed against my side, and I sighed in thanks, grateful for the warmth.

We sat there for a long time. Over an hour, I noted when I glanced at my watch, though Miles frowned so vehemently I didn't check again. Now and then I'd glance at him from the corner of my eye. He still stared resolutely at the patch of garden, his expression remote as Cleopatra's sphinxes.

Another hour might have passed. The wind shifted. The rain stopped, and it felt warmer; the light slanting through the linden branches grew tinged with violet.

Beside me, Miles abruptly drew a deeper breath as his body tensed. His face grew rigid, his eyes widened, and his mouth parted. I must have moved as well—he hissed warningly, and my gaze flashed back to the swath of green.

At the base of the plane tree something moved. A falling leaf, I thought, or a ribbon of peeling bark trapped between the tangled roots.

Then it gave an odd, sudden hop, and I thought it was some sort of wren, or even a large frog, or perhaps a child's toy.

The something scurried across the turf and stopped. For the first time I saw it clearly: a creature the size of my balled fist, a hedgehog surely—pointed snout, upraised spines, a tiny out-thrust arrow of a tail, legs invisible beneath its rounded torso.

But it was green—a brilliant, jewel-like green, like the carapace of a scarab beetle. Its spikes weren't spikes at all but tiny overlapping scales, or maybe feathers shot through with iridescent mauve and amethyst as it moved. Its eyes were the rich damson of a pansy's inner petals, and as it nosed at the grass I saw that its snout ended in a beak like an echidna's, the same deep purple as its eyes. I gasped, and felt Miles stiffen as the creature froze and raised its head slightly. A moment later it looked down and once more began poking at the grass.

My heart raced. I shut my eyes, fighting to calm myself but also to determine if this was a dream or some weird drunken flashback inspired by Miles.

But when I looked again the creature was still there, scurrying obliviously between tree roots and cowslips. Its beaklike snout poked into the soft black earth, occasionally emerged with a writhing worm

22

or beetle impaled upon it. Once, the wind stirred a dead leaf: Startled, the creature halted. Its scales rose to form a stiff, brilliantly colored armor, a farthingale glimmering every shade of violet and green. Vermilion claws protruded from beneath its body; a bright droplet appeared at the end of the pointed beak as it made an ominous, low humming sound, like a swarm of bees.

A minute crept by, and when no predator appeared, the scales flattened, the shining claws withdrew, and the creature scurried as before. Sometimes it came to the very edge of the garden plot, where upright paving stones formed an embankment. I would hold my breath then, terrified that I'd frighten it, but the creature only thrust its beak fruitlessly between the cracks, and finally turned back.

In all that time I neither heard nor saw another person save Miles, silent as a statue beside me—I was so focused upon the creature's solitary hunt that I might have been bludgeoned or robbed, and never known it.

Gradually the afternoon wore away; gradually the world about us took on a lavender cast that deepened, from hyacinth to heliotrope to the leaden, enveloping gloom of London's winter twilight. Without warning, the creature lifted its head from where it had been feeding, turned, scurried back toward the plane tree, and disappeared into one of the holes there. I blinked and held my breath again, willing it to reappear.

It never did. After a minute Miles leaned back against the bench and stretched. He looked at me and smiled, yet his eyes were sad. More than sad: He appeared heartbroken.

"What the *hell* was that?" I demanded. Two teenagers walking side by side and texting on their mobiles glanced at me and laughed.

"The emerald foliot," Miles replied.

"What the hell is the emerald foliot?"

He shrugged. "What you saw—that's it. Don't get pissy with me; it's all I know."

He jumped to his feet and bounced up and down on his heels. "Jesus, I'm frozen. Let's get out of here. I'll walk you back across the bridge."

My leg was asleep so it was a moment before I could run to catch up with him.

"For fuck's sake, Miles, you have to tell me what that was—what that was all about."

"I told you all I know." He shoved his hands into his pockets, shivering now himself. "God, it's cold. It's called the emerald foliot—"

23

"*Who* calls it the emerald foliot?"

"Well, me. And the person who showed me. And now you."

"But who showed you? Are there more? I mean, it should be in a museum or a zoo or—Christ, I don't know! Something. Are they studying it? Why doesn't anyone know about it?"

Miles stopped beneath the overhang at the entrance to the tube station. He leaned against the wall, out of the wind, and a short distance from the throngs hurrying home from work. "Nobody knows because nobody knows, Robbie. You know, and I know, and the person who told me knows. And I guess if he—or she—is still alive, the person who told *him* knows.

"But that's it—that's all. In the whole entire world, we're the only ones."

His eyes glittered—with excitement, but also tears. He wiped them away, unashamed, and smiled. "I wanted you to know, Robbie. I wanted you to be the next one."

I rubbed my forehead, in impatience and disbelief, swore loudly, then aligned myself against the wall at his side. I was trying desperately to keep my temper.

"Next one what?" I said at last.

"The next one who knows. That's how it works—someone shows you, just like I showed you. But then—"

His voice broke, and he went on. "But then the other person, the first person—we never go there again. We never see it again. Ever."

"You mean it only comes out once a year or something?"

He shook his head sadly. "No. It comes out all the time—I mean, I assume it does, but who knows? I've only seen it twice. The first time was when someone showed me. And now, the second time, the last time—with you."

"But." I took a deep breath, fumbled instinctively in my pocket for a cigarette, though I'd quit years ago.

"Here." Miles withdrew a leather cigarette case, opened it, and offered one to me, took one for himself, then lit both.

I inhaled deeply, waited before speaking again. "OK. So you showed it to me, and someone showed it to you—who? When?"

"I can't tell you. But a long time ago—right after college, I guess."

"Why can't you tell me?"

"I just can't." Miles stared at the pavement. "It's not allowed."

"Who doesn't allow it?"

"I don't know. It's just not done. And you—"

He lifted his head to gaze at me, his eyes burning. "You can't tell

anyone either, Robbie. Ever. Not until it's your turn, and you show someone else."

"And then it's over? I never see it again?"

He nodded. "That's right. You never see it again."

I felt a surge of impatience, and despair. "Just twice, in my whole life?"

He smiled. "That's more than most people get. More than anyone gets, except us."

"And whoever showed you, and whoever showed her. Or him."

Miles finished his cigarette, dropped it, and ground it fastidiously beneath the tip of one oxblood shoe. I did the same, and together we began to walk back upstairs.

"So how long has this been going on?" We stepped onto Hungerford Bridge, and I stopped to look down at the fractal view of the park, no longer green but yellowish from the glow of crime lights. "A hundred years? Thousands?"

"I don't know. Maybe. I mean, the park wasn't always there, but something was, before they made the embankment. The river. Enormous houses. But I think it's gone on longer than that."

"And no one else knows?"

"No one else knows." He gazed at the park, then glanced over his shoulder at people rushing across the bridge. Someone bumped me, muttered, "*Sorry,*" and trudged on. "Unless everyone does, and they're all very good at keeping a secret."

He laughed, and we started walking again. "Why did you decide to tell me?"

"I don't know. I've known you so long. You seem like someone who'd appreciate it. And also, you can keep a secret. Like you never told about Brian and that dog in Sussex."

I winced at the memory. "Is there a set time when you tell the next person? Or do you just make up your mind and do it?"

"You can tell whoever you want, whenever you want. Some people do right away—the next day, or a week later. But I think most people wait—that's what I was told, anyway. Though you don't want to wait too long—I mean, you don't want to wait till you're so ancient and infirm you forget about it or die before you tell the next one."

I must have looked stricken, because he laughed again and put his arm around me. "No, I'm fine, Robbie, I swear! I just, you know, decided it was time for a change of scenery. Warmer climes, adventures. A new career in a new town."

We'd reached the far side of the bridge.

"I'll leave you here." Miles glanced at his mobile, read a message, and smiled slightly before glancing at me again. "I'm not falling off the end of the earth, Robbie! I'll be in touch. Till then—"

He raised a finger and touched it to my lips. "Not a word," he murmured, then kissed my cheek in farewell, spun on his heel, and began striding back across the bridge.

I watched him go, his fawn-colored greatcoat and wide-brimmed hat, until night swallowed him. For a few minutes I stood there, gazing past the bridge's span to the dark river below, the image of a gemlike creature flickering across my vision and Miles's kiss still warm upon my cheek.

Then I turned, head down, as a blast of wind blew up from the underground station, and hurried to catch my train.

Secret Breathing Techniques
Ben Marcus

I HAD APPARENTLY BEEN living in one of the towns that was now gone. According to reports, I held my own against one of the younger organizations. I fought well and long. The ending of the report is muddy, with many foreign words and phrases, and an indecipherable series of pictures. There is no clear sense that I survived.

Photographs of my body had circulated, flags had been stitched with secret instructions.

There were instances of my name in the registry—the spelling varied, and my date of birth was frequently listed as unknown. A scroll of hair, probably my own, was taped to the paper. Mention was made of what must have been my house, a vehicle I summoned to cross the water (skirmishes, courtship, evasions—the report is unclear), and the amount of sacking I had contributed to the yearly mountain effort. I ranked slightly above average.

People wrote of seeing me in the morning by the water; several photographs featured me wearing a beard, concealing something in my coat. A Nacht diagram rated me favorably, prior to the revision. The Wixx index claimed I might have perished. I read accounts of myself ostensibly accompanying a family to the market on Saturdays. I may have been their assistant; I may have been their captor. The wording is vague. Some sentences depicted me handling the bread in an aggressive manner, as if searching for something inside it.

It is possible I was collecting samples. I would not rule it out. It would explain the long clear jars I found stored in my clothing that day when I woke. But it would not explain why those jars were empty.

In the clearing beyond where I'd slept there were men smashing spades against the sand, the sound of children holding their breath. It was the first promising sign I had seen. I knew to breathe in threes, to squint, to crouch while surveying, lest I be deceived. Such were the ways I would keep myself alert.

Elsewhere in cities the men were reportedly listless, sleeping in long troughs lining the town square, their exhalations steaming in unison over the river. It would be the season of strategic fatigue. Many citizens carried slender needles and used them to induce sluggishness. Exertion had been mostly ruled out since February. Motion was under a quota.

I practiced a paralysis style I'd learned as a child as I waited for the others to stop moving. The footage, if examined, would depict a man awash in the brush. That man would not come when called. That man would not even speak. But inside him there would be life, of sorts. A kind of loud activity that would constitute his secret.

As far as I knew, I had not been breathing well that day. It was too early in the season to steal much air from the region and I was favoring my lungs for the later peril. This was called pacing. If you did not pace, you blew out. If you blew out, you were left roadside, where picking occurred, where feeding occurred, where a type of casual violence might visit.

But after a full day of travel from the city, I crouched in the scattered pine needles and allowed myself several full breaths, which filled my chest like one of the early waters and brought on several uncomfortable memories. There was no time to extract the paper cutouts from my knapsack, to stage a scenario alleviation, so I exhaled shallowly, through a mouth shape that I rarely used, one that reminded me of my younger self, until the memories grew thin again and retreated outside my person.

I should start with those moments I can relate firsthand, which will restrict me to events involving the mountain and the town. It reminds me of the beginning to a famous old story: *"There was a town, above which loomed a mountain, beyond which threatened a sky, from which came a certain person."* Is it simply a coincidence that my story begins the same way?

I am confident I can tell the truth about such matters, that my information is worth imparting, though I recognize my confidence to be a decoy. There will be areas of the report I will fail to relate, usually toward the bottom of each exhalation, where I become emotional and inaccurate. I perform more reliable thinking on the front end of an inhalation.

This report will omit references to a so-called rescue. This report will omit references to an apparent secret breathing technique called the Charlesfield, a method of acquiring air ostensibly bestowed on certain of my partners in the effort. This report will not assert assisted methods of remaining aloft. This report will restrict itself to what is possible, surely a lamentable limitation, but one that is unavoidable.

No mention will be made of a man my mother once knew who breathed through paper.

There were great days of greenery. I saw the sun firsthand. Its proximity made me feel shy—I was just so many years old, I knew just so many things, I felt sensations I could not describe. The shiny items on our path each day were touchable, but we were smart to refrain from contact. Touching them had early on proved fruitless and disappointing. A man should know better than to erase the distance between himself and an object. He should not destroy distance. It would be perilous to reduce my curiosity by knowing things.

Every time I woke up a man lingered over me with calipers, breathing heavily, his mouth as slack as a bag. He posted measurements outside our tents, recording the day's changes—American numbers—our bodies alternately bloating and shrinking as we approached the summit.

Our first task each morning was to assess altitude. This was done with our mouths open, facing upwind. The number was then carved into a stationary rock and dated, in case the altitude in that area would change.

Mr. Hawthorne was small in the mouth cavity, as with many of his family, who could not all open their mouths at once, since they shared dilation privileges. He used his hands to dilate the opening, but he was frequently knocked to the ground anyway. He used people as lean-tos. Those of us with larger mouths stood strong in the valley bluster, letting the area breathe for us.

I spat something up that looked potentially revealing, so I dried it to a shriveled husk on a south-facing rock, and then pocketed that husk for later examination.

There would be four of us this time to make the mountain effort. Some science had gone into the devising of this number, but it was not for me to fathom. We were brought in to face the townspeople at noon on the eve of our trip. I had not met the other three efforteers, and tradition demanded we did not regard each other, so I stood apart from them and kept my head down, practicing a Spanish breathing style that promoted indifference.

Someone's mother sat foremost in the auditorium. She looked to lord herself over all of us. She had the arms of someone in charge. It was easy to feel suspicious of her. She was the first to throw the forecast sticks at us. I watched her pale arms folded in her lap. I do not know why looking at the mother's arms should trouble my focus the way it did, but I was certain for a moment she was covered in canvas, which would have been poor foreboding. I did not wish to see a cloth-covered lady, particularly before a journey. I had read enough of the Bible to be afraid. During my introduction, which featured a three-quarters time signature that flowed from the Description Hole, I moved into the center of the room and crouched, wheeling in a circle so all could see me. It was the standard promotional style.

A small crush of applause emerged from the floor grille, clearly prerecorded. I tried to blush. These people would all be dead soon, and I was embarrassed for them.

If I had thoughts, they occurred as hard noises in the foreground, a kind of thunder I walked into to discover instructions. Even though motion was mainly restricted, it was the primary way to discover what to do. The thoughts were mainly of myself. I rehearsed what I would do in certain scenarios, should the scenarios arise, though the scenarios were mostly unlikely or impossible.

One of the unlikely scenarios was that we, the four hikers, would return alive. We nursed the possibility regardless. I rehearsed a living posture. A probablist followed us through the valley, chanting his numbers. He walked with short, hard steps and surveyed the landscape, throwing his Estimate Sticks into the distance, which made a sound like small bones snapping. We knew not to try to outrun him, for we needed to save energy when the incline came, yet it was difficult to hear him decrease our chances for survival as we progressed,

his numbers growing shorter and less exotic as we walked, his mouth cinching over time into the smallest little button.

We desired to walk toward the longer numbers, but those always seemed behind us, and behind us was where the sun prohibited access. The probablist sang such a song that we saw no animals for days.

There was a morning of thin, false air when we kept to our tents. I could not say which morning it was, but I could hear how fake the day was, how artificial its sounds and smells.

A good map will determine what cannot be breathed, since inhalation toward behavior changing is based on a rough calculus of hills, valleys, and water.

Our maps were fair to good that day, though mine were colorless, and smelled of children.

My partners utilized ventilators ornamented with items from their homes, and alternated surveying the site through their scenario flaps, which filtered out color and the smaller organic life. I parceled my own breaths and rebreathed what I could.

Each breath that I saved in my shirt, that I rebreathed, produced in me a standstill, a deep pause, that generated a slowness even in my partners, so that if I chose to, I could cover all of us in the clear syrup until we froze. It was my first sense that I could stifle their progress entirely through breathing styles of my own invention. It would be another notion I kept to myself, however much my mouth seemed to want to report it.

On the first day of complete air, small sentences became available to our group, sentences such that children might use if they were dying. It was undecided who should use them. A coldness due to elevation prevented most of us from speaking, but someone among us must have felt warm in the mouth, because there arose a quiet language that filled the tent, inducing older feelings in me that I would have preferred to avoid. I knew that an overdeveloped sensitivity would ostracize me from my partners, so I practiced an inner translation of all that I heard, until I was speaking again in a simple child's voice that used tones mostly of wonder and awe. This was a speech that my face found strenuous and foreign, but I persisted.

Knowingness, I sensed, was a peril. Belief was a peril. Certainty

was a peril. I chose a low conflict mode and wore it deeply. I adopted a silent accent.

A notion arose that our bodies were being used as a repository for feelings that were not our own. We were being employed as storage containers. Who created this notion I do not know, but we were all at once nodding to each other, affirming a belief that had yet to be fully articulated. In any case there was the sense that we were acting together.

This language in the tent was producing certain attitudes and ideas in us: We should climb only at night. We should burn a shirt each morning. We had been sent from the town in a purging action. We should escape the statistician, who had lapsed into inaccuracy. The statistician was a withered old man from Gregge. Our people at home were being killed. Our people at home had been killed. Our people at home were no longer there—but then where would they be?

The suspicion I kept to myself: It was I who had accomplished this purging and killing, through actions I no longer cared to remember. Why else would I have felt so uncomfortable? I looked at the statistician, slumping against the tent wall, his mouth embossed with a customized Gregge that shone in a conventional way. We had all conspired to look so seductive. It seemed useful to remain open to the possibility that I was this man, or a portion of him, even though his shallow, wet breathing style seemed entirely foreign to me. How appropriate, then, that this person of remote techniques was a facet of myself I had been ignoring?

Silence was the tactic I favored.

The first real day I remember was the day of needles, since all of us had courted a partial paralysis as a mode of prayer. It followed the day of grain, which I only read about later. In the day of grain a prediction was issued regarding tomorrow, tentatively termed the day of blankets, since a smothering had been predicted, which of course would prove untrue, and would be retracted. I regarded this tentative prediction with suspicion, since the day of needles had forced me from my tent on a long, steep ascent, free of partners, even though climbing alone was deemed aggressive, violent, asking for retribution. I used a one-person language on myself and purged most of my confusions. Once my vocabulary had been exhausted I resorted to gesture, and when my limbs and face were stricken w/ fatigue I fell back on thought, though that too was a kind of secret motion,

requiring a high-speed travel of blood through my body, a greedy travel that I knew would soon put me in further danger.

Even as I climbed, I knew that a prediction had been made that I would climb alone, struggling against a loose stream of rocks. I carried the prediction within me, unsure of how public it had been and why I again was suffered to know something incidental and unimportant that had yet to occur.

If confronted, I would claim the need to establish a lookout position, though my real motivation would remain hidden, even from myself. I would simply not know what I had been doing, and this would have to be acceptable. But from then on—and this really happened—I would remain isolated from the others, outside their language. I would satisfy their need to produce a treason, a killing. Alone in my corner of the tent, uncomfortable with English sentences and their mouth-breaking force, I would look like the perfect target for their weapons. It was comforting then to discover that I might be of some use.

There were too many tactics to trace. We had surpassed our strategy quota. I was tired of having ideas. Luckily there were men among us, high-altitude persons, who were eager to think for the group. Not only did they think, but they spoke of what they thought, and if that wasn't extreme enough, they believed what they spoke and seemed ready to enforce their ideas with weaponry. I wished that just for a moment I could feel, however fleetingly, that I was not controlling their mouths.

There would be nothing more comfortable to me than knowing I had failed to understand entirely everything up to this point. I wish I could say I did not know the meaning of the word "mountain." A comfort, to not understand sentences. A comfort, to fail to recognize people. A comfort, to find all languages foreign.

I would feel so relaxed to know that I never understood my expedition, that sentences of unbearable sound came from my head.

If only I could know something as simple as that.

In truth, I had a fairly clear sense of my name and my purpose. I understood my people to be dead. I felt a kind of invisible harm circling me that I knew the others would only call air.

When I looked down on the town from the high ledge we had gained, I saw nothing.

The Personasts:
My Journeys Through Soft Evenings and Famous Secrets

Stephen Marche

IT HAD BEEN TWO YEARS since my last soft evening and I arrived forty-five minutes late to Madeleine Reid's sprawling neocolonial in the Tuscan Hills subdivision an hour and a half outside San Diego. In the living room, a young Asian woman had already covered herself in Dressdown's rags and dung-smeared leaves and sat in the empty space at the center of the room scratching her arms and chest, muttering low profanities. A magnificent collection of throws covered the twelve-piece beige sectional, and the other six guests were either watching or dressing. Somebody had already taken the throw of Ninja, and was hiding behind the curtain of the nearest window. The young man nearest me began putting on Mitzi. Mitzi is simple: a gingham dress with a crinoline and a pack of Lucky Strikes. Mitzi smokes and walks barefoot. A friend of mine who regularly becomes her describes Mitzi as a seventy-year-old woman who wakes up in a twenty-two-year-old's body. Even though she never exposes herself and would never dare touch a man, she considers herself very risqué indeed, old-fashioned in her sluttiness.

A fiftyish woman with close-cropped hair had just put an unlit cigar in her mouth. She was Monopoly. Sponge-bag trousers, silk top hat, and morning coat are the other elements of Monopoly's throw. Because of the ludicrous vocabulary and the fact that he's constantly comparing himself to Winston Churchill, I assumed for years that Monopoly was based on Conrad Black, and I was only convinced otherwise when another Personast told me she had seen Monopoly spun in a Dallas suburb in the early seventies. The name, combined with the turn, is probably a tip-off. Americans assume he's a version of the plutocrat character from the game Monopoly. It does explain the name and the top hat but not the sour mood. Perhaps Monopoly is a combination of the two, or perhaps neither. The origin of any highway is never better than vague.

Suddenly Dressdown screamed out: "My back crunches like candy

in a six-year-old's baby teeth. Pain candy. Positronic confibulators! Pain candy! Why won't any of you help me?" To me the greatest pleasures of Personism are such expected surprises. In *Melodies of Self*, published in 1999, Columbia sociologist and practicing Person- ast Carol Reinhardt described soft evenings as "living tension between posing and becoming, a tension so unstable that it vibrates into a kind of bell tone. It's a tension between posing and being, but it's also a relief of that tension, a relief into noisy silence." Ninja somersaulted through the center of the room into a low crouching warrior's pose. His eyes shifted back and forth for a moment. Then he rolled back to the periphery.

I remember almost nothing from the rest of the soft evening because I soon entered myself for a spin as Nick Charles. The others followed quickly afterward, as The Old Gunfighter, Seagull, and Mr. Clean. Madeleine, our host, entered last, as Joan. We spun a lot of turns that night: Violent B, The Mercy Man, Rufus Wainwright, Sammy Sexy as Shit, Oliver Twist, Mary Magdalene, Scaramouche. Two highways I had never encountered before came—Tramontate and Gumper. The former reminded me vaguely of Luciano Pavarotti, the latter of a beautiful teenage girl's teddy bear. My other memories of the evening are nothing more, really, than a series of cool, glitter- ing, ephemeral impressions. This was the softness I had craved in my return to Personism, the softness of the highways and afterward the security of the quiet rooms. Lost in the suburbs, I was home again.

Soft evenings always end with quiet rooms. Before the spins every door in the house is left open, until one by one the members leave the highways for privacy. Madeleine was kind enough to provide each room with noise cancellation headgear and I relished the smooth letdown—like a hot shower after the big game—for perhaps too long. When I emerged, I was again the last one to the party.

The turns had all been tucked away. Madeleine introduced me to the group, a fairly typical assortment for a soft evening. Maxwell Cho, architect, and his stay-at-home wife, Geraldine, had just moved from San Francisco. The other married couple, Quincy and Khadija, were both copyright lawyers—the box-ticking world-builder types. The lesbians, Marcie and Sammy, looked like young Grandma Moseses. Together they owned a sex shop catering exclusively to women. We had the typical conversations: models of cars, babysit- ters, cleaning ladies, vacations, mortgages, renovations, gas prices, and above all real estate. Intimate abandon doesn't end the need for small talk.

"Are you new?" Marcie or Sammy asked me. For a moment I worried that I had misperformed my spin along the highway, that they thought I was a newbie. Then I remembered I had arrived late. She was asking me if I was new to the city.

"No, I'm just getting back into the highways," I replied.

"You took a break?"

"Two years."

"Like Björk."

The Icelandic pop star is the celebrity most open about her Personism. In a recent article in *Rolling Stone,* she discussed falling into and out of the practice. It was the same article that had made such controversial claims about the blindings in Evanston, Illinois, being motivated by Personism. Marcie or Sammy and I changed the subject. We were making the rest of the room uncomfortable. Personasts do not talk about Personism at soft evenings; in playgroups and parking lots and soccer practices, yes, but not at soft evenings. The latest "revelations" about Personism in the press have made these silences even more necessary.

Accurate figures on the rise of Personism are difficult to come by. The census keeps no record of Personism because it is not considered a religion. The sociologists who have tried to establish its scope arrive at wildly different conclusions. Estimates for the US and Canada begin at seven hundred thousand and reach as high as several million. Everyone agrees, however, that Personism is spreading. "Every suburb now has its nightly session, and where the suburbs go, Personism follows," writes Carol Reinhardt. "It was a major force by 1982. In the past twenty-five years, Personism has doubled and redoubled countless times." Due to the casual nature of attendance probably no definite answer as to the exact number of Personasts is possible. Other questions are more haunting and urgent to outsiders: What is the source of the power in this movement that has no institutions and no leaders? What emotion transports the Personasts into their whirligig of shifting identities? What insanity makes them perform the "famous secrets," branding themselves, releasing wild animals on city streets, burning money?

My own off-and-on relationship with Personism is more or less typical. When I was seventeen, a girlfriend brought me to my first session. At university, I dropped the soft evenings because I had other things to explore. Then I started work at the quality assurance

department of a multinational legal publishing company in Scarborough, Ontario, and began attending soft evenings at least once a week. My favorite group was over an hour and a half away, deep in an industrial park on the other side of town. My spins with them lasted over two years, my longest uninterrupted stint on the highways.

Manny Seligman, in his 1993 book, *The Gods Beyond the Wall: A Field Guide to Spiritual Sprawl*, identifies over three thousand different highways. Many highways are simply well-known historical personalities: Jesus, Buddha, JFK, Malcolm X, Byron, Lorca, Mao, Hitler, Bob Dylan, and so on. Local variations are common. In Canada, I've seen Pierre Trudeau; in California, Ron Howard. Celebrity highways have a tendency to appear and disappear violently. At the time of writing, Paris Hilton appears nightly all over the continent but in six months to a year she will have vanished completely. Purist Personasts tend to look down on celebrity spins because they're so shallow.

Highways from literature are rare but often deeply felt and are more or less permanent: Oliver Twist, Bruce Lee, and King Lear will always have a place at good soft evenings. Commercials produce highways: The Michelin Man, Mr. Clean, and Harpy the Happy Housewife. Other highways represent not people so much as ways of speaking. The highway called Confucius utters aphorisms, but these aphorisms are not limited to Confucian sayings. I have heard Confucius quote Marcus Aurelius, Zen koans, and Led Zeppelin lyrics. The Homer highway would not be recognizably Homeric to a Classics scholar. He just speaks with extended, overblown metaphors.

The vast majority of highways present no clear origin and don't fit any category. The most common are Lili, Dressdown, The Baron, The Swinger, Violent B, Scarface, Dick, The Craving, Mr. Bibbly Burton, Trampoline, Vocallisimus, and The Seagull. To complicate the system even further, many highways seem to stand between categories. Often these in-between highways are feminine. Joan, for example, is a combination of Joan of Arc and Joan Baez dressed in flapper clothes. Barbra and Simone similarly fuse celebrity (Barbara Streisand and Simone de Beauvoir) with fictions (Barbra is a visitor from outer space and Simone is a cynical gardener).

Any explanation for the mass appeal of Personism has to be found in the experience of the soft evening. The soft evening is soft because it is careless, forgetful, the easiest liberation. In the softest evenings, the exquisite loss of the highways stretches into a feeling of distance,

a crack that is also a chasm between oneself and everything that matters. After a very soft evening I sometimes feel like I can see into the spirits of strangers in their cars or on their lawns or at their windows. But soft evenings are also profoundly silly. They are childish pranks, larks.

To understand Personism, however, one also has to recognize the power and beauty of the "famous secrets," which, because they are so poorly understood, tend to be the aspect of Personast practice most frightening to outsiders, the basis of the wildest rumors. If soft evenings are the downtown core of Personism, then the famous secrets are the suburban sprawl. They are the ceremonies for the loyal few, for those who experience Personism as a part of life rather than an escape from it.

Waste is a big theme in the famous secret ceremonies. A mortgage-burning party is the most common famous secret. Burning piles of one-dollar bills is common as well, and pouring bottles of champagne or vodka into sewers. Other famous secrets seem designed to leave minute marks on other people: giving large sums of money, like twenty thousand dollars, to mentally ill homeless men, or buying the clothes off their backs or paying them to clean up messes of caviar. Other famous secrets focus on the body: deep tanning, excessive exercise, fasting, tattoos or brands (generally of a small gray cloverleaf or red octagon). Sometimes Personast ceremonies integrate easily into religious life. The release of doves at weddings began as a famous secret. Other ceremonies act as replacements for religious rituals. A Personast funeral involves placing the deceased's ashes into a simple clay pot, hiking into a silent place, walking a hundred yards from the path, and leaving the pot behind.

My own experiences with famous secrets have been rare but powerful. In my sessions at the legal publisher's, I once witnessed a friend, with a salary of $27,000 a year, burn a small pile of hundreds amounting to nearly seven thousand dollars. The power of the gesture made me sick to my stomach. I dream about it frequently. The sole Personast funeral I attended, in the San Bernardino National Forest, was an overpowering encounter with mortality. But I have always fantasized about trying one famous secret in particular: the liberation of animals. As a celebration of my return to Personism, a pilgrimage of sorts, I decided to try it at last. It would also be a chance to explore the world of organized Personism, which had

expanded during my hiatus from a handful of semiprofessional out-
fits into a real growth industry. Every Personast I knew wanted to set
me up with a company he or she had used. In the end, I went with
Jed Cushing's Cloverleaf Tours based out of Canmore, Alberta, in the
heart of the Canadian Rockies.

Jed is a friendly man but reserved, as might be expected from a pro-
fessional Personast. His business is famous secrets, and he has the
perfected tan and wiry strength of a man whose work is outdoor
leisure. The offices of Cloverleaf Tours, where we met to plan my
trip, were in a cool basement off Canmore's main street. Every
surface was cluttered with Personast paraphernalia. The walls were
covered with photographs from his adventures. Our initial meeting
was comically brief. I introduced myself. He suggested a package
of silence and release at a cost of five hundred dollars. I agreed. He
showed me the door. I wasn't offended by the brevity of the meeting,
though. Some of the famous secrets can be shared only by strangers.

I awoke the next morning to the polite antiseptic bleating of my
alarm clock at 3:30. I listened for a while to the buzzing of the power
lines outside my window and made sure to clean my ears thorough-
ly after a shower.

Jed was waiting for me in the lobby, his Audi parked outside. The
faint murmuring of the Muzak was painful to him, I could tell. We
didn't even say hello. By the time we arrived at Sunshine Mountain
a few hours later, dawn was just beginning to play on the far faces.
The hill was more or less abandoned for the summer but past the
deserted chalet a phantom ski lift continued lifting nobody to no-
where. We loaded ourselves onto a seat and immediately I was aware
of the sound of the breeze. What I assumed was a perfectly still day
was fragile and ragged twenty feet up.

The view was sublime—the shifting penumbras of the rising sun
against the mountains, deer passing below, flocks of birds. I concen-
trated on the sound—the minute tick-tick-ticking of the chair on the
wire, the vast, vital cling-clang as the chair hook caught the rotor of
the pole, and always the wind.

At the top of the hill Jed led me along a small path through stands
of evergreens. The meaty crunch of our boots on the crushed gravel
was deafening. As we crossed an Alpine meadow, even the squelch
of our socks in boots and our boots on the grass were overloud. I
noticed the sound of my boots more than the colors of the hundreds

of wildflowers. We descended beyond a small tarn, through a steep valley filled with galumphing boulders. The valley ended in something like a pile of these boulders, which resembled a cyclopean stairway. Jed stopped me with his hand. He pointed down.

I had to go down alone into the rocks.

There I found silence.

All ambient noise was blocked by the alignment of the stones, all wind too. My own heart's noise grew into a syncopated cash register. It took me a few minutes—or it felt like a few minutes despite my loss of all sense of time—to remember the expected practice for this famous secret. I brought my heart rate down as low as possible. I listened consciously to the silences before and after my heartbeat, paying attention with effort to their encompassing nonsounds.

Soon I was dwelling in true silence. It's no exaggeration to say it was the greatest alleviation of my life.

I dwelt in the silence until a stray host of sparrows overhead passed and wrecked it.

The walk down to the Sunshine Mountain parking lot was so depressing I nearly wept. Others had warned me but their warnings hadn't prepared me. I felt caged in my senses. I craved an end to the sun, to the razorback edges of the mountains, the ruby poppies, my own skin, and above all to the noise. You can't shut your ears, that's the cruelest fact of anatomy, I remember thinking.

It was midafternoon by the time we arrived back at Jed's Audi. He popped the trunk and brought out a cage of Boreal chickadees. And once I released the birds from the cage, the feeling of self-loathing, of loathing at having a body, vanished with them into the mountain air. The genius of the famous secret entered my spirit with all its smoothness and coolness.

Jed was chatty as we drove back to Canmore. "We had perfect weather. When it rains or it's really windy, I don't bother. Sometimes the clouds change in the upper levels and I have to come back with the customers four, sometimes five, times until they find the silence."

"How did you discover that location?" I asked.

"I was a hiker before I became a Personast and I used to love that hollow. I used to hike up there all the time to visit. I didn't know why."

I asked if his hiking had flowed into Personism naturally. "Not at

all. It's like the opposite of loving nature or environmentalism. It's waste. Oblivion."

His sudden friendliness was a relief to me. I was going to spend the night in Canmore and I asked him if he could set me up with a soft evening. He demurred apologetically, claiming he didn't spin on the highways anymore. "I get my fill up here on the mountain during the day." Jed had been on over a hundred famous secrets in foreign countries, in places as distant as Antarctica and Kyrgyzstan. He owned the most expensive noise cancellation technology currently available. "Fifteen grand," he said, tapping the small black ball on the dashboard, which explained why the car was so utterly quiet. His basement held two sensory-deprivation tanks.

"How many trips a week do you take?"

"In the summer as many as three or four. That's all kinds of famous secrets, though. Not just silence and release."

Canmore is a perfect spot for a business like Cloverleaf Tours. Not only is there enormous traffic from the United States and increasing numbers of European Personasts who have bought property in the Canadian Rockies, but the suburban growth in nearby Calgary, an oil town in a boom, offers a handy domestic market. "Every week they plant a new bed of roses and I'm the one with the bouquets," Jed said.

I asked what he thought attracted so many people to Personism.

"Have you seen the trees in those Calgary suburbs? Five-foot trees in the middle of the horizon. City ordinances say you got to have them. That's the only reason they're there. You can live in Pine Lake Hills or in Pine Hill Lake. You get lost. 'Oh no, you're on Riverview Drive in Pleasant Mount View. You want the Riverview Drive in Pleasant Mountain View. It's a very easy mistake to make.' And like that. Which is why I'm here."

The next morning I happened to drive through those suburbs on my way to the airport. The overpasses and cloverleafs in their sublime curves twisted counterintuitively around the never-ending subdivisions, the cathedral-like malls, the walls soundproofing life from the roads, the otiose, mocking patches of grass and sidewalk. This landscape shaped Personism as surely as the Arabian desert shaped Islam or the cool lake of Galilee shaped Christianity. It is also the landscape that shaped me.

In the 1995 case *Reno v. Whittaker*, the United States Supreme Court denied tax-exempt status for Personism on the grounds that it

didn't qualify as a religion. According to the court, Personast activities lack an articulate set of beliefs. Jews, Christians, Muslims, Buddhists, Hindus, and atheists all participate at soft evenings without any sense of contradiction. The term "cult" also doesn't apply. No institution benefits from the soft evenings and leading a session doesn't offer financial or status advantages.

Nonetheless, sociologists and journalists generally treat Personism as a new religion for lack of a better approach. Brett Groundsman, author of *Bless This House: How New Religions Are Shaping Suburban and Exurban American Life,* justified his inclusion of Personism with the claim that its ritual contains "a complete vision of life and the place of the self in the universe." Groundsman had to find this "vision" in peripheral famous secrets surrounding birth and death, ignoring the fact that the majority of Personasts have never heard of these famous secrets and it's hard to see what vision of life, other than ephemerality, one can find in soft evenings.

In search of an answer, or at least clearer questions, I attended the seventh annual conference of SIPS (Society of International Personast Studies) held at the Newport Beach Marriott Hotel in Orange County, California, this past November. The conference venue was almost too appropriate. The hotel's wide grid and large rooms meant that we more or less had to commute to the lobby. The building was attached to Fashion Island, an open-air luxury shopping plaza.

At the opening night, over three hundred professors from two hundred universities drank pinot grigio around the lobby fountain. Mark Grenstein, a professor of sociology at Duke University and the president of SIPS, introduced himself. He was a tall man, at least six foot six, with a slightly vulture-like stoop, an English formality of dress, and courtly manners. He had heard that I was working on an article about my experiences as a Personast. To change the subject, I complimented him on the venue and remarked on its appropriateness to the subject of the conference.

"Yes, Orange County is something of a homecoming. Our first conference in October 2001 took place in Orange County." He himself had not begun his work on Personism then. A colleague at Duke had attended and reported back on the scope of the movement. It coincided powerfully with his own research on faith and human geography. Around that time too, he had attended his first soft evening.

"That's the funny thing about SIPS," he said. "Ninety-nine percent of us practice what we preach, which sounds admirable but

43

doesn't offer the greatest deal of objectivity."

I asked him if the lack of distance was that unusual; the leading scholars of Buddhism tend to be Buddhists, Catholic theologians are Catholic, and so on.

"I'm not saying it's unusual, I'm saying it's problematic. Besides, Personism is not a religion. Above all it's not a religion. Come hear my talk. The entire point of Personism is that it's not a religion."

Professor Grenstein was called away by a SIPS member who wanted to discuss an article in *Rolling Stone*. The whole party was abuzz with the *Rolling Stone* issue. Six months earlier the magazine had claimed ("White Voodoo," May 2007) that a series of blindings in Evanston, Illinois, were the responsibility of "Personast cells" in suburban Chicago. Over the course of two months during the summer of 2005, fifteen people, all homeless men and prostitutes, were dropped in front of Glenbrook and Highland Park Hospitals missing their eyes. They had no recollection of how their eyes had disappeared. Most Personasts, myself included, found the idea that Personasts could blind people absurd. The violence it would take to rip out the eye of a stranger would be opposite in every way to the spirit of relief in soft evenings. It didn't help his credibility that the author, while claiming to be a Personast himself, made basic mistakes. Soft evenings are not like orgies. If we were capable of orgies, we wouldn't need Personism. He also included a description of animal slaughter that could not have been more inaccurate. Silence and release are famous secrets, not holding and killing.

Everyone at the conference agreed that some kind of statement needed to be made and that SIPS was the appropriate body to make that statement, but who was going to make it and how were less clear.

Then at exactly 9:30 the question was abandoned and the hotel lobby emptied. Too late I realized that I had forgotten to make my own arrangements for a soft evening.

Day one of the conference was humming when I managed to navigate the labyrinth of the hotel's hallways to the conference center. The choice of panels and variety of approaches were baffling. In the morning, I heard a member of the faculty of religious studies at Harvard analyze the latest statistics on Personism. Her analyses were new because they took into account the financial and racial criteria of the participants, but her conclusion, as far as I could tell, was

that Personasts were all members of the middle class. Next, Gary Portsmouth, who chairs the urban studies department at Syracuse University, gave a fascinating dissection of the Lili and Mitzi highways, tracing both of them back to a character in Colette's autobiography, *Earthly Paradise.*

As it turned out, I was going to know Gary well by the end of the conference. After lunch, I attended a panel on the rising popularity of Personism on the Upper West Side of Manhattan. One panelist described it as our "Paul Moment"—the moment when experience separates from setting. The man beside me tapped me on the shoulder. It was Gary Portsmouth. "That is quite a misunderstanding, if you are a reporter. A misunderstanding of Paul, of Personism, of the Upper West Side. Allow me to show you."

At SIPS, the soft evenings begin in the middle of the afternoon and end early in the morning. They are different from ordinary soft evenings in their precision and hallucinogenic intensity. The throws, which for most devoted Personasts are four or five objects, become entire costumes with makeup and masks at SIPS. At Gary's session a whole suite had been cleared and filled with two dozen coatracks. People stripped naked before they spun into their highways. Improvisations and integrations were flawless. In the course of the next two days, I witnessed and became the greatest highways of my life. Not only did I meet a dozen fresh highways, like Ivy, Samsung, and Simón Bolívar, but the common ones like Violent B and Sammy Sexy as Shit were illuminated in excruciatingly vivid new ways.

I pulled myself away only to eat and sleep, but did manage to catch the keynote address by Mark Grenstein that wrapped up the conference: "What Do They Dream about in Paradise?" I caught the last five minutes anyway. Less than a dozen people were in attendance. The lecture hall could easily have sat five hundred. "They claim that we're ultimately hollow, that we're just a series of resonant hollow gestures," Mark was saying. "Loneliness is the new epidemic. Loneliness kills more people than heart disease." His voice echoed with double meaning through the hall empty of dreamers too busy dreaming to talk about dreaming.

After the lecture, Gary and I drove out of Orange County. We had agreed to meet some fellow Personasts at an Olive Garden in the City of Industry. There were closer Olive Gardens but after two straight days of highways, we wanted to talk. If we stayed close to

the hotel, conversation would soon develop into a soft evening, we all knew.

"They're all going to be talking about the blindings," Gary said. "That's all they're going to talk about."

"Sensationalism."

"No, it's true. I was in Evanston. The lunatic fringe, but it's there. Soft evenings, then silences, releases, the wastes, the burnings, the self-etchings. You can see. They call it eye popping. The same with the fetuses in Atlanta."

"Why don't you mention it to the others?" I asked after a moment.

Gary shrugged.

The Olive Garden was harder to find than we expected. I needed to stop at a liquor outlet for a few bottles of peach schnapps just in case a soft evening broke out, and the slight change in plans had thrown us off course. We turned off a freeway onto a jammed three-lane highway. It took us half an hour to find a turn off the highway, and we took it. The sun by this time had nearly set. It took us another half hour to find a highway going the right way, and then Gary accidentally drifted into the exit lane. We found ourselves in a dead-end back alley at the rear of what looked like a refinery. A youth standing out of the shadows on a loading dock cocked himself out of the darkness with pure menace, slackening the leash of a furious pit bull.

Gary swiftly executed a three-point turn and accelerated us back the way we came. "That guy would make a good highway," he said, smiling.

Poiuyt!
J. W. McCormack

—For Julie Whitney

MY UNCLE PENROSE DIED and left behind his islet in the Windwards, purchased with royalties from his famous syndicated column where, under the mantle of *The Pareidolic Professor Penrose,* he had for years synthesized the roles of advice columnist, mesmerist, and architect of incognizable illusion into a singular vocation. Besides his menagerie of small dogs, ducks, and rabbits (familiar to his multitude of readers from their frequent appearances in his incongruently pieced puzzles and optically outstripped pictograms), his death made orphans of his devoted audience, whose hopes to receive an explanation for his last enigmatic installment of replies to their life troubles and tenderly articulated marital dilemmas were now as arch and insubstantial as the depthless polyhedron some hobgoblin had had chiseled on his tombstone independent of any orders from the professor's named executor—myself.

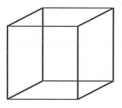

At the funeral I was thronged. Why, wondered Fertile Missoulian, was an egg donor like a Maltese Cross? What was the key to the comparison the Professor had made between Oedipal Ontarian's absent father and the grainy face discerned in astral photographs of the Cydonia Mensae region of Mars? And what was the meaning of his recommendation that Lachrymose Morphodite in Calhoun County consult Patinir's triptych *The Penitence of Saint Jerome* and imagine that the first and third segments were folded in on the centerpiece? The service had been a debacle from the outset. The lines of the eulogy I'd stayed up all the night before writing warped in my

throat like café walls and the cut-cost chair they'd brought me proved to be a long bench that only cohered to the dimensions of a chair when you stood directly in front of it. And then, halfway through, the mourners leapt from the folding seats to storm the pulpit, demanding the solutions drowned inside their maker's brain. Impossible to salvage from chaos the memorial of a man whose life had been devoted to order, albeit order that existed as an often-baffling alternative to closed-circuit Q&A. All that was left was to unravel myself from their outstretched hands, each clutching a newsprint clipping illustrated with Möbius strips or the Ouroboros, and run a hazy line from the graveyard to the forest, where the midmorning light that streamed vertically between the branches disfigured the pinstripes of my suit, making me appear first near, then far, and then seem to disappear completely.

Once I was a person drugged with what pills were manufactured to cure—I was too sad to swallow. I'd seen sheaves of relations carried away by tubes harnessed to hospital beds, leaving obscure initials carved into the front pages of books and the trunks of trees, now referencing nobody. In passing car windows I'd watch drained faces superimpose over my own, then pass without altering a hair in the transition. And when I looked into the clouds expecting to see heavenly shapes, some imaginary symbol of earthly release, I saw only a swollen sky relieved neither by rain nor rendition. I was careful not to mistake these fancies for thoughts. Of my line, I alone was without talent, the only unblinking bead on a scintillating grid. A placeholder, and that place was an island, inherited alongside the dogs it was my duty to care for, where I was determined to complete the column that I was convinced had been a long code from beginning to end, instructions delivered by my uncle to the world from which he had found the way out. Already, at this early stage, his was the hand drawing my own. Strange—I had forgotten to ask anyone what the old man had died of.

On the plane, I ogled the scores of sporting events in airline magazines and filled in crossword puzzles with palindromes, even going so far as to strap on my complimentary headphones for the in-flight movie once our headlong thrust into premature nightfall began to amass the corresponding darkness. Spurts of rain battered the window slits and an uncorked concern overtook me—not over the sequence of jostles that gradually anointed the fuselage's population of balding heads with the spotlights of Fasten Seatbelt signs, but because I was seated at a tantalizing angle to a brunette three rows away with her head tilted toward the screen. *Suppose,* whispered the acrimonious lizard that had lately taken up residence in my intellect, *our ingenue should turn to order a drink!* He had a point— it would take but a slight fluctuation of the possible to trigger a hideous reconstitution of what few features I could make out into those of an old hag, lumpen and undifferentiated as a hand-carved marionette.

—But surely, I told the lizard, faces have interior and exterior dimensions just as planes do, and immediately observed that the full-blown storm clouds were perforated with little keyholes. And through each I glimpsed a plane just like mine, moving at the same rate through a clear blue sky.

Innumerable hours later, the bickering time zones ground to a halt and allowed the island to appear, all volute mountains hairy with plants and spidery esplanades that crackled out of the few domes of civilization left to dot what was truly a meager, if febrile, plot of nowhere, cut astray even from the tangerine-colored sea that somehow failed to frame the island's misty filaments and distant beach fires. I could have cupped it in my hand; fountains of sand and coral reefs seeping between my fingers, my palm imprinted with the gaseous O of a volcano.

—Look, I said to a stewardess as we began our descent, it's got three peninsulas.

49

—Look again, she replied, it's only got two peninsulas and an atoll.

But as the heightening stems of palm trees and reemergence of proportion between herky-jerky causeways, sparkling pools, and golf courses delivered us from the irrelevant scale of air travel, I dissented over the question of the central peninsula. True, its surface was wrapped in mud and sand and sediment, leaving only the imperfectly eroded protrusion that the stewardess had mistaken for an atoll. But it was still there. And also not.

The plan was for me to meet my uncle's assistant at the single-strip airport, a task requiring only that I remember my own name. But if I had been expecting some obsequious ectomorph in a lab coat, doing his best to keep the remains of his engineering dissertation out of a conversation peppered with fawning second banana–isms while concealing pencils with his ears—then, suffice to say, I was delighted to be mistaken. Heather was a dark-haired blonde with red lips, blue eyes, a tartan skirt, no shoes, and curiously heavy armpits that hung like sleeping bats from her green halter top, not to mention nails that matched in molten complexion the bouquet of ti leaves she presented me with in the baggage claim, citing local custom and good fortune. *But how can we accept such excessive tribute,* hissed my lizard, *when you've already brought a cornucopia? I spy two warm papayas, a wet bay leaf in a painted betel nut, a pineapple—but my, where have you hidden the rind?* Heather said hers was the only name in the language you could draw a line straight through, a sensibility that bespoke my uncle's influence as surely as the spoonerisms that plagued her discourse. In sum, she was a laughing lilac chaser who drove good cars badly, philosophizing outlandishly hued birds and tropical blue latans whose leaves opened like a fan of swords as we raced along ridiculously sylvan precipices and holy bridges on our way to the villa. She was also, I noted, a Sapphic. But even over this potential killjoy the island had set a rainbow: Apparently, my late uncle's other assistant was her twin sister, Mary Qualia, temporarily on the mainland where Heather said she worked as a "psyjective obchologist." Interesting.

Excerpts from Heather's lecture on the island's indigenous flamingos:

—They're stone to eating pricks—from the genus Phoenicopterus, like what Queedo was dean of—though they prefer sea monkeys—you need X-ray glasses or else they look like shrine brimp—which is how flamingos keep their pins skink. They can sleep with half hemispheres—meaning the mind half goes where the body half isn't and verse vica. The professor could also sleep with half hemispheres.

—Hmmm. Did you mean *prone to eating sticks?*

—What did I say?

We passed a turbulence of bare-fingered trees (victims of an invasive gall wasp) that clutched at our passing and parked between a red palm, a purple palm, and a yellow palm so as to divide our vehicle into a neat trigon that so much suggested a parked car that the car itself vanished into its own silhouette.

Two towering Norfolks kept sentry at the base of a trail we followed up into a leveled-off plaza wedged between two hills. There, the first of the belvederes that ringed the villa stamped an aural vault into the otherwise one-way timbre of the sea breeze and the barking of small dogs. I shortly discovered that our destination existed at the node of three life cycles, these being faunal, floral, and sidereal, since the garden's figuration of colonnades, pagodas, and aquatic-looking bellflowers mimicked a better galaxy where astigmatic bunny rabbits crowded atop the exposed roots of an untended arboretum like snowdrops and dogs broadcast an attitude of slavering, snout-to-snout delight from the ends of the variegated leashes they were engaged in winding round an obelisk carved with fractal centaurs, heads and hooves basking in each other's negative space. To these marvels tally fountains, gazebos, an observatory, a stable, and stairs that descended the far slope only to sink straight into the ocean. There was even a hedge maze hung with mirrors that doubled the domain of the garden's sprawling screw pines and provided a constant fascination to the flocks of ducks that patrolled the rows. All this planetary

wonder could only relegate the adobe that housed the laboratory to the status of an overshadowed asteroid, sinking at the rate of the invisible plates and volcanic fissures that had gradually merged the infinitely ruffled Spanish-style roof with the crenulated shells and stones entrenched midavalanche all along the massif.

—We had a cathedral, intimated my host, but it was flooded when the water rose. And in any case, that was before the professor forsook the church for the native idols.

Sure enough, glinting from the beady penumbra of fowls that cluttered the water I could make out two immense steeples protruding from the brine, seaweed muffling the lambency of the sun as it passed through the stained glass.

A duck with a red bill flew into my arms. I asked if it was a cultivated breed.

—That's not a ruck. It's a dabbit.

Whatever it is, spat my lizard, *best consume the beast to impress the warm-blooded female.* (He was often telling me to eat things; I presume he wanted company.)

Most of the papers were coping with The Pareidolic Professor's death by running commemorative reprints of his most lauded pieces, the ones you tended to see on desk calendars and coffee mugs. Nonetheless, I was eager to inhabit my station as ghostwriter, so I made myself at home in his laboratory—or as at home as one could be, faced with the etching of the professor's brooding likeness that entirely occupied the wall opposite my desk. I gathered he had found this monolith preferable to mirrors. I familiarized myself with the Penrose archive, from his early days at *MAD* to the state-of-the-art modulations that had made his name and fortune. Of this, a generous proportion had presumably been spent on his precious mineral and rare-book collections, two passions he had consolidated by having each highly sought volume embossed with a different sequence of stones: *Cardenio, Love's Labour's Won,* and Homer's *Margites* bound in jasper, fluorite, and cinnabar, *The Gospel of Eve* bound in smoked quartz, Gogol's three-volume *Dead Souls* bound in

wolframite, the secret diaries of Lewis Carroll all bound in cassiterite, Joyce's *A Brilliant Career* wrapped in rutile, Walser's twin classics *Tobold* and *Theodor* lovingly touched up with feldspar and gypsum, alongside Bruno Schultz's zircon *Messiah*, Herman Melville's moroxite *Isle of the Cross*, and a signed first edition of Ambrose Bierce's *The Dead Sinner of Carcosa* covered in vivianite. There was also a great deal of Isaac Babel.

I soon struck upon a routine. Each morning I'd wake to sea and sun and, as though proposing a third element, eject the durian fruit that Heather insisted I have with a little maté each night before bed (not for health reasons, but because she said it made me ripe for visitations in dreams and knew how much I hoped to receive an audience with my late uncle). After breakfast, I exercised on a spinning treadmill programmed to go quantitatively faster relative to the number of blinks I made per minute—a variable it arrived at by virtue of two electrodes plugged into my tear ducts:

My own exercise complete, it was time for the dogs' constitutional. These usually began sluggishly, with an hour devoted to harnessing each reluctant hound to its leash, at which point they bounded ahead of me like a bunch of balloon poodles (in fact they were corgi, dachshund, basset, and beagle—not counting the inevitable mestizos). We'd mosey down to the beach and I'd strap on a pair of skis and two thermoses: one of water and one containing a gourmet meat substitute that smelled horrible, but had the advantage of ruining the taste of duck, should they ever actually catch one. Next there'd come the tinny complaint of a trumpet and Heather soon appeared astride her horse, Persistence of Vision, rider and steed framed in heraldic pose by one of the grotto's embrasures. Two raps of the riding crop and the chase would commence, frightening crustaceans back into their shells, Persistence of Vision trotting down the coastline with four dozen paws on her trail, and I haplessly driving two troughs into the sand—one into which I squirted food while haphazardly coating the other groove with water—cursing the rabbits and fowls that turned

up underfoot. Once my corn-fed huskies had adequately expended themselves, I'd lead them back along the parallel breakfast plates I'd etched into the sand, then back up to the villa, where the ensuing typhoon of dog piss would water the hedge-maze monocots, which grew taller in inverse proportion to the row of deflating bladders (Heather claimed the hala was a "walking tree," which went some ways toward explaining why the maze seemed to wind itself anew each night, only occasionally parting its flowers to form an entrance).

Aside from seeing that Persistence of Vision was regularly shod, bath time was my last chore of the day. This assembly-line operation I achieved by sliding each roly-poly land seal in through the sliding window of the washroom, then into a succession of wicker baskets filled with soap and shampoo. Every dog on the island was named Poggendorff, making it a cinch to call each thoroughly sudded canine hop-to before the high-powered fan that straightened their fur into its usual pattern of dappled ovoids, chessboard birthmarks, and milk white dominoes. The better I got at wrangling the Poggendorffen, the shorter the days got—and, conversely, the longer the dogs got.

Six times a day there was ferry service to some of the larger islands, so Heather went gay-clubbing after dark and the racket she made coming home with her crazy boots on the linoleum was the least of the night's disturbances. Walking trees, shadow puppets, distant tattered sails, and horrible things washed up on shore. And then the howling, not of the dogs happily snoring in their belvederes, but from (I was sure of it) inside the house. Only once had I awakened to ponder crawl spaces, crack open closets, and lean in close to the chipped paneling in the laboratory, and the sight of my uncle's oversized intaglio, his countenance changed by the hour, was enough to send me back to my fortress of sleep, where I replaced the scurrilous rabbit I found sleeping on my pillow.

I was scarcely more at home in domestic strife, not mine of course, but that of my first batch of lovelorn acolytes. For Inflategrante

Delicto in PA, locked into a one-way affair with a plastic doll, I designed a chart modeled after the Sephiroth with one side illuminating the merits of flesh and blood and the others the undeniable pluses of simulacrum, which I dubbed "The Vinyl Separation" (*With any luck*, my lizard chimed in, *the simpleton will kneel between his beloved's thighs and suffocate before your so-called advice can reach him*). To cure the havoc afflicting Brokenhearted-in-Baghdad, whose trail of open-ended relationships was reaching Restoration-play proportions back home, I prescribed contemplation of the trefoil (*Good one, Svengali*, sniffed my lizard, *why don't you just paint a cross on him and shove him in front of a machine gun?*). For Foundling in Pensacola, I contented myself with quoting Plotinus at length (*It would have been kinder of his parents to have devoured him*, quipped my indefatigable lizard).

I clutched my temples and felt my familiar's claws pruning my medulla.

—Why do you have to criticize everything I do? I don't see you offering to help.

Oh, but I am helping, sneered my lizard as he fastened his jaws about my thalamus. *All your best ideas have always come from me. You're nothing but a prestidigitator. A protoplasm! A plagiarism!*

Plagiarism: Why hadn't I thought of that? Clearly, I had to take a page from my uncle's book. But which one? There were whole folders full of unused enigmas and shelved illusions. I'd gotten all the way to the professor's diaries when I stumbled upon an aberration even more striking than those tailored for the credulous eyes of others: an almost imperceptible scrawl in the margins. A curiosity among curiosities. Why would the professor reduce his characteristically neat handwriting to such minuscule writ? Unless—unless this was the key I had come to the isle to find, the answer that promised to elevate me beyond vain pretender, laboring in the master's shadow. Face to face with my ancestor, I perceived a vase and proceeded to the observatory with my prize.

One of my uncle's maxims: "The moon you see in the water is the true one." It must have been an impostor, therefore, that peered down from the central telescope, shrinking in the lens as I worked the crank. Spindly heliostats and catoptric spyglasses orbited my way like sunflowers until my arm strained and the observatory's considerable vision was focused inward, diverted from the stars to bear upon a minute scrap reading:

> Under the Chateau parquet / docks in amazed disarray /
> horsebraid cache / Loch mien with the Finn's fresher /
> eye. Up in rows cracked / a foul face. Freeze and follow the map /
> A dark ghastly tomby air, a weight, the spade /
> the crooked straight. Herd waters / adore but a line dotter.

All of which meant nothing to me. Mercury, Saturn, Sagittarius, Virgo; idle signs and shooting stars passed through the sky, but down here was a baffled cipher who, besides having the gall to be miserable in an island paradise, was now reduced to peering the wrong way through telescopes at the parting fustian of a sphinx. The professor's realignment with the random weavings of water through sand, blood through entrails, the merging of his frequency with the radio static that blasted up and down the surf from beach blankets and blinking towers meant that some answer must be forthcoming. All I had to do was listen. Pay attention to things. But oh, I could hear my lizard laughing all that night, his breath filling up my corpus callosum as I tried to dream faster than he could bite and swallow.

Fortunately, the morning brought distraction. Heather's sister Mary Qualia was due back from the mainland, her professional obligations concluded for the season. We broke with our usual chores and, trailing a fan of impatient animals at our heels, went down to the water to meet her boat. We swung our legs from the end of the rocks and at length a sputtering mote appeared on the horizon, swelled to the size of a golf ball, then developed a tiny sail attended by a little pygmy sailor—but there it stopped, prisoner of a strange effect of excessive ocean and surfeit of sun so that, though its approach was evidenced by the grind of the motor, the drops of salt that rained upon our faces, it remained the same relative size of the distant drowned steeples and the cay's protruding spike. At a loss for how best to manage this mirage, Heather handed me a length of rope and tied one end to a naupaka tree sprouting improbably from the crusty coastline while I swam out with the other. The line was still

quite loose when I reached the hull and, tying the knot known as Gordian, helped our latest castaway ashore.

Far be it from me to observe that the manner of Mary's arrival was any less cogent than the notion that the altogether convexly proportioned Mary Qualia was Heather's twin—you might as well try telling a tree it can't grow in sand—and anyway, I was forced after two or four double takes to admit that they did share exactly the same nose. As for Mary's pedigree as a mentalist, it soon emerged that I had been much mistaken in taking "obchologist" for a spoonerism. The brilliant Dr. Qualia was a practicing therapist of hat racks and staple guns, a councilor of lamps and blenders, a reconciler of pencil sharpeners who studied the neurophysiology of flowerpots, interpreted the dreams of padlocks, mimeographed the sex lives of balls of twine, and shrank the heads of snow globes. I had to admit a certain basic phenomenological sense in diagnosing the couch before advancing to the person lying upon it, but couldn't resist asking what it was that attracted her to the inanimate and made the inner lives of vacuum cleaners so appealing?

—Because, she replied, they see inkblots as they really are.

We spent the day unpacking the patients Mary had seen fit to travel with and arranging her entourage of davenports and taborets in the room above mine. Dr. Qualia's leave of absence had been motivated by oversaturation of the pupils, a condition that called for nocturnal living and a room decorated exclusively in black and white: black curtains, white floors, black lights, white flowers, and a black-and-white television tuned to a rerun of *Columbo* whenever Mary Qualia wasn't practicing her hobby of home surveillance. It was great fun to install cameras all along the escarpments, topping off fountains, poking into hedges and behind the eyes of caryatids. At night, when the lamentations of suburban housewives and dyspeptic pornography addicts kept me awake, I'd visit Mary's room. Together we would spy on the affairs of animals, watching dogs bury bones in bird nests and mischievous rabbits take turns paddling about in the shallow pool

where the villa's stairs submerged, whispering secrets to the ducks that, being the only tribe equipped to travel across the flooded peninsula, ferried news from the banished cay; and also the hala trees slowly ambulating from one side of the garden to the other and the odd pair of tourists carrying out furtive courtship in the green tinge of the algae.

Of eyes we had no shortage. But even a completely unified field of vision falls short of any surface that hides another, more elusively textured species of spectacle. One month ended and another began, identical to its predecessor in each flowering and sunbeam, distinguished only by the presence of an invisible trespasser who left oddly irreconcilable parallels scratched into the sand beside my fading ski lines each morning.

That our ominous visitor failed to materialize in the blurry monitor told me that this phantom was only the first outright physical manifestation of the mystery still concealed behind my uncle's parting riddle. I read backward and sideways, held the page up to mirrors, made notes of all possible homophones and instances of anastrophe, applied numerological equivalents to each letter only to become momentarily and abortively convinced that the whole thing was a cunning acrostic. I performed staggering feats of anagogic unraveling and, still, words remained as maddeningly insubstantial as the hounds whose moans and clawings, as though from somewhere inside the walls, were occasionally drowned out by an even more horrid threshing or (worst of all) by Persistence of Vision neighing in her stable, a desolate whinny picked up by the wind and passed through a chorus of conch shells so the sound that reached my window echoed:

<div align="center">

murder MURDER **MURDER**

</div>

That was when my lizard made his move. Somehow I hadn't realized that while I'd hunched half asleep over the professor's microgram, my restless parasite had been watching with pointed pupils

through my eardrum, mordantly waiting for the right time, the right angle, when my head was no longer airtight, but so far ajar that thoughts whistled straight though without leaving a mark. When that time came, it came with a *POIUYT*, my lizard having braced two claws against the outside of my earlobe and fired himself like a tumescent frond through a suction-powered slingshot. He landed on the ceiling of the study, preening each newly three-dimensional scale as he unfolded from the impact crying, *Free! I'm free!* and scuttling under the cover of a light fixture.

—Hey, that was a dirty trick. What is this, a mutiny? I thought we were a team.

Bah, hissed the fugitive, *don't you try to guilt-trip me, pink thing! I'm made of guilt, hatched of doubt and self-reproach. I am the onerous basilisk of dejection. I am the fearsome skink of despondency!*

—All the same, you're a long way from an ideal ecosystem. A diet of fear and bad dreams is one thing. But I wonder how your digestion will adjust to flies and cockroaches. You'll come crawling back once some beagle decides to turn you into a chew toy. And then there're the flamingos—

The prodigal lizard poked out his slender horny head and, faster than he could flick his tongue, I was on him, slamming a bulgy volume of Pythagoras hard against the pumice. That same hiss that I'd heard lurking behind migraines subsided in the room, but when I peeled back the cover, I found only a flattened tail.

—*Ooh, that was my favorite part! You'll pay for that, mammal!*

On the ceiling's far corner, I spied my newly bifurcated foe gradually going translucent, disappearing into the crosshatchery until all that remained was two bloodshot eyes winking from the cornice.

Alone again, but for the cries of beasts, the dreams of women, and my uncle's larger-than-life likeness. His expression seemed to have changed again—something to do with the lissome shadows of the waves losing their crests as they washed up on my wall.

The island had other inhabitants, recalcitrants and wanted men whose comings, goings, and exportation of certain crops I'd been encouraged not to inspect too closely, and I contented myself with exacting rent upon their garrets and bungalows. Still, it was always a shock when, lost in the monotony of the day's chores, I'd look up from the croton and starfruit to confront a sallow face emerging from coral dendrites and bone white dreadlocks, chewing a stick of sugarcane and spying with smoky eyes upon whatever labor I inevitably moved to cover. This day in particular it was not my own privacy I was protecting, but that of the supine dachshund whose privates were currently at the receiving end of my snips and sutures. Heather said the island's canine constituency had begun with a single pair of star-crossed crossbreeds, but Poggendorff had begat Poggendorff at a rate independent of their isolation, so the occasional spaying was a must. Having patched up our latest odalisque, I rewarded the bitch's brave face with a handful of plankton and together we bounded downshore, where a luau was under way.

The island's sun sustained its fever though never altered its elevation, so the occasion for the ceremony (for which we'd wrapped salmon in ti leaves, broiled a wild pig in a pit fire, and baked cakes that tasted exactly like bread) might have been Beltane or Samhain or Walpurgis Night or, for all I knew, Makahiki. Persistence of Vision, half crazed by the clatter of painted coconut shells hung round her neck, chased the phantoms the torchlight had torn out of her and smeared along the cove like a strip of film. Sweet Mary Qualia knelt gutting yellowfish and cracking open crabs on a mat whose harvest from one of the maze's walking trees had reduced its progress to an almost imperceptible crawl. Only Heather was unaccounted for. Before I could ask, she appeared—naked in the blaze of the bonfire, one hand bearing a staff made of taro root and carved with a death's head while the other clutched the coral hilt of a curving knife. Lacking Botticelli's shell, she stood upon a dais thatched with wiliwili, the devouring wasps still perched on the branches, stingers and starfish curling around her ankles.

I made some remark to Mary Qualia about the change in her sister to which the therapist answered, absently:

—She isn't really my sister. Just try to play along.

Whoever she was, she drained the nectar from a nautilus shell and the ocean held its breath as her tied tongue emerged to utter this refrain:

Bleat the shell and bow the sail
(East winds wind west to join the dance)
Drowned dailors seize solphins by the tail
(Southern sextants turn boreal for the chance)
Solcano vummits court the dothy freep
And mone stonkeys guard the slermaid's meep

Breptune's neath stirs bearls from their ped
(The Stea of the Sar oams at the falter)
Pele's blood wathes blue baves red
(The yipper clearns to be wrecked on Gibraltar)
And Artic antoctopi fondle the ice
O Thin Thresher, accept this sacrifice

She plunged the knife into a starfish and its five points jerked toward Sirius before tapering up like a crinkled hand around the blade.

The coal-braised meat made a fire in our throats, so we put it out with agave juice, vodka, and ale brewed from the diaphanous fungi that you found splattering the island's under-places. I forgot to find anything amiss when Heather handed us torches and led us to a secluded cellar on the island's outskirts. Mutineers once stored wine here, but the professor had remodeled it into an oversized camera obscura. Mary and I stood inside while Heather held a candle to the pinhole and recited the stories whose illustrations came loose from the wall to clothe our bodies with legends: Theseus and Gilgamesh passed over our eyelids with their bulls, Gawain charted four of Camelot's seasons in the space between our nipples, and Daniel coaxed lions back beneath our armpits. The hagiography persisted, speaker unseen even after Heather had joined us inside the theater where our bodies tessellated perfectly, lips breathing warm kisses into the hollow of a slender neck, elbows overlapped against the inlets in our abdomens where ribs were formed, bowed shoulders swallowed by the backs of knees.

I heard music—only it occurred to me it wasn't music, but the voice that troubled the casements at night. The god of the island. The god of the volcano. The Thin Thresher. By the time I stumbled outside, the full-on threshing had dulled to a sideways scratching that, followed to its source, revealed the dog of the night before—because it was morning now and mellow light covered the hole in which Poggendorff, perhaps searching for her missing tubes, was paws deep after a night of digging. A murky twinkle shone out of its center.

—What've you got there, girl?

It was a black mirror, of the kind used to paint picturesques. I held it between my thumb and forefinger and, when I looked into it, the bougainvillea and reedy coastline attenuated to fit inside its tinctures, growing slim and crowded. Viewed in this manner, the island resembled nothing so much as one of my uncle's analects, his advice to, say, a moonstruck mattress salesman torn between two futons.

My room in the villa testified to my ex-lizard's mounting dissolution: dead cockroaches on my nightstand, footprints up and down the ingles, the beryl incrustations scraped off out of my uncle's copy of Agathon. Worst of all was what he'd done to the microgram, rearranging the stanzas of my fruitlessly annotated transcription to read:

> Under the Chateau parquet /
> eye. Up in rows cracked / adore but a line dotter. /
> Loch mien in with the Finn's fresher /
> the crooked straight. Herd waters/ horsebraid cache /
> A dark ghastly tomby air, a weight, the spade /
> docks in amazed disarray / a foul face. Freeze and follow the map.

Oh well. One demented chain of folderol is good as another and, anyway, we each have our own wishful way of seeing. Mary Qualia, for example, went out less and less following the luau, preferring to witness the island through the soothingly secondhand prism of her camera installation. Heather took to spending afternoons seated in one of the garden gazebos peering through a camera lucida at the flooded cathedral and amputated isle, painting a scene that I noticed bore no resemblance to either. After some inspection, I realized this was because one of the notorious gall wasps that had reduced the wiliwili trees to bare pairs of praying hands had lodged on the glass, causing a superimposition of the panorama with the identifying mark on each insect's thorax:

As for me, I had accepted the black mirror as The Pareidolic Professor's parting gift to his nephew. An amulet, a platelet, a palette upon which everything was rendered at its most minimal, at its *least*. Maquettes of monkey cities apprehended in the boughs of trees straightened out into empty armatures and the faces of clocks no longer looked so sad. Now men in the moon and apparitions of the Virgin Mary had better watch their step lest they cross into the dark glass that doubled as my eye and be revealed as mere astral indentations and mold stains. Even the half flowers of the hedge maze parted to receive me—only the presence of Mary Qualia's hand on my shoulder held me back.

—It's only fair to warn you: If you go in there, you won't come back. At least, not the way you were when you went in.

—Mary, I didn't hear you coming. What are you doing here?

—I'm not *here*. I'm there, she said, pointing toward the cay. I'm a sleeper agent.

—What does that mean?

—I'm asleep. If you tried to take my hand in yours, you'd reach right through me. The professor taught me how to sleep with half hemispheres before he disappeared. Now I travel between shores, trying to find where his daughter is keeping him. That's *if* he's still alive, which I could be wrong about.

—You mean Heather? But I thought she was his assistant.

—No, *I* was the assistant. I was a Gestalt psychologist helping him develop a puzzle that would solve the problem of love. We were conducting experiments with pattern and shape, color, longing, and the invariance of a certain just-out-of-reach desire. But then the flood separated the island's two centers. He got lost in his own logic. And that confusion found a form. For you see, every time someone enters the maze, something exits on the other side.

—Then it falls to me to find the place between. I'm the beneficiary. Anyway, I've already lost everyone. Plus my lizard. Questions are the only family I've got left.

—And an answer would be like offspring. Have it your way. I'm afraid you won't see me again. But if you *do* make it to the center, here. Remember this.

She showed me her fingers. Upon the smallest was a red ring with tiny gold letters stamped across the ruby. I leaned in closer. At that moment, she jerked back as though hearing a sudden sound and vanished. Or rather, woke up.

A puzzle that would solve the problem of love—a noble inclination (and not only because it meant the professor had been plotting to put himself out of a job). To think that, by some twist of the collective Rubik's cube, you could cure the heartache of old men, reconcile feuding familials, and coax squandered feelings back into the heart, like a fern that stirs after being brushed by a fingertip. Then again, maybe solving the problem of love meant erasing the need for it. But of koans and conundrums, I no longer had use. Frankly, I had my own problems. Like where my dubious cousin was hiding now that the gazebo held only a humming infestation of wasps and how I'd managed to miss the murder plot brewing in plain sight while straining myself in the pursuit of cryptograms. No, what I had wanted an answer for there was no answer for. But if I was smart, there was still a chance I'd get out alive.

I dangled the black mirror like a lantern and flowers melted away. Since I had no string to save my place in each winding of the pines, I stole the seeds of the monocots and set them down among the ice plants, only to have a duck swoop out of hiding and dart away with his prize whenever I was halfway to the labyrinth's next blooming bend. The same duck every time, my playmate until I lost him amid green alleys, swervy as eels, and wound up running into a cul-de-sac whose trim walls closed like clams around my outstretched fingernails. The mirrors hung along the hedges portrayed me as a fat, laughable monster, as a bulbous gnome, a hunchbacked old man, a corpse, an elongated elf—I resisted the urge to shatter them for fear of being further duplicated. Walking trees or no walking trees, I told myself the maze was perfectly logical in layout and that it was only the temptation to see jeering jester faces assembled among the moistened bark or crouching between scratchy roots that threatened to mislead the unwary ratiocinator. Instead I looked into my talisman and it showed me the way to walk: backward, one-two, one-two, easy-does-it, over mushrooms that failed to misguide me despite their recurrence twenty feet later.

This maze was my body, I listened to my blood, I proceeded like a

virus in reverse and reached the center on the heels of something else, some mottled, brown, hairy mutant with a face like a baby werewolf that snorted once and bounded away with a feathered heart in its jaws. I squatted over the mangled animal he'd left behind and recognized my playmate—and in the duck's dismembered stomach I recognized Mary's ring.

The trees began to spin. It certainly wasn't my imagination. The assembled screw pines were circling the clearing, dos-à-dos. I wiped blood from the ring and slipped it on in preparation for the chase, expecting the hala and bellflower to impersonate chess pieces and wade in at any second for the pivotal squeeze.

When they made their move, spiraling inward as if to seal a lock, I leapt for it. Soon I was slipping through knotholes and dashing under roots in steadfast refusal to look back and, despite the wooden fingers I felt scrape across my scalp, still clutching the mirror and wearing the ring like the initiate of some Mithraic order. I mimicked the rabbits I could just make out through the leaves as I clambered through timbers on my way into the wide open. I arrived on all fours, eye to eye with rabbits whose fabled left-foot luck must have expended itself in my rescue; it was evident that some hitherto undiagnosed myxomatosis had taken hold of the flock. Swollen paws, elephantine tumors, and bone pain that caused their eyes to tear up and oscillate in my direction. The ducks too were under assault, molting into scraggly skeletons, fleeced by an abrupt evolutionary disfavor for which I felt somewhat responsible, as though by loosening the labyrinth's knot I had exposed the island to the wrath of a God formerly content to overlook its offenses to reason, natural order, and consequence.

As for the villa, six new steps had appeared in the previously sunken stairway, the first indication of what a more meticulous eyeball confirmed—that the water was draining from the central peninsula, hoisting the cathedral up out of the waves and revealing,

beneath the cay, another villa just like mine, its balustrades and bao-
babs still sticky with seaweed and barnacles. The threshing that had
lurked at night had grown brave enough to disrupt the daytime, com-
bining the effect of an air-raid siren with that of a chalkboard tossed
willy-nilly through a hay baler. I fled indoors, to the laboratory, where
the bedlam of the outdoors had manifested as an intruder's ransack
of my personal effects. Everywhere, crossed-out pages, snapped pen-
cils, shattered paperweights; even the airline magazines I'd saved
from my flight had been defaced, the crosswords rewritten to read:

S	A	T	O	R
A	R	E	P	O
T	E	N	E	T
O	P	E	R	A
R	O	T	A	S

My desk had been completely stripped, save for the microgram. I
placed one hand on the paper, unsure whether I did so to keep it
steady or tear it in two. It was then the light snagged the gold letters
on Mary's ring. I brought my face to my fist and discovered that what
I'd believed to be a ruby was in fact a folded piece of red film em-
bossed with a disjointed series of freelance commas, capitals, and
consonants that, once removed and traced over the microgram, ren-
dered the riddle more or less as follows:

> Under the shadow of the cay, I, Penrose cracked a door.
> But a lying daughter locked me in with the Thin Thresher.
> The crooked strait heard what her horse brayed. Catch a dark glass.
> To my heir: Await the spayed dachshund, a maze, disarray a fowl,
> face the frieze, and follow the map.

I read it for the first time, as though I had never read it before, as
though this shipwrecked message to which I was the bottle hadn't
been an induced incubation, implicit in each turn of the screw so far.
Clearly, it was a little late for eureka; upstairs, I heard the familiar
scraping of Heather's boots on the linoleum. Only one of the warn-
ing's instructions remained unfulfilled, the one that commanded me
to face the frieze, which I did, in loose definition and to no immedi-
ate effect. It was only once I'd reached out to take hold of my uncle's
illustrated beard that I realized the portrait I'd been staring at since I
arrived—wasn't.

The old man's whiskers were a garden, the ocean reclined in his hair, his cracked lips refashioned the villa as a game of Clue, and the cathedral towers spilled from his nostrils, all of it splendidly bird's-eye. The bridge of the nose connected the island as I'd come to know it with its pristine state, before the flood had rendered it one-fold. And the picture was no picture at all, but a hallway curiously slanted so as to disguise in one-dimensionality what was in reality an urgent hieroglyph set askew, the anamorphic skull on the carpet. When I spotted Heather's shadow on the staircase, I swallowed a breath and stepped through a threshold that expanded to accommodate my flight.

I oriented myself along what had been a mole on my uncle's upper lip, now unfolded into an avenue of passageways. I did my best to imprint the map's most relevant twists in my memory, pleased that I no longer had a lizard to munch through my short-term, before passing into a gallery once packed with rare and precious paintings that, judging from the colored carnations that streaked the walls and pooled upon the floor, had had the misfortune to occupy one of the first gullets filled by the flood. There followed a bizarre cuneiform that, unless I missed my guess, served as a record of my uncle's sexual conquests and indiscretions, interrupted by faded photographs of their presumable outcomes. The moony faces of children soon developed into a family tree, conveniently organized by legitimacy, where I recognized roughly half my relatives. There was I, a chubby papoose nestled between mother and father. And at a diagonal, sure enough, a brooding pubescent who could not have been other than the "lying daughter" herself, she whose matured and malefic silhouette snapped into focus at the threshold, holding something sharp and glinting in her left hand.

I followed the threshing into the now-unbarred basilica and waded into a waist-high deluge that had left fish flopping in the pews and converted the crucifixion into a blasphemous tableau of stigmatic

squid and sea green Marys. The cathedral's high vaults endowed the Thresher with a disembodied pitch that belched from nave, organ, and apse, all without giving up its origin. From the overgrown confession booth there seethed a familiar under-cusp: my ex-lizard, now full grown into a shiny-scaled crocodile.

Your head was a happy home, funny creature. But it got crowded. I know your complexes and subliminal urges by their first names, I know your nightmares by scent. But I have a new master now. Now I am a hunter in the house of God.

A snout protruded from the door. The monster's yellow sickle-shaped peepers came skimming across a portion of the water it was unfair to call surface, for in its depths the whole stained-glass stations of the cross had found a home in cracked neon scarlet and sunspots of bright, biblical orange. I converted my fear to a mathematical formulation and the cathedral metamorphosed into its conceptual foundations, the way it must have looked from inside its architect's eyes, a host of golden means and rectangles. I waded to the reliquary, flung open the doors, and, finding in place of any relic or monstrance a no-doubt equally hallowed collection of zoetropes and kaleidoscopes, grabbed a gold-rimmed phenakistoscope and forced it into the croc's widening protractor. As I held my breath and dove in the direction of the sacristy, I saw the couple pictured on the fan dancing from inside the monster's upheld jaws. Good. At least *somebody* was having fun.

I came up for air where the water was mostly shallow and the worst I had to fear from the stagnant crisscross of pools that gradually developed in place of the pelagic baptismal of reptiles was catching sight of my reflection. From puddle to puddle I seemed a different man. I followed the church basement in tunnels that, by a series of circumvolutions, brought me to a seraglio at the center of the island. I gathered my uncle had entertained his mistresses here. On second thought—was that a bed or a catafalque? Was this a

boudoir or a burial place? Heather, having crossed through the church and eager to clarify the distinction, sent her threats ahead of her.

—You can hun but you can't ride, my fittle lool. I tried to protect you for the fake of samily, but you had to go and get clever. Now I have cho noise but to give you to the Thresher. Your sones bill wink to the bottom of the flea soor. You won't theel a fing if you come out now. I'll pake it mainless. Face it, there's no one to miss you hack bome. I'm your kext of nin. Come and reek lefuge in my roving sarms.

I had to hand it to my uncle. He had tried to warn me, sneaking out in dreams to plant clues in the sand and tucked inside phonetics. But even he couldn't have slept through this racket and rumpus. Barking, threshing, and the buzzing of wasps. I stood before a door I'd seen in dreams, the same one that had variously opened into childhood playrooms or the half-buried classrooms of high school or, if I was lucky, that portion of eternity where my family was kept prisoner by a mercy that waited for me at the end of the road, the great convergence—which is precisely where I was. I took the knob in my hands. As I did so, Heather unpeeled from one side of the corridor brandishing her knife. And from under the colonnade exactly opposite, something else appeared, some native of the other-place I'd glimpsed under the cay. A mimic of Heather's movements, a far more plausible twin than Mary had ever been, closing in at the same rate and with the same proportions, only black as oil and shaded by a veil of wasps, with contorted welt-smothered limbs soaked in a substance that left red, sticky footprints across the floor.

I cracked the door. I cracked it a little more. I opened it and furry paws thumped against my chest. Paws and fur were all the howling kennel within shared in common with the Poggendorffen, and a few of these subcanine crawlers lacked even those requisites. Some had no skin to dress their muzzles, others were missing chunks of flesh where rabid scabs had spread in place of a coat. A hideous, unkempt pack of flea-bitten hellhounds, the island's necrotic, morlock underbrood, the same misbegotten breed as the minotaur I'd glimpsed in the hedge maze. They seized my sleeves in their jaws and I felt myself being dragged away on a living carpet of teeth and bone, a violator of what was recondite for a reason, an unwelcome unifier of opposites, to face judgment on the other side of the island. To await the will of the Thin Thresher.

Faraway, across the sea, there is a happy place. They live in a mirror there. The fruit is sweet, the animals are cheerful, and, provided the local gods are satisfied, it never floods. If you tour the gardens, you may catch sight of someone like you behind the rows. If so, look away. And I might be there, offering to take your hat as I politely wait for you to connect my name to that of the celebrated advice columnist. I'll introduce you to my doting wife, Heather Penrose, and to my many relatives who, having flown up from the mainland to live with us in the villa, will open their windows to wave hello. If you ask, I'll tell you how peaceful life is on our little island. If you think you hear sounds at night, don't be afraid; it's only Heather's students going through their vocal exercises (as a speech therapist, she's quite renowned). I'll place wiliwili flowers in your hair and we'll drink a toast to the memory of my merry old uncle. It's remarkable; he always remembers to pick up a crate of Brunello when he's on the mainland.

Or, if you enter the island from the other side, you might be greeted by a pair of girls, nearly identical, but certainly not sisters. They'll tell you how they defied both their fathers to be together and show you their book of newspaper clippings. Just because we live on an island, they'll tell you, doesn't mean we're isolated. You might notice a square on each of the binder's pages where something has been conspicuously scissored away, the monthly advice column. And, should you ask them why, they'll exchange a shy look and reply:

—Because love is not a problem for everyone.

Uranus

Joyce Carol Oates

THE PARTY WAS IN *full swing*—like a cruise ship that has left the dock and is plying its way through choppy waves out of the harbor—glittering with lights and giddy with voices, laughter, music. The party was her party—hers and her husband's—in fact, today was her husband's birthday—and at the farther end of the living room Harris was in a fever pitch of conversation, surrounded by his oldest friends who'd been postdocs with him at MIT in Noam Chomsky's lab, 1963–64—he wouldn't detect her absence, she was sure.

Seven fifty p.m.—near dusk—a strategic moment for the hostess to slip away between the swell of arrivals, greetings, cocktails and appetizers, and the (large, informal) buffet supper that would scatter guests through the downstairs rooms of the sprawling old Tudor house at 49 Foxcroft Circle, University Heights.

How many years the Zalks had hosted this party, or its variants! Leah Zalk took a childlike pleasure seeing her house through the eyes of others—how the rented tables were covered in dusky pink tablecloths—not the usual utilitarian white—how the forsythia sprigs she'd cut the previous day from shrubs alongside the house were blossoming dazzling yellow in tall vases against the walls—the beautiful, flickering candlelight in all the rooms—track lighting illuminating a wall of Harris's remarkable photographs taken on his travels into the wilder parts of the earth—in a corner of the living room a guest who was clearly a trained pianist playing cheery show tunes, dance tunes of another era—"Begin the Beguine," "Heart and Soul"—alternating with flamboyant passages of Liszt—the rapid, nervous, rippling notes of the *Transcendental Études* that Leah had once tried to play as a girl pianist long ago.

A party in *full swing*. What a relief, to escape.

Between her eyes was a steely cold throb of pain. Quickly it came and went like flashing neon she had no wish to acknowledge.

Leah made her way through the crowded dining room and into the kitchen where the caterer's assistants were working—made her way through the back hall to the rear of the house—pushed open a door

that opened onto a rarely used back porch—and was astonished—disconcerted— to see someone leaning against the railing, smoking—a guest?—a friend?—this individual would have to be an old friend of the Zalks', who'd had the nerve to make his way into the rear of the house to the back porch—yet Leah didn't recognize him when he turned with a startled smile, cigarette smoke lifting from his mouth like a curving tusk.

"Mrs. Zalk? Hey—h'lo."

The young man's greeting was bright, ebullient, slightly overloud. Leah smiled a bright-hostess smile: "Hello! Do I know you?"

He was no one she knew—no one she recognized—in his mid or late twenties—somewhat heavy, fattish-faced—yet boyish—looming above her at six foot three or four—with bleached-looking pale blond hair curling over his shirt collar—moist and slightly protuberant pale blue eyes behind stylish wire-rimmed glasses—an edgy air of familiarity and intimacy. Was Leah supposed to know this young man? Clearly he knew *her.*

He bore little resemblance to Harris's graduate and postdoc students and could hardly have been one of Harris's colleagues at the institute—he had a foppish air of entitlement and clearly thought well of himself. He wore an expensive-looking camel's hair sport jacket and a black silk shirt with a pleated front—open at the throat, with no necktie—his trousers were dark, sharp pressed—his shoes were black Italian loafers. In his left earlobe a gold stud glittered and on his left wrist—a thick-boned wrist, covered in coarse hairs—a white-gold stretch-band watch gleamed. A cavalier slouch of his broad shoulders made him look as if, beneath the sport jacket that fitted him tightly, small wings were folded against his upper back.

A crude sort of angel, Leah thought, with stubby nicotine-stained fingers and a smile just this side of insolent.

"Certainly you know me, Mrs. Zalk—Leah. Though it's been a while."

How embarrassing! Leah had no doubt that she knew, or should have known, the young blond man. As she'd pushed out blindly onto the porch she'd been rubbing the bridge of her nose where the alarming pain had sprung—she wouldn't have wanted anyone to see her with anything other than a hostess's calmly smiling face. If Harris knew he'd have been surprised, and concerned for her.

Leah could not have told Harris how early that morning—in the chill dark of 4:00 a.m.—she'd wakened with a headache, a sensation of dread for this party they'd hosted every spring, at about the time of

Harris's birthday. Somehow over the years the Zalks' party in May had become a custom, or a tradition, in the institute community: Their friends, colleagues, and neighbors had come to expect it. Through the long day Leah had felt stress, mounting anxiety. She was sure that Harris had been inviting guests by phone and e-mail, far-flung colleagues of his, former students of whom there were so many, without remembering to tell her, and that far more than sixty guests would arrive at the house. . . .

"Yes. A while. . . ."

"How long, I wonder? Five, six years. . . ."

"Well. That might be. . . ."

"*You're* looking well, Mrs. Zalk!"

Now Leah remembered: This emphatic young man was the son of friends whom she and Harris saw only a few times a year, though the Gottschalks, like the Zalks, lived in the older west-end neighborhood of University Heights. The young man had an odd first name—and he'd matured alarmingly—Leah was sure that the last time she'd seen him he'd been an adolescent of twelve or thirteen with a pudgy child's face, a shy manner, hardly Leah's height. Now he carried his excess weight well, bursting with health and vigor and an air of scarcely suppressed elation like an athlete eager to confront his competition.

He was smiling toothily, the smile of a child of whom much has been made by adoring elders. Leah felt herself resistant to his charms—wary of his attention. In a lowered voice he said, "Remember me?—Woods? Woods Gottschalk? Dr. Zalk and my father used to play squash together at the gym."

Squash! Leah was sure that Harris hadn't played that ridiculous frantic game in years.

"Of course—Woods. Yes—I remember you—of course."

In fact Leah vaguely recalled that something had happened to the Gottschalks' only son—he'd been stricken with a terrible debilitating nerve illness or a brain tumor—or was she confusing him with the son of other friends in University Heights? What was most disconcerting, Woods had grown so *large,* and so *mature.* So *swaggering.* She was sure she hadn't seen the Gottschalks enter her house—she wondered if Woods had dared to come alone to the party.

Woods murmured, with an air of deep sympathy, "Yes, it's been a while, Mrs. Zalk. You can be sure—I've been thinking of you."

The blandly glowing face assumed, for a moment, a studied look of gravity. The eyes behind wire-rimmed glasses moisted over. Woods

reached out for Leah—for Leah's hands—suddenly her hands were being gripped in Woods's hands—a handshake that quivered with such feeling, the rings on Leah's left hand were pressed painfully into her flesh. As if a blinding light had been turned rudely onto her face, Leah's eyes puckered at the corners.

"You've been so *brave.*"

How uneasy Woods was making her!—his very name obtrusive, pretentious—why didn't he call himself Woody, as anyone else might?—staring at her so avidly, hungrily—as if awaiting a response Leah couldn't provide. *Brave?* What did this brash young man mean by *brave?*

Leah didn't like it that he was smoking. That he hadn't offered to put out his cigarette. Nor had he made even a courteous gesture of shielding her from the smoke as another person might have done in similar circumstances. *She* had never smoked—had never been drawn to smoking—though her college friends had all smoked, and of course Harris had smoked, both cigarettes and a pipe, for years.

At last, Harris had given up smoking when he was in his late thirties. Proud of his *willpower*—for he'd loved his pipe—he'd smoked as many as two packs of cigarettes a day—and had done so since the age of sixteen. Giving up such a considerable habit hadn't been easy for Harris, for he'd been involved in a major federal grant project in his institute lab that frequently required as many as one hundred work hours a week, and smoking had helped relieve the stress of those years —but Harris had done it and Leah had been proud of her husband's *willpower.*

"It's wonderful to see you smile, Mrs. Zalk! You are well—are you?"

"Yes. Of course I'm 'well.' And you?"

Leah spoke with an edge of impatience. How annoying this young man was!

As Woods talked—chattered—Leah stared at a swath of pale blond hair falling onto Woods's forehead—yes, his hair did seem to be bleached, the roots were dark, shadowy. Yet his eyebrows appeared to have been bleached too. A sweetish scent of cologne wafted from his skin. Woods Gottschalk was a stocky, perspiring young man yet oddly attractive, self-assured and commanding. His face was an actor's face, Leah thought—unless she meant the mask face of a Greek actor of antiquity—as if a face of ordinary dimensions had been stretched upon a large bust of a head. The effect was brightly

bland as a coin, or a moon. Lines from Santayana came to Leah—a beautiful poetic text she'd read as a graduate student decades before: *Masks are arrested expressions and admirable echoes of feeling, at once faithful, discreet, and superlative. Living things in contact with the air must acquire a cuticle, and it is not urged against cuticles that they are not hearts . . .*

"As you see I've stepped outside—outside time—and slipped away from your party, Mrs. Zalk. In one of my incarnations—speaking metaphorically, of course!—I'm an emissary from Uranus—I'm a visitor *here*. People of your generation—my parents' generation—and my grandparents' generation—are so touching to me. I so admire how you carry on—you *persevere*. Well into the new century, you *persevere*."

Leah laughed nervously. "I'm not sure what option we have, Woods."

"Look, I know I'm being rude—circumlocution has never been my strong point. My mother used to warn me—you knew my mother, I think—you were faculty wives together—'Take care what you say, dear, it can never be unsaid.'" Woods paused. He was breathing deeply, audibly as if he'd been running. "Just, I admire you. I'm just kidding—sort of kidding—about Uranus—being an emissary. See, I did a research project in an undergraduate course—History of Science—a log of the NASA ship *Voyager* that was launched in 1977 and didn't visit Uranus until 1986—one of the Ice Giants—composed of ice and rocks—the very soul of Uranus *is* ice and rocks—but such beautiful moon rings—twenty-seven moons at a minimum! Uranus ate into my soul, it was a porous time in my life. Now I am over it, I think! Mrs. Zalk—Leah?—you are looking at me so strangely, as if you don't know me! Would you care for a—cigarette?"

"Would I care for a—cigarette?" Leah stared at the blandly smiling young man as if he'd invited her to take heroin with him. "No. I would not."

She was thinking not only had she not seen the Gottschalks that evening in her house, she hadn't seen either Caroline or Byron—was it Byron or Brian?—in a long time. In fact hadn't she heard that Caroline had been ill the previous spring. . . .

"It doesn't matter, Mrs. Zalk. Really."

"What doesn't matter?"

"Cigarettes. Smoking. If you smoke or not. Our fates are genetic—determined at birth." Woods paused, frowning. "Or do I mean—*conception*. Determined at *conception*."

"Not entirely," Leah said. "Nothing is determined *entirely.*"

"Not *entirely.* But then, Mrs. Zalk, nothing is *entire.*"

Leah wasn't sure what they were talking about and she wasn't sure she liked it. The disingenuous blue eyes gleamed at her from behind the round glasses. Woods was saying, with a downward glance, both self-deprecatory and self-displaying, "My case—I'm an endomorph. I had no choice about it, my fate lay in my genes. My father, and my father's father—stocky, big, with big wrists, thick, stubby arms. Now Dr. Zalk, for instance—"

"Dr. Zalk? What of him?"

Dr. Zalk was Leah's husband. It made her uneasy to be speaking of him in such formal terms. Woods, oblivious of his companion, plunged on as if confiding in Leah: "My grandfather too. You know—Hans Gottschalk. He was on that team that won the Nobel Prize—or it was said he should have been on the team. I mean, he *was* on the team—molecular biologists—Rockefeller U.—who won the prize, and he should have won a prize too. Anyway—Hans had ceased smoking by the age of forty but it made no difference. We'd hear all about Grandfather's 'willpower'—as if what was ordinary in another was extraordinary in him, since he was an 'extraordinary' man—but already it was too late. Not that he knew—no one could know. Grandfather for all his genius had a genetic predisposition to—whatever invaded his lungs. So with us all—it's in the *stars.*"

"Is it!" Leah tasted cold. She had no idea what Woods was talking about except she knew that Harris would be scornful. *Stars!*

"*I* think you're brave, Leah. Giving this party you give every May at about now—opening this house—that shouldn't become a mausoleum. . . ."

And now—Woods was offering her a drink?—he'd slipped away from her party with not one but two wineglasses and a bottle of red wine? "If not a cigarette—you're right, Leah, it's a filthy habit—genetics or not—how's about a drink? This burgundy is excellent."

Leah was offended but heard herself laugh. When she told Harris about this encounter, Harris would laugh. It was not to be believed, this young man's arrogance: "I have an extra glass here, Leah. I had a hunch that someone would come out here to join me—at large parties, that's usually the case. Like I say, I'm an emissary. I'm a Uranian. I bring news, bulletins. I'd hoped you would step out here voluntarily, Mrs. Zalk—I mean, as if of your own free will. So—let's drink, shall we? A toast to—"

Leah had no intention of drinking with Woods Gottschalk. But

there was the glass held out to her—one of their very old wedding-present wineglasses—crystal, sparkling clean—just washed that morning by Leah, by hand. Unable to sleep she'd risen early—anxious that the house wasn't clean, glasses and china and silverware weren't clean, though the Filipina cleaning woman had come just the day before.

Woods held his wineglass aloft. Leah lifted hers reluctantly as Woods intoned: "'The universe culminates in the present moment and will never be more perfect.' Emerson, I think—or Thoreau. And who was it said, 'Who has seen the past? The past is a mist, a mirage—no one can breathe in the past.'" Woods paused, drinking. "From the perspective of Uranus—though Uranus is just the word; the actual planet is unfathomable—as all planets, all moons and stars and galaxies are unfathomable—even the present isn't exactly *here*. We behave as if it is, but that's just expediency."

Leah laughed. What was Woods saying?! All she could remember of Uranus was that it was—*is?*—unless it had been demoted, like Pluto—one of the remote ice planets about which no romance had been spun, unlike Mars, Jupiter, and Venus. Or was she thinking of—Neptune? She lifted the wineglass and drank. The wine was tart, darkly delicious. It had to be one of the last of the burgundy wines her husband had purchased. Woods was saying, "These people—your friends—Dr. Zalk's friends—and my parents' friends—are wonderful people. Many of them—the men, at least—I mean, at the institute—extraordinary, like Hans Gottschalk and Harris Zalk. You're very lucky to have one another. To define one another in your institute community. And the food, Leah—this isn't the institute catering service, is it?—but much, much better. What I've sampled is excellent."

"The food is excellent. Yes."

"*I* could be a caterer, I think. The hell with being an emissary. If things had gone otherwise."

Leah was distracted by the deep back half-acre lawn that was more ragged, seedier than she remembered. Along the sagging redwood fence were lilac bushes grown leggy and spindly and clumps of sinewy-looking grasses, tall savage wildflowers with clusters of tough little bloodred berry blossoms that had to be poisonous. And a sizable part of the enormous old oak tree in the back had fallen as if in a storm. This past winter, there had been such fierce storms! But Leah was sure that Harris had made arrangements for their annual spring cleanup. . . . She felt a stab of hurt, as well as chagrin, that the

beautiful old oak had been so badly wounded, without her knowing.

"What do you do, Woods, since you're not a caterer? I mean—what does an emissary actually *do* for a living?"

"Oh, I do what I am doing—and when I'm not, I'm doing something else."

Woods's tone was enigmatic, teasing. His eyes, on Leah's face, flitted about lightly as a bee, with a threat of stinging.

"I don't understand. What is it you *do?*"

"Strictly speaking, I'm a dropout. I've dropped out of time. Make that a capital letter T—Time. I've dropped out of Time to monitor eternity." Woods laughed, and drank. "The crucial fact is—*I am sober*—these past eleven months—eleven months, nine days. I am not a caterer—not an emissary—I just bear witness—it's this that propelled me here, to deliver to *you*."

Was he drunk? Deranged? High on drugs? (Leah halfway remembered she'd heard that the Gottschalks' brilliant but unstable son had had a chronic drug problem—unless that was the Richters' son, who'd dropped out of Yale and disappeared somewhere in northern Maine.)

"My news is—the apocalypse has happened—in an eye blink it was accomplished." Woods spoke excitedly yet calmly. "Still we persevere as if we were alive, that's the *get* of our species."

"Really? And when was this apocalypse?"

"For some, it was just yesterday. For others, tomorrow. There isn't just a single apocalypse, of course, but many—as many as there are individuals. There is no way to speak of such things adequately. There is simply not the vocabulary. But make no mistake"—Woods shook his head gravely, with a pained little smile —"you will be punished."

Now it was *you*. Leah shivered. She'd been thinking that Woods was speaking with cavalier magnanimity of *we*.

"But why? Punished?"

"Why?" Woods bared big chunky, damp teeth in a semblance of a grin. "Are you kidding, Mrs. Zalk?"

"I—I don't think so. I'm asking you seriously."

A rush of feeling came over her. Guilty excitement, apprehension. For Woods was right: Why should *she* escape punishment? A Caucasian woman of a privileged class, the wife of a prominent scientist—long the youngest and one of the more attractive wives in any gathering—a *loved woman, a cherished woman*—how vain, to imagine that this condition could persevere!

78

"Global warming is just one of the imminent catastrophes. The seas will rise, the rivers will flood—the seashores will be washed away. Cities like New Orleans will be washed away. History itself will be washed away, into oblivion. It happened to the other planets—the Ice Giants—long ago. No one laments the passing of those life-forms. None remain, to lament or to rejoice. In our soupy-warm earth atmosphere there will arise superbugs for which medical science can devise no vaccines or antibiotics. There will arise genetic mutations, malformations. These are the 'devil's frolics' as it used to be said. Entire species will vanish—not just minuscule subspecies but major mammalian species like our own. There will be as many catastrophes as there are individuals—for each is an individual fate. But you will all be punished—when the knowledge catches up with you."

"You've said that but why? Why 'punished'? By whom?" Leah spoke with an uneasy lightness. This was the way of Harris—Harris and his scientist friends—when confronted with the quasi-profound proclamations of nonscientists.

The pain between her eyes was throbbing now and her eyes blinked away tears. A kind of scrim separating her from the world—from the *otherness* of the world—and from invasive personalities like Woods's—had seemed to be failing her, frayed and tearing. She'd been susceptible to headaches all her life but now pain came more readily, you could say intimately. Harris—who rarely had headaches—tried to be sympathetic with her, stooping to brush his lips against her forehead. *Poor Leah! Is it all better now?*

Yes, she told him. *Oh yes, much better, thank you!*

Though in fact *no.* Except in fairy tales no true pain is mitigated by a kiss.

"Because you'd had the knowledge and hadn't acted upon it. Your generation—your predecessors—and now mine. Human greed, corruption—indifference. Humankind has always known what the good life is—except it's fucking *bor-ing.*"

Woods spoke cheerily and as if by rote. There was a curious—chilling—disjunction between the accusation of his words and the playful banter of his voice, and again Leah was reminded of an actor's face—a mask face—fitted on the young man's head like something wrapped in place. Defensively she said: "Evolution—that means change, evolving. Species have always passed away into extinction and been replaced by other species. But no species can replace *us.*"

"Wrong again, Mrs. Zalk! I hope your distinguished-scientist

husband didn't tell you something so foolish. *Homo sapiens* will certainly be replaced. Nature will not miss us."

Woods laughed, showing his teeth. Leah stared at him in dislike, repugnance. This arrogant young man had so rattled her, she couldn't seem to think coherently. She'd been wanting badly to leave him—to return to the comforting din of the party—by now Harris would have noticed her absence, and would be concerned—but she couldn't seem to move her legs. In a festive gesture Woods poured more wine into Leah's glass and into his own but quickly Leah set her glass aside, on the slightly rotted porch railing. Woods lifted his glass in a mock salute and drank.

"Yes—we will miss one another, Mrs. Zalk—but nature will not miss *us*. That's our tragedy!"

"How old are you, Woods?"

"Forty-three."

"Forty-*three!*"

Leah wanted to protest, *But you were a boy just yesterday—last year. What has happened to you. . . .*

Woods's face was unlined, unblemished, yet the eyes were not a young man's eyes. Through the wire-rimmed glasses you could see these eyes with disturbing clarity.

He's mad, Leah thought. *Something has destroyed his brain, his soul.*

"Well. I—I think I should be getting back to my party—people will be wondering where I am. And you should come too, Woods—it's cold out here."

This was so: The balmy May afternoon had darkened by degrees into a chilly, windblown dusk. Dead leaves on the broken oak limbs rattled irritably in the wind as if trying to speak. Leah retreated quickly before Woods could clasp her hand again in his crushing grip.

She would leave her unsettling companion gazing after her, leaning against the porch railing that sagged beneath his weight. Cigarette in one hand, wineglass in the other, and the purloined bottle of burgundy near empty on the porch floor at his feet.

How warm—unpleasantly warm—the interior of the house was, after the fresh air of outdoors.

At the threshold of the crowded living room Leah paused. Her vision was blurred as if she'd just stepped inside out of a bright, glaring place and her eyes hadn't yet adjusted to the darker interior. In a

panic Leah looked for Harris, to appeal to him. She looked for Harris, to make things right. He would slip his arm around her to comfort her. Gravely he would ask her what was wrong, why was she so upset, gently he would laugh at her and assure her that there was nothing to be upset about, what did it matter if a drunken young man had spoken foolishly to her—what did any of that matter when the birthday party Leah had planned for him was a great success, all their parties in this marvelous old house were great successes, and he loved her.

Harris didn't seem to be in the living room talking with his friends—they must have moved into another room. The party had become noisier. Everyone seemed to be shouting. From all directions came a harsh, tearing laughter. The pianist who'd been playing Liszt so beautifully had departed, it seemed—now there was a harsher species of music—a tape, perhaps—what sounded like electronic music—German industrial rock music?—primitive and percussive, deafening. Who *were* these people? Was Leah expected to know these people? A few of the faces were familiar—vaguely familiar—others were certainly strangers. Someone had dared to take down Harris's wonderful photographs from his world travels—in their place were ugly splotched canvases, crookedly hung. The dazzling yellow sprigs of forsythia had been replaced by vases of artificial flowers with slick red plastic stamens—birds of paradise? The rental tables were larger than Leah had wished and covered with garish red-striped tablecloths—who had ordered these? Without asking her permission, the caterers' assistants had rearranged furniture, Harris's handsome old Steinway grand piano had been shoved rudely into an alcove of the living room and folding chairs had been set up in place of Leah's rattan chairs in the sunroom. The buffet service had begun; guests were crowding eagerly forward. In a panic Leah pushed blindly through the line of strangers looking for—someone—whom she was desperate to find—a person, a man, from whom she'd been separated—in the confusion and peril of the moment she could not have named who it was, but she would know him, when she saw him, or he saw her.

From The City & the City
China Miéville

<div align="center">1.</div>

I COULD NOT SEE THE STREET or much of the estate. We were en-
closed by dirt-coloured blocks, from windows out of which leaned
vested men and women with morning hair and mugs of drink, eat-
ing breakfast and watching us. This open ground between the build-
ings had once been sculpted. It pitched like a golf course—a child's
mimicking of geography. Maybe they had been going to wood it and
put in a pond. There was a copse but the saplings were dead.

The grass was weedy, threaded with paths footwalked between
rubbish, rutted by wheel tracks. There were police at various tasks.
I wasn't the first detective there—I saw Bardo Naustin and a couple
of others—but I was the most senior. I followed the sergeant to where
most of my colleagues clustered, between a low derelict tower and a
skateboard park ringed by big drum-shaped trash bins. Just beyond it
we could hear the docks. A bunch of kids sat on a wall before stand-
ing officers. The gulls coiled over the gathering.

"Inspector." I nodded at whoever that was. Someone offered a cof-
fee but I shook my head and looked at the woman I had come to see.

She lay near the skate ramps. Nothing is still like the dead are still.
The wind moves their hair, as it moved hers, and they don't respond
at all. She was in an ugly pose, with legs crooked as if about to get
up, her arms in a strange bend. Her face was to the ground.

A young woman, brown hair pulled into pigtails poking up like
plants. She was almost naked, and it was sad to see her skin smooth
that cold morning, unbroken by gooseflesh. She wore only laddered
stockings, one high heel on. Seeing me look for it, a sergeant waved
at me from a way off, from where she guarded the dropped shoe.

It was a couple of hours since the body had been discovered. I
looked her over. I held my breath and bent down toward the dirt, to
look at her face, but I could only see one open eye.

"Where's Shukman?"

"Not here yet, Inspector . . ."

"Someone call him, tell him to get a move on." I smacked my

watch. I was in charge of what we called the *mise-en-crime*. No one would move her until Shukman the patho had come, but there were other things to do. I checked sightlines. We were out of the way and the garbage containers obscured us, but I could feel attention on us like insects, from all over the estate. We milled.

There was a wet mattress on its edge between two of the bins, by a spread of rusting iron pieces interwoven with discarded chains. "That was on her." The constable who spoke was Lizbyet Corwi, a smart young woman I'd worked with a couple of times. "Couldn't exactly say she was well hidden, but it sort of made her look like a pile of rubbish, I guess." I could see a rough rectangle of darker earth surrounding the dead woman—the remains of the mattress-sheltered dew. Naustin was squatting by it, staring at the earth.

"The kids who found her tipped it half off," Corwi said.

"How did they find her?"

Corwi pointed at the earth, at little scuffs of animal paws.

"Stopped her getting mauled. Ran like hell when they saw what it was, made the call. Our lot, when they arrived . . ." She glanced at two patrolmen I didn't know.

"They moved it?"

She nodded. "See if she was still alive, they said."

"What are their names?"

"Shushkil and Briamiv."

"And these are the finders?" I nodded at the guarded kids. There were two girls, two guys. Midteens, cold, looking down.

"Yeah. Chewers."

"Early morning pick-you-up?"

"That's dedication, hm?" she said. "Maybe they're up for junkies of the month or some shit. They got here a bit before seven. The skate pit's organised that way, apparently. It's only been built a couple of years, used to be nothing, but the locals've got their shift patterns down. Midnight to 9:00 a.m., chewers only; nine to eleven, local gang plans the day; eleven to midnight, skateboards and rollerblades."

"They carrying?"

"One of the boys has a little shiv, but really little. Couldn't mug a milkrat with it—it's a toy. And a chew each. That's it." She shrugged. "The dope wasn't on them; we found it by the wall, but"—shrug—"they were the only ones around."

She motioned over one of our colleagues and opened the bag he carried. Little bundles of resin-slathered grass. *Feld* is its street name— a tough crossbreed of *Catha edulis* spiked with tobacco and caffeine

and stronger stuff, and fibreglass threads or similar to abrade the gums and get it into the blood. Its name is a trilingual pun: It's *khat* where it's grown, and the animal called "cat" in English is *feld* in our own language. I sniffed it and it was pretty low-grade stuff. I walked over to where the four teenagers shivered in their puffy jackets.

"'*Sup, policeman?*" said one boy in a Besź–accented approximation of hip-hop English. He looked up and met my eye, but he was pale. Neither he nor any of his companions looked well. From where they sat they could not have seen the dead woman, but they did not even look in her direction.

They must have known we'd find the *feld,* and that we'd know it was theirs. They could have said nothing, just run.

"I'm Inspector Borlú," I said. "Extreme Crime Squad."

I did not say *I'm Tyador.* A difficult age to question, this—too old for first names, euphemisms, and toys, not yet old enough to be straightforward opponents in interviews, when at least the rules were clear. "What's your name?" The boy hesitated, considered using whatever slang handle he'd granted himself, did not.

"Vilyem Barichi."

"You found her?" He nodded, and his friends nodded after him. "Tell me."

"We come here because, 'cause, and . . ." Vilyem waited, but I said nothing about his drugs. He looked down. "And we seen something under that mattress and we pulled it off."

"There was some . . ." His friends looked up as Vilyem hesitated, obviously superstitious.

"Wolves?" I said. They glanced at each other.

"Yeah, man, some scabby little pack was nosing around there and . . ."

"So we thought it . . ."

"How long after you got here?" I said.

Vilyem shrugged. "Don't know. Couple hours?"

"Anyone else around?"

"Saw some guys over there a while back."

"Dealers?" A shrug.

"And there was a van came up on the grass and come over here and went off again after a bit. We didn't speak to no one."

"When was the van?"

"Don't know."

"It was still dark." That was one of the girls.

"Okay. Vilyem, you guys, we're going to get you some breakfast,

something to drink, if you want." I motioned to their guards. "Have we spoken to the parents?" I asked.

"On their way, boss; except hers"—pointing to one of the girls—"we can't reach."

"So keep trying. Get them to the centre now."

The four teens looked at each other. "This is bullshit, man," the boy who was not Vilyem said, uncertainly. He knew that according to some politics he should oppose my instruction, but he wanted to go with my subordinate. Black tea and bread and paperwork, the boredom and striplights, all so much not like the peeling back of that wet-heavy, cumbersome mattress, in the yard, in the dark.

Stepen Shukman and his assistant, Hamd Hamzinic, had arrived. I looked at my watch. Shukman ignored me. When he bent to the body he wheezed. He certified death. He made observations that Hamzinic wrote down.

"Time?" I said.

"Twelve hours-ish," Shukman said. He pressed down on one of the woman's limbs. She rocked. In rigor, and unstable on the ground as she was, she probably assumed the position of her death lying on other contours. "She wasn't killed here." I had heard it said many times he was good at his job but had seen no evidence that he was anything but competent.

"Done?" he said to one of the scene techs. She took two more shots from different angles and nodded. Shukman rolled the woman over with Hamzinic's help. She seemed to fight him with her cramped motionlessness. Turned, she was absurd, like someone playing at dead insect, her limbs crooked, rocking on her spine.

She looked up at us from below a fluttering fringe. Her face was set in a startled strain: she was endlessly surprised by herself. She was young. She was heavily made-up, and it was smeared across a badly battered face. It was impossible to say what she looked like, what face those who knew her would see if they heard her name. We might know better later, when she relaxed into her death. Blood marked her front, dark as dirt. Flash flash of cameras.

"Well, hello, cause of death," Shukman said to the wounds in her chest.

On her left cheek, curving under the jaw, a long red split. She had been cut half the length of her face.

The wound was smooth for several centimetres, tracking precisely

along her flesh like the sweep of a paintbrush. Where it went below her jaw, under the overhang of her mouth, it jagged ugly and ended or began with a deep torn hole in the soft tissue behind her bone. She looked unseeingly at me.

"Take some without the flash too," I said.

Like several others I looked away while Shukman murmured—it felt prurient to watch. Uniformed *mise-en-crime* technical investigators, *mectecs* in our slang, searched in an expanding circle. They overturned rubbish and foraged among the grooves where vehicles had driven. They lay down reference marks, and photographed.

"Alright then." Shukman rose. "Let's get her out of here." A couple of the men hauled her onto a stretcher.

"Jesus Christ," I said, "cover her." Someone found a blanket I don't know from where, and they started again towards Shukman's vehicle.

"I'll get going this afternoon," he said. "Will I see you?" I wagged my head noncommittally. I walked towards Corwi.

"Naustin," I called, when I was positioned so that Corwi would be at the edge of our conversation. She glanced up and came slightly closer.

"Inspector," said Naustin.

"Go through it."

He sipped his coffee and looked at me nervously.

"Hooker?" he said. "First impressions, Inspector. This area, beat-up naked? And . . ." He pointed at his face, her exaggerated makeup. "Hooker."

"Fight with a client?"

"Yeah but . . . if it was just the body wounds, you know, you'd, then you're looking at, maybe she won't do what he wants, whatever. He lashes out. But this." He touched his cheek again uneasily. "That's different."

"A sicko?"

He shrugged. "Maybe. He cuts her, kills her, dumps her. Cocky bastard too, doesn't give a shit that we're going to find her."

"Cocky or stupid."

"Or cocky *and* stupid."

"So a cocky, stupid sadist," I said. He raised his eyes, *Maybe.*

"Alright," I said. "Could be. Do the rounds of the local girls. Ask a uniform who knows the area. Ask if they've had trouble with anyone recently. Let's get a photo circulated, put a name to Fulana Detail." I used the generic name for woman-unknown. "First off I

want you to question Barichi and his mates there. Be nice, Bardo, they didn't have to call this in. I mean that. And get Yaszek in with you." Ramira Yaszek was an excellent questioner. "Call me this afternoon?" When he was out of earshot I said to Corwi, "A few years ago we'd not have had half as many guys on the murder of a working girl."

"We've come a long way," she said. She wasn't much older than the dead woman.

"I doubt Naustin's delighted to be on streetwalker duty, but you'll notice he's not complaining," I said.

"We've come a long way," she said.

"So?" I raised an eyebrow. Glanced in Naustin's direction. I waited. I remembered Corwi's work on the Shulban disappearance, a case considerably more Byzantine than it had initially appeared.

"It's just, I guess, you know, we should keep in mind other possibilities," she said.

"Tell me."

"Her makeup," she said. "It's all, you know, earths and browns. It's been put on thick, but it's not—" She vamp-pouted. "And did you notice her hair?" I had. "Not dyed. Take a drive with me up Gunter-Strász, around by the arena, any of the girls' hangouts. Two-thirds blonde, I reckon. And the rest are black or bloodred or some shit. And . . ." She fingered the air as if it were hair. "It's dirty, but it's a lot better than mine." She ran her hand through her own split ends.

For many of the streetwalkers in Besźel, especially in areas like this, food and clothes for their kids came first; *feld* or crack for themselves; food for themselves; then sundries, in which list conditioner would come low. I glanced at the rest of the officers, at Naustin gathering himself to go.

"Okay," I said. "Do you know this area?"

"Well," she said, "it's a bit off the track, you know? This is hardly even Besźel, really. My beat's Lestov. They called a few of us in when they got the bell. But I did a tour here a couple years ago—I know it a bit."

Lestov itself was already almost a suburb, six or so k out of the city centre, and we were south of that, over the Yovic Bridge on a bit of land between Bulkya Sound and, nearly, the mouth where the river joined the sea. Technically an island, though so close and conjoined to the mainland by ruins of industry you would never think of it as such, Kordvenna was estates, warehouses, low-rent bodegas scribble-linked by endless graffiti. It was far enough from Besźel's heart that

it was easy to forget, unlike more inner-city slums.

"How long were you here?" I said.

"Six months, standard. What you'd expect: street theft, high kids smacking shit out of each other, drugs, hooking."

"Murder?"

"Two or three in my time. Drugs stuff. Mostly stops short of that, though: The gangs are pretty smart at punishing each other without bringing in ECS."

"Someone's fucked up then."

"Yeah. Or doesn't care."

"Okay," I said. "I want you on this. What are you doing at the moment?"

"Nothing that can't wait."

"I want you to relocate for a bit. Got any contacts here still?" She pursed her lips. "Track them down if you can; if not, have a word with some of the local guys, see who their singers are. I want you on the ground. Listen out, go round the estate—what's this place called again?"

"Pocost Village." She laughed without humour; I raised an eyebrow.

"It takes a village," I said. "See what you can turn up."

"My commissar won't like it."

"I'll deal with him. It's Bashazin, right?"

"You'll square it? So am I being seconded?"

"Let's not call it anything right now. Right now I'm just asking you to focus on this. And report directly to me." I gave her the numbers of my cell phone and my office. "You can show me around the delights of Kordvenna later. And . . ." I glanced up at Naustin, and she saw me do it. "Just keep an eye on things."

"He's probably right. Probably a cocky, sadist trick, boss."

"Probably. Let's find out why she keeps her hair so clean."

There was a league-table of instinct. We all knew that in his street-beating days, Commissar Kerevan broke several cases following leads that made no logical sense, and that Chief Inspector Marcoberg was devoid of any such breaks, and that his decent record was the result, rather, of slog. We would never call inexplicable little insights "hunches," for fear of drawing the universe's attention. But they happened, and you knew you had been in the proximity of one that had come through if you saw a detective kiss his or her fingers and touch his or her chest where a pendant to Warsha, patron saint of inexplicable inspirations, would, theoretically, hang.

Officers Shushkil and Briamiv were surprised, then defensive,

finally sulky when I asked them what they were doing moving the mattress. I put them on report. If they had apologised I would have let it go. It was depressingly common to see police boots tracked through blood residue, fingerprints smeared and spoiled, samples corrupted or lost.

A little group of journalists was gathering at the edges of the open land. Petrus Something-or-other, Valdir Mohli, a young guy called Rackhaus, a few others.

"Inspector!" "Inspector Borlú!" Even: "Tyador!"

Most of the press had always been polite, and amenable to my suggestions about what they withheld. In the last few years, new, more salacious and aggressive papers had started, inspired and in some cases controlled by British or North American owners. It had been inevitable, and in truth our established local outlets were staid to dull. What was troubling was less the trend to sensation, nor even the irritating behaviour of the new press's young writers, but more their tendency to dutifully follow a script written before they were born. Rackhaus, who wrote for a weekly called *Rejal!*, for example. Surely when he bothered me for facts he knew I would not give him, surely when he attempted to bribe junior officers, and sometimes succeeded, he did not have to say, as he tended to: "The public has a right to know!"

I did not even understand him the first time he said it. In Besź the word "right" is polysemic enough to evade the peremptory meaning he intended. I had to mentally translate into English, in which I am passably fluent, to make sense of the phrase. His fidelity to the cliché transcended the necessity to communicate. Perhaps he would not be content until I snarled and called him a vulture, a ghoul.

"You know what I'm going to say," I told them. The stretched tape separated us. "There'll be a press conference this afternoon, at ECS Centre."

"What time?" My photograph was being taken.

"You'll be informed, Petrus."

Rackhaus said something that I ignored. As I turned, I saw past the edges of the estate to the end of GunterStrász, between the dirty brick buildings. Trash moved in the wind. It might be anywhere. An elderly woman was walking slowly away from me in a shambling sway. She turned her head and looked at me. I was struck by her motion, and I met her eyes. I wondered if she wanted to tell me something. In my glance I took in her clothes, her way of walking, of holding herself, and looking.

With a hard start, I realised that she was not on GunterStrász at all, and that I should not have seen her.

Immediately and flustered, I looked away, and she did the same, with the same speed. I raised my head, towards an aircraft on its final descent. When after some seconds I looked back up, unnoticing the old woman stepping heavily away, I looked carefully instead of at her in her foreign street at the facades of the nearby and local Gunter-Strász, that depressed zone.

2.

I had a constable drop me north of Lestov, near the bridge. I did not know the area well. I'd been to the island, of course, visited the ruins, when I was a schoolboy and occasionally since, but my ratruns were elsewhere. Signs showing directions to local destinations were bolted to the outsides of pastry bakers and little workshops, and I followed them to a tram stop in a pretty square. I waited between a care-home marked with an hourglass logo, and a spice shop, the air around it cinnamon-scented.

When the tram came, tinnily belling, shaking in its ruts, I did not sit, though the carriage was half empty. I knew we would pick up passengers as we went north to Besźel centre. I stood close to the window and saw right out into the city, into these unfamiliar streets.

The woman, her ungainly huddle below that old mattress, sniffed by scavengers. I phoned Naustin on my cell.

"Is the mattress being tested for trace?"

"Should be, sir."

"Check. If the techs are on it we're fine, but Briamiv and his buddy could fuck up a full stop at the end of a sentence." Perhaps she was new to the life. Maybe if we'd found her a week later her hair would have been electric blonde.

These regions by the river are intricate, many buildings a century or several centuries old. The tram took its tracks through byways where Besźel, at least half of everything we passed, seemed to lean in and loom over us. We wobbled and slowed, behind local cars and those elsewhere, came to a crosshatching where the Besź buildings were antique shops. That trade had been doing well, as well as anything did in the city for some years, hand-downs polished and spruced as people emptied their apartments of heirlooms for a few Besźmarques.

Some editorialists were optimists. While their leaders roared as

relentlessly at each other as they ever had in the Cityhouse, many of the new breed of all parties were working together to put Besźel first. Each drip of foreign investment—and to everyone's surprise there were drips—brought forth encomia. Even a couple of high-tech companies had recently moved in, though it was hard to believe it was in response to Besźel's fatuous recent self-description as "Silicon Estuary."

I got off by the statue of King Val. Downtown was busy: I stop-started, excusing myself to citizens and local tourists, unseeing others with care, till I reached the blocky concrete of ECS Centre. Two groups of tourists were being shepherded by Besź guides. I stood on the steps and looked down UropaStrász. It took me several tries to get a signal.

"Corwi?"

"Boss?"

"You know that area: Is there any chance we're looking at breach?"

There were seconds of silence.

"Doesn't seem likely. That area's mostly pretty total. And Pocost Village, that whole project, certainly is."

"Some of GunterStrász, though . . ."

"Yeah but. The closest crosshatching is hundreds of metres away. They couldn't have . . ." It would have been an extraordinary risk on the part of the murderer or murderers. "I reckon we can assume," she said.

"Alright. Let me know how you get on. I'll check in soon."

I had paperwork on other cases that I opened, establishing them a while in holding patterns like circling aircraft. A woman beaten to death by her boyfriend, who had managed to evade us so far, despite tracers on his name and his prints at the airport. Styelim was an old man who had surprised an addict breaking and entering, been hit once, fatally, with the spanner he himself had been wielding. That case would not close. A young man called Avid Avid, left bleeding from the head after taking a kerb-kiss from a racist, "Ébru Filth" written on the wall above him. For that I was coordinating with a colleague from Special Division, Shenvoi, who had, since some time before Avid's murder, been undercover in Besźel's far right.

Ramira Yaszek called while I ate lunch at my desk. "Just done questioning those kids, sir."

"And?"

"You should be glad they don't know their rights better, because if they did Naustin'd be facing charges now." I rubbed my eyes and swallowed my mouthful.

"What did he do?"

"Barichi's mate Sergev was lippy, so Naustin asked him the bare-knuckle question across the mouth, said he was prime suspect." I swore. "It wasn't that hard, and at least it made it easier for me to *gudcop*." We had stolen *gudcop* and *badcop* from English, verbed them. Naustin was one of those who'd switch to hard questioning too easily. There are some suspects that methodology works on, who need to fall downstairs during an interrogation, but a sulky teenage chewer is not one.

"Anyway, no harm done," Yaszek said. "Their stories tally. They're out, the four of them, in that bunch of trees. Bit of naughty naughty probably. They were there for a couple of hours at least. At some point during that time—and don't ask for anything more exact because you aren't going to get it beyond 'still dark'—one of the girls sees that van come up onto the grass to the skate park. She doesn't think much of it because people do come up there all times of day and night to do business, to dump stuff, what have you. It drives around, up past the skate park, comes back. After a while it speeds off."

"Speeds?"

I scribbled in my notebook, trying one-handedly to pull up my e-mail on my PC. The connection broke more than once. Big attachments on an inadequate system.

"Yeah. It was in a hurry and buggering its suspension. That's how she noticed it was going."

"Description?"

"'Grey.' She doesn't know from vans."

"Get her looking at some pictures, see if we can ID the make."

"On it, sir. I'll let you know. Later at least two other cars or vans come up for whatever reason, for business, according to Barichi."

"That could complicate tyre tracks."

"After an hour or whatever of groping, this girl mentions the van to the others and they go check it out, in case it was dumping. Says sometimes you get old stereos, shoes, books, all kinds of shit chucked out."

"And they find her." Some of my messages had come through. There was one from one of the mectec photographers, and I opened it and began to scroll through his images.

"They find her."

*

Commissar Gadlem called me in. His soft-spoken theatricality, his
mannered gentleness, was unsubtle, but he had always let me do my
thing. I sat while he tapped at his keyboard and swore. I could see
what must be database passwords stuck on scraps of paper to the side
of his screen.

"So?" he said. "The housing estate?"

"Yes."

"Where is it?"

"South, suburbs. Young woman, stab wounds. Shukman's got
her."

"Prostitute?"

"Could be."

"Could be," he said, cupped his ear, "and yet. I can hear it. Well,
onward, follow your nose. Tell if you ever feel like sharing the whys
of that 'and yet,' won't you? Who's your sub?"

"Naustin. And I've got a beat cop helping out. Corwi. Grade-one
constable. Knows the area."

"That's her beat?" I nodded. Close enough.

"What else is open?"

"On my desk?" I told him. The commissar nodded. Even with the
others, he granted me the leeway to follow Fulana Detail.

"So did you see the whole business?"

It was close to ten o'clock in the evening, more than forty hours
since we had found the victim. Corwi drove—she made no effort to
disguise her uniform, despite that we had an unmarked car—
through the streets around GunterStrász. I had not been home until
very late the previous night, and after a morning on my own in these
same streets now I was there again.

There were places of crosshatch in the larger streets and a few else-
where, but that far out the bulk of the area was total. Few antique
Besź stylings, few steep roofs or many-paned windows: these were
hobbled factories and warehouses. A handful of decades-old, often
broken-glassed, at half capacity if open. Boarded facades. Grocery
shops fronted with wire. Older fronts in tumbledown of classical Besź
style. Some houses colonised and made chapels and drug houses:
some burnt out and left as crude carbon renditions of themselves.

The area was not crowded, but it was far from empty. Those who

were out looked like landscape, like they were always there. There had been fewer that morning but not very markedly.

"Did you see Shukman working on the body?"

"No." I was looking at what we passed, referring to my map. "I got there after he was done."

"Squeamish?" she said.

"No."

"Well . . ." She smiled and turned the car. "You'd have to say that even if you were."

"True," I said, though it was not.

She pointed out what passed for landmarks. I did not tell her I had been in Kordvenna early in the day, sounding these places. Corwi did not try to disguise her police clothes because that way those who saw us, who might otherwise think we were there to entrap them, would know that was not our intent, and the fact that we were not in a bruise, as we called the black-and-blue police cars, told them that neither were we there to harass them. Intricate contracts!

Most of those around us were in Besźel so we saw them. Poverty deshaped the already staid, drab cuts and colours that enduringly characterise Besź clothes—what has been called the city's fashion-less fashion. Of the exceptions, some we realised when we glanced were elsewhere, so unsaw, but the younger Besź were also more colourful, their clothes more pictured, than their parents.

The majority of the Besź men and women (does this need saying?) were doing nothing but walking from one place to another, from late-shift work, from homes to other homes or shops. Still, though, the way we watched what we passed made it a threatening geography, and there were sufficient furtive actions occurring that that did not feel like the rankest paranoia.

"This morning I found a few of the locals I used to talk to," Corwi said. "Asked if they'd heard anything." She took us through a dark-ened place where the balance of crosshatch shifted, and we were silent until the streetlamps around us became again taller and famil-iarly deco-angled. Under those lights—the street we were on visible in a perspective curve away from us—women stood by the walls sell-ing sex. They watched our approach guardedly. "I didn't have much luck," Corwi said.

She had not even had a photograph on that earlier expedition. That early it had been aboveboard contacts: it had been liquor-store clerks; the priests of squat local churches, some the last of the worker-priests, brave old men tattooed with the sickle-and-rood on their

biceps and forearms, on the shelves behind them Besź translations of
Gutiérrez, Rauschenbusch, Canaan Banana. It had been stoop-sitters.
All Corwi had been able to do was ask what they could tell her about
events in Pocost Village. They had heard about the murder but knew
nothing.

Now we had a picture. Shukman had given it to me. I brandished
it as we emerged from the car: literally I brandished it, so the women
would see that I brought something to them, that that was the pur-
pose of our visit, not to make arrests.

Corwi knew some of them. They smoked and watched us. It was
cold, and like everyone who saw them I wondered at their stock-
inged legs. We were affecting their business of course—plenty of
locals passing by looked up at us and looked away again. I saw a
bruise slow down the traffic as it passed us—they must have seen an
easy arrest—but the driver and his passenger saw Corwi's uniform
and sped by again with a salute. I waved back to their rear lights.

"What do you want?" a woman asked. Her boots were high and
cheap. I showed her the picture.

They had cleaned up Fulana Detail's face. There were marks left—
scrapes were visible below the makeup. They could have eradicated
them completely from the picture, but the shock those wounds occa-
sioned were useful in questioning. They had taken the picture be-
fore they shaved her head. She did not look peaceful. She looked
impatient.

"I don't know her." "I don't know her." I did not see recognition
quickly disguised. They gathered in the grey light of the lamp, to the
consternation of punters hovering at the edge of the local darkness,
passed the picture among themselves and whether or not they made
sympathy noises, did not know Fulana.

"What happened?" I gave the woman who asked my card. She
was dark, Semitic or Turkish somewhere back. Her Besź was
unaccented.

"We're trying to find out."

"Do we need to worry?"

"I . . ."

After I paused Corwi said, "We'll tell you if we think you do,
Sayra."

We stopped by a group of young men drinking strong wine outside
a pool hall. Corwi took a little of their ribaldry then passed the
photograph round.

"Why are we here?" My question was quiet.

"They're entry-level gangsters, boss," she told me. "Watch how they react." But they gave little away if they did know anything. They returned the photograph and took my card impassively.

We repeated this at other gatherings, and afterwards each time we waited several minutes in our car, far enough away that a troubled member of any of the groups might excuse himself or herself and come find us, tell us some dissident scrap that might push us by whatever byways towards the details and family of our dead woman. No one did. I gave my card to many people and wrote down in my notebook the names and descriptions of those few that Corwi told me mattered.

"That's pretty much everyone I used to know," she said. Some of the men and women had recognised her, but it had not seemed to make much difference to how she was received. When we agreed that we had finished it was after two in the morning. The half moon was washed out: After a last intervention we had come to a stop, were standing in a street depleted of even its latest-night frequenters.

"She's still a question mark." Corwi was surprised.

"I'll arrange to have the posters put around the area."

"Really, boss? Commissar'll go for that?" We spoke quietly. I wove my fingers into the wire mesh of a fence around a lot filled only with concrete and scrub.

"Yeah," I said. "He'll roll over. It's not that much."

"It's a few uniforms for a few hours, and he's not going to . . . not for a . . ."

"We have to shoot for an ID. Fuck it, I'll put them up myself." I would arrange for them to be sent out to each of the city's divisions. When we turned up a name, if Fulana's story was as we had tentatively intuited, what few resources we had would vanish. We were milking leeway that would eradicate itself.

"You're the boss, boss."

"Not really, but I'm the boss of this for a little bit."

"Shall we?" She indicated the car.

"I'll walk it to a tram."

"Serious? Come on, you'll be hours." But I waved her off. I walked away to the sounds only of my own steps and some frenzied back-street dog, towards where the grey glare of our lamps was effaced and I was lit by foreign orange light.

BioticaKF

Jon Enfield

FOR THE FIRST TIME SINCE the herd's birth, the prairie's walls and aisles slowed their flexing and throbbing. Eventually they shivered into a dark pink stillness.

Warren had again stopped his rounds to peer through the shatter-proof window at the slaughter prep in Prairie 14. The membranes had almost completely ruptured, and the evening-shift collies had long since closed the doors on the swollen meat. All the prairies were soundproofed, but Warren had turned on the speakers connected to the interior mics. His speakers were reproducing a mildly distorted version of the music coming from the prairie's own speakers—classical piano, slow contemplation alternating with urgent runs. Chopin Scherzo op. 31, no. 2, said the display. Warren knew it well. He had no choice. It was one of the twenty-six songs played nonstop for the fifth-floor herds. All the prairies played music, though nobody knew why. Some said it was an homage to the banjo-toting cowboys who had crooned campfire songs to their cattle. Some said there was a science to it, that the beat counts and key changes somehow corresponded to the algorithms governing each aisle's individual flex and sway. Others said no way was it science, or why would the eighth-floor guys get to play nothing but forties show tunes and eighties hair metal? If they really did, of course. There were a lot of rumors about the eighth floor.

The Chopin fizzed, then shut off completely as dozens of high-pressure jets began to sizzle and thud distilled water against the herd's motionless flesh.

The jets would run for fifteen minutes, so Warren resumed his rounds through the dimly lit corridors and prairies. He wished that Eusebio were there to play ambush. But Eusebio had called in well, so when Warren entered Prairie 9, he was alone with the half-lit and half-sinister meat. From the ceiling, Sinatra sang "My Way."

Herd 9 was only a couple days behind 14, and the room was exercising it vigorously, sending the wall cattle flexing and frolicking mathematically through grasslands stored on the servers. Each aisle

had its own complicated rhythms, each flapped like a greasy sheet in a strong wind.

Warren walked carefully, keeping to the narrow green path marked on the aluminum floor. In a mature prairie, a collie who stepped outside the lines could get smacked by especially vigorous or bulky meat. His first week on the job, Warren had slipped sideways on a slick of leaked 4-blood and staggered a few steps out of the zone. Before he'd regained his balance, an aisle had knocked him to the ground. After that, he'd believed the whispers about collies buffeted even inside the safety zones, about collies asphyxiated by overgrown aisles. Some collies muttered that the aisles weren't quite so insentient as Biotica claimed, that the muscle had its own sullen consciousness—primitive, vengeful, and vastly patient.

Keeping mostly to the wider corridor cutting perpendicular across the aisles of Prairie 9, Warren made a show of looking intent and attentive for the cameras and whoever might be monitoring them. Looking attentive gave him something specific to do—in his seven months at Biotica, he'd never understood his task in the prairies themselves. "Tending to the herds," the training videos had said. None of the collies knew what that meant, though. It wasn't as if there were heels to nip, strays to round up. The servers did the work. They governed the aisles' matrices, which had dozens of sensors monitoring everything from volume and density to the subtler points of biochemical composition. When the servers commanded it, the matrices sent out the cascades of mild charges that made the aisles flex. The matrices pumped in nutritionally calibrated 4-blood, pumped out its depleted residue. Occasionally, a collie would need to slap an emergency patch somewhere exposed to air by a membrane tear, but even that was rare and getting rarer. Warren suspected that the collies were just there to inject ambulatory and demonstrable agency into a process that, really, could have been left entirely to the machines and the herds themselves. Or not agency so much as spectation. Witnessing, one might say.

Back at 14's window, Warren saw on the display that the in-floor heating system had already raised the floor's surface to 75.6°C and held it there for the required five minutes. When he returned twenty minutes later, the entire room had cooled to 3°C and razor-sharp titanium blades on hydraulics had just begun to slide along the inner margins of the matrices, slicing off ponderous slabs that lapped against each other before sliding reluctantly to the floor. Once the knives reached bottom, small gyrations of the matrices themselves—now

more metal and plastic than meat—began to pop out the last scraps of still-clinging flesh. As this was happening, insectoid BattleBot creatures ranging from tabby sized to labrador sized scuttled in to cut the slabbed meat with built-in circular saws. Warren muted the sound so that he wouldn't have to listen to the high, grating whirring.

After the bots stilled their blades and retreated, automatic scrapers shoved the meat toward a conveyor belt exposed by the temporary retraction of the section of wall near the floor. The meat completely conveyed elsewhere, the wall lowered again, its seam virtually invisible. The rinsing jets began again. After the floor was again heated to 75.6°C and then dropped to match the new room temperature of 23.7°C, the polymer foundation for the membranes would be pulled into place on either side of the aisles, top to bottom, like so many great sheets of milky cling wrap. Two days later, the membranes would finish their primary growth, and a new herd would begin to swell.

The entire slaughter and cleanup took less than three hours, and, as always, it left Warren bubbling somewhere between anxiety and queasiness. This time he had six long hours to spend among the other herds' increasingly mutinous undulations. He wished that he'd called in well.

Call in well? he'd asked his first day on the job.

Gotta be sick to work this job, my friend. Eusebio flashing bright teeth but, Warren realized, meaning every damn word. All the best warnings came disguised as jokes.

Noreen parked the new Corolla in the circle drive of her parents' McMansion. Warren stood, thrashing in and out of his navy blue collie blazer, yanking his collie tie tight and loose. He was slick already in the August evening sludge. Even if he took off the blazer and the tie, he told himself, he'd still be wearing dress slacks and a button-down. He'd still be better dressed than her parents.

No, he'd only be more formally dressed. If he could've imagined being better dressed than the McCarthys on this or any day, he wouldn't have worn his Biotica uniform six hours before his shift started just to prove some point that at that moment he couldn't even explain to himself.

In the end, he threw both blazer and tie on the front seat and ambiguously told himself, *I'm still wearing the slacks.*

99

He slammed the car door. "They did ask about you."

"Warren."

"Well, Elizabeth at least—"

"Warren. They don't even remember who *you* are," Noreen said. "And when they could remember me, they hated me."

"That sounds familiar." Warren held out his arms as if to say, *Even so, I have returned to the exurbs, cap on head and waiting for the organ to grind, all for you, beloved wife.*

Noreen snapped, "We're around back." She started walking.

We. Warren stood there a long time, his body burgeoning with a half-pitched fit. Then he stalked the cobblestones after her.

In the backyard, arcs of water collapsed as the fixed sprinklers deferentially paused their languid swiveling long enough for Warren to pass. A roving sprinkler, a shiny ratlike bot with a half-inch hose for a tail, scuttled past him on its way to a cluster of azaleas. Another rat sprinkler fell dry and whiz-spooled twenty yards back into its housing.

Standing beside a barbecue made from more steel than an East German car, Noreen's father, Jeff, was playing Frisbee fetch with a robot that looked and moved like a Roomba Olympian. Jeff stood straight and smiling, looking like East Egg at leisure.

As always, Warren soon found a gin and tonic in his hand and his bank statement nailed face-out on his forehead. Standing with Jeff, he gulped half his drink and watched Noreen and her mother, Ally, standing over some perennials near the artificial stream marking the property's edge.

Jeff again flicked the Frisbee to the edge of the lawn, and the robot whirred after it.

Marinade was bubbling out of the tenderloin like crude from old-time claims. Warren eyed the meat carefully, pleased to eventually spot bone. His herds had no bones.

As Jeff flipped the steaks, he held one up for emphasis and said, "Your big boys should talk to our big boys."

Your big boys, meant Jeff, *who for all you know could be Venusians running Biotica as part of a plan* To Serve Man, *should talk to my big boys, with whom I golf after meetings in San Diego and DC.*

Although Jeff's success in hooking and deboning defense contracts for Qui Custodet had long earned him a frightening salary (and all the civilian-side free toys he wanted), he and Ally had grown up no richer than Warren's family. They still woke up nights worried that

the failure zombies would claw forth from the earth and stagger remorselessly toward their only child. They needed to know that Noreen would have shiny, well-dressed children and that she and those children soon enough would live in a big house just down the road. But their daughter had taken a chancy path. Instead of law school, she'd gotten the master's in the humanities that had introduced her to Warren. And then, instead of consulting for Accenture, she'd started teaching high-school English. Which was *OK*. At least she was at a high-end prep school. Still, it meant that she should've found a safer husband, a five-nines, seven-figure man whose parents paid people to wake nights and worry on their behalf.

"We just got an interesting little contract," Jeff explained after Warren refused to bite on the big boys. "Some Wilkinson stuff. Meat-powered bots. So your tech and our tech would be a match made in heaven."

"But you guys are already working on hunter AIs, right?" Warren asked. "You don't need Biotica. You just need to give your bots little orange vests."

Jeff laughed. You had to give Jeff credit. He laughed handsomely.

Eusebio was sick again. They hunted each other through the mazes of corridors, the intrico of waving meat. Eusebio got him good in Prairie 7, jumping out from behind an aisle while still chatting over the headset.

Warren staggered backward, but the herd nudged him upright. He skittered nervously back into the green.

"Jesus, you scared me," Warren said.

Eusebio tapped the mic. "Hold it real close and basically whisper. People hear you on the headset but not in real life."

That might have been it. Or it might have been "Flight of the Valkyries" playing at high volume for the herd. Either way, Eusebio had come out of nowhere.

They vacated the room and began again. Warren turned his headset down so that he could barely hear Eusebio. The corridors were loud. Or not loud exactly. Intensely audible. All the minor whirrs and clicks were like a rain forest at night, Warren imagined. He heard scuttling without any source.

"The guys on the eighth floor have branding irons now," Eusebio said or sounded like he said. Warren refused to turn up his headset.

"Somebody brought them up in a golf bag," Eusebio continued.

"They brand the herds in the cameras' blind spots."

Warren whirled toward a creeping movement, but it was only the sinusoidal swaying of 11's aisles, visible through the big window.

Again, he felt watched, and not necessarily by Eusebio. He went back to mentally crafting a work anthem. *Oh, beautiful for this high-rise, for meat that feels no pain.*

"They heat them with acetylene torches. The brands. Doesn't take that long."

For cows and such that have no knees and never grow a brain. Biotica, Biotica, God shed—Wide around a corner so that Eusebio couldn't leap at him. It didn't make sense, though. Even if the eighth-floor guys could find blind spots in the camera-crowded prairies—even if, first, they could find blind spots somewhere else in which to heat the irons—how would they smuggle the irons into the blind spots? You didn't just stick a red-hot iron down your pants.

Maybe he should flip it around, brain first, no pain second. *Oh, beautiful for—*

Hands on his shoulders, pushing him forward. Warren stumbled a few steps along the brightly lit corridor. "How the hell?"

Eusebio just smiled.

"Is that true, about the branding irons?" Warren asked.

TSA nearly killed Warren's great-aunt and -uncle. A couple of orange-alerted idiots younger than Warren had pulled Elizabeth and Jer out of line for interrogation because they had one-way tickets and no baggage. Elizabeth and Jer were eighty and swayed in their airline wheelchairs like houseplants under a heat vent, and these pimple mutts in their bright blue Barney Fifes were letting their hands stray to the pepper spray on their belts.

"Please step back behind the line, sir. We have to take them for questioning, and you can't be there."

Warren had just checked Elizabeth and Jer out of the hospital. They'd broken their hips tripping over one another in her sister's driveway, and then they'd lain, fevered and shattered in urgent care, their faces changing color as LEDs flickered fractions of life and death at them. They'd already been dissolving mentally, and this had done the rest. Even after being discharged, they weren't really fit to travel, but the doctors had said they'd only get worse. So Warren was bringing them home, or at least to their home city and a room at unfamiliar Pine Creek. Of course, they didn't know that. They

didn't know how—*that*—they'd gotten to the airport.

"Step *back*, sir."

Elizabeth and Jer were gone for nearly forty-five minutes before different officers wheeled them back.

It had been months since then, and Warren still wondered what the TSA could have said to his aunt and uncle for that long. Warren had a half hour in him at best. And the only thing that kept him there even that long was that he sometimes heard his inner voice telling God and the TSA, "Nearly wasn't good enough, you bastards."

Today in Pine Creek his aunt was watching the beautician give her a haircut. A few weeks earlier, Warren had connected a cheap webcam to Jer and Elizabeth's television so that they could watch themselves watching themselves. They enjoyed it with the fascination of a dog discovering its reflection. Which was just as well, since lately they rarely remembered how to pick a different channel.

The beautician was cutting away some of the bag-lady snarls that Warren had failed to brush out. Elizabeth was complaining that somebody had stolen her socks, turning her eyes suspiciously toward the beautician. Warren stood at the threshold, watching his uncle break out of jail.

Jer had been a big man, well over six foot and far broader at the shoulders than Warren would ever be. During Warren's childhood Saturdays, Jer had one-handed the noisy gas mower around the yard, happy in the task, his hard arms stretching the flimsy sleeves of his undershirt, his feet moving a nimble near-rumba. He was still a big man but bloated where he wasn't whittled, and his balance had deserted him. Even scraping along with his hand on the hallway railing, he teetered.

Today Jer wanted to escape to a bank where he had $700 in checking, where all the tellers tingled with the notion that men would soon set foot on the moon. Tuesday it had been $300 in an Eisenhower administration credit union. It was always some bank, some time. Always something terrible had happened, and Jer needed to get to the money he'd saved to keep his family safe.

Elizabeth seldom left the room. She wanted to catch all the people stealing from her. At least, Warren thought, neither she nor Jer had ever accused him of stealing from them. Apparently, some submerged part of them remembered having raised *someone* as their son, even if they couldn't entirely connect Warren to the pudgy boy who'd flinched his way from age five to fifteen. They didn't even accuse him of stealing the house in the suburbs that he'd sold to

cover their expenses, mostly because they'd forgotten about it entirely.

Warren had surprised himself by feeling sad to sell the house, sad that they'd forgotten it. After all, throughout his childhood, its walls had rustled with nagging failures and disavowed resentments. Still, there sometimes had been peanut butter sandwiches and tests taped to the refrigerator. He supposed that sometimes you didn't mourn what you'd lost so much as what replaced it.

Warren watched his uncle sway and shuffle down the handrail. Jer had yet again refused to shower, and his pajamas poked out from under his clothes. One of Elizabeth's pink socks was tearing open at the heel of his fluid-swollen foot. Warren felt the urge to slap an emergency patch on it.

Jer had ten more feet to go to the midway bench. When he reached it, he'd need to rest a bit. While resting, he inevitably forgot about escaping, and when someone came for him, he'd follow cheerfully back to the room.

Once his uncle reached the bench, Warren went inside to search the room. He found two of Elizabeth's blouses wadded beneath Jer's bed, a pair of Jer's soiled underwear in the bathroom trash, and Jer's new flannel shirt behind his recliner, the pocket inexplicably torn off. There was no sign of Jer's bottom teeth, now missing for a couple weeks. Warren didn't think that his uncle would understand or endure a replacement fitting. Besides, during the recent meal that Warren had managed to sit through with his open-mouthed aunt and uncle, Jer had seemed willing and able to gum and beaver his way through Pine Creek's thoroughly cooked green beans and suspicious ground chuck. Warren wondered whether it would be wrong to just forget the teeth.

"And what do you do for a living?" Elizabeth asked the beautician for the fourth or fifth time since Jer had started down the corridor.

"I make you pretty, honey. And there you are. We're all done."

Warren stuck his head out the door. A staffer was leading his uncle toward the room.

"We are?" Elizabeth asked. "With what?"

Muzak "My Way" seeped through the soft chandeliers. All the wait-staff, Warren noticed, kept carefully to unmarked narrow tracks between the crisp pink tablecloths. Warren ordered a vegetarian option and fretted. He'd long ago stopped eating the free company lunches out of the vague fear that they were *doing* something to

him, long ago started going to the gym in earnest. Even so, he couldn't shake the feeling that he was becoming a little sloshy, a little undulant.

"What?" he asked, at the edge of panic.

Ally was asking him about his ambitions.

"What are they really? Not what you do, of course, we understand about that. What you *want* to do."

To not find the kind of Jesus, he said in politer words, who, like a subtly moldy yard-sale throw rug, will fill the last twenty years of my life with stink and contamination. To not, after those twenty years, lose everything, including my throw-rug Jesus, during a high-temperature brain sanitization. To survive my family and yours. To die solvent, continent, and precise in my regrets.

Honesty, he remembered during the resulting silence, was not a social grace.

"Good veal," Jeff said brightly.

Warren carried hand sanitizer in his duffel. Pine Creek was full of people who stared perplexedly at toilets. He always showered when he came home, scoured himself pink and raw with the rough side of the sponge. He'd clatter the shower doors with his elbows and the heels of his hands just to feel the reassuring thwack of bone.

Noreen's hand pushed the door ajar to tease his dick. He slapped the hand sharply.

He was sorry before she slammed the bathroom door. She'd married him when he had no dowry to offer but Sallie Mae, Pine Creek, and vat meat. If she wanted his insentient meat to burst its membranes in her direction now and again, she was entitled. Untoweled and sopping, he caught her in the hallway and they led one another to the bedroom.

During her climax she leaned close and they put firm hands to the backs of one another's skulls. *This,* he thought as he fell asleep, *this is my ambition, but without so much dread and scraping on either side.*

"BioticaKF grosses $300 million annually. We have over a hundred employees, plus another hundred independent truckers. And in two months we start accepting web orders. As CEO, I have a lot of responsibility. Plus, there are laws and regulations like you wouldn't

105

believe. Inspectors—FDA inspectors, organic inspectors, kosher inspectors. You name it, somebody is dropping by with a coring bit and a clipboard."

Elizabeth nodded encouragingly. With the remote, Jer made himself and his wife appear and disappear.

After four years' technical proofreading, Warren had longed for the life of the mind. Imagining himself doctoral and tweedy, he'd enrolled in the master's degree program as a first step. After a year and forty thousand dollars, he'd realized that he'd been hoping for a different kind of life, or mind. Not that it would have mattered. By graduation, he'd become half orphan, half parent, and his imagined futures had vanished. Jobless, useless, and giddy with vengefulness toward his ambitions, Warren had read a grad-school friend's blog post about Karl Friedrichs, an obscure East German scientist who had spent his entire adult life attempting to grow insentient meat.

Like a startling number of his compatriots, Friedrichs had been convinced that unlocking the secrets of technological protein would ensure East Germany's nutritional future. Such meat, they'd proclaimed in their 1957 Insentient Meat Manifesto, "would effect a transformation in the objective conditions of agricultural production with the consequence of making just so much more certain the global triumph of the dictatorship of the proletariat." Friedrichs had tried without success to usher in that transformation until 1973, when he'd died of a particularly large and malignant liver tumor.

"After Friedrichs's death, nobody continued his research. I stumbled across his notes in the archives of the Magdeburger Museum für Ungewöhnliche Erfahrung when I was backpacking through Europe. Science had come a long way in twenty-five years, and I realized that I could succeed where he'd failed. I cobbled together some patents and then went looking for venture capital. And now here I am, chairman of the board of BioticaKF."

"That's nice. And what do you do for a living?" Elizabeth asked.

Karl Friedrichs had led Warren to Biotica, which had been looking for "ambitious men and women interested in working at the forefront of scientific nutrition." An irony-anosmic HR staffer had approved his application, and Warren had thought of Noreen's trust fund and taken the job.

After his first night at Biotica, he'd unclipped his ID and told his aunt and uncle that he was a manager there. Since then he'd worked his way up the ladder. Now when he skipped a visit to Pine Creek, he was on the company jet to San Diego or DC. Or Addis

Ababa. People, he'd tell them during his next visit, were starving in Ethiopia. In the Sudan. *But not for long,* he'd say solemnly. *Not for long.*

"We tell people," Warren whispered, "that the 'KF' is in honor of Karl Friedrichs. But it's not, not really. It's for the initials at the top of all of his research notes. It actually stands for *Kufefleisch.* Vat meat. I like 'vat meat,' even if 'cultivated protein' sells better."

Jer turned off the TV, replacing their image with their reflection.

"Vat meat is a growth industry," Eusebio whispered over the headset.

"Nyuck, nyuck."

"But not for us. Here, you need science to get ahead. Except I don't need science . . ."

Warren looked around wildly. Too late. The back of his head stung at a blow from Eusebio's palm.

". . . to get *your* head," Eusebio finished. He trash-talked in a borrowed accent: "I got no idea how your ancestors' sorry asses made it out of the jungle. One lion cub with an empty belly and you're dinner, bitch."

Eusebio's slap tingled still on Warren's scalp. The sensation and the skin itself seemed to jiggle beneath his hair, making him feel gelatinous. Were you what you guarded? Eusebio might be getting more like a collie—maybe a wolf—but Warren felt more and more like an invertebrate cow.

"What's wrong with you lately?" Eusebio asked.

"Not sure. Guess I've been feeling a little well."

Eusebio laughed, flashing his teeth.

The next time Jer escaped, Warren stood in the hallway and watched Elizabeth instead. The Tuesday Methodists had taken over the common room to sing hymns with their grandpa. Warren's aunt came to the door of the room, then crept along the hallway toward the corner. She often looked back as she went, not at Jer but at their room. Nobody was going to steal anything else from her.

She knew all the words, Warren realized. Almost imperceptibly, she mouthed them as she craned her head nervously around the corner to see the singers, as she looked suspiciously back at the doorway to her room. Her head swiveled with slow, regular precision, her mouth singing silently the whole time. Once, though, she paused

midsweep and midnote to smile at Warren as if they both were really there.

Jer watched himself die while autumn was still gaudy on the trees beyond his window.

"The fascinating thing my scientists are finding is how much faster vat meat grows in space," Warren told Elizabeth, his fists rhythmically clenching and unclenching like clutched sacrificial hearts. "Perfectly spherical too. NASA is interested. But nothing's practical yet. The density's too low, for one thing."

Elizabeth again noticed Jer's empty chair, this time in the TV. "Where did Jer go?"

She cried again when Warren told her. She was still crying when she forgot why and asked again where Jer had gone.

Warren tried more lies about microgravity, but they didn't help him. And he couldn't make himself lie about Jer, so he couldn't help his aunt. He stood behind her with a hand upon her bird-boned back, afraid any embrace would pulp her. The hand seemed to comfort her, though. She smiled a little when she asked who he was and what he did for a living.

When he realized that he would destroy something if he had to tell her again, he went down the hall and sat on his uncle's forgetting bench.

The funeral would be in two days, and he had to decide whether to take his aunt. Would her husband's funeral be a fact like Warren's identity, something she could know even if she couldn't remember it? Or would wheeling her there be an act of elaborate cruelty? Warren pictured her trying to pull herself from the chair by the rim of the coffin and dying as the coffin toppled onto her. He pictured Eusebio at the wake, ambushing mourners, or just wearing a black cowl and advancing slowly, scythe in hand, across the room toward them.

He made a sound vaguely like laughter.

Biotica, Biotica, God shed—Biotica, Biotica, We love your vast vat meat. It sure tastes good—Nah.

The funeral was in a day. Stopping at nearly matured Prairie 3, Warren turned off "Unchained Melody" and stepped inside, standing carefully on the green to test his eulogies.

"Jerry Mallory," he intoned, "had $3,000 in a bank account in LaSalle Bank. Jerry Mallory had $275 in Jefferson National. Jerry Mallory . . ."

This died deservedly on the herd's stolidly swaying dignity.

"More days than not, more days than most, Jerry Mallory did the best he could to do the best he knew. It's not his fault he was born, and it's not . . ."

Maybe the meat did know something, or maybe knowledge wasn't the point. It wasn't that Warren needed to be kind. But honest—there was something like honesty called for in this spot, as much as if some John the Baptist had snuck through branding crosses on every aisle.

Warren remembered a barbecue one summer when he was about fourteen and pustulent with acne and intensity. Jer was mowing, Elizabeth was gardening, the burgers were defrosting, and the starlings in the Dutch elm were dive-bombing anybody who neared their egg-heavy nest. The cut grass had smelled so cheerful. Even though the burgers had ended up a little burnt, the day had tasted good and Warren had felt a flash of optimism as acute and life saving as the one he'd felt the first time he'd dozed off beside Noreen.

Warren paced the narrow green bands, life sloshing warm and tortured through him. Tomorrow there would be words, but for now the memory was the eulogy.

Feral

Julia Elliott

THAT AUTUMN A PACK of feral dogs swept into our schoolyard, barking and keening and charging the air with an electrifying stench— wild festering creatures, some bald with mange, others buried in comical clumps of matted frizz, or hobbling on three legs, or squinting through worm-eaten eyes. Rip Driggers was on the porch of my portable, cooling off after a laughing fit, and he came scrambling through the door, waving his fists and spitting, "Dogs, dogs, dogs, hundreds of 'em—craziest mutts you ever saw." We were into the sluggish haze of afternoon, picking at a Dickinson poem, the room smelling of sour socks. And my dozing seventh graders dashed from their seats to the windows. The dogs were their salvation, mongrel hordes pouring in from strange, magic parts of the earth.

"Holy shit," screamed Bobby Hutto. "I never seen so many dogs in my life."

The creatures skittered around the playground, yapping at each other, squirting piss onto swing sets, sniffing each other's piss, pissing on each other's piss, snorting at each other's anuses and snarling. They threw themselves into tangles of squealing and flew apart again. They scrambled around in little circles.

The principal emerged from the cafeteria, peered at the dogs, and then hurried back inside. A minute later his nasally drone issued from the PA system: "A collection of stray canines has entered our playground area. Teachers and students must not leave the main building or their portable classrooms. Please check to make sure all doors are closed and locked." I stood at a window watching the wild beasts prance in the sun. Children who had cell phones were gabbling with parents, describing the antics of the dogs.

In less than fifteen minutes a fleet of trucks and SUVs glittered in the school's front drive. Certain mothers sat idling, chatting with their kids on the phone, but no one could leave the building yet, even though the dog pack had moved down to the soccer field, even though the SPCA, the humane society, the police and fire departments had all been called, even though the soul-stirring, apocalyptic

110

wails of multiple sirens announced that authority figures were speeding nigh.

Suddenly I'd found myself past thirty, shacked up with a fussy bald man nine years my senior who enjoyed monitoring every facet of our household—finances, thermostat, hot-water heater, water and electricity usage, grocery bill, lawn maintenance, and pest control. His brain had become a grid of interlocking systems. His eyes were shrinking into beads as the years went by—he who had once been a luminescent lover, a beautiful, pale trembler with soft bangs covering his eyes. I don't know how this had happened. But now he sat by our sliding glass door, clutching his Beeman air rifle, some of his old pluck surging back as he scanned the yard for curs.

"The bastards," as he called them, had chewed our plastic garbage cans to shreds, had consumed every edible morsel in our trash, had strewn the remaining filth far and wide. The hunger-crazed creatures would come in the night and gobble up anything vaguely organic—sprouting potatoes, blood-smeared butcher paper, old leather slippers, or gory tampons—and then they'd puke; they'd eat their own warm puke; they'd run in crazy circles, pausing to glop steaming mounds of crap onto our green lawn—a masterpiece of emptiness—now polka-dotted with yellow nitrogen stains.

Last week the dogs had sprayed our garage with their spicy pee and sent my husband into a tizzy. He removed every object, pressure-washed the area with bleach water, and then slathered key spots with Get Serious! pet odor and pheromone extractor. At night he slid his recliner close to the sliding glass door to keep his vigils. While consuming exactly three Budweisers, he'd brood with his gun in the dark, waiting for that moment when the brutes would come whirling into his flood-lit territory, rearranging the molecules of air with their yipping and fried-egg stink. Shooting did not kill the dogs, nor did they seem to remember from one night to the next that they'd been shot, but the yelp of a struck dog made my husband smile. And he, a passionate advocate of gun control, kept threatening to buy himself a serious firearm.

I watched TV alone. Each night the evening news spouted facts about dog packs. Feral dogs, fast becoming a worldwide menace, dwelled in condemned buildings, junk car lots, sewers, abandoned strip malls, and old barns. They invaded human territory to scavenge and hunt. They killed in teams, herding livestock, cats, and rodents

111

into corners where they tore them into bite-sized chunks. The American pet craze had led to an epidemic of abandoned dogs. A rash of dog-fighting rings had flared in rural ghettos of the land. And the repressed wolfish instincts of domestic dogs had been coaxed out, had transmogrified within weird new species.

The fighting champions of packs naturally ruled over the ex-pets as well as the bait dogs—smaller, wimpier dogs once bred to rile the fighters. You could recognize a bait dog by its shabby condition, its downtrodden vibe, and crippled state: etched with scars, half blind, riddled with abscesses, and often lacking limbs, they slunk and whined around the glorious, snapping fighters—sinewy beasts with bear claws and yellow shark teeth. Some of the more splendid alphas had long incisors like baboons. Others had needle claws that retracted into their toe pads like those of cats. Legions of freakish specialists had stepped out of the woodwork to describe these evolutionary quirks of reverted dog species, and they, along with innumerable dog-bite victims, bewildered farmers, and owners of dismembered cats, were always being interviewed on TV.

My favorite dog specialist was some kind of evolutionary psychologist who'd written his dissertation on the mating habits of wild primates that had forgone foraging to scavenge human food. He'd made his mark with a documentary on a troop of Hamadryas baboons who spent their days picking through the rubble of a Saudi garbage dump. And now, back in the states, Dr. Vilkas had become interested in what he called de-domestication—approaching the question of instinct from the opposite end. He wore army fatigues. He shot his own footage with a digital minicam. Half artist, half scientist, he looked a little wild himself, peering through greasy black bangs with an unnerving set of glowing eyes. Though an American citizen, Dr. Vilkas had a trace of an accent, trilling and growling, and the way he pronounced his Zs made me blush.

He sported bite-proof arm and leg bands and drenched himself with special pheromones to keep his beloved dogs from attacking him. He skulked among them, filmed them eating and fucking and suckling their scraggly young, filmed them squealing in the throes of birth and barking with joy as they sabotaged a Dumpster or disemboweled a rat. He filmed the parasites that sucked their blood and offered ghoulish close-ups of their maimed and infected bodies.

Dr. Vilkas followed dog packs as they migrated among urban dead zones, blighted farm belts, and dying towns. Our own town fit the usual profile: failing schools, rinky-dink chicken farms, and closing

plants, an obese and debt-strapped populace who fed on processed food, their offspring suffering new configurations of hyperactivity disorders and social dysfunction, children who gobbled generic methylphenidates and performed miserably on standardized tests.

Dr. Vilkas gave no advice on how to deal with the dog epidemic. He eluded authorities who wished to hunt down and exterminate the dogs. Though he seemed to know something about the dogs' roaming and sleeping patterns, he remained tight lipped on this subject while talking about the social habits of the dogs: their complex hierarchies, mating strategies, choreographed hunting tactics, territorial urination, intricate sensitivity to pheromones, body language, and variations of barking.

Howl, growl, yowl, snarl, yap, yip, woof. Each vocalization meant something, and domestic canine pets could pick up some of these messages. When a reporter asked Dr. Vilkas how frequently pets were tempted away from domestication into wildness, the specialist warned dog owners to keep their animals secured—chained, caged, or locked inside their homes. And though he encouraged them to invest in sturdier leashes and to read books on canine psychology so as to recognize signs of restlessness, he couldn't disguise his excitement over the thought of tame animals being lured from their lives of monotonous sycophancy by the siren calls of ferals. His strange eyes shone. And he gazed longingly at the horizon where a chemical plant huffed bright puffs of filth into the sky.

Outside, the autumn afternoon swelled golden, and the children squirmed in their desks. They looked grubby, their clothes rumpled, their hair greasy. I assumed their parents were distracted by the dog epidemic—everyone was. Because the children chattered of nothing else, most teachers had given in to their obsession. We designed dog-themed lesson plans. The principal arranged for specialists to speak in the auditorium. Some even made classroom visits. Today in my world history class, we'd watched a film on the history of canine domestication, learning that around a hundred thousand years ago, the first dogs had split from wolf species, emerging from forests to lurk near human territories—not put off by humans' special decadent stink or the racket of human doings, eventually creeping up to human fires, dazzled by smells of roasting meat. In a time-lapse sequence, a wolf morphed into a German shepherd, which morphed into a collie, which morphed into a cocker spaniel, which

morphed into a teacup Chihuahua, sending the children into howls of laughter.

But now in English a warm miasma of boredom had settled on my class. Eyelids fluttered. Heads drooped. The restless among them jogged their knees, tapped their pencils, glanced toward windows. And then Tammy Stucky, swatting the air in front of her frown, said that Bobby Hutto had cut one. A foul smirk smoldered on Bobby's freckled face—poor little Bobby, whose father hosed down the gut room at the poultry plant with scalding bleach water. And then three football players blasted long farts, timing their stunt with hand signals. Children covered their noses. They gasped and pretended to faint. Several cheerleaders scrambled from their seats to the air-conditioning vent, stood panting over it, screaming "pigs" and rolling their mascara-crusted eyes.

That's when Tonya Gooding spotted the dog pack, leaping from the trash-strewn copse that separated our schoolyard from a Burger King parking lot, splitting the day wide open with their barking and feral verve.

"Damn," she cried, "look at them run. Looks like they flying."

Though I motioned for the kids to keep their rears glued to their seats, all but Jebediah Jinks, a preteen preacher with crackpot parents and eleven siblings, flew to the windows. I sighed and took my usual station at the door.

"A sign of the end times," Jebediah preached from his desk. "A plague like frogs or locusts, except only with dogs, or like them swine Jesus put the demons in. We got war, we got AIDS and hurricanes, we got terrorists and obesity and homosexuality and dogs. You think God's trying to tell us something?"

The other kids just tittered.

And the dogs came romping and snarling, tussling and woofing, mongrels big as panthers and little as squirrels, mutts with mounds of crusted frizz, bald curs with skin like burnt cheese, hounds with lion's manes, canines with dreadlocks matted over their eyes. Short dogs waddled on stumpy legs. Tall dogs loped like spooked gazelles. And the big, rangy fighters led the pack, nipping their inferiors and pissing up a storm.

"The dogs will eat Jezebel," croaked Jebediah, ogling Tammy Stucky's leopard-print miniskirt. "He who belongs to Ahab and dies in the city the dogs will eat, and he who dies in the field the birds of the sky will devour."

Then I saw Dr. Vilkas sprinting from the woodlet after the pack,

his camera hoisted, lank hair streaming. My heart lurched. My ears burned. And I stepped out onto the porch and locked the children inside. I could barely hear their muffled screams, so loud was the clamor of dogs. The air smelled of Fritos and urine. And hot winds blew, as though the mongrels had brought their own weather. I gripped the railing and watched Dr. Vilkas creep up on a skirmish between two alphas.

In the middle of the playground, two gape-mouthed fighters were hurling themselves at each other—a liver-colored pit bull against a spotted mastiff. I could hear the clack of their teeth. The dogs snarled and growled, retreated and flew together again, lifting a cloud of orange dust. Dr. Vilkas stood two yards from them, squinting into his camera. When the dust cloud dispersed, the triumphant pit bull was dancing around the fallen mastiff. But then the creature stopped cold, sniffed the wind, and looked right at me. As though fired from a cannon, it flew toward my portable, leapt over a stunted juniper, and landed in the sad little place right below my porch where my children had spit a thousand loogies into the dust.

The dog snarled at me. It opened its wet, rank maw, and I gasped at the sight of its jumbled teeth. The dog's slimy frog eyes quivered as it watched me. Its breath—the breath of a bone chewer, a dung eater, a slurper of vomit, devourer of garbage, guzzler of hot salty blood—flowed from the creature in thick, long wheezes. The animal growled. And I fingered the keys in my pocket, backing toward the door. The children, watching this spectacle from within, yelled and pounded the windows. And Dr. Vilkas was scrambling toward me, holding some object in both hands—his camera, I thought—figuring he'd film my disembowelment.

I dropped my keys, heard them clatter against the wooden porch and bounce onto the ground. The pit bull's neck hackles shot up. Its gums quivered. The creature sprang three feet into the air then fell on its side, flopped around in the dust for a few seconds before rolling into a motionless heap.

"You OK?" said Dr. Vilkas, who now stood beside the dog.

"Did you kill it?"

"Stunned it with a portable electrode dart." Dr. Vilkas waved his newfangled aluminum gun. "The animal will revive in five to ten minutes."

"I'm glad you didn't kill it."

"Really?" He smiled. "You know it's illegal to shoot them with real guns."

"I know. Actually, my . . . I mean, someone I know bought a tranquilizer gun."

Dr. Vilkas fixed me with his large green eyes. He had scars on his cheeks, scruffed with faint stubble. He had a beautiful mouth, wide and full with womanly quirks. He stooped to pluck my keys from the ground, and when he handed them to me, his fingertips tickled mine.

Sirens took the air again and the dogs started howling. The pack scrambled east, as though chasing after the sun. And the fallen pit bull let out a little croak, twitched its hind legs, and squirted a feeble stream of pee.

"Better get inside your classroom," said Dr. Vilkas, "before this beast revives."

I slipped back into my portable where the children had turned off the lights to better see. They cheered for me. Girls pressed in to hug me, wet eyed, smelling of French fries and imitation designer perfumes.

I found my husband on the back stoop, hunched with his new tranquilizer gun, three beer cans methodically crushed and stacked at his feet, ready to be boxed and hauled to the scrap metal recycling center.

"You're almost an hour late," he said.

"Emergency meeting," I said. "The dogs came back to school today."

For some reason this made my husband frown.

"You left three lights on. The kitchen faucet was dripping. The garage was open. You forgot to padlock the garbage cans. You left toast crumbs on the counter, and you wonder why we have a roach problem."

"We don't really have a roach problem."

"Ha!"

"We had a meeting before school and one after—about the new safety procedures. And then the dogs came, so the meeting was delayed."

"I needed you here. I wanted to run through the drill."

"Drill?"

"With the cages. Remember? We've got to get the fallen dogs into cages within twenty minutes. That's how long the tranquilizer darts last, on average, and for some of the larger species, who knows what our window of op will be."

"Why don't we run through it now?"

"Because it's dusk. The dogs always show up at dusk or else after midnight. Haven't you ever noticed that? And now, if they come and I hit one, we won't be able to work efficiently as a team."

My husband was sporting hunting chaps. He wore his new Hex-Armor bite-proof gloves, purchased on the Web from a veterinarian supply emporium. He'd bought a pair of dog-kicking boots, with treads for running and steel toes, and I'd seen him practicing, kicking logs, smashing the snouts of invisible monsters. But now he slumped on the bottom stoop—all dressed up for our drill. And I'd stood him up.

I patted his scalp. I sniffed the air for whiffs of wild dog. My husband, perpetually congested from allergies, could never smell the animals coming, could never sense the bustle in the air, the electromagnetic hullabaloo that made my spine buzz and brought a pleasant fizzle of panic to my heart, even before the animals tumbled into my field of vision like a promise kept.

"The dogs won't come tonight," I said.

"How do you know that?"

"Feminine intuition."

"Whatever."

"I think I may have a more developed vomeronasal organ than you do." (I was sort of joking, smiling as I said this, but I half believed it.)

"What the fuck is that?"

"Pheromone detector, a throwback organ maybe, deep in the nose."

Some people had sensitive ones, moist and throbbing and bristling with neurons, while other people's were all dried up, almost nonexistent.

I opened the sliding glass door.

"It's like half the population has lost its sense of smell," I said.

"The air conditioner's on, you know."

"But it's getting cool. Why don't we open some windows?"

"How many times do I have to explain? We live on low land. Moisture breeds mold and mildew. This house was not designed for the open air. In this humidity, without air-conditioning, it would rot away in no time. Do you know what that would do to our property value?"

"It would plummet?"

For some reason, this made me laugh. I knew all about humidity

117

and its effects on our house—this was one of those conversations we had over and over for ritualistic, perhaps even religious purposes. My husband kept a humidity meter posted above the kitchen bar, and sometimes, when he felt especially restless, he'd roam the house at night with his integrated, probe-style thermohygrometer, sticking its supersensitive bulb under chairs and sofas and beds, sliding it into drawers and cabinets, sometimes crawling into our shower to monitor subtle changes in the closed-off air, snorting to himself and jotting data in his notepad. I'd even seen him thrust the bulb into his own mouth, his nostrils, his ears, smiling slyly, the way he used to grin when our love was like a living creature, breathing in the room with us.

I closed the sliding glass door. I went to check my e-mail.

There was a message from our principal with an attachment that contained a list of experts willing to make special classroom visits. I scrolled to the bottom of the page where I discovered the e-mail address of Dr. Ivan Vilkas, evolutionary psychologist and forerunner in the burgeoning field of de-domestication.

Dr. Vilkas was scheduled to visit my world history class. My students fidgeted and fussed. Whispery agitation erupted in problem areas. Gobs of slobbered paper flew from certain mouths, smacked against the napes and cheeks of certain targets. It was a hot, muggy day, our air-conditioning system on the blink. And the children's sweat smelled metallic, as though spiked with new combinations of minerals. Their lips looked redder than usual. Most of the kids needed haircuts. And Jebediah Jinks, eyes shining with excess moisture, would not stop mumbling biblical gibberish—he might've been speaking in tongues, for all I knew. Girls snorted and giggled. They passed notes that demeaned the poor boy. And an ugly plot seemed to be brewing among the football players—they whistled ostentatiously, gazed up at the mold-spotted ceiling, cracked their beefy knuckles, and smirked.

We were discussing an archaeological excavation in Iran, where a tomb containing both human and canine remains had been discovered, the dog skeleton curled in a jar, the man buried with daggers and arrowheads.

"This means that he was an important man," I said. "And that the dog was probably a pet."

"Or he might have eaten it," said Rip Driggers. "My daddy says

chinks eat dog. Maybe they eat mutts in Iran too."

"But why would they put a dog skeleton in a jar?" asked Tammy Stucky.

"Maybe it was a cooking pot." Rip snorted. "They probably boiled his flesh off."

"Gross," said Tonya Gooding. "You're one sick puppy."

"And you're a biatch," snapped Rip. "Ruff ruff."

"Watch the language," I said. I could no longer send Rip outside to calm himself. And the principal's office was swamped these days, delinquents clogging the hallway outside his lair. All I could do was move troublemakers to unpleasant areas of the room, make them clean the dry-erase board, deny them their time on our virus-wracked Dells.

Just as it began to rain, Dr. Vilkas arrived, his knock quick against my hollow aluminum door. I found him grinning on my little porch, spattered with damp, clutching his laptop and a tangle of cables.

"PowerPoint presentation," he said, tapping his computer.

"It's that guy," said Rufus Teed.

"I saw you on television!" said Tonya Gooding.

We had thirty-five minutes left until this class ended and my planning period began, so we had to hustle to get his laptop hooked up to my digital projector. As we searched for the right cable, rain beat harder against the flat tar roof of my ancient portable. The children murmured and sniggered and pinched each other. Cryptic underground smells oozed up from vents. Dr. Vilkas asked me to cut the lights, and I stood in the humming darkness with my arms crossed over my breasts.

"Well, now," he said, flashing his first slide (a diagram of the canine nasal system). "We don't have much time, so I'm going to jump right in."

A strand of hair flopped over Dr. Vilkas's right eye. He rubbed his palms together and smiled at the students, his chin disappearing.

"While the human nose contains about five million scent receptors," he began, "the average dog snout boasts over two hundred million."

After pausing to let the drama of his opener sink in, he lapsed into an incomprehensible lecture, describing the receptor neurons and olfactory epithelium of the vomeronasal organ, its dark, squishy fluid-filled sacs, its mucus-slaked cellular microvilli, which absorbed innumerable odor molecules. As he descended deeper into thickets of technical jargon, his sentences became endless, his accent became

119

heavier, and his body hunched as he paced.

The children could not take their eyes off the odd man. One by one, their mouths popped open. They sat stock-still in their cramped desks. When the bell rang, Dr. Vilkas had not progressed past his first slide. Rather than darting from their chairs, the children rose like zombies and gathered their books. They filed out slowly, glancing back at the evolutionary psychologist before slumping out into the drizzle.

We stood alone in the dark, musky room.

"I had a film I wanted to show them," Dr. Vilkas said.

"That's too bad," I said. "I would have loved to have seen it."

"Well, you could. I mean, we could watch it right now. If you're free."

The classroom smelled marshy, with a trace of something coppery that I could almost taste. Who knew what chaos of desperate, pheromonal signals my poor caged students pumped out, day after day in our dank little portable as the beauties of the world glimmered beyond their reach in the mythical places they watched on screens? We sat in their tiny desks toward the back of the room, in the territory of the football players, where a turbulent energy still seemed to hover.

The film, a montage of hundreds of individual canines caught in the act of sniffing, had no sound. We watched one silent dog after another thrust its snout toward this or that reeking object: a pile of dung, a urine spot, a dead cat, a heap of aromatic human garbage or battered Nike tennis shoe. We watched dogs take long, contemplative whiffs of each other's anuses. We saw them snorting hectically at each other's genitals. Male dogs patrolled invisible borders, adding their own messages to the mix. Female dogs snuffled their fragrant pups. Old and crippled dogs nosed their bodies all over for signs of doom.

Halfway into the film Dr. Vilkas started talking about the different kinds of pheromones: territorial scent markers creating boundaries, alarm pheromones warning of looming dangers, male sex pheromones conveying the special genotype of each species, female sex pheromones announcing optimum fertility, and then there were comfort pheromones, released by nursing females to calm their worried young.

"The world is a whirling tangle of significant odors," said Dr. Vilkas. "And humans are blunt-nosed fools, evolving over the years into increasingly visual animals."

"Is it possible for us to pick up some of the dogs' messages?" I asked him. "Without really knowing what we're picking up?"

"We don't really comprehend the human vomeronasal organ," he said. "Scientists are just beginning to understand a glimmer about human pheromones, how they direct our behavior, how they give us very particular impressions about each other."

The film ended and the room went dim, gray storm air glowing outside the windows.

"Sometimes," I said, "before the dog pack appears, here at school or at my house, I get this special tingling feeling."

"Where?"

"I don't know. In my brain, my spine. The nervous system, I guess. I don't know if I really *smell* anything at this point."

"Very interesting," he said, rising from his desk. "I have an appointment, but I'd like to talk more about this . . . phenomenon. We could . . . I don't know."

"Meet somewhere?"

"Yes, we could do that."

Dr. Vilkas walked to the media cart and closed his laptop.

"Like for coffee, maybe," I rasped.

"Or maybe we could conduct some tests, scientific experiments, with the dogs."

Dr. Vilkas dropped one of his cables and picked it up, put it down on the media cart, shook my hand with his hot hand, tucked his laptop under his army jacket, and walked out into the rain.

"Late again," said my husband, who held a Baggie of fetid meat in his hand, bait for the new leghold traps he'd positioned in shallow trenches around our yard. We were standing behind the garage, beside our new aluminum garbage cans, a hot spot for canine activity.

"The dogs," I said.

"Did they come to school today?" he asked, a sarcastic twang in his voice.

"No. But we had another meeting. Working out the kinks of certain safety procedures."

"What kinds of safety procedures?"

"Rabies prevention."

"Which involves?"

"You know, detection. Symptoms. Vaccination. Rabies is a virus."

"Duh."

"And we've got something this Saturday, something on crowd control."

"I thought you were going to help me install the electric fence."

"An electric fence won't keep them out."

"How do you know? Intuition?"

"No. Actually, a dog expert who spoke at school said so."

Suddenly I felt very alert. Wind blustered through the trees, shaking drops from the leaves. Something zinged up my spine. I thought I smelled Fritos.

"I know you think I'm crazy, but I feel like they're coming," I said. "I really do."

"It's too early. They always come at dusk."

"At school they usually come in the afternoon. I'm going inside."

"Plus, they've never come when it's this wet out," my husband called after me.

I was jogging toward our house. The mist felt good on my tingling skin. I think I heard my husband laughing at me, or maybe I heard a braying dog. By the time I reached the back porch they were already streaming into our yard. I heard our trash cans clanking together. My husband yelled, came running around the side of the garage, scrambled into the closet where he kept his power tools, and shut the door. He was safe, so I could laugh triumphantly on our back stoop, one foot from the door but still outside in the electromagnetic air, my head thrown back, my neck muscles rippling, a long liquid howl shooting out of my throat. The dogs didn't plunder or scamper or linger around, but tumbled right through, a stinking river of fur and clamor that flowed through our side yard, dipped down into the gulch that had just been cleared for a vinyl-sided mini McMansion, and disappeared. I couldn't tell whether they'd gone west or east and, with my heart still thudding, I ran inside to e-mail Dr. Vilkas.

"A tingling?" said Dr. Vilkas.

"Yes, beginning at the crown, dropping to the top of my nape, moving down my spine, and then, well, from the coccyx to the pubic bone, an, um, quivering in between."

"In between?"

Dr. Vilkas was smirking. I'm not sure if he believed me, and perhaps I did exaggerate, but he was also tipsy, slurping exotic liquid from something called a Scorpion Bowl—gin, rum, vodka, grenadine, orange and pineapple juice—a drink that'd arrived with a flaming

crouton afloat in the middle of it, making Dr. Vilkas giggle and rub his palms together. There was a straw for each of us, but I'd taken only a few sips. We sat alone, deep in the interior of the Imperial Dragon, a strip-mall restaurant with several windowless rooms, the inner room a jungle of plastic vines with two golden bulldogs cavorting by a miniature waterfall. We dined in a gilded pagoda. Pentatonic lute tunes flowed from speakers. The air-conditioning, set low, smelled moldy.

Dr. Vilkas tore a chicken wing apart and gnawed gristle from the bones. The way he hunched over his food reminded me of a praying mantis, his face an uncanny blend of ugly and beautiful. He had long eyelashes and greenish temple veins. Soft lips and acne-corroded cheeks. Hypnotic eyes that burned above his receding chin and slab of a nose.

"It could be a reaction to the overwhelming whirl of pheromones the dogs put out. Have you always been this sensitive?"

"Sort of, but this is different."

"Different how?"

"I don't know—like something in my brain's opened up."

"Is there any chance you're pregnant?"

For some reason, in this red-lit, windowless room, with Dr. Vilkas's head hovering two feet from mine, the word *pregnant*, applied to my own body, evoking my invisible husband, uttered with a guttural dip toward the word's heavy, eggy letter "g," brought a hectic flush to my face.

I wondered if Dr. Vilkas would've asked this question in the businesslike bustle of a coffee shop, or at school, in the fluorescent brightness of my portable.

"No," I mumbled. "I mean, probably not. I seriously doubt it. Though I guess it's not impossible."

My cheeks felt hot. I vaguely remembered having sex with my husband once in the last month, late one night on the couch, struggling to concentrate, fidgeting to achieve a comfortable position, the television buzzing on mute.

"I don't mean to pry into your private life, but pregnancy would explain an intensification of olfactory perception."

Dr. Vilkas smirked again. He smiled at the oddest times, undercutting the professionalism of his words.

I imagined him scrawny and naked, sneering, moving toward me with the purple heat of his erection, his chest narrow, hairless except for a few wisps around his nipples, his thighs shaggy, his fingers

splayed to clamp my shoulders, to hold me steady for a proper mount. I saw myself drawing my knees up. I could smell the bleach in the motel sheet. And there would be other smells, intimate and bodily, pumped from his glands and blending with odors of feral dog. His breath would also have an odor, a mix of food and toothpaste and the health of his mouth, bacterial colonies, his tongue and gums seething with organisms, infinitesimal animals bursting with the drive to swarm. The room would reek of his equipment, plus the ghostly effluvia of inhabitants past, layers of eagerness and disappointment, ecstasy, bitterness, rage, feebly radiant but there, almost pulsing.

His wallet on the nightstand. His underwear on the floor.

"I've got to go now," I said, pulling cash from my purse, stacking it in front of me, wrinkled and grubby with the sweat of a million human hands.

"What?" said my husband, for I had kissed him on the mouth; I had probed with my tongue until tasting the animal depths of him, hoping to pull this part of him out into the waning day. But he was fiddling with his electric fence, which had a short, and I was drunk after all, my heart getting ahead of itself, red leaves fluttering down from the maple trees and squirrels going about their business.

"You've been drinking," he said.

"Just a cocktail," I said, "with a few of the teachers, after the workshop. But look at me now: I'm home."

I was pacing in little circles around him.

"And we should do something," I said.

"What do you mean?"

"I don't know. Go somewhere maybe?"

"Where?"

"I don't know. A walk?"

"What about the dogs?"

"Take your stun gun. That would be fun."

"I don't feel like it," he said. "I'm kind of involved with this. And it's about to get dark." He turned back to the manual that had come with his electric fence system.

"Well, I'm going," I said, taking big strides away from him. I was crossing the street now, dipping into the gulch where the mini McMansion had sprouted up overnight. I looked back, half expecting to see my husband scrambling after me—apparently the idea of

wild dogs tearing me to pieces didn't bother him, or perhaps he hadn't even seen me stalking across the street with my fists clenched.

I started to run. I jogged into the scrap of woods where a doe had been killed by the dog pack just last week, hunted and cornered and stripped of flesh, her bones cracked open and scattered. It was getting dark, and the terror I felt was like a ringing in my blood, an addictive stirring of something I hadn't felt in a long time, ancient feelings pouring from deep nooks of my brain, charging my body with stamina. I could run forever, I thought, and I kept going, scrambling up a weedy hill until I reached the top. I watched the sun sink into the pond of an empty golf course, and then I sat in the dark for a spell, wondering what to do.

The next week a cold front came, and the children arrived bundled, their winter things musty from summer storage, their eyes lit with the false promises of different weather. The old heat pump groaned, and smells of burnt dust floated up from the vents. The children were squirmy. And my mind kept going blank. The words on the pages of my books would go blurry, and I'd squint up at the children's faces, forgetting why I was confined with so many restless young mammals. Each day I turned off the lights. I showed them films about dogs—*Benji, Lassie, Cujo*—making their minds converge into a single entity—gray, staticky, amorphous—and their bodies sit still.

I saved *Cujo* for after lunch, the most difficult period, and it seemed that the reign of terror held by the crazed, slavering dog would never end, that Cujo had always ruled the endless afternoon with his fury and wet, red snapping mouth. But then, by two o'clock on Friday, the dog lay dead. His exhausted hostages were finally crawling from their dusty Ford Pinto into the harsh summer sun. My children were finally filing out into the cold, bright day. And Dr. Vilkas was finally standing outside my portable, hunched in his army jacket, his face freshly shaven and vulnerable looking, like the skin of a baby mouse. The wind flapped his hair and I could see the crow's-feet that etched the corners of his eyes, a sprinkling of dandruff in his dark hair, two cuts on his chin.

"I called you," he said.

"Oh, yeah. We were . . . I mean . . . installing an electric fence. All week."

"I called you about the experiment, of course."

"Experiment?"

"Your preolfactory neurological sensations and detection of canine activity."

"Right."

"Whenever you're free, we could set something up."

"People tend to romanticize so-called wildness," said Dr. Vilkas, who did not drink so much as open his mouth and splash wine down into his dark, gurgling throat. "So when a dog joins a feral pack," he said, "it does not, in any sense, break free—it simply exchanges one set of rules for another."

"Yes," I said, sipping my wine carefully. I could already feel dark vapors dancing up from what was probably the reptilian part of my brain.

We were in his room at Days Inn, the butter yellow curtains drawn, sitting at a little breakfast table beside the window in a cone of lamp-light, two beds floating in the darkness beyond, one of them rumpled, the other pristine. The vinegary smell of our sub sandwiches still hung in the air. And I thought I could smell a faint, sulfuric whiff of dog, lurking beneath food odors and the sick cherry tang of an air freshener.

Dr. Vilkas insisted that a few drinks sharpened his intuition, that a little wine helped him think about the dogs in refreshingly new ways, and that sometimes, on certain evenings, when his brain chemistry conspired to make his head glow, he could figure out the whereabouts of the feral pack. This was all he would reveal about his dog-tracking techniques. When I pressed him, he answered me with his trademark smirk. He twiddled his thumbs in a way that I imagined would become annoying to someone who knew his tics. He tossed more wine into his maw.

And then, padding around me in his sock feet, smelling of wet wool and wine and the deeper animal brines of armpits, he applied wireless electrodes to my scalp, metal sensors the size of fleas, sifting through my hair with his fingers. He put on his boots. He sipped the last of his wine and smiled. Wearing my invisible EEG helmet, I followed him out into the night—big, bright moon, sweater weather, a single cricket chirring in the shrubs. He cleared a spot for me on the seat of his jeep. He brushed crumpled Hardee's bags to the floor, and I thought: The poor, scrawny creature probably hasn't eaten a single vegetable in months; the methodical man probably scarfs down the same things day after day, hitting desolate

126

drive-throughs out at the edges of human terrain where feral dogs make their dens.

We drove down toward the river, asphalt turning to tar and gravel turning to crusher run. Then hitting rocky dirt, we bounced along, the road flanked by meadows of dead goldenrod. An electrical substation loomed ahead, three fat transformers rising up like old-fashioned robots. Dr. Vilkas had a little can of Comfort Zone DAP—dog-appeasing pheromone, a synthesized version of the stuff produced by lactating bitches to calm their young—and we sprayed the tart substance on our clothes. We went to a place deep in the meadow, down near the water where the dogs sometimes slept, the goldenrod trampled and matted, the air musky and ammoniac, tinged with a familiar, fried salty smell.

"They've rested here," he said, kneeling on the ground. "How do you feel?"

"I don't know," I said. "Nothing too exciting."

"Faint amygdalic activity," he said, studying the crude cartoon on the laptop screen that represented my brain. "Perhaps a stirring in the hypothalamus. Let's move on."

We climbed back into his jeep and drove in the moon-bright night, skirting the old mill village, taking a back highway into a desolate neon-lit area flush with check-cashing shops, car-title-loan joints, strip clubs, and used car lots. Beyond a cluster of gas stations, out near an interstate exit, an abandoned Target was sinking to ruin. Dr. Vilkas said the dogs sometimes took shelter there, but it was too dangerous to venture inside. He had a bottle of merlot in his backpack, and we sat in the parking lot, a weedy void of crumbling asphalt, its pole lights long dead. We drank in the moonlight, passing the wine between us, listening for the yip and stir of canines. We watched the sky for the flutter of bats, pointing in silence when they dipped jaggedly into our sight.

Dr. Vilkas whispered of the mysteries of echolocation. He told me that dolphins and whales used the same kind of biological sonar, drifting in deep-sea gloom, clicking at high frequencies, their pulses penetrating the delicate anatomies of fish. And that certain birds that lived in caves could navigate the blackness of intricate chasms.

Dr. Vilkas handed me the bottle. His fingertips grazed my warm palm. He gazed at his laptop. He detected faint activity, he said, perhaps in my *nucleus accumbens*, though it could be difficult to tell with cortical electrodes. He asked me if I felt any of the special tingling sensations I'd described at our last interview, and I thought that

perhaps I did, a stirring of the hair follicles that ran down my nape, a vague prickling of the spine, heat in my cheeks. Dr. Vilkas looked at me and then back at his screen. He said my *cingulate gyrus* did seem to be stimulated, that my *orbitofrontal cortex* showed signs of activity. And then I felt wind on my face. A bubble of warmth moved up from my coccyx, bounced from vertebra to vertebra, and then dissolved pleasantly in my brain.

"And there's this salty smell," I whispered. "Don't you smell that? Like corn chips."

Dr. Vilkas didn't answer. We both stood up. We knew the dogs were coming, and we smiled knowingly at each other when they materialized in a rush, pouring around the left side of the building, their barks blurring into a single smear of sound, their exuberant stink ringing in the air, their bodies whirling into tornadoes of doggish activity and then dispersing into subgroups. The pack appeared to have doubled in size, now over two hundred strong, Dr. Vilkas estimated.

"Do they see us?" I asked him, my mouth dipping close to his ear.

"Yes," he said, leaning toward me, "though they smelled us first, but the DAP spray should keep them from attacking."

When they began to race around the edges of the parking lot, circling us, sniffing out the borders of this territory, I felt a delicious terror. I took two steps forward and glanced back at Dr. Vilkas, who hung behind, grinning at the diagram of my mind, my feelings lit up, garish in yellow and red.

"Your brain's really pulsing," he seemed to shout, though I couldn't be sure, for different groups of dogs were pressing in on me, stink and noise and wind merging into a single whirl of sensation, their warmth humming against my skin, their fur floating in the air above their spastic bodies, drifting into my mouth and nostrils, tickling mucous membranes. I sensed the hot blasts of their panting, the throbbing of two hundred hearts, the clatter of four thousand toenails. I felt their tongues, pimply tentacles smelling of death, sliding over the flesh of my hands. And now Dr. Vilkas was moving toward me through the canine sea, waist-deep in fur and slaver and stink, his shirt unbuttoned, his hair kinetic from the wind the dog pack always whipped up. He bobbed along, buoyed toward me, until, hurled at my feet, he squatted on the crumbling asphalt.

Tongue lolling, he panted. He sniffed my suede tennis shoes, licked my ankles with his small, fierce tongue. He snuffled my knees. He pawed my thighs and smacked his lips. He threw his head

back and howled, Adam's apple pulsing, until the dogs joined in. They sat on their haunches. Every last animal found a patch of territory on which to squat and bay. They pointed their elegant snouts toward the moon, yowled and keened and squalled until the air smelled marshy from their breath.

Ourselves, Multiplied
Jedediah Berry

THE DOPPELER IS *an eight-inch hypodermic needle fitted to a humming microengine of the professor's own design. The orange liquid in the reservoir glitters and churns, only partly stabilized by the coolant distributed over the glass in a web of veinlike tubes. At the base of the engine is a handle coated in ribbed black rubber: the bicycle grip he picked up at a yard sale for two dollars.*

"This helps to ensure precise delivery," Professor Zinc explains. "The device is heavy, and it may buck a bit when it's deployed, so you need to keep a firm hold on it."

He stands at the head of the dining-room table, shirt unbuttoned, while his assistant Sang-mi taps her clipboard against her thigh. Normally she'd be taking notes, but the burn on her hand still hurts, and besides, she isn't sure yet where the professor's going with this.

He grips the doppeler with both hands and extends his arms before him, aiming the needle at his chest. There's already one scar there, between the second and third ribs. He says, "The doppeling fluid must be administered directly into the heart. An inch off the mark and the results would be disastrous."

"Shouldn't someone help with the procedure?" Sang-mi asks. "I thought intracardiac injection is recommended for emergencies only."

"Every use of the doppeler is an emergency," the professor says, "and it should be self-administered. If you cannot bear to plunge the needle into your own heart, then you have no business using it."

The two went to stay for a few weeks at the professor's hill-town farmhouse. It was a restful period for them both, this retreat from the university. He was on sabbatical, she on academic leave. Twice they took his butter yellow Volvo to the local co-op farm for supplies. He'd never helped with the labor, but he donated money and parts to

130

keep the farm's one tractor in good repair, and received freshly slaughtered pork in return.

It was late autumn so they kept a fire going in the woodstove. He cooked for her while she read, and she did the dishes while he collected kindling. She sewed new buttons onto his jackets after he worried them off. They went for walks by the creek. They reviewed schematics.

"Look, I've invented something," Sang-mi said.

He was at the kitchen table, working on a watercolor of a squirrel skeleton he'd discovered in the garden. He set aside brushes and examined her design. "You've incorporated a shortwave transceiver."

"Like you're always saying, reappropriate the outmoded paradigms as a defense against future obsolescence."

"You foresaw the death of the communications infrastructure following the Collapse. But I fail to understand the purpose of these EEC filters."

"They're designed to isolate certain patterns."

"And broadcast them?" The professor hummed doubtfully.

"Not just broadcast them. The transceiver echolocates their companion frequencies. I call it the amoroscope. You can use it to track down lost loves."

The professor sat back in his chair and thought about that. It was clever of her to set him a trap like this, and he liked an assistant who could keep him on his toes. She must have spotted the pictures of Martha around the house.

"We can start work on it tomorrow, if you want," Sang-mi added.

He traced a finger over the lines of the diagram and tapped it a few times, forcefully, as though he might somehow punch through to the heart of the matter. Then he snatched up the paper and crumpled it into a ball.

"The future has no use for this thing," he said.

She knew she'd surprised him, that first day, when she didn't unpack her things in the master suite, but took the guest room at the front of the house instead. The light was better there, and from the desk beside the bed she had a view of the apple trees at the far side of the meadow, the hills beyond. A view like that would be good for her work.

"Not that I won't visit sometimes," she'd told him, but she hadn't yet.

Or she had. Sang-mi was a chronic sleepwalker, and she didn't know the extent of her nighttime wanderings. In her sleep she was a shrewd explorer. Already she'd woken in the root cellar, in the orchard with her hands full of apples, in a room off the kitchen she hadn't known was there, empty except for an old reel-to-reel tape player.

One night she woke in a strange place, dusty and cold and cavernous. Pale light leaked through long cracks in the sloping walls, and the wind tickled her bare ankles. On the ceiling, pale yellow webs swelled as though with the house's own breath.

She ran from that place, stumbling down a set of stairs to emerge back in her bedroom. It was the attic she'd found, and the only access was in her room, through a door hidden behind the mahogany tall-boy. She must have moved it in her sleep.

Calm now, Sang-mi noticed the lit cigarette in her hand and dropped it into the glass of water by her bed. She smoked, but only in her sleep. She wasn't even sure where her somnambulist self stashed the cigarettes. That other Sang-mi kept all kinds of secrets from her.

For example: Sang-mi had never been in love—not even with Andrew, certainly not with Zinc. But she thought the other Sang-mi had probably been in love, was possibly in love even now. How else to explain all the post office receipts she kept finding in the desk drawer, the ink stains on her own fingers, the sheets of writing paper with indentations from words on a now absent page?

Somebody was writing letters.

Sang-mi took out one of those pages and rubbed it with the edge of a pencil to see the words imprinted there. *The end is near*, it read. *Come home.*

And that was fine. She had plans of her own.

Most evenings after dinner, Professor Zinc retired to the barn so he could check up on his adversaries. A bank of visual displays was mounted to the back wall—thirty separate screens, each angled for optimal viewing from the hammock he'd strung between two supports.

Tonight he lit the kerosene heater, fired up the observation relay, and dropped into the hammock with remote control in hand. A few button pushes called up feeds from a dozen surveillance cameras he'd secreted in various locations over the years.

He found Dean Warren, late at the office again, sipping from a tumbler and fudging budget reports. Three years in a row the dean had tried to cut funding to the department of post-Collapse studies. The man was afraid to see theory put into practice, that was all, so Zinc kept him in line with blackmail and soporifics.

The professor widened his search, activating cameras planted in bus stops, Laundromats, restaurant kitchens. So many people to keep track of, and most of them didn't know they were his enemies.

He spotted Andrew Cardigan, one of his own students, stumbling drunk from another party in the woods. Zinc had once favored the lad, thought to raise him to a place of eminence during the coming breakdown and reconstruction, but Andrew had developed a crush on Sang-mi and that made things too complicated. Zinc convinced him to volunteer as a test subject for a few of his own experiments, and months later Andrew was still suffering from the side effects: bouts of vertigo, memory loss, antisocial behavior, satyriasis. Now, somewhere downtown, Andrew leaned over a trash can and vomited.

Zinc winced and quickly activated more feeds, spiraling away from the city, then beyond the borders of the county, the state, the nation that—he was certain of it—would one day be grateful for the work he was doing.

He paused at a video feed from Kuching International Airport, Borneo. This camera wasn't one of the professor's own—he'd high-jacked the signal from the airport's security system after it became a location of interest.

Tonight it showed him just what he'd been looking for. Zinc lurched forward in his hammock: He knew the man at the front of the security line in spite of the beard, which he wore now in an ostentatious French fork.

There was a hubbub over at the X-ray machine, and guards were preventing anyone from moving through to the gate. They asked him a few questions, pointing to a plain box wrapped in brown paper they'd set on a table.

"Present for me?" Zinc said, but ignored the package and zoomed in on the man's face instead. Only three years old, and already the beard was so thick.

The line shifted and another face appeared on camera. When he saw her, Zinc felt a tiny electric shock in the region of his chest scar. He zoomed back out: long, skinny throat, sleek black dress, slim arms, feet bare for the security inspection and of slightly different size. The woman stumbled on her way toward the metal detector, all

clumsy elegance, and the man with the French fork took her hand.

Sang-mi was suddenly at the professor's side. "Cocoa?" she said.

Zinc switched off the feed from Borneo. Sang-mi was in her pajamas, two steaming mugs in her hands. Had she seen?

She climbed into the hammock with him and turned over his mug—a remarkable display of balance—then gave the display screens a cursory look. "Poor Andrew," she said, sipping her chocolate.

Andrew walked now with the help of a younger, round-faced kid in a red hooded sweatshirt. They stood in the light of some dive bar's neon display while Andrew tried to check the time. His wrist was bare, though—he must have lost his watch or sold it.

Seated on a jet over the Atlantic, a three-year-old man caresses his lover's hand. Her flesh is always cold at these altitudes. Should he signal for a blanket?

No, he should not.

The three-year-old man strokes his beard. "Darling," he says, "you know we have to do this. You know we have to confront him."

Martha puts a finger to his lips, shushing him. She has her own reasons for returning, of course, but he's never thought to ask.

On his lap, the brown-paper package containing his invention emits a white-noise hiss. She still can't believe they let him on the plane with that thing.

The professor's private laboratory was off the pantry, in a post-and-beam addition built just for the purpose. Here he had everything he needed to conduct his research into post-Collapse survival methodologies, and the equipment was itself modified to function after the fall: The pumps were steam powered, the spectrometers and computers ran off a solar panel he'd installed on the roof, the lasers . . . well, he would have to let the lasers go, eventually.

In the meantime he was working on a communications system composed of light signals projected onto the undersides of cloud banks. Ideally, the alteration to the airborne particles would be persistent—painted clouds!—allowing a township equipped with the device to alert people for miles around of any trouble. He had already worked out color codes to indicate "food shortage," "flooding," and "cannibal attack."

Sang-mi came in without knocking. He could smell the cigarette smoke on her clothes—she'd been sleepwalking again.

"Found this in the guest-room closet," she said, dropping something onto his workbench. "You've been keeping these for, what, three years now?"

It was a shoebox. Zinc didn't have to look—he knew what was in there. Two shoes, stiletto heels, the right a full size larger than the left.

Sang-mi flipped open the box and stroked an arch of black leather. "Do you think she's going to come back for this someday? Why would anyone want to come back here, Professor?"

Zinc set down his soldering iron and turned on the stool. "Are you jealous?"

Sang-mi moved closer, close enough for him to wrap one arm around her waist. Gazing at the mazes of the circuit boards, she put her hand down his collar and found the scar on his chest, itself a little maze. She fingered the circle of eddied flesh and said, "I see the way you look sometimes. Like you've got a plan for me. Something you're not telling me about."

He put his head against her belly. "I've got all kinds of plans for you," he said.

Professor Zinc sets down the doppeler. Its microengine rattles against the surface of the oak table, so he slides it onto a cloth place mat. In its supercooled reservoir, the doppeling fluid swirls and sparkles.

"Tell me how you injured yourself," he says.

Sang-mi glances at the burn, which spans three fingers of her right hand and is just beginning to blister. "It happened while I was stoking the woodstove. Looks worse than it is."

"Of course," Zinc says.

Sang-mi flips quickly through her notes. "You told me once that you invented the doppeler because of your wife. Because of Martha."

"It was intended to test her loyalty. But now it may be the key to our survival. Following the Collapse, we'll need as many able-bodied citizens as we can find to help rebuild. We'll need people we can trust. But we can only trust ourselves, so we'll need ourselves, multiplied."

Sang-mi has to use her left hand, and she's worried that the

notes will be illegible. "You've never told me if the preliminary test was successful."

"It was years ago that I began to doubt my wife's fidelity, so I conceived of a way to trick her into revealing her true self. I used the doppeler, plunging it into my heart, and my double was born from my own body." The professor touches the quarter-sized scar on his chest. "The experience was painful and, I admit, a little unnerving. Nonetheless, my creation, whom I named Zink, was a perfect replica. We got along quite well actually."

"Until he ran off with your wife," Sang-mi says. "But, Professor, was that really a fair test? If he was your perfect replica, how can you say that she betrayed you?"

Zinc slams his fist on the table, and the jolt causes the doppeling fluid to glow a brighter shade of orange. "I couldn't stand the thought of her with another man," he says. "This was the only way to learn the truth and not burden myself with the unbearable."

Sang-mi switches back to her right hand, trying not to wince at the pain. The words blur through her tears, and for the first time since she arrived at the professor's farmhouse, it occurs to her that she didn't tell anyone where she was going.

Except Andrew, of course. But the long freeze may already have killed him.

At the gas station, the only one in this hill town, Sang-mi lingered for a while by the magazine racks. Professor Zinc was still outside, pumping gas, when a round-faced boy in a red hooded sweatshirt sidled up next to her. She'd learned that Samovar, as he called himself, took pride in always being on time, especially in clandestine matters.

She returned the comic book she was reading—*Stepsister of Frankenstein!*—and the boy immediately snatched it up. He flipped pages until he found the piece of notepaper Sang-mi had left for him there.

Written on it was a list of laboratory equipment, along with the address of the professor's farmhouse and a name: Andrew Cardigan. *Go to the woodshed and wait for me there,* the note read.

The bell over the door rang as Zinc came in. "Want anything?" he called to Sang-mi.

"Ice pops," she said. "Blue or purple."

Zinc sighed and went dutifully to the counter. He had to wait,

though. The boy was already at the register, paying for his comic with money unwrapped from a well-stuffed billfold.

At the desk in her room, Sang-mi tried to quell doubts about her new work by sketching probability charts, Venn diagrams, unicorns. She couldn't concentrate, though, because of the noises coming from behind the house. Mechanical grindings were followed by booming thuds, then whistles like the launching of fireworks.

She couldn't see the backyard from her room, so she shoved her notes into the drawer and went downstairs. Through the kitchen window she saw the professor dressed in yellow fisherman's coat and hat, his face and clothing splotched in some bright blue substance. Mounted to the old abandoned millstone in the yard was a device that resembled both a cannon and a kaleidoscope. When the professor yanked a pull cord, a cylinder at its base revolved and loaded a liter-sized capsule of colored fluid into the chamber; then a puff of smoke and a shrill whine as a beam of light shot into the air.

Sang-mi rushed outside. "Is it really working?" she called.

Zinc scowled at her. "What does it look like to you?"

She gazed skyward and immediately saw the problem. The heavy cumulus clouds overhead should have been the perfect test subjects, but they had taken on a bloated, uneasy appearance, roiling and rent through in places. Instead of dyeing the clouds, the machine was tearing holes through them.

"They look angry," Sang-mi said.

"Is that your scientific analysis?" Zinc asked.

"Maybe a few adjustments—"

"To hell with adjustments," he said, and yanked the pull cord again and again, pummeling the cloud bank with a dozen more shots. The mass whirled and darkened each time it was struck, until finally it took on a somber vermilion hue. The professor laughed as he continued to discharge the device.

Sang-mi retreated slowly toward the house. Zinc's signal was working, but no one who saw it would know that it was a signal— they would only be terrified. Sang-mi recalled something Dean Warren had once said to her at a faculty cocktail party: "Your mentor's research is supposed to ensure human survival after the Collapse, but I wouldn't be surprised if he brings the damn thing about."

Out of ammunition and out of breath, Zinc leaned against the barrel of the machine and watched his subject thrash and slither across

the sky. The cloud bunched and clotted, darkening nearly to black. Then it fell out of the sky in a single mass. Dark droplets rained over a wide swath of the valley, coating it in ink, sending terrified birds screeching into the air. Down in the village, sirens began to sound.

The professor pulled a tarp over the device, then tore the gloves off his hands and threw them to the ground. "A few adjustments," he said, and went gruffly past her into the house.

Earlier that year, at the beginning of the spring semester, Sang-mi and Andrew Cardigan had sat in a coffee shop, sketching out a formula to represent their relationship. They passed a paper napkin back and forth over the table, adding variables that stood for length of time acquainted, number of furtive glances, pet peeves, frequency of conversations, terms of endearment.

Their physical relationship had so far been conservative—they hadn't "gone all the way," as Andrew put it—and the creation of this formula was seen by both parties as a prerequisite for further intimacy. She was a spelunker and had a brown belt in tae kwon do; he knitted and watched nature shows. He dreamed of kites, she of pebbles in metal buckets. All this was integered and integrated. The equation itself warranted a place within the equation, resulting in a recursive sequence that spilled over several more napkins.

"It's hopeless," Sang-mi said at last.

They had just put in algorithms to represent family background: her father's restaurant business, his privileged childhood, her mother's undiagnosed agoraphobia, his father's collections of model airplanes and racist jokes.

Andrew wanted to keep going, but she took his hand in hers and took his pen away.

"It doesn't balance out," she said. "Even if we want to be together, the world won't let it happen."

"That's dull, pre-Collapse thinking," Andrew snapped. He swept one of the napkins off the table and tore another in half. "See all this? Gone in a few years, along with the financial institutions, the transportation system, most civic services, and my own racist father, hopefully, so you don't have to kill him with your spin kick. We won't need to worry about what the world thinks."

Sang-mi sat back in her chair. Only a few weeks in Professor Zinc's class, and Andrew was already beginning to sound like him. "You actually want it to happen, don't you?" she said.

He took her hand back. "This counts," he said. "Even this. Every moment figures in."

She wasn't looking at him, though, because a boy in a red hooded sweatshirt was standing in the coffee-shop window, staring at them.

Andrew glanced over and quickly turned away. "Weird," he said. "I keep seeing that kid everywhere I go."

The professor straightens his jacket and says, "In any case, their betrayal ran deeper than I could have anticipated. Zink, in his spare moments, had secretly begun to work on inventions of his own. I found the schematics one day for something he called the ruminator. A simple enough contraption, but its creation would have grave consequences."

"What did it do?"

The professor snorts. "Nothing less than freeze time for all eternity. The entire universe brought to a halt. My fear, you will understand, is that Zink may already have activated his device."

Sang-mi is taking notes again, but she needs to keep him talking. "Wouldn't we know that it had been activated?" she asks. "Or rather, since we're still moving around, can't we be reassured that it hasn't been?"

"Certainly not. You forget that the passage of time is an illusion to begin with. A result of human memory and the limits of perception. Indeed, it could be said that the ruminator does nothing more than make a true thing truer."

"Which is what?"

He sounds impatient now. "That every instant is infinite and endlessly divisible. But, Sang-mi, you must imagine the burden of that knowledge. The activation of Zink's device would paralyze us—paralyze those of us cognizant of its function at least. Every gesture, every word, weighted with the significance of an eternity."

Professor Zinc looks down: His hand is trembling, and he has just worried another button off his jacket. He drops the button on the table; it rolls, clatters, and is still. "For everyone else," he says, "the effects would be minor. A sense of fracturing, of a wrongness with the world, a barely perceptible dividing of moments, one from the next, like the darkness between two frames of a film reel. Then perhaps a profusion of new tenses, and a generalized feeling of heartbreak. Whatever that is."

"You miss him, don't you?" she says. "More than you miss your wife."

He doesn't hear her. "Terrible," he says. "Every moment would figure in. Everything would count." Button gone, he's pulling now at the loose fiber on his jacket.

Sang-mi sets down her clipboard. "I'll get a needle and thread."

Sang-mi took the jar of compost out to the garden and heard a whispering from behind the woodshed. She put the jar down and armed herself with a trowel, then went slowly toward the voice that was—she was sure of it now—calling her name.

Andrew stood with his back against the rough pine planks of the woodshed. His clothes were torn, his eyes bloodshot and wild.

"I had to break into the department lab," he said. "What are you building? It's not for him, is it?" At his feet was a burlap sack. He tapped it with his sneaker, and a few components spilled out of the bag. Sang-mi saw the power relay she'd been waiting for.

"You got my message," she said.

"Samovar found me at a party. He said he was impressed with my moves, or something like that. I don't understand kids—they're like little aliens. But this one thinks he's my sidekick. He actually uses that word. Sidekick."

Sang-mi knelt, went quickly through the contents of the sack, then pulled it shut. No sign of the professor in the farmhouse; he must have been back in the barn. He'd been spending more and more time out there.

"I love you, Sang-mi," Andrew said. "You're all I think about."

"How many women have you slept with since the last time I saw you?" she asked.

Andrew took a step toward her, but she raised the trowel and he stumbled back.

"Professor Zinc's experiments," he said. "They did something to me. I haven't been right ever since." He knelt and dug the fingers of both hands into the soil, heaving as though he might vomit.

"You're sick, Andrew."

"I don't know where I'd be if it wasn't for Samovar."

"Is that even his real name?"

"No. He said he changed it when he ditched all his old friends so he could be my sidekick." Andrew rolled his shoulders, blinked a few times. "Sang-mi, you're the only girl I care about."

It had been at least a week since he'd shaved, his hair looked greasy, and he smelled like the compost she'd come out here to dump. When was the last time he'd gone to class?

"Listen, Andrew, I need you to hide out for a while. Stay in the woodshed—he won't find you in there. I'll bring food when I can. But for now I need to get to work."

Andrew coughed into the crook of his arm. "Go," he said, sniffing. "I'll be fine. Just hurry, before he spots me."

Sang-mi went back to the house with the sack slung over her shoulder. She kept close to the sunflowers, using their tall stalks for cover. When she looked back, she saw the woodshed door sweep shut.

Snow fell, the sky emptied and filled again. Sang-mi brought Andrew a thick sleeping bag, hot soup, comic books from the gas station.

"These are so good," he said, as though he'd never seen a comic book before.

The professor spent more of his time alone, working on watercolors mostly, or flicking through security feeds in the barn. Some days he didn't bother changing out of his plaid pajamas, and his projects lay ignored on his laboratory workbench.

Sang-mi might have been able to rouse him out of this state, but she let him spiral further and further from his work. She could gather notes later, and anyway, she needed time to focus on her own pursuits.

In the attic, the place her other had discovered for her, she built a second laboratory. It was rudimentary but functional, stocked with the equipment Andrew brought for her, powered by a rogue line she'd spliced to the professor's solar panel. When she threw the power switch, the place hummed with life, and the old timbers of the rafters were bathed in a shifting, spectral light.

It was ready.

She stood over the control panel, throwing levers to send inquisitive pulses through the machine of her making. Tacked to a cork board was the wrinkled, coffee-stained schematic she'd rescued from the trash. Zinc had failed to see the utility of the amoroscope. But after the Collapse, the first thing people would do was seek out the loved ones sundered from them by the darkness, the fuel shortages, the failure of the telecommunications system. Too many would stumble desperate and blind into the wilds of a new disorder. With

the amoroscope, at least, they might stumble in the right direction.

As the machine's signals normalized, the lights on the display settled to deep magenta and the transceiver emitted a low thudding sound. Sang-mi attached the electrodes to her head and took a deep breath.

Immediately the emerald pixels of the old display tumbled through coordinates. The machine had the equation of Sang-mi's heart and was seeking its match. She adjusted knobs to fine-tune the search. The echolocation was working more quickly than she'd expected, but Sang-mi had never been in love: On whom would the signal fix?

A tremor, a sickening electrical hiss: The lights brightened momentarily as orange sparks flew from the back of the transmitter. Sang-mi disconnected components but it was too late to prevent an overload. She burned the fingers of her right hand on a singed cable and reeled from the machine, tearing the electrodes from her head.

The lights on the control panel dimmed. In the near dark of the attic, Sang-mi sat on the floor, her injured fingers in her mouth. The old dot matrix screeched and puttered. The printout, when she saw it, tendered results she could not possibly believe were correct.

A rented car. A drive up a treacherous mountain road. Everything but the vehicle is still. The trees laden with snow, its weight the burden of an eternal present. Winding among the trees, curving alongside and sometimes passing under the road, a narrow stream, frozen.

Sang-mi went downstairs to bandage her hand but found the professor waiting for her in the kitchen. His beard was trimmed and he was dressed as though to teach a seminar, in a clean striped shirt and corduroy jacket. "Good afternoon," he said brightly.

"Hi," she said.

"Would you come with me to the dining room? There's something I'd like to show you." He left without waiting for an answer.

Sang-mi looked at her hand—the burn was bright red and puffy. She snapped a stalk of aloe from the plant above the sink and dabbed its ichor over the wound. Then she took her clipboard from the counter and went into the dining room.

On the table was an eight-inch hypodermic needle equipped with

an electric engine instead of a plunger. The fluid in its reservoir was bright orange and visibly unstable.

"You've been busy," she said.

"So have you. But this, I must admit, is not the newest of my inventions." His every word was crisp and carefully chosen, utterly professorial. Sang-mi was, in spite of herself, a student again.

Zinc patted the device with something like reverence. "I created this three years ago. I've promised before to tell you about it, and it's time I made good on that promise." While he was speaking, Zinc unbuttoned his shirt. There on his chest Sang-mi saw the scar he'd told her had been left by something called the doppeler.

But the throbbing in her fingers made her think of her own invention, that pile of slag in the attic, its impossible determination. And it occurred to her, just then, that she'd been so distracted by her work in the last few days that she'd forgotten to bring food and water to the woodshed.

"I don't care about him the way you do," Martha says. "He created you. For fuck's sake, he is you. You have to understand that for me it's different."

Zink, seated at the end of their hotel-room bed, listens to every word, but none of her explanations are helping. Instead, they only make him more despondent. He is, after all, a three-year-old.

"But we have to do this together," he whines, fiddling with the paper wrapping of the box on his lap.

She pities him a little then. When they fell in love, she saw in Zink everything she admired in Zinc, minus the self-importance, the paranoia, the pessimism. But the copy is just as stubborn as the original, just as obsessed.

She kneels beside him, puts her hand on his hand on the box. "You'll be fine without me."

"You said you wanted to come with me," he says.

"Not for him, though. Not for you."

The professor circled the table and came toward her. "Forget the needle and thread, Sang-mi. You understand what the doppeler does. I need you to prepare yourself."

Sang-mi backed away from him, away from the professor's invention, which hummed more loudly now, as though in anticipation.

143

"It's the only way," he said, running his fingers through the pale curly hair on his chest. "We need to be prepared. And with more of you at my disposal, we'll be better equipped to contend with the inevitable."

"You told me it has to be self-administered. You said the subject must be willing to bear it."

"You'll bear it," he said. "I have faith in you."

Andrew was in the doorway, arms outstretched, blocking her escape. There were dead leaves in his hair and a rotting smell coming off him. He grinned at her, tongue lolling.

Sang-mi drove her elbow into his chest, and Andrew, too slow to react, buckled and fell against the wall. But the professor had caught up with her by then; he grabbed her arms and bent them behind her back.

"This is all according to your own design," Zinc said. "Keeping your work secret from me, allowing trespass to one of my own enemies, forcing me to bargain with him."

Andrew sauntered over, clutching his ribs but still grinning. There was blood in his teeth: He must have bit his tongue when she hit him.

Zinc spoke quietly in her ear. "Don't worry, I've only promised him a copy. I'll need the original here with me. We still have so much work to do."

"Work to do," Andrew echoed, his swollen tongue making slush out of the words.

"Prep the injection site," Zinc told him.

Andrew brightened at this—for a moment, at least, he was the professor's chosen again. But when he started to unbutton Sang-mi's blouse, his eyes went unfocused and he swayed on his feet. He was forgetting what he was doing, thought he was doing something else.

Sang-mi recoiled from him, and the professor spun her away.

"The injection," Zinc said.

Andrew shook his head, remembering the bottle of antiseptic in his pocket. He cast Sang-mi apologetic glances as he applied the solution to the area over her breast.

Zink's tears leave dark spots on the brown paper as he unwraps the package he's carried with him from the other side of the world. He tosses the paper aside, shivering in the cold. The ruminator is

simple in appearance, a plain black box with a single red button on top: an invention's only invention.

He's so lonely. So terribly lonely.

Zink leans back in the hammock and sets the ruminator on his chest, then finds the professor's remote control. The screens on the wall give him views onto a thousand different sights. Really, it's pretty nice in here. He likes what Zinc's done with the place.

The professor must have forgotten about Sang-mi's brown belt in tae kwon do, because he looked genuinely surprised to find himself on the dining-room floor. "My back," he said, trying to sit up.

She moved fast, disabling Andrew with a swift roundhouse that knocked the dead leaves out of his hair. Then she went for the doppeler, but it wasn't on the table where Zinc had left it.

At the opposite end of the room stood Samovar, Andrew's self-appointed sidekick. The boy's red hooded sweatshirt was unzipped, and with one hand he held his T-shirt bunched at his throat. The doppeler was in his other hand, needle pointed at his own bare chest.

Professor Zinc got to his knees. "Not one-handed," he said, but it was too late: With an abrupt shout, Samovar plunged the needle into his chest. There was a whooshing sound as the doppeling fluid drained from its reservoir, then a shuddering in the old floorboards as the microengine delivered an activating charge. The boy fell to his back, convulsing while he clutched the doppeler's bicycle handle.

They all hurried over to him. Andrew loosened each of the boy's fingers and the professor drew the needle slowly from his chest.

"He missed," Zinc said. "He was off by an inch at least."

Sang-mi had buttoned her blouse and taken up her clipboard again. She stood over them, making notes.

The injection site was red and festering. Streaks of orange appeared beneath Samovar's skin as the doppeling fluid coursed through his body. He shook with a second spasm, and Andrew took Samovar's head in his lap to keep it from striking the floor. "Oh, Sammy, Sammy," he said, stroking the boy's hair.

"It's too late to stop the reaction," Zinc said, "but we may be able to retard the progress of the mutagen."

"We'll move him into the lab," Sang-mi said.

All at once a dozen more blisters appeared on the boy's flesh. The blisters bubbled and widened, and some began to assume recognizable shapes: There on Samovar's face was a little foot, five toes

145

flexing. Just above his appendix, what appeared to be a fin strained outward, then separated into five grasping fingers.

"Oh," said the professor. "Oh my."

Several of the blisters took the shape of tiny human faces. Sang-mi stopped taking notes as the eyelids of one of them popped open.

"Forget the lab," the professor said. "Too dangerous. Help me get him into the cellar."

Andrew took Samovar's arms and the professor got hold of his ankles. Together they dragged him into the kitchen, and Zinc opened the cellar door. They were arguing over who should carry him down the steps when Samovar opened his eyes and sat up, gasping. He looked at his hands and screamed, looked into the dark of the basement and screamed again.

Zinc shoved him through and closed the door. There were a few pitiful knocks from the other side, then they heard him tumbling down the stairs. It was quiet for a moment before the boy resumed screaming. There were other screams, too: quieter, high pitched, like the chorus of a newborn ward.

Andrew sat shaking on the kitchen floor while the professor stood beside him, tugging another button on his jacket.

Sang-mi capped her pen. "I quit," she said.

The next few days were quiet. Andrew took the other guest room and spent most of his time asleep beneath a pile of moth-eaten quilts. Professor Zinc returned to his laboratory—the cloud machine was still giving him trouble, he said, and he didn't have time to worry about what was going on in the cellar. Sang-mi packed her bags and started living out of them, waiting for the roads to clear. Every so often she'd find the amoroscope's printout in her pocket, though she kept burying it at the bottom of her suitcase.

Each morning, Zinc made coffee in the stove-top percolator and they drank together at the kitchen table, sipping quietly. Then it was snowing again, and the professor went out to shovel the walk.

"It made sense at the time," Andrew said to Sang-mi, trying again to apologize for what he and Zinc had tried to do. He was compulsively buttering toast, had made a pile of it at the center of the table.

Sang-mi rubbed her bandaged hand and said nothing.

"He told me about your invention," Andrew went on. "So I thought maybe it would be OK. I mean, you built that thing so you'd always be able to find me."

146

"I didn't know who I was looking for," Sang-mi said.

Andrew held his knife still for a moment, and a square of butter slipped off it and onto the table. There was a scrabbling sound at the basement door, and they both turned to look.

Samovar never asked to be let out, but his appetite was growing exponentially.

"Almost ready," Andrew called, and fetched another two slices from the toaster.

Late that night a windstorm took out the power lines. Professor Zinc emerged from his laboratory and found the others in the front room, close by the flickering light of the woodstove.

They gathered candles and Zinc opened a bottle of wine. He and Sang-mi played checkers while Andrew looked on, bewildered by the rules. "It's all so fucking diagonal," he said, and went to the kitchen to find a snack.

"Don't leave the fridge open too long," Zinc called after him.

They heard him going through the cabinets, the pantry. Then something fell and shattered. "Sorry," he called. "Jar of pickles."

Sang-mi shivered. "I'm going up to get a sweater."

"Careful on the steps," Zinc said.

She took one of the candles and left him alone at the checkerboard. The professor eased back onto the sofa, gazing at the small sooty window of the woodstove. How lucky he was to have his students with him on a night like this, he thought, a night he otherwise would have passed alone, eyes shut against the dark. He sipped his wine and stretched his feet closer to the stove. "Just get the bigger pieces of glass," he called to Andrew. "We'll clean up the rest in the morning."

"OK."

"You have your shoes on, I hope."

"Thick socks."

The wind picked up and Zinc could hear it howling through the attic. Sang-mi's invention was still up there, dead and cold. It was his fault, he knew, that she hadn't been able to tell him about her work. He'd been wrong to let the three of them splinter and drift apart. They needed one another, and the world needed them. Either one of his students, he knew, might now be plotting revenge, but that would only bring them closer. He would bear them with him into the future somehow, even as the future fell apart.

"Sang-mi!" he called. "Andrew! What's keeping you?"

147

"Here," Sang-mi said from the top of the stairs.

"Here," said Andrew, still in the kitchen.

"Here," came another reply—Samovar's—from someplace at the back of the house.

"Here," Samovar again, in the dining room.

"Here," he called from the foyer.

"Here," from Andrew's room.

"Here," from the master bedroom.

"Here," from behind the sofa.

The professor stood and spun around, sloshing wine over the checkerboard and extinguishing one of the candles. In the dim light he saw the flash of a red sweatshirt there, behind the antique Windsor, and another there, reflected in the window, then there, in the doorway.

"What have you done, Andrew?"

He was suddenly at the professor's side. "The broom was in the stairwell," he said. "I must have forgotten to close the door."

Sang-mi came running in, cupping her candle with one hand. "Something grabbed my leg," she said.

Footsteps sounded from different regions of the house, then a cold draft swept through the room as every door—front, back, side porch— opened and closed repeatedly. Andrew, terrified, hugged Sang-mi until she threw him off.

Zinc patted his student's head. "We'll have to keep our wits about us now," he said.

They stood together, close to the woodstove, listening, but the only sounds were the whistling of the wind and the snapping of the fire in the stove.

Elements, thought the professor: the alchemy of some bold and dreadful new experiment. "I'm going out to the barn," he said.

Sang-mi and Andrew wrapped themselves in blankets and hunkered down by the woodstove. Andrew had started to smell better since he'd moved from the shed to the house, and all the sleep was doing wonders for his nerves. Still, he looked tired and scared as they sat there, jumping at every creak the house made.

Sang-mi armed herself with a fire poker, and together they listened to the scrape of Zinc's shovel as he made his way up the slope to the barn. Then they heard the big door swing open and shut, and it was quiet again.

"How long do you think he'll stay out there?" Andrew asked.

"I don't know," she said.

"Why don't you love me?" he asked.

"I don't know," she said.

Andrew drifted off a few minutes later, head rolled back onto a sofa cushion. Sang-mi tried to stay awake as long as she could, but at last she slept too.

She woke behind the wheel of the professor's Volvo. It was warm in the car, and her bags were piled in the backseat. She must have sleep-driven the two miles into town. The car was idling in front of the old hotel that was identified only by a sign over the door that read TAPROOM.

The snow had stopped falling, and the sun just crested the peaks to the east, casting the whole town in a cold red glow. A woman in a blue parka and black jackboots stood by the hotel door. The porch swing was still rocking on its chains—she must have just risen from it.

What was she doing out here at this hour? She came toward the car, stepping carefully through the snow, and opened the passenger-side door. Before Sang-mi could say anything to stop her, she'd climbed in beside her and closed the door.

Only then did Sang-mi recognize her from the photos she'd seen in the professor's house. It was his wife, Martha, and she was beautiful. Sang-mi's invention hadn't lied.

"I got your letters," Martha said. "I came as soon as I could."

Sang-mi stubbed out her cigarette, and she and Martha kissed. She wanted the moment to last forever, and maybe it did.

Andrew Cardigan woke to a cold room. The fire had gone out and Sang-mi was gone. She'd left a note for him, though. In it, she said that she had to check the accuracy of some coordinates. She said she didn't know if she'd be coming back.

Andrew went into the kitchen. The professor wasn't there, so he made coffee himself, then wandered the house while he drank it. It would be a good idea, he thought, to get some new comic books today.

"Sang-mi?" he called, just to make sure.

No reply, but he heard someone moving around in the kitchen so he headed back downstairs. Samovar was at the stove with a dish towel thrown over his shoulder and a spatula in one hand.

149

"Oh, hi," Andrew said. "Making breakfast?"

Samovar nodded. He looked good, and that was good to see. Andrew had been worried about him.

"Lots of eggs," Andrew said, and Samovar nodded again. The boy was scrambling them three or four at a time, and collecting them in a big salad bowl. There was toast too.

Andrew found a napkin and tucked it into his collar, but Samovar didn't bring the eggs to the table. Instead, he stuck a fistful of forks into the front pocket of his sweatshirt and handed Andrew two dozen empty bowls. Then he picked up the bowl of eggs and went to the back door.

Andrew got up and hurried along behind him.

They climbed the sloping path up to the barn. A second Samovar was there with the professor's shovel, clearing the snow that had fallen in the night. Two more were in the backyard, their sweatshirts bright red against the glittering snow, removing the tarp from Zinc's cloud-painting machine. A few more were at the edge of the forest, chopping firewood.

"Wow," Andrew said. "Did you bring all those sweatshirts with you?"

Another Samovar was at the top of the hill. He opened the barn door for them, and they set the eggs and bowls on a table inside. Andrew watched as the crowd of boys converged on the barn. When each had a bowl of eggs, they all sat down and started eating—all except for the one Andrew had found in the kitchen. He took what was left in the big bowl and brought it to the back of the barn, where the professor's hammock was strung up.

Andrew snagged a piece of toast and followed him. It was warmer back here by the kerosene heater. Two men were in the hammock, seated so they faced one another with their legs tangled. One was Professor Zinc, and the other man looked just like him, but with a bigger beard. Perched on the other Zinc's chest was a black box that emitted the hiss of a television tuned to nothing. The box had a red button on it.

Andrew pressed the button. Nothing happened, so he pressed it again. Still nothing.

The Samovar was feeding forkfuls of egg to Professor Zinc. The professor kept very still, and moved his lips just enough to accept the food. After a few minutes, Samovar moved over to the other man and gave him what was left. The two men kept their eyes locked the entire time.

150

The other Samovars had finished eating, and some of them tumbled back outside and started a snowball fight on the hill. Andrew went to watch them with the first Samovar still at his side.

"Are all of you my sidekicks now?" Andrew asked.

The Samovar nodded.

Andrew took a deep breath, and it seemed to him that the clear winter air swept something old and ragged out of his skull. "We'll continue with the professor's work," he said. "We have to hurry, though. I think this is what the end of the world looks like."

With the help of his sidekicks, he had the cloud machine in working order by lunchtime. By midafternoon, he'd made several improvements, and it was time to test it.

The Samovars who were inside doing laundry came out to watch, and the few who'd been tinkering in the lab joined them on the slope. Andrew was working on a new color-coding system, and he decided to give it a spin, even though no one seeing it would know what it meant. Not yet, anyway.

The end is near, he wrote with painted clouds. *I love you. I'm sorry. The end is near. Come home.*

The Stolen Church
Jonathan Carroll

TINA AND STANLEY WYKOFF stood waiting for the elevator to arrive. Both of them were nervous. Both were dressed nicely but still kept checking each other constantly to make sure nothing was wrong— no zipper open, no button undone, no unruly hair sticking out in the wrong direction.

She looked at her hemline and wondered for the sixth time if her dress wasn't too short. She'd asked Stan twice and he said no, but still . . . Hands in his pockets, he fussed again that maybe he should have worn his dark blue suit and not this black one. Wasn't black too funereal? And what about the red tie? Granted it was dark, almost crimson, but wasn't red too festive? The tie was Tina's choice and he was glad she'd been so adamant about it—"Wear your red one. It goes with that suit." So the decision was out of his hands. But now here he was wearing her decision and what if it had been the wrong one? What if he walked in and they were dismayed by his choice of necktie? What if they were offended? Which reaction would be worse?

His parents were long dead by the time he met the woman he asked to be his wife. Perhaps unfairly, he waited three years after they were married before he told Tina about this meeting. Naturally she thought it was a joke when he first said it, but even so it was a pretty bizarre joke. Just the way he phrased it was strange: "In two years my parents want to meet you."

They were having breakfast on an overcast October morning and things between them were going great. Not one unhappy blip on their screen. Both of them were thrilled about how beautifully they fit together. So now what was this? She didn't say anything for a while—only stared at him over the rim of her pink coffee cup as if waiting for him to say part two, which would either be a punch line to the joke or the explanation for one pretty weird sentence. When he didn't say anything else for too long, she felt compelled to prompt him. "I don't understand—your parents are dead."

Stan rubbed a hand across his mouth and the sheepish look in his eyes said he'd rather be anywhere else on earth right now than here

telling her this. Finally he took a long, deep breath. After slowly letting it all out he said, "There's something I didn't tell you yet about my family."

And now here they were in the lobby of a nondescript apartment building waiting for the elevator to take them up to visit his dead parents.

"Moe and Al, right?"

He nodded but didn't say anything.

"Short for Maureen and Alfons, right?"

He nodded again and looked at his shoe.

"You really called them Moe and Al when you were growing up? Not Mom and Dad?"

"Neither of them liked Mom and Dad. They said those names made them feel old."

"But Moe and Al sounds like a comedy team. Like Laurel and Hardy."

His eyes jumped up from his shoes to her face, as if she had said something crucial or surprising. But then the pilot light in his glance died and he looked down again. "What can I say? That's what my parents wanted me to call them." His voice was low and growly now, as if any moment it might suddenly roar and bite her.

She turned her back on him and walked away. What was she doing here? She'd obviously married a crazy man and only now was it coming out. That's what any normal person would think. Darling, you have to meet my parents—they're dead. The elevator clunked to a stop behind her. She didn't move.

"Slushy!"

"Al!"

The air filled with the high yips of small dogs barking furiously. Turning around, she saw a short man dressed in full clown makeup and costume—right down to a blue fright wig, big round red nose, and flat yellow shoes the size of tennis rackets. Running around in frantic circles and then jumping on her husband's legs were two pugs—a black one and a beige one. Stanley was trying to hug the clown and pet the leaping dogs at the same time.

"Heyyy, Laurel!" he said happily, patting the black pug on its head.

There was so much going on between the men and dogs that it was quite a while before anyone paid attention to her. Eventually one of the dogs—the black one—detached itself from the scrum at the elevator and came over to sniff her shoes. When she bent down to pet the little animal, it growled and stepped back.

153

Her husband saw this and said, "Oh honey, don't do that. He hates women. Pet him instead." He pointed at the beige pug. "Pet Hardy. He loves everyone."

"So, son, are you going to introduce me to my new daughter-in-law or am I just going to have to do it myself?" The clown clomped over and grabbed her in a tight embrace. He was warm and smelled strongly of cologne: a cologned clown. That's what she thought while being hugged and tentatively giving some hug back.

He abruptly pushed her away but then held on to both her arms. "I'm Al and you're Tina."

She nodded stiffly. He pulled her in again, embraced her hard, and then let go for good. She was so thrown off balance by all his pushing and pulling that when he finally let go, she staggered on her high heels.

"She's cute, Slushy. You married a very cute girl."

Stanley smiled and nodded. Why did his father call him Slushy?

"Come on, let's go upstairs and see your mother." Alfons went back to the elevator and opened the door. The two dogs trotted in first, followed by the clown, then Stan (who was usually very gentlemanly and held all doors for her), and last Tina.

"How have you been, Al?"

While the elevator moved slowly upward, they all stood facing forward.

"Can't complain. Death's not so bad. They keep you busy."

"And Moe?"

"Well, you know your mother—give her lobster tails and chocolate mousse every meal and she'll still find something to complain about. But, hey, that's why we love her, right?"

His son chuckled. "It's so nice to see you. It's been a long time."

"That's for sure, sonny. Five years." The clown sighed.

Tina looked down. Both dogs were sniffing her leg. The elevator suddenly filled with a ferociously bad odor. Her husband whistled. "I see the dogs are still lethal."

"Yeah, Laurel's farts can always melt your eyebrows."

She looked at the animals. Both were staring up at her. Which one was Laurel again? The smell made her want to retch.

"Tina, how did you feel when Stan told you about us?"

Instead of answering, she slid a look at her husband. He caught it and shrugged.

"It took him three years to tell me."

Beneath the white makeup Alfons frowned. "Three *years!* My

God, son, that's not right."

"I know, Dad, but you know, it's not the easiest admission to make."

"Your mother and I were married thirty-seven years and we never held anything back from each other."

"Nonsense! You lied to each other all the time. Don't forget I was there; I heard a lot of lies growing up."

The clown crossed his arms over his chest and frowned. Her husband grumbled, "Some things never change." The dogs continued staring at her. Everyone remained silent and tense in the elevator until it stopped with a bounce at the fourth floor. When the doors slid open, the dogs raced out and she followed, glad to escape.

There was nothing special about where they were. It reminded her of any hall in any middle-class apartment building. Even the surroundings smelled typical—old rugs, stale air, and meat cooking somewhere.

Alfons walked down the hall toward a door about thirty feet away. He was far enough in front of them so that she was able to quietly ask Stan why his dad was dressed as a clown.

"I don't know," he snapped at her, still angry with his old man.

She stopped right there and, putting both hands on her hips, said, "All right, that's it—not another step. I am not going in there. I've had enough."

The two men stopped too and looked at her.

"What do you mean?" Stan asked in an annoyed voice.

"You lied to me for three years about this and now you're rude? And your dead father's dressed up as a *clown*. His hair is *blue*. Are those enough reasons? Would you like some more?"

"Come on, honey. Just do it for me."

"Why? Can you give me one good reason why I should?"

Down the hall his father said, "The stolen church."

She gasped and moved quickly forward.

Her husband looked at her and smiled. "What does it mean?"

"I don't know."

He shifted the pillow beneath his head. *"The stolen church?"* He repeated her words slowly, emphasizing each one.

"That's right. And as soon as your father said those words, I started walking toward their door. That was all I needed to hear."

They were lying in their bed. Bright sunlight shone through the

window, welcoming them to a new morning.

"It's weird how many things from our real life crossed over to my dream. But what about that clown bit?"

"I don't know, Tina, it was your dream. And a strange one it was, I might add," he said in a bad Scottish accent.

Stanley's parents *were* dead. They'd owned two pugs named Laurel and Hardy. When he was a little boy, Stan's nickname was Slushy because that was his favorite drink.

"Did your father ever dress up like a clown for one of your birthday parties?"

"Nope."

She lay on her back and looked up at the ceiling. "I hate dreams. Just when you get right to the edge of some great discovery or insight, it goes bizarre or suddenly ends. All they do is leave you confused or feeling cheated after you wake up."

He didn't say anything. She kept staring at the ceiling, waiting for him to respond. When he didn't, she turned to him. Stanley's eyes were fixed on her shoulder.

"What? What are you staring at?"

Silently he pointed at the sheet beneath her. She twisted to look but didn't see anything. "*What?* What are you pointing at?"

"Under your shoulder. There are words."

Turning completely over, she rose up onto her elbows. Beneath where she'd been lying, words were written on the bedsheet. In black block letters were the words "the stolen church," "Slushy," "lobster and chocolate mousse," and others.

Both scrambled off the bed to opposite sides. Scrawled across the entire white bottom sheet were many words written in the same rough but distinctive handwriting. "Laurel and Hardy," "elevator," and "three years" were some of them. Glancing at each other, Tina and Stanley were too shocked to say anything.

Long seconds passed before he asked, "Who's Petra Pagels?"

Tina didn't really hear the question because she was seeing words now that she didn't recognize either. She rushed them through her alarmed mind to see if they had any relevance. When they didn't, she asked her husband, "Who is Audrey Bremmer?"

His head snapped up and he looked at her fearfully. She pointed at that name on the sheet.

"And what's Mar . . . mite? What's Marmite?"

Once or twice a year Stan still dreamed about Audrey Bremmer. Audrey who had appeared three nights before his wedding and said

after so many years of failed pursuit, "Tonight's your night." Grinning, she'd added, "It's my wedding present to you." Hours after it was over he had walked into her kitchen. She was sitting at the table naked eating Marmite out of the jar. He had never heard of the dark, murky stuff and after one taste, never wanted to hear of it again. Nevertheless that's what he usually dreamed—some variation of Audrey and her Marmite.

And who was Petra Pagels? Tina's sexy one-night stand back in college. She had never told her husband about it because, well, she wasn't a lesbian or anything like that and, besides, we've got to keep some secrets to ourselves, right?

But their bed disagreed. Scattered across the white bottom sheet were words, names, and phrases that spelled out many things from their lives, among them every one of their biggest secrets. Nothing remained hidden. Some of the words were so cryptic or mysterious that their meaning would remain unknown unless the keeper translated them. Nevertheless they were all there, written large and clear enough for both people to see.

The more the couple stared and processed the words written on their bed, the more they grew to understand. And with that understanding came the realization that some of the words they didn't know were likely their partners' deepest secrets, none of which had ever been divulged.

Eventually their eyes lifted and they snuck peeks at each other. Who was going to speak first? What *could* they say? Their nervous eyes were full of suspicion and wonder. Both wanted to talk, to ask each other questions, to discuss this event right now: Perhaps together they could discover why it had happened. But the pair remained silent, equally stunned and too frightened to say anything about this dark miracle.

Ironically, they had a similar idea at almost the same time—sleep. Did this have anything to do with their sleeping together?

He thought, when you're asleep your guard is down completely. Could something like this happen because you're defenseless and lying next to another person who's in the same state?

She thought, nothing's more intimate than sleeping together—not sex, nothing. You're completely vulnerable. There's an extraordinarily special trust and bond in the act of sleeping inches away from another person night after night. Could that bond have caused this?

Blank-faced he asked, "Is this a good thing? I mean—"

She knew exactly what he meant. She tossed a hand in the air. "I

157

don't know. I guess it depends on what we do with it. Do you want to tell me who Audrey Bremmer is?"

He looked at that radioactive name on the bedsheet and asked his wife, "Do you want to tell me who Petra Pagels is?"

Tina flashed a weird guilty smile but remained silent.

Dropping to his knees, Stanley put his chin and both hands on the bed. Sliding his arms forward, he moved them back and forth across the sheet, across the many black words there, across the secrets they had never told each other for so many good and bad reasons. His arms kept moving back and forth, as if they were windshield wipers. "It's all here, isn't it? Everything we've kept hidden. Everything we don't know about each other." His arms stopped and he looked up at her. "If I tell you all my secrets, will you still love me?"

On the other side of the bed Tina slipped to her knees so that they were now eye to eye across the flat white field between them.

"Maybe. Maybe if we tell, we'll love each other more. But maybe not."

He had to ask, "Did you do this? I mean—"

She smirked because moments before she had wondered exactly the same thing about him: Maybe *he* had powers and made this impossible thing happen.

But watching Stan's reaction, she was certain now that neither of them could have done this alone. It was sleeping side by side through a thousand nights of their young marriage that had somehow caused this to happen—caused this binary weapon to fuse and explode. Their two hearts or souls or whatever had *combined*, met somewhere in the mysterious realm of sleep, and agreed to tell each other everything in the light of day, for better or worse.

"What if we just wash the sheet? Take it into the kitchen right now and toss it into the machine. Or even just throw it the hell out! We'll buy a new one. What do you think?"

But both of them instinctively knew for certain that wouldn't work. If this had happened to them once, then it was sure to happen again no matter how hard they tried to make it go away. Hidden secrets like Audrey Bremmer and Petra Pagels were concrete proof of *that*.

No, there was no avoiding it—from now on, every time the couple slept together, those parts of themselves that wanted their partner to know everything—every secret, every nook and cranny of their souls—would find ways to convey all of the things this husband and wife were too afraid or ashamed to tell each other when they were awake.

For some reason, love, sleep, and candor had taken them both hostage and would show no mercy.

Once again her husband extended an arm across the bed. This time it was obvious that he was reaching for her hand. She hesitated but then reached out too. The bed was too wide for them to touch in the middle. His hand went as far as the word "Alfons." Her hand touched on a man's name too, a name she hadn't seen before, but now that she did she moved quickly to cover it with all of her fingers.

A Design History of Icebergs and Their Applications

Scott Geiger

ENGINEERS OF THE LITTLE ICE AGE agonized over every move and countermove. Decisions were achieved cautiously, as each detail, however subtle, met with a feat of scrutiny. Lining a gutter with icicles required a week's effort by a team of three. To puzzle up with frost the windows of a saltbox house took just slightly less effort. A complex project, such as Oscar Kuo's classic snowed-in Oldsmobile, was expected to consume years of a career. Whatever can be said about that first generation of designers, they were in no hurry. Out of the black hat of memory they pulled winter detail by detail, with the occasional aid of a photograph or a holiday postcard or a set of mittens once attached to the cuffs of a heavy coat. That slick pane of ice encasing the air-conditioner's grille. Starry pixels of snow, seen in halos about street lamps. Crescent-shaped drifts bowing across the acres of cornstalks to the anemometer atop a tall tripod of aluminum legs. These memories heightened in resolution, year after year. And as techniques and applications kept pace, the cost of materials fell. Ordinary families could now afford to frost their own windows. Municipal authorities developed wintering programs. Snow was delivered and spread throughout parks. Ice was installed up in the trees. Pavements were made slippery then sprinkled with rock salt as warnings were posted: "Hazard."

Decades of naturalism defined the Little Ice Age, whose scope ranged from single snowflakes to glaciers in the Ligurian Alps. Winter was sketched, modeled, and built according to a rigorous process of design. So the season and the practitioners who made it possible were celebrated and issued accolades or chunky medals for distinction and service. Children around the world idealized them, children who had no experience whatsoever with a firsthand winter.

Among them were fraternal twins Clement and Angela Goodsun, who grew up making snowmen and mounding up snow forts in the parks of suburban Massachusetts. Clement would remember his favorite park, which contained a steep and bald hill that was groomed

160

every winter and visible through the sunny haze from the streets below. Even on the outskirts of town he could see this bald hill with its historic fire lookout, atop which Clement had stood and surveyed. All Angela saw was that gradient between spots of groomed winter and the rest of the city. On a weekend afternoon, the teenage Angela Goodsun would walk the perimeter of their yard or the border of a park, photographing the point at which snow elapsed into blond grass, paving, gravel, and the oily matter of leaves decomposed. Clement studied geo-engineering; Angela earned a degree in landscape architecture while excelling in economics and finance. Clement completed several additional tests to certify as a winter science professional. They worked apart from one another in several cities until, at age twenty-nine, they submitted an entry for Maine State Pier Winter Garden, the annual competition to create a winter landscape for an old pier in downtown Portland. Their proposal featured a snowy massif that could be scaled by different paths to reach gathering spaces from which the city and ocean were handsomely framed. In his presentation of the massif, Clement cited the steep and bald hill, as all the greats he had studied sourced their designs through poignant memories of the past. Afloat around the pier at varying distances, however, was a scattering of luminous, irregular objects.

The jury interpreted these lights, seen in plan and perspective, with ambiguity. Are they buoys? They look to me like a system of waterborne lamps whose positioning might vary as a means of indicating ocean conditions. Is their light calibrated to match the cold color of the moon? I don't see anything about them in your brief. Can you characterize your decision to include them in the project? Are they ornamental? Are they functional?

Icebergs, replied Angela Goodsun. It's a necklace of icebergs.

A necklace? They are glowing.

The illumination is internal.

Do they melt?

No, she said. They are not that kind of iceberg.

The Goodsuns won. And that winter, beyond the freshly constructed massif, was a sequence of blue-white icebergs without any precedent in memory. The installation remained invisible to those not on the pier until after dark, when the icebergs illuminated. Considerable positive feeling accumulated toward the icebergs; widespread approval was won among residents and visitors alike. Tourists arrived to witness the icebergs, to photograph them, and then post

about their experiences. Kayakers were seen paddling close enough to embrace them. A theory circulated attributing the plan of the iceberg necklace to the *I Ching*. Another compared the icebergs to crop circles, to Stonehenge, to popular constellations. The city council and chamber of commerce even considered keeping the Winter Garden open until June. They agreed to close on the scheduled day in March only after they learned that the treading of so many feet had worn down the massif. A few of the icebergs short-circuited too. One iceberg was stolen, never to be recovered.

In an interview taped many years after the state pier, Clement Goodsun reveals that he and his sister had no understanding that they would identify the objects as icebergs. Angela's answer had been impromptu. Clement announces in the interview, I have never felt I had a stake in putting winter back into the world. It never sticks, you know. Months go by, we have to take winter down. The season is a conceit for us, for our work, a vehicle rather than an end unto itself. People look at al-Khobar and they can't understand why it should be there, where they never had any winter at all. They don't say the same things about Rhode Island or Maine or other parts of this country where we've built because there is consensus about what winter is, where it's allowed to be, where it's trespassing.

In the months following the completion of the Maine State Pier, the Goodsuns agreed to create two identical projects utilizing icebergs: one at Port Judith, Rhode Island, the other at al-Khobar, Saudi Arabia. Twin icebergs for twin designers. The projects' sponsor, a consortium of anonymous investors, cited a passion for great public spaces. But the state pier was already a park unto itself in which the icebergs were the secondary element. Shop drawings show the Maine State Pier icebergs at fifty-four inches in diameter and approximately six feet in height. These two identical icebergs the Goodsuns designed next leapt forward in scale to almost modern dimensions, featuring some five hundred square feet of surface area above the waterline. Requirements that the icebergs be visible from shore and have a capacity to host small landing parties defined their scale and form. Scalloped in plan, they were massed so that the interior of the curve ascends into jagged terraces topped by an enamel white crest. The outer curve is a sheer wall rising straight up from the water. Mostly opaque, the icebergs reflect sunlight, although closer inspection reveals some translucent spots rippled with frosty white veins. Nowhere, however, were they actually cold. They channeled the ocean temperature but were not themselves cold. They contained

no internal illumination, which required them to be spotlit from shore after dark. Only a belt of red beacon lights glowed faintly along the crest. Both Port Judith and al-Khobar planned to complement their icebergs with their nations' flags until the Goodsuns intervened, issuing a statement. Winter, they said, has no nationality.

The twin Goodsun icebergs opened a new section of the Whole Winter Catalog, what has since come to be called supernaturalism. What was left of the Little Ice Age tradition withered as citizens posted statements about how simple snow and ice were no longer enough. I do not linger with snow; snow is like a crowd of strangers, laughing together about a joke I cannot possibly get because their lives are so much better than my own life. Each year I take a small amount home in Baggies and I save an icicle or two because, who knows, my grandkids might like to see it someday, the old-fashioned snow.

Another Goodsun interview, with Angela alone, dates from the years right after Port Judith and al-Khobar. She gives her opinion on the expectations set by her work. She is smiling, seated at her desk, one leg crossed, showing her foot in a dark sock. A red fabric band holds back her blonde hair. Angela says, I remember painting the windows and spreading that thick old-timey white paste all over our steps with a trowel. Winter was all very nice, very safe back then. Supernaturalism leads to a more lifelike winter, definitely far less predictable, absolutely more difficult to control. The opportunity Clem and I saw in the icebergs for Port Judith and al-Khobar was that they could be a sight for everyone to see from shore but they could also become a destination. And the idea just exploded. We were right.

Think of the launches departing. Aboard are the families, the couples, the part-time retirees with their devices standing by in camera mode. Everyone safe inside life vests. Bells above the ticket booth toll as each launch pulls away. Wind streams against the flag mounted on the stern. Over evening departures, fireworks detonate in snowflake geometries. They are going at last, after gazing out over the water from their bedrooms, from their offices downtown, from highway bridges, from behind computer monitors. Passing on the highways they have tried to count the number of icebergs. They have tried to gauge an approximate distance for how far out there these icebergs really are. How are nautical miles different from regular miles? The launch accelerates in open water, nodding the travelers

up and down. Striking changes to the icebergs' appearance occur as they draw closer. There are more of them. They aren't just cone shapes. Nor are they two-dimensional as somebody was saying back on shore. Aren't they a whole lot larger than you expected? Frosted white by day, a luminescence turns on after dark, no brighter than a flashlight held inside a child's closed mouth. Linda Demonchaux first achieved this effect in her iceberg at Vancouver. Arrayed in tissues throughout the iceberg's fabric are tiny light-emitting diodes.

The icebergs resolve into view, exhibiting characteristics never before considered. The travelers hold their breath as the launch decelerates, its motor quieting. Uncertainty arouses them, working both anticipation and fear, as one iceberg in particular appears to be their destination. The natural world's rugged character is conveyed in the formal and material qualities. In the spirit of the Goodsuns, they are constructed with concave as well as convex surfaces mixed with open terrain. Ideal qualities are present as well, including navigable ice caverns, crevasses, and the capacity for adjustable levels of that inner illumination. The travelers' encounter with the iceberg involves no reception, no ramps, no stairs—only a worn metal gangway used to disembark. Their first steps are uncertain, as if the iceberg might suddenly tip under their weight.

A rule of thumb: Icebergs available to parties such as the one described above must offer appropriate square footage for the average number of travelers anticipated, if the solitude and sublime quiet are to be effective. A landing party too closely crowded together cannot experience truly meaningful moments, however well designed the iceberg may be. Some planners will spec only smaller-scale icebergs, the kind that might be visited by canoe for a picnic lunch. Mexican Alejandera Pérez is the foremost creator of miniature icebergs, what she describes as "everyman islands," while Studio Shioya of Roppongi has perfected a design able to be arrayed in several smaller individual pieces or as a single large iceberg. Others prefer mansion-like icebergs, designed to feature three, four, sometimes even five interior spaces, such as caverns and galleries. In this way, some of the party can visit inside the iceberg while other members remain outside, very much alone in their exposure to the elements. Federica Gallon's iceberg for Dubrovnik interprets the city's medieval walls in its wide, high massing situated parallel to the waterfront. It accepts no visitors and is accessible to maintenance crews only by helicopter. Critics wondered about Dubrovnik, if the project aims to be only a sight, might not holography be just as successful? Gallon defied them

again in a similar sequence for Lima, Peru.

Travelers must have enough time with the iceberg to find their own relationship to it. It's so empty, so bluely white or so whitish blue, and how meticulously textured. What coarseness here. But so delicate there. And see how smooth? Like feather but so densely packed. The sunlight pools over the iceberg's face, pushing shadows back into their corners and crevices only to draw them right back out again as the day wages. Nowhere is anything written. There are no patterns to be found. No familiar materials like wood or stone or metal are visible, though amounts of grit and gravel accumulate as visitors pass through. It is crucial travelers are not left so long with the icebergs that they become too comfortable or begin to study their surroundings. In the distance are more icebergs still, all massed differently and yet unexplored. The launch pulls away, its wake caressing the iceberg.

In theory, visibility and access to icebergs are restricted to the months formerly assigned to winter, when an iceberg, however fantastically, could have arrived from the pole. Also in theory, travel to and from an iceberg or an ice floe should be limited within this open season. Rochester, New York, allows access only on Sundays during the month of December, and then only when the weather is fair. Grooming the surface of an iceberg is expensive and time consuming, yes, but the best reason to limit access may be that it preserves the iceberg's popular appeal. A few communities that do offer year-round access require advance reservations or restrict trips to only a few days each month. Not all communities can afford this restraint. If a municipality is overly eager for a return on its investment, it often contracts with a big boat operator who takes as many people out as possible as often as possible. Planners and designers must be cautious. However exceptional an iceberg is, its application and management are of even greater importance. Should its effects wear off, an iceberg or floe is little better than those huge seaborne rafts of polypropylene bottles, condoms, six-pack rings, and shrink-wrap.

About this problem, Linda Demonchaux has said that all the really great icebergs are unknowns. I could never reveal the locations, she says. Even if it brought some of my good friends new work.

Much of the best work in winter science is sealed behind nondisclosure agreements, never to be photographed or filmed. Icebergs are no exception. There are towns for the wealthy, resorts, where snow and ice are expertly groomed to match specific weather conditions. They have real penguins and genuine seals, enormous flocks of

seabirds and giant white bears that swim between the icebergs. Lucky designers invited to work in such places keep mum about what they have seen and what they have built.

One in seven public icebergs has been the scene of occupancy. This is when an individual or group travels to and then lives aboard an iceberg for a period of time. Much depends on the outlook and character of the occupants, who could be seasoned adventurers or simply young lovers out to practice their feelings. More common is a solitary figure with a tent and a space heater plugged to a solar battery plus a stock of dried beans or smoked meat products or packaged meals. They smoke cigarettes and drink rice beer or whiskey or soju or cane liquor. A pistol may be involved. Knives, hooks, spiky crampons, walking sticks are among their common equipment, as if occupants expect to find the iceberg vaster than it had appeared from land. The remoteness of icebergs that makes them such appealing destinations also makes them especially expensive to patrol. Some security solutions are on the market, like the costly Minotaur, which amounts to a roving set of cameras and a stun gun. Other nightly measures range from the dramatic (submerging the iceberg) to the primitive (loosing Rhodesian ridgebacks). Most communities, with no obvious or cost-effective recourse, allow the icebergs to float openly in the dark each night. If a case of occupancy is discovered, any news of it is tightly suppressed. Studies show that public awareness of even a single occupancy diminishes an iceberg's affect, just as a single bad tooth defeats a smile.

After an eight-month occupancy by the Hayden family, the sequence of icebergs created by Victoria Lenaerts and David Dudley to celebrate the harbor at Depoe Bay, Oregon, was withdrawn and demolished. But a documentary about the family's experiences, called *Hardship: The Haydens,* has lately become a sensation and Depoe Bay is now in the process of fabricating icebergs to match their demolished originals.

With occupancy arose the notion of the iceberg as a floating residence, a genre as old as the boat. The "crystal lantern" houses created by former lighting designer Seungyeoun Moon for a suite of Korea's wealthiest families exemplify this startling trend. In plan and section, they resemble some of the most successful contemporary work, though designed in a different spirit with a totally different program using very different materials. Formalizing occupancy is

seen as a threat to the role icebergs play in the collective imagination, and the Winter Science Institute has struck images of it and references to it from their Whole Winter Catalog.

The appeal of icebergs also extends to inland communities, who make an astonishing number of frozen lakes available to themselves. What they do is find a low hollow or gulley, have it surveyed and then fit with a frozen lake. After a few weeks, once skating has run its course, a prefab iceberg is ordered and assembled. The lake is cut and the appearance of the iceberg is established, often at a low level of realism to keep costs down. Maybe the ice of the lake won't fit flush against its edges. Or the lake itself might be too translucent, revealing that the iceberg is only mounted to the surface like a checker glued to its square on the board. But it is all very affecting nonetheless. People will gather still, standing on their iceberg, looking back over the crisp surface of their new lake, the sun shining down through haze. Those below wave at their neighbors. Messages are shouted back and forth. The children leap off, causing the poured, smooth surface of the lake to creak beneath the crowds' feet.

Think of a woman coming alone, just before the dinner hour, to cross the solid lake and climb the iceberg. Picture her paused on the uppermost corner, seen against the peach sky that contains all the newly replenished birds. A highway in the distance shuttles its cars back and forth. Everyone remembers their alertness atop an iceberg or alongside a frozen lake, a moment ringing with sensation. Right then, life is full and rewarding and larded with significance. And when teams arrive in early spring to demolish the lakes and dismantle their icebergs, families often gather to watch them work. No weeds or grass is left where the lake was installed, and the area must be combed for any remaining pieces of ice before it can be reseeded. An odor of thunderstorms then hangs for weeks over the site.

Deployed in the Ariake Sea off the Japanese city Saga are two very large icebergs plus a third smaller one, all built in the supernaturalist tradition. Ten years after the original trio, the city has just released a fourth iceberg, smaller yet and quite low in profile. At first sight, it disappoints; its purpose is not clear. Compared to its neighbors, its circumference is notably smaller. But closer inspection shows that the iceberg is fabricated from a material more like clear

resin or acrylic than the lustrous white ice typically specified. And agape at the center of this fourth iceberg is a double-wide staircase of that same material leading down, as if inside there could be a boutique, a cafeteria, a subway station. The reservations list to visit Saga #4 and descend those stairs is already twelve months long. Photographs are prohibited, so posts about trips to Saga #4 are full of anguished descriptions. Words poorly encapsulate the experience.

Accounts report that these stairs lead to a winding ramp whose contour is marked underfoot by strips of fluorescent magenta. People hurrying up the steps sometimes shout to visitors: Descend at your own risk. Watch out, watch out. There is a great deal of shouting in many languages, and laughter until the corridor blooms into a cavern whose walls climb into a peaked vault. Through the ceiling and walls of the iceberg, actual sunlight filters down into the cavern, while along the floors and walls faint blue diodes are embedded. Unprogrammed galleries and subgalleries stretch away from this main chamber, leading along different paths to a point deeper within the iceberg. Visitors report that, at its lowermost point, the iceberg features a sloped wall against which you can lean and look up through all the translucent chambers toward a faint afterlife of sky. Black against that light is the mobile constellation of small shapes made by the other visitors above. With an ear against the wall, one supposedly hears all the sounds made by this minimal and blatantly artificial iceberg. It is in fact very cold there at the bottom, they say. And lighting in this final room is done to produce dim reflections along the walls. There is a sense, also supposedly, that you have arrived at a place apart from past experiences. They say that what you have known about the world thus far is no help here.

Critics writing on Saga #4 observe that it is very much an iceberg about icebergs: We are able to travel to it, then pass through it, and inside it contains its own pavilion for viewing it. Happening on all sides, meanwhile, is the ocean's volume, with darkness, coldness, indifference enough to compete with outer space. It spells a unique trauma for visitors.

Saga #4 was a collaboration between Kenichi Shioya of Studio Shioya and artist Alan Kepler. Shioya had been an assistant with the Goodsuns for the Port Judith iceberg, then moved on to supervise several of their other projects before returning to Japan. Despite the many joke pieces in its portfolio, Studio Shioya brings to bear a strongly supernaturalist style. Generally with its work, however, the larger the scale, the fewer the self-conscious moves. Alan Kepler has

never spoken out about the design of Saga #4, not even to state his role in the process of its creation. Although he is old enough to remember winter, the material selected for the iceberg suggests that Kepler was not interested in memories. Online footage of Kepler, seen discussing some of his earlier work (a collection of booby-trapped suitcases, boxes, and crates), catches him saying that his ideal medium would be the old-fashioned haunted house. Saga #4 might be considered closely in this context.

I make threats, Kepler says. Nothing would make me happier than if all of my work came out of the galleries and the private collections and was just placed out in ordinary life. It would focus people on the present, which is all the time anyone can be sure of.

Saga #4 is considered by most to be a single, lively exception to supernaturalism. But there are groups actively working within winter science to make statements about the mission to replenish nature. Gdansk-based Goodbye Clock is only the most well known of them. Goodbye Clock founder Fabian Moser is a writer of manifestos and a speechmaker. In one of his archived speeches, Moser argues, Our work is a loud noise against consensus. We are trying to get everyone's attention and remind them that there is an opportunity now to install something in nature's stead rather than just these stuffed animals. Is it possible now to proceed along new lines with new methods and use new technologies? Yes, I know so. We want to throw out the Whole Winter Catalog, to stop work on all the projects now under way.

Moser met his co-founder Ostap Gruss after posting a manifesto against the new icescape commissioned for Gdansk's waterfront. The two wrote letters, appeared on radio and television, and organized lightly attended protests that did little to halt the implementation of the new icebergs. Neither has a background in winter science, architecture, or engineering. Gruss drove a truck before founding Goodbye Clock. Moser is an industrial designer and sculptor by training.

Goodbye Clock's reputation rests largely on published conceptual work. With commissions principally from institutions and private collections, it has admittedly built few real icebergs. Urine yellow icebergs. Constantly foaming icebergs, which, like giant indigestion tablets, froth for hours before vanishing into the water. The iceberg impregnated with ash from the California forest fires. Icebergs made from Cor-ten steel that plunge into the ocean never to be seen again. Goodbye Clock's most well known project is in fact a small

supernaturalist iceberg about the size of a yacht—suspended from an elaborate tensile cable system nine feet off the ground in a private garden in the United Arab Emirates. Long days shine off that unmelting ice. Dinner parties are held there, a long table and comfortable seats assembled directly beneath the iceberg. In the morning, passing tanker ships can see the sunlight it reflects. During the afternoon and evening, it shades the client and his guests. Ostap Gruss, in his lectures, tells of how the guests are always looking up nervously from their plates.

Goodbye Clock is said to have two portfolios. First, its purely conceptual and gallery work, now the subject of so much scholarship and critical opinion. Second, its private commissions, whose scope and character are better left unknown. But for a firm so interested in its statements, it is strange that Moser and Gruss are not able to work more in the public eye. Goodbye Clock submissions to recent competitions in Estonia and Portugal were disqualified as antagonistic.

Moser says, We don't think we're the next Goodsuns. We're playing John the Baptist to something big that is coming next. And when the history is compiled, I want them to say, Yes, Goodbye Clock, it was ahead of its time. Moser and Gruss were never distracted by convention. They'll say, Winter science? That was just taxidermy.

The future of the field will necessarily include measures to recycle and reuse elements of winter. Applications completed during the Little Ice Age were deemed so expensive that they had to be saved for use again the following year. Only as costs declined and public agencies adopted wintering plans did snow and ice find their way into landfills. That furry line between groomed winter and town streets, which so preoccupied Angela Goodsun as a teenager, existed throughout the world, wherever families and communities could afford winter. The popularity of larger and larger icebergs adds to this challenge, which has drawn the attention of urban deconstructors like Sebastian Gutierrez. Gutierrez has planned the deconstruction of vast portions of the American Midwest and Germany's Ruhr Valley. In his most famous photograph, Gutierrez is seated on a length of American highway that has been excavated and rolled like so much dough. Winter science is a new practice area for him but it is one in which he hopes to soon specialize. Gutierrez says, Like everything people build, we need these winter items only slightly more than we need to get rid of them. There is a precise moment when that balance

tips in the other direction. We need to able to determine that moment as soon as possible, then get set with the solutions for disposal, deconstruction, and possibilities for reuse.

Gutierrez calls for all icebergs and winter phenomena to be dismantled each year at the end of March. Such a measure would cap excessive creativity, requiring everyone to start all over again next year. Gutierrez says, OK, we know that icebergs need to be unique to be effective. In a township with a population of twenty-five thousand people and three icebergs, how long will it be before everyone has visited the icebergs two, three, four times? How long are they going to want to look at them? Next winter, they're all going to another township or a big city to view their icescapes. And what if no one comes to see the three icebergs anymore?

Studio Shioya again stands out for the flexibility of its icebergs, some of which are broken apart and then transported for use in houses, stores, and public parks. A recent trend in Japan saw umbrellas and canes made from reclaimed icebergs. And a Majorcan shoe brand recently began to sole its shoes in Europe's recycled ice.

Among the unbuilt projects in the Goodsun portfolio is a proposal for an operable ice floe. According to Clement Goodsun's sketch, this collection of icebergs would drift slowly down from Wisconsin to Chicago during the weeks ahead of Christmas, and, upon arrival at the Chicago waterfront, the floe would become the scene of a holiday festival. Each iceberg would have a different program: a Kristkindlmarkt, eating and drinking, choral music, sledding. A built variation on this concept exists in the Netherlands, where each year twelve icebergs travel south along the Wadden Sea from Friesland past the Afsluitdijk and Amsterdam to come ashore near The Hague. Known as the Zuiderzee Monument, the project recalls ravishing floods and vast winters the Dutch used to know. Outwardly, the icebergs appear to abide by strict supernaturalist rules. No tour boats visit as they pass muddy beaches and medieval townships and the windswept island farms. A low and tremulous syllable sounds in the distance as the icebergs negotiate the shallows of the Wadden Sea. For their navigation, the icebergs rely on a geosynchronous satellite that steers their underwater propellers and directs asterisks of omnidirectional tank treads at their base.

The Zuiderzee Monument is the recipient of nineteen international awards yet its designer is anonymous. What sets the Zuiderzee apart, one citation reads, is its total persuasiveness—not as a naturalistic winter phenomenon but as a vivid and powerful character in

the lives of the Dutch population. Here is a new winter, a season apart from memory, untied from authors, all but autonomous.

The Zuiderzee's annual voyage from Friesland to The Hague varies every year, the four-week course plotted randomly by the computer aboard its satellite. It begins each year on the first Friday in the month of May at the Ems River. Along the Frisian coast, they light bonfires and host vast outdoor picnics. Out into the murky Wadden they venture in tall boots, drawing close as they can to the voyagers, recording video, posing in photographs before them. No one tries to climb aboard, no one interferes with their progress. Traffic over the Afsluitdijk is partially blocked to accommodate onlookers, who stand for hours with binoculars in hand, children fixed on their shoulders. When the icebergs at last come ashore near The Hague, a tremendous welcome greets them. Bands and flags and politicians await the final groans of the icebergs as they lodge into the seaside. Then there is a great rush to scale them and people clamor over one another, often in their underwear or bathing suits, to press their skin up against the icebergs. Much to parents' alarm, children chase up the icebergs' sides; inevitably, one of them slips and falls shrieking into the black waters. Colored flags of no special significance are raised up high on the icebergs. Musicians play, cooks grill and fry, and men, women, and children all drink more deeply than they had previously anticipated. Then the naked sky shows all its stars.

Sooner than later, claims Sebastian Gutierrez, we'll need a kind of purposeful forgetting, a letting go of winter.

When the Dutch wake up the following day, they might revisit the beach and admire the absence of their celebrated Zuiderzee Monument. Meanwhile, out on one of their great highways, freight trucks are hauling the icebergs away to a storage facility until winter comes next summer.

Dowsing for Shadows
Karen Russell

Hold the serpent by its head or neck.
Direct its tongue towards the horizon.
Listen.

—Post-it retrieved from the Traveling Souk

THE TRAVELING SOUK WAS a sun-licked Winnebago parked many dirt miles from I-8, what Jim called the last lost highway through the Sonoran. It was run by a man who introduced himself as Sheik Al, greeting them with lemon water in plastic Dixie cups and a tube of Wet Naps. One cube of ice for each of them. These Al presented with the gallant pageantry of a mullah offering mint tea in Fez. Sheik Al was a graying shirtless man in overalls with a towel wrapped around his head, his nipples pink as roses.

"Wet Nap, missus?"

Flea was standing near the RV's shuttered windows, trying hard to return the Sheik's smile. It was so hot inside the trailer that the light itself seemed to curl and wisp. The girls stood behind her, staring at Sheik Al with saucer eyes: Twif, the oldest, was nine, a scrappy, epicene age; Zi, the baby, had just turned five. Sheik Al tilted his chin at them.

"They yours?"

"No. They're my boyfriend's." Al smiled blankly, blinked. This sentence didn't compute at first for most people. "I'm Flea—Stephanie—and this is Twif."

Twif gave her a murderous look. She was tall for nine and came up to Flea's shoulder, her braids split down the middle like some Apache warrior's. She took a step backward, a step to the right, as if she were beating Flea at a game of corporeal checkers. She stood before Al with a grim, settled expression, arms crossed to indicate that she was her own chaperone here.

"She's not married to our dad," Twif said loudly, but Sheik Al had stopped listening. He was in the corner fiddling with the radio knob, trying to will the Eagles into a fuller existence inside the RV walls. Their voices piped through the speakers with some wariness, like

173

ghosts reluctant to haunt Al's grimy 'bago.

"Desperado . . . ," he grinned at them. "What are you folks in the market for? Jewelry? Souvenirs? Lemme take you out back."

Jim, boyfriend of Flea, father of these two young daughters, had sent everybody into the Traveling Souk while he worried the car. Flea's belly still ached with that dyspeptic pleasure of a fear confirmed, what she'd always thought of as a terrible, female pleasure, a link to Cassandra. She'd told Jim back in Louisiana that the Chevy couldn't make the trip and, sure enough, right around the state line black smoke had started to pour from the hood.

"God, I *told* you so, Jim," she'd said, watching the smoke chug upward with a strange exhilaration.

"Dragons!" the girls squealed. "There's a dragon inside the car!" and then Jim had pounded his fist on the dash and shouted an exotic swear word that silenced everyone. They'd seen a sign from the road— THE TRAVELING SOUK, SHEIK AL'S INLAND ARK!!—and pulled in to find a bathroom and a phone. Flea had been pleasantly surprised to discover a translucent fingernail of soap in the Souk's frightening "latrine." So far they were one for two—no telephone lines out here, and Sheik Al explained that he didn't trust cell phones, which gave you brain cancer.

Now Al led them around back to a cloth labyrinth: half a dozen connected tents pitched in the "backyard," a cinnamon brown scrubland behind the Winnebago. Al's backyard seemed to extend to the sky's pale blue corners. A few dead trees ghosted around the tents. "Palo verdes, girls," Flea mumbled. She wondered if she was doing the wrong thing here. Sheik Al unzipped the flap of the first tent and they all crowded in. Twif and Zi gasped—the inner walls of the tent were upholstered with tiny mirrors, rounds of glass the size of bottle caps. Zi kept pausing to stare at her chandelier selves, a million Zis twinkling to infinity. Twif pushed forward—"Look! All these boxes here. . . ." Dozens of open trunks and cartons filled the tent's interior. Flea knelt and peered into one marked FOR CLOTHING: reams of cloth in foreign colors, coastal colors: sea green, emerald, shrimpy pink. Blues with a fishy iridescence. Flea had been expecting the Souk to sell ancient microwaves and "vintage" clothes that looked suspiciously like Al's laundry—but these fabrics were beautiful. She sank both arms up to their elbows into the trunk and pictured undersea trenches, sightless monsters. She had a sudden impulse to blindfold herself with one, to let that cool marine blue slip over her eyes.

"And what can I get you today, lady?" Sheik Al said, crouching behind her. Up close, he smelled of cigarettes and citrus. "Anything—"

Really, what Flea wanted to buy was a hiding place. A secret, reliable font of darkness. But this was like shopping for the doorknob to an ocean or a recurring dream, and nothing she could say out loud to Jim, much less Sheik Al. He was sitting cross-legged on the tent floor with a Cheshire grin.

"How much for this?"

A sign taped up in the trailer window behind him read: DOWSING SNAKES. POISON MAPS. FLAYED SKINS. Beneath this stood a globe that had been covered in burnished snakeskin.

"The world's not for sale, ma'am," said Al. "That there is my own property." He tapped a nail against one blue-black snake scale in America, said, "You are here" like he was making a joke. Flea stared at the vacant coordinate and felt a little chill.

Twif, meanwhile, had crawled over to examine the basket labeled DOWSING SNAKES.

"You want a dowsing snake, sweetheart? You know how to use one?"

Sheik Al walked over and reached into the basket. He pulled out a dowsing snake—a real snake, Flea saw, no plastic toy or carved thing of wood. Light ran in a white freeway along its scales. The thing had oil-drop eyes. The rattle looked like a miniature beehive on her palm.

"See this? Taxidermied, gals. Stiff as Moses' staff!"

Al was scribbling out HOW TO DOWSE on a Post-it pad. "Well, girls, your ma"—he looked over at Flea, remembered—"your friend here can tell you about the old dowsers. Nowadays we've got plenty of water, we pipe it in from Devil's Whelk. Our problem, girls, is a drought of shadows. We use these snakes to find reservoirs of shadows. There are deposits of nightfall pure as springwater all over this fine country, ladies, it collects in caves and gullies and stews in some such pockets like old rain. Here," he said, and handed the serpent to Flea with a lewd wink. "Hold it like this. Now, when you hear its rattle go off, that's how you know you're getting closer."

"You must think we're easy marks," mumbled Flea, counting out bills.

"Please," he grinned. "Snakes are easy. I could sell a pair of rainbow bifocals to a blind man. I could sell a good death to a child. . . ."

Flea hustled the kids out of the tent. Jim was waiting for them

outside, his gray shirt soaked with sweat.

"Flea, honey." He had his statesman's face on, the one he used to deliver the worst news. "I can't stop the leak in the radiator. We've gotta call and cancel the motel reservations. I don't think we're going to make it out of the state tonight."

"We can't call anybody. There's no phone here." She smiled at Jim. "The Chevy's dead, we're stranded in the desert . . . we're in a B movie!"

Flea thought the creases in Jim's face gave him a kind of sad nobility, like a bulldog's pedigreed depression. It was what had attracted her to him in the first place, his frank liquid eyes in such a beat-up face. They were "in recovery" together, a phrase that Flea liked because it made her feel safe, as if they were dating inside a pillowy chrysalis or something. Jim had asked her to coffee after a twelve-step meeting, where the doctrine of powerlessness had puttied her up and it was easy to feel that this was fate, God's will, her first date with Jim. Normally she could drink a whole pot of coffee but that night Flea didn't lift her mug once.

Flea had known from the beginning about Jim's Texan daughters. She'd seen photos, talked to Zi on the phone twice, and she'd told herself that everything would be fine once she met them. Surely, Flea thought, she had some latent maternal instincts that would get activated by the children's presence.

"You can stay a night or two at the Diggings, brother." Somehow Al had managed to slink up behind Jim unnoticed. "You can probably make that. It's just five miles up the road, you'll feel like sardines, sure, staying in Eolia's tin-can motel, but at least the price is right. And if the car craps out on you, folks, you just walk right on back to the Souk. Sheik Al will help you, *grantis.*"

Flea thought he meant *gratis.* She didn't trust a man who referred to himself in the third person. They had reservations at a Best Western in Fullerton with clean linens and free shampoo vials, vending machines with 7UP and peanut-butter crackers; Eolia's "tin-can motel" sounded like a place where they'd all get tetanus in their sleep. She raised an eyebrow at Jim but his face was a tired, boiled mask. He threw his hands up as if she'd accused him of something. "Please, huh, it's just one night!"

"I didn't say anything." Flea looked away. *Sorry I'm not more enthused about sleeping in a can.*

Everybody piled back into the car, and even the girls knew enough to halt the manufacture of opinions. They watched the coolant vent

from the orange hood in great curtains. The only noise inside the car came from the wheezing Chevy itself, as if the four of them were traveling inside the sickroom of a dying relation. Finally Flea pulled the dowsing snake out of the bag.

"You ever heard of one of these, Jim? It's a dowsing snake. You use it to dowse for shadows, big underground rivers of them, you know, like the pioneers did. . . ."

She watched Jim crack a slight smile in profile. "The pioneers, eh? That's what Sheik Al told you the dead snake was for? For finding shadows?"

"You know, the way the old Bedouins use their sticks to find water. . . ."

"Dowsing for suckers!" His laugh sounded tired. "Well, girls, what do you say? Wasn't that nice of Stephanie, to buy you those . . . things?"

"Thank you, Steph-a-nie."

"For?"

"For our snakes."

For maybe twenty minutes the girls were in love with their new toys, pointing the taxidermied vipers at one another and making forked lightning noises—"Zzzzzt!"—and then, like synchronized divers, both girls collapsed against the seat belts. The dowsing snakes lay forgotten underneath the nudist colony of Barbies and the yellow skeleton of a Connect Four. Flea squeezed Jim's hand on the clutch but she didn't slide a hand against his groin, didn't kiss him, in case Twif was just pretending at sleep.

They were taking the girls on a vacation to the World of Darkness in Fullerton, California. The park was supposed to be a replica of Dante's Inferno, complete with lava slides and lakes of blood and a howling Cerberus puppy for the kiddies—even Zi was tall enough to ride the Ticks of Cerberus, a bunch of fat black bumper cars. Jim had fought hard for Disneyland but the girls won the day by staging a hunger strike in the backseat. Jim had broken down—"All right, all right, you little terrorists, we'll pay forty bucks a pop to go to hell. You happy now?" Twif gave him a Gandhi smile and bit into a small plain cheeseburger, ending her protest. "Hooray!" Zi crowed. "Cerberus! The World of Darkness!" Flea wondered when Mickey Mouse had let his gloved hand slide from the pulse of America's children.

They'd spent their last night in "civilization" at a nameless purple motel in Tucson, a place that had distinguished itself from the Wendy's drive-through and the funeral parlor with a glowing red VACANCIES sign—a sign that Flea kept, for some reason, reading as VACCINES. Jim had yawned and fallen fully clothed onto their bed, leaving Flea to get his girls ready for sleep. Somehow she had managed to corral them in the motel bathroom and get the sisters' tiny seed-pearl teeth brushed, get them into pajamas. Was she supposed to sing some stupid song to them now? Flea consulted her own face and found no answers there. Her eyes looked beady and addled in the mirror. Zi spit in the toilet and Twif tore the soda brown shower curtains down while imitating Tarzan and Flea just let everything happen. She felt fraudulent, transparent in the blue light of the bathroom. Any jury would take one look at the damage Flea had done to her own organs and demand that the girls be kept safe from her influence.

Outside the door she could hear Jim snoring lightly—he'd left a rerun of *Alf* playing on the TV. When she was a kid in Ohio, maybe a few years older than Twif, she used to watch that show. She remembered liking it because the star was just a snouty puppet in a red cable-knit sweater, there was no shouting in that TV family, no bad surprises, and Alf's jokes were reassuringly lame. There was no punch line that she couldn't guess. Flea climbed onto the porcelain ledge of the tub with the torn brown curtain bunched in one hand; screams of laughter erupted from the other room, the hysterics of an old audience, and she started and nearly lost her balance. *Give me a hand, Jim*—but Jim's snores had taken on the sandpapery rasp of true absence.

Flea got down and opened the adjoining door and led the girls to their bedroom. For a full minute she was alone with them in the dark, struggling to find the light switch. This room had no window and the darkness was thick with warring smells, cleaning fluid and the generic travelers' musk that ran beneath this, beer and breath and cigarettes. For no reason Flea's heart was suddenly pounding.

"I'm scared of the dark!" Zi cried, but when Flea reached for her hand she slid away.

"Not me," Flea mumbled. "Not after a long day in the sun. . . ." In that moment she hated Jim for leaving her alone with them. When the light came on she saw both girls wedged in the corner, as near to the door frame and as far away from her as they could manage.

"You're doing a good job," Jim told her when she reentered their

room. Hooting from the TV had woken him, he said, and now he was sitting up in the bed and rubbing his under-eyes purple. "The girls like you."

On the motel TV, Flea watched a documentary about chimpanzees who had taught themselves how to pull up baobab roots and make spears out of them. *Still awfully primitive, of course,* the primatologists joked, *these chimps aren't exactly Spartan warriors—but impressive for an ape, yes?* This avuncular British voice-over was paired with footage of a giant ape plunging a spear into his rival's heart.

"My God!" Jim said. "Is this a pay channel?"

Flea found herself musing that human children quickly learned how to do a similar trick, to chip away at the rock of an adult's love for them and fashion these glintings into weapons. Long before a baby could even reach outside its crib it was an artisan, hammering its hunger into a long, thin cry.

Flea told Jim she wasn't sure she ever wanted children.

"Well, my girls are here to stay, Flea." Jim's voice had climbed the walls, floating on a balloon of incipient sleep. "I mean, you want me, they're coming . . . that's not what you mean? You're bringing up the subject of apes with spears at one a.m. exactly why, then? Christ, Flea, what am I supposed to say to all that?"

Kids might not even be a possibility for Flea, the gynecologist had said; he had her on a heavy dose of hormones to "get things jiving again"—his phrase, as if he planned to hang a disco ball inside her uterus. "You've really done a number on yourself, sweetie," the gynecologist had told her with a parental cluck, shaking his head over Flea in her paper gown on the examining table, as if she were a feckless thirty-two-year-old junior cheerleader and her body was a first car that she had totaled.

"You're sober now, though?"

No doctor could tell her for certain if she was sterile or fertile; she had been fifteen the last time she'd gotten a regular period. "No guarantees, my dear," the doctor told her, "and I wouldn't recommend motherhood right now anyways, eh, given your history. . . ."

"Oh, no," she'd said. "I wouldn't try for *that*, doctor," and then laughed stupidly as if the doctor had just made a howler of a joke. In fact, Flea was terrified of getting pregnant, terrified of giving birth and the accomplished fact of children—she just wanted the feeling that she *could* again was all. She hadn't gotten a period in all the years she'd been using, and she hadn't gotten one since getting clean, and this emptiness felt taut and wrong to her, like a dark mimic of

pregnancy. (She had tried and failed to explain this to Jim once, the way she'd imagined her sterility as a bad swell inside her.) The nothing that she wanted now was spacious, it was something else: a zero to gird her. A bright, fertile number.

Twif and Zi woke up in the backseat and began playing with their harem of naked Barbies, unperturbed by the Chevy's death rattles. Nude Barbies did their nude kicks on the seat backs. Then Twif pulled her dowsing snake out of the bag and made it do something truly shocking to one of the dolls in the chorus lineup. Flea laughed and clapped a hand over her mouth. The Barbie smiled generously for the duration of this assault.

"Jesus, Twif!" Jim shouted. "Put that snake away. Who taught you to do that? That's just nasty, honey. Why don't you put the Barbies' clothes back on and make them start a business or something?"

Flea found Twif's round face in the rearview. For a second their eyes met, and Flea watched as Twif withdrew the Barbie like a spear and stared hatefully back at her.

They almost didn't make it to the Diggings. They steered the smoking car between two etiolated mesquite trees and parked. A woman dressed like an aging hippie greeted them at the edge of the camp— she had flowing pink skirts and long peppery hair that looked like her last vanity. When they'd first pulled up she'd been staring into the sky with a face blank as cork, but as soon as Jim introduced himself she became snappy, as if they were keeping her from some appointment. The Diggings used to be some kind of religious commune and was now just a shell of belief. Flea had never heard of these people or their particular religious group but Jim got excited, asking about certain rituals and court proceedings. He'd seen some kind of PBS documentary about them.

"That was a long time ago now," the woman said. "I never had any dealings with that lot."

The cult people had left behind the "tin cans": Quonset huts, dozens of them, all of the Diggings illumined with their junkyard shimmer. These were WWII surplus, the woman told them, sold to civilians in the forties for $1,000 a unit. Most of the people in the Diggings had moved in after the true believers left, and Flea's overall impression of the Diggings residents was just that, people living in the ashes of a great fire. A few scrappers waved at them from the dirt road.

"Eolia runs the motel. She's probably babysitting up near the yurts, or you might catch her out doing a reading—she's a psychic, Eolia, the real deal. You ought to get a reading while you're here."

Jim took a daughter in each hand and set a military pace through the squatter city, his jaw tensed. Flea trailed behind, feeling the gazes of the people at the Diggings, spook-eyed men and women fanning themselves outside tents, RVs, aluminum shanties, their eyes settling lightly as insects against her skin or thudding into her like stones.

"Not much to do around here, I guess. . . ."

Yurt-dirt-blurt-squirt, the girls began to sing.

They passed gray-green agave and star clusters of ocotillos. The girls were like tiny census takers, assiduously counting all the cactus arms, and Flea watched Jim's bad mood dissipate as he walked behind his daughters. Twif, she saw, had brought the two dowsing snakes along in the shopping bag. They passed more shitbox trailers, more of the Quonset huts that loomed on the Diggings' outskirts like buried weather balloons. They found Eolia on a rainbow-striped mesh chair outside her trailer, fanning herself with a Walmart circular: thin and brown as an apple core and old beyond reckoning, with peculiar light eyes. Cataracts? Flea wondered.

"You the folks come for bedrolls? Spending the night with us?"

For a moment everybody looked at Jim, who shrugged and nodded, ducking his head in a way that was almost bashful.

"Well, come in and I'll get you set up. You girls can play with my boys while I talk to Mommy and Daddy here." She tried a wink.

"She's not—"

"I'm Stephanie," Flea said, extending a hand. "These are my boyfriend's girls."

The boys in question were playing in the russet weeds a few yards off.

"Nope." Zi drew a circle around herself with her snake's head and refused to step outside it. "Don't feel like playing."

"C'mon, sweetheart, don't be rude to the nice lady. Nothing to be scared of. Don't you trust your daddy?"

Zi gave her father a mournful look. She was a short, chubby kid who swung her arms like a policewoman when she walked. As Flea watched, the wind lifted and erased Zi's circle, and later she would wish for the fossil of the child's first suspicion, the first clear suggestion that all was not well at these Diggings.

181

The boys, Flea noticed, had not looked over once the entire time they'd been standing there.

"Go on, go play with them," Jim said. "Don't be wallflowers."

Flea didn't think the girls were wallflowers—in fact, she approved of their natural leeriness. These Diggings kids looked like shrunken marauders. One young Goliath of an eight-year-old was holding a skinny kid by his ankles and forcing him to walk around on his hands—like a game of wheelbarrow, Flea thought, except that the ground here was no golf green lawn but burning dirt covered with rocks and golden cholla needles. A child about Zi's age was toddling around in white Jockey underwear and cursing like a tattooed skipper. None of these kids was wearing shoes. Twin boys were crayoning taupe and bloodred on butcher paper in the sand, a tableau so close to normal that Flea found herself reluctant to look over their shoulders. Where were the other little girls? she wondered. Where were the parents?

"What's wrong with these kids?" Twif whispered. "Don't they take baths?"

"Now, honey, just because somebody looks different than you doesn't mean they're *wrong*. . . ."

Beneath Jim's sunglasses his nose had turned a splintered mauve. Flea didn't say anything. At night she let Jim slide inside her as she bit his neck, softly, repeatedly, telling him his own name a dozen times until he came. What did that sort of contact with a father entitle her to give these girls? So far the most intimate encounter she'd had on this trip was with Zi, who'd shot a pudgy hand under the bathroom stall of a Las Cruces rest stop to receive stolen McDonald's napkins from Flea's purse.

Jim and Eolia had disappeared inside her trailer. Twif and Zi moved a few steps closer to the boys' circle and were now watching, mesmerized, as the inverted boy winced forward on his knuckles.

"Leave him be," Flea shouted, surprising herself, and all the boys turned to look at her. The barrow-boy craned up with a null expression. He was wearing a striped T-shirt like Pugsley Addams and his cheeks were blue with acne. Poor kid, Flea thought, and flashed him a wide smile.

"Mind your own business, you city bitch," the boy snarled, boring into Flea with such a mature hatred that she took a step back. He laughed and spit at her, or tried to—luckily he was perpendicular, a bad angle for spitting. The twins went back to their coloring.

Flea cleared her throat. "I'll be back, girls," she said. When she

turned and saw Twif and Zi still sucking on their braids at the circle's edge she felt pulled toward them on the scale, closer to these girls in age than Jim. Her own childhood rose like a lump in her throat. How was it that Jim's daughters made her feel like a dumb kid herself instead of a figure, an adult? Flea was pretty sure it was supposed to work the other way around. *I don't want to protect them,* Flea thought, *I want to cower with them,* and she felt the backward suck of her bad years before Jim.

It was a shock to exit the sun.

Inside, Eolia and Jim were sitting at a wire table. Eolia had set down a sleeve of saltines, brown mustard, cheese slices aglimmer behind plastic, two chipped mugs of water. They all munched politely. The crackers had the papery nothing taste of some illness held at bay—diabetes? Hypertension? Flea bit into a flabby cheese slice and Eolia smiled at her like the world's spookiest party hostess.

"So now I guess we'll have to find someone who can tow us to a mechanic," Jim was saying. Eolia kept nodding and nodding across the patio table like she already knew all this, which irritated Flea. *She can't be a very talented psychic,* thought Flea, *not if she mistook me for a mom.* The trailer was furnished with a cheap lawn set, the kind of plastic and wicker stuff intended for poolside use. A blue mesh parasol bloomed over the table. Flea almost made a joke about this—pool furniture in the desert, ha—and then stopped herself. Ironies belonged to another world, a coastal world, probably, where they sprouted like bitter mushrooms in the salt air. That sort of joking didn't seem right for the Diggings, where everybody seemed to be trying very earnestly to stay alive.

"Do you think the girls are OK?"

"Oh, they're fine." Eolia waved her spotted hand. "Those are my boys."

Eolia couldn't shut up about the glories of the Diggings commune in its youth. For a psychic, Flea thought, she really seemed to have her neck craned in the wrong direction.

"Hundreds and hundreds lived here in the sixties, young people, all sorts of people, hundreds of shiny cars out here. . . ."

"Hundreds?" Jim frowned.

"Dozens, easy," Eolia amended, annoyed. "Music all the time, every kind you can imagine—cymbals, guitars, the marimba. . . ."

Outside the sun had turned the horizon to pale powder. In the distance the Quonsets glowed like alien topiaries.

"Now, lemme do a reading for you," said Eolia. "Palm or tarot.

You'll just have to be patient, because my vision's not what it used to be. You'll laugh, but I'm going blind in all of my eyes. . . ."

Twif picked the right boy to approach.

"Hullo, city girls," he said. His eyes were pale as a cat's and long hanks of greasy black hair hung in his face and fenced in their glow. "We are the Stayaway Boys, and I am the Leader."

"What's your real name, guy?" Twif asked. She had her suspicions about this kid—the Leader looked about a year younger than she was and his gang didn't seem at all organized. A pug-faced boy poked her in the side and told her in an irritated whine that city girls were not allowed to know the Leader's name.

"OK. So, *the Leader:* What's there to do for fun out here?"

The Leader cleared his throat. Very solemnly, he spit on his hand and slicked his cowlick straight back. Twif giggled because this was funny but also, in a strange way, a little scary. He let his eyes roll back in his head until only the gelatinous whites were visible.

"Beyond the ocotillos," the Leader said, "beyond the tall agave, beyond the cathedral of the blue sky lies the Swimming Hole."

It was a spot in the desert where the shadows pooled, the Leader continued, a spot that *moved,* quick as a snake, from place to place: Now it was in a ravine, now a canyon, now an old phosphate mine. Dark came geysering up from the other side of the world and collected there. The story came out as smoothly as a polished stone, and Twif wondered if this Swimming Hole business was something the Diggings kids had to memorize, like the Pledge of Allegiance—talking about this dark place, the Leader sounded the way Zi did when she recited their home address.

"Na-uh. You're lying, you're making that BS up. How far is it to get there?"

"Oh, it's not far!" a small boy blurted.

"Not *very* far . . . ," they added, all gleaming.

The Stayaway Boys told Twif and Zi they could only give them directions part of the way, and after that they would have to use their dowsing snakes because the entrance changed position and dimension with the sun. The sidekick twin used his crayons to draw them a crude map.

"You're not coming?"

"Sorry, city girls," said the big one. "We got *schoolwork*." He leaned forward and held his ribs, grinning moonily at them. "We got

too much *homework* to do."

Twif thought the map was pretty useless; it looked like the kid had drawn a hat and a tic-tac-toe board. She took the bag with the snakes and got them both out, handing one to Zi.

"Point the tongue like this," she said, "and tell me when you hear it rattle, OK?"

They walked a quarter of a mile to the east; in the distance, you could see where the saguaro forest grew out of the pale hills like stubble on their father's Sunday chin. Twif led the way. They went sledding on their heels down into an old riverbed—shining with mineral, great polygons of salt crystals left behind when the water evaporated. A few blue blossoms pushed out of the dry banks like tiny puffs of breath. Zi kept stooping and trying to eat them—"for survival"—she'd seen some Bugs Bunny cartoon about this—until Twif grabbed her hand and yanked her forward. Twif kept her chin high and her spine rigid in case the boys were following them. The girls walked forward like this for what felt like a very long time.

Eventually, Flea abandoned Jim to his fate. Eolia had kept on offering—insisting, really—to read their palms, until finally Jim scooted forward and placed his big hands on the table. The old witch raised Jim's palm until it was level with her little chin and studied it with the same penny-pinching look that she had earlier fixed on the Walmart circular. As Flea watched, Eolia began to stroke the red hairs on Jim's knuckles.

Flea coughed once. "I think I'll go check on the girls."

Outside, the boys had scattered; there was only one twin left, playing with a skinny black puppy in the dirt.

"Have you seen my . . . have you seen the two girls?" Flea asked. The twin cocked his head to the right without looking up at her. "That way."

"*Ma'am,*" he called after Flea, breaking the syllable like a knife twist.

The wind in the sagebrush made a misleading sound, like the roar of a green gale over the ocean. The girls weren't here but she wouldn't panic, would she, because where could they have gone to? The only hiding places were behind her, unless the girls were on their bellies; everything north and east of here was tabletop flat. Flea had the sensation that she was standing at a kind of threshold—she could still hear the tents from the Diggings flapping behind her, a

flock of tethered birds. I'd better run back, get Jim, she thought, but instead she found herself hurrying forward, possessed now by a peculiar inertia—the feeling that *something, something bad* was happening to Twif and Zi and that there wasn't time to backtrack. She could feel sharp rocks the size of molars through her sneakers as she jogged. Then Flea looked down and saw a snake in the underbrush.

She let out a scream as she fell backward, crushing musky scent out of a creosote bush. The thing didn't move to strike her. It was one of the dowsing snakes, Flea realized—Zi's snake, the taxidermied rattler. For a moment she thought she felt a tiny hand on her back—Zi?—but when she whirled around there was no one there, just the dull creosote and a poker-faced frilled lizard regarding her.

"Twif? Zi?"

Without really thinking about it, she had raised the snake to a dowser's position. The snake felt stiff as a broomstick in her hand. She pointed the tongue at the thin terrestrial cloud of her own shadow but the snake didn't move. Of course it didn't, Flea thought, it's just a con for the tourists. . . . Flea felt very stupid now, gorged on and cramping with her own stupidity—but she didn't lower the snake. She was getting this weird boost to her equilibrium by holding it forward, it seemed, and she stumbled overland like a blind woman with her cane, a crutch to touch the white horizon.

"Zi? Twif?"

For their first few days together Flea had felt irrationally angry about the girls' strange monikers. She was afraid to pronounce them. The names "Zi" and "Twif" felt to Flea like a test she'd been set up to fail, as if each syllable of their names were their mother's hand pushing Flea away from them, those consonants looped around them like barbed wire. Flea had caught herself wishing terrible things: Why couldn't these kids have names like "Mary" or "Sue," stolid American names that were like latches you could hold on to, why couldn't they look less like their lovely red-lipped mother and more like Jim? She had called the girls "you" for most of this trip. She didn't touch them if she could help it. Waiters and gas jockeys everywhere seemed to take note of this, squeezing their eyes and shouting their epiphany at her like a quiz-show answer: "You ain't the mother?" There was some prejudice against her in the animal kingdom, Flea felt that. Stepmothers were wicked in literature, stepfathers cuckolds in nature. Jim told her that she was being crazy.

"Jesus, honey, these things take time," Jim had said. "Are you fucking kidding me? Are you kidding me?" he said in a softer voice.

"We've been on the road—what—three days? Ease up and things will go better for all of us."

That conversation had happened yesterday, road-aeons ago. Now Flea screamed the girls' names until her voice turned coarse—"Twif! *Zi!*" She could feel the pop of every knuckle around the snake. It felt like the most natural thing in the world to call their names now, Flea thought darkly. And if she found them she would run to hold them without the slightest hesitation.

Zi, as it turned out, was the world's crappiest dowser. She kept making the rattle go off by accident, then laughed hysterically, dropping her snake. Sometimes she held her snake like a golf club and tried to hit the fat bullet-headed lizards and the iridescent yellow ones. Lizards scampered everywhere, very likely confused, Twif thought, by the dead snake's head flying at them from the sky.

"Zi, the poor lizards! Quit goofing off."

In the west the sky was rotting like a peach. The snakes were frustratingly mute. Twif thought that they had better find the Swimming Hole before night fell, because if the darkness spilled everywhere, how were they supposed to find one pool of shadows? That would be like using flashlights to find the sun. Once Twif had written Zi a secret note in homemade invisible ink but then she'd accidentally knocked a bowl of lemon juice onto the paper and when they'd tried to shine Twif's message into visibility it had never appeared—the lemon juice had eaten away those first words, turned the letter into a glowing square.

"Let's hurry up," Twif called, watching the sun tock closer toward the mountains. "I don't think these dowsing things will work when it's totally dark."

They wove around an odd grouping of lightning-forked trees, a sort of plant that Twif had never seen before. Maybe this meant that they were getting closer. Twif thought with great satisfaction of how happy her father would be when she and Zi came back, how astonished when Twif told him that they'd found the Swimming Hole all by themselves—she assumed that her dad and Stephanie knew about it already because the Stayaway Boys had made it sound like a landmark of national importance, the Grand Canyon or the Bermuda Triangle. . . .

Twif felt a music begin in her hands.

At first the noise reminded her of the lawn sprinklers at Mom's

house, *wick-awick-awick,* and then it grew to a steady, insistent thrum, not quite rhythmic—there was something mechanical about it, and Twif thought of a school video she'd seen on a sub day about industry, a million white corn kernels sliding down a metal chute.

"This way!" Twif crowed. But it was Zi who saw the shape first. It announced itself as a dull shimmer of air that gradually clarified into a kind of low-slung house. Another one of those weird huts, Twif saw, Kwan-somethings, although this one looked brand-new, the steel rust-free and icy. Light sparkled and curved in a bright band along this house's hemisphere so that Twif couldn't quite *see* it (in fact, when she closed her eyes she got a red afterimage of something that didn't look like a house at all). When she opened her eyes the hut was right in front of her, a squat structure like a half-buried barrel. The panes were made from a funny opaque glass. When Twif held the snake's head up to the window, the black ribbon slid a quarter inch farther out between its leathery lips and she let out a delighted shriek—well, this was really neat, she thought, the ribbon was a real tongue. The rattler was whirring in her hand and the sound seemed to be happening *inside* her head now too, swelling until her head felt huge as a pumpkin and there was a floaty ache behind her eyes. Zi let out a little moan behind her and tugged at Twif's elbow.

"I know, Zi," she said, imitating their mother's voice. "It's hurting me too. Maybe the noise will stop once we get inside. OK, on three. Ready? One . . ."

But the door pulled back, as if some suction were holding it in place—almost like their refrigerator at home, Twif thought; the girls dug in their heels and pulled with their small conglomerate weight until they heard it give a little. Another tug opened it completely. It felt tens of degrees cooler in there, and Twif wondered how that was possible. How could it be baking outside and cold as a January morning in this room? Twif didn't want to frighten Zi but she thought those Diggings boys might be hiding inside, waiting to play a trick on them.

"Shhh!" Zi said, covering her ears. "Your snake is too *noisy.*"

"I'm trying to turn it off. . . ." How did this thing run? She searched along the snake's smooth belly for a battery compartment. The snake's eyes looked wet and alert; Twif thought that the cleft in its black tongue might have flicked up at her. Its rattle felt like a shivering bird in her right hand. With her free hand Twif found Zi's stout fingers and tugged her through the door. Neither girl made a

peep but they both tightened the lattice of their fingers. The door had shut behind them.

"Zi?"

Twif had lost her own hand. She could feel her sister's clammy grip but she couldn't find Zi's face. She looked over her shoulder for a ripple of glass but found more blackness, a seamless blank. Twif swung her leg back and did not touch a frame. She tried again, expecting the thud of the wall, and this time her heel flew. Twif swallowed a scream and pushed down hard into her sister's knuckles, which felt sharp as jacks under her skin.

"You OK, Zi?"

Twif realized that even the darkest nights in her bedroom in Rickville were shot through with witchy blues and purples, a subtle afterspell of color from streetlights and the moon. But this hole was pure blackness. Nobody had slept in it, nobody had dreamt in it. Twif wasn't sure how to articulate what the difference was but she just knew. She held her breath and felt the air swell huge and cold as a lake inside her. And Twif knew they were in the right place (*The Swimming Hole!*) because as she and Zi moved into the hut's interior she could feel the air eddying around them like water. She had a surprising sensation of lightness in her body, as if she might kick up and leave the ground. But the boys had gotten it wrong! Twif thought. This Swimming Hole was not a hole at all. It didn't seem much like a hut, either—inside, there was a buzzy sense of great space, as if you could walk forward for miles and miles without ever reaching the opposite wall. A sky seemed to vault above them; somehow from the inside it didn't seem as though the room had a ceiling. There was a floor, of sorts, but Twif clamped down on her sister's arm like a vise because even this seemed to be disappearing.

Flea wasn't sure how far she'd walked but she could barely see the Diggings now, just a flash of sun on metal. She could feel the distance pebbled in her vertebrae, the aching small of her back. Before the Chevy gave out they'd been on Highway 86 and every other car had been border patrol but there was no one here, there was no "here" to get to, really—just the T-junction dirt road that had petered into the Diggings. The ground here had a cracked, maniacal look, black and carmine shale like a magmata checkerboard, and in the distance she could just make out the wet ash smudges of the White Mountains.

What kept Flea moving forward was the girls' cries in her imagination. Flea knew there was nothing heroic about this; she was just obeying an old code. In fact, hunters had been exploiting this impulse for years, hadn't they, Flea thought, tripping on a spray of gravel. Making calls and whistles that mimicked the distress cries of other species' young. Hunters ciphered bull alligators in the Florida swamps by imitating the squeak of hatchlings, they summoned deer with the bleat of a fawn in distress. . . .

She was too focused on finding the girls to notice much beyond the tilting blue sky, now spiked with magenta on its western edge, the three-dimensional mosaic of mesquite and barrel cactus that she zagged through. The dowsing snake kept time with its cascading beat. It was too easy to jinx yourself with this goddamn thing, Flea thought, to let your panic fool you into making the wand rattle. Excitement only fed the illusion, causing her hands to tremble harder.

Somebody was sitting stiff as a mannequin behind a wrinkled legume tree.

"Al?" It was Sheik Al, turbanless now, using one of the cactus needles as a toothpick. He nodded and smiled at Flea in a vacant way, as if he couldn't quite remember her but didn't want to be rude, and he continued needling his teeth, smiling, smiling, as if their meeting here in the middle of the Sonoran Desert were just a neutral coincidence.

"Al, what are you doing way out here?"

"Oh, you got turned around, didja?" His voice had changed completely. It was nasally but uninflected, monotone. He whittled some nastiness from behind his teeth and paused to examine it, his brows dipping in a scholarly furrow, and this should have been comical but Flea felt close to screaming.

"What do you *need*, lady?" he said. "What do you really, really need?" He thunked two fingers against the blue rivers on his wrist and repeated his lewd wink from the Souk.

"I'm trying to find the children, you remember them? Jim's girls. . . ."

Flea was scared, but her fear was quickly giving way to a familiar detachment, a sort of cottony exhaustion that in the past had so often spread throughout her chest and insulated her from all responsibilities.

"The girls are fine. They're back at the Diggings. Or they're not," he mused philosophically, "or they're elsewhere. Just goofing on you,

probably, a little hide-and-seek. But you! You want to know where *you* are?"

Sheik Al stood up. His eyes were burning and he continued his all-the-time smiling at her, the neckline of his overalls sagging like a second grin. The sky was a vast blue silence behind him, nailed through with tiny cactus wrens, one raptor wheeling in the blank thermals.

"You are beyond repair." His face seemed to be swelling in odd places as he spoke; a light red spot had appeared beneath his left eye. Sheik Al lifted one shaggy brow, dropped it.

"You're not Al," Flea said quietly.

"You only saw the first tent, lady," the Al-thing snarled. "I have several."

It took a step toward her, and Flea smelled something deep and rank that she couldn't place but that set off some primordial alarm inside her. She let her gaze snag on the cactus wrens beyond the Al-thing's shoulders, feeling faint. One of its eyes was bulging at her above its static grin.

"Tell me where Jim's girls are. I don't need anything else from you."

"Ah, but I know better."

I'm diseased, Flea thought, *and this thing smelled me. My fault that I've been caught out*—and she felt that this predator must have scented it, her emptiness, the old badness inside her, the way the dowsing snakes were supposedly able to scent the shadows in holes. Flea's hand traveled to her throat. She thought: *I'm an easy mark.*

Al brightened or, to speak more accurately, the thing inside Al's eyes brightened, Al's features losing their solidarity and sagging like a loose rubber mask. Something aged and lantern yellow peered out at her through its Al-eyeholes; the skin on its forehead began to bubble.

Flea dropped into a crouch and scanned the ground for any sort of weapon—a stick, a sharp rock—but when she looked again the Al-thing was gone. Flea, her heart still pounding, checked behind the nearby cactus, wove between the legume trees in a wide circle: nothing. Flea bent to lace her sneakers with trembling hands, certain that she was going to retch. She could still feel Al's eggy breath on her face.

Flea had tried all sorts of hallucinogens and as a kid she'd had bad nightmares but even the worst of those visions had a frailty about them, a sort of funhouse instability, everything doubled or squashed

flat, so that the better part of her could always say *not-true, not-true.* "Not true," she tried now—but this encounter had been different. She could still feel a crawling pastiness across her forehead, as if her own face were experiencing an allergic reaction to Al's disintegration.

Great branching families of columnar cacti stood before her, saguaros like some foreign police force, wearing their white blossoms like foppish berets; a crop of orange and magenta blossoms sprouted amid the rocks. There was a signpost in the middle of the scrub:

NO TRESPASSING

But surely this was a prank or a misprint—there was nothing else here. There was nobody around for miles.

The dowsing snake began to rattle.

Oh, come on, I'm doing this. Staring down at the rattle, Flea was reminded of how she and two friends used to pretend to move the plastic pointer on their Ouija board. She wasn't hearing anything mystical, she decided, and she hadn't seen Al, she was just thirsty and frightened. *You idiot,* she thought, *that rattling is just the sound of your own nerves jangling.* And yet when she looked up there was some structure looming just before her; she didn't understand how it could have snuck up on her. It was one of the T-rib Quonsets, with the same prefab dimensions of the huts at the Diggings, maybe sixteen feet across and thirty-odd long. Somebody had nailed boards over the windows and painted eerie crescents on these, moons or eyelids. Was this some old military storehouse? she wondered. A meth lab? A church for the Diggings' failed prophets? She ran toward the plywood door and almost missed a red half circle against the paler sagebrush: a child's headband was twinkling in the dirt.

The door opened with no resistance whatsoever, with a slight sucking sound, in fact, a cold vacuumlike tug of air. Goose pimples prickled along her bare arms as she entered, and in one blink the outside world was gone. Just like that, the door had shut somehow and erased the sun. Flea stepped into the Quonset and was swallowed by a darkness that blew her pupils open.

YOU ARE HERE, Sheik Al had told them, the black scale fitted like an eyelid over the map.

"Twif?"

"Zi?"

And then, after a longer pause: "Al?" She tried to whirl around to

find the door—she had taken maybe three steps forward. There was nothing behind her. Flea pivoted into one hip and reached out with both hands: nothing. *OK,* she thought. This is not *possible.* She breathed heavily in the dark, waiting for her eyes to finish their adjusting. *I'm in a Quonset hut,* she told herself, forcing her breath to slow, *I'm in a tin can, I am in one room with walls and a door and my eyes are just having trouble with the contrast, it's all that brightness outside, probably my eyes can't manage the transition. . . .*

But just the thought *outside* made her want to cry out. Where was the goddamn door? She lunged forward in the direction in which she believed she had entered the hut a moment ago and went sailing into empty space, regaining her balance at the last instant. OK, forget the door, Flea thought, where was the wall? As she walked forward she had the sense that she was in some kind of vault and moving toward an even vaster cavity. She held out her hands and felt freezing air thread through her fingertips; she tapped the air with her dowsing snake, hoping to knock on anything solid. No walls, no resistance. It seemed like the only friction left in the world was happening inside the dowsing rattle. After a while Flea became aware of a subtler sound washing over the floor, a hiss like a stream rushing over rocks. When she slid a foot toward the gurgling, though, her sneaker stayed dry; instead there was a papery rustle, as if she'd disturbed leaves carpeting a forest floor. She did scream then—the dowsing snake's belly had crimped in her hand.

She turned two dumbfounded circles and ran forward, not thinking now, hoping only for the sweet shock of a wall, and she might have continued running blindly forward like this for a long ways except that a stab of fear made her stop. The ground still felt level—there had been no incline or alarming dip—but she'd had an animal apprehension that she was on the lip of a great fall. Nothing like this had ever happened to Flea before, and she wondered if this voice that was speaking to her now only stirred in the absence of every other sense. Flea froze. She took a step backward, away from the ache of space in front of her. She could feel the dense cone of gravity that she often felt on the butte near Jim's house, where without warning the yellow land abutted the sky. Oh, it's bottomless, Flea shuddered, and felt an old old vertigo.

What was your bottom? was a common question in the circles she now traveled in. *When did you bottom out?*

Flea wished that she had listened to Eolia when she was rambling

on about the Diggings commune. What was it those pilgrims had worshipped? Was this a relic from their period, an old storehouse of shadows of the sort Al had talked about? She knew that insects could survive in dormant form, as eggs or pupae, and she wondered if she and the girls had stumbled into a large unlit carapace. What could be growing inside a darkness this thick? Flea stifled a giggle.

The girls, the girls. *Keep it together,* a stern voice in Flea counseled. *Keep moving forward.*

She started talking to herself out loud again, reciting her one sentence like some newly minted catechism: "This is just an ugly steel Quonset, this is a building and I am inside it. . . ." She slid her left sneaker forward and felt the muscles in her thighs tense for a long fall.

"Fuck!" The dowsing snake had moved again and this time she'd *felt* it, she'd dropped its lengthening belly and heard a thud as it hit the floor, and then the snake had slid around her bald ankle. She heard its rattling moving overland and found herself chasing the sound as if it were a disappearing flare.

"Twif! Zi!"

No one would blame me if I fainted here, she thought, and she loved thinking this, it was like preparing a bed for herself to sleep in. *Nobody could expect me to save a fly in here, much less two girls. . . .* She surprised herself by continuing forward. Each step involved a muscular argument—how was she supposed to walk over pure air? At a certain point she got down on her knees and crawled. There was something sticking to her fingers—dead leaves? Flea wondered. Some kind of thin paper? Flea heard herself calling for the girls until she became hoarse. She heard the paper rasp against her knees. She sent her fingers spidering forward and shut her eyes.

After a length of time that meant nothing to her, five minutes or fifty, Flea stopped crawling. She was covered in the tissue material that carpeted the floor; it had gotten on the back of her neck somehow and flaked off in between her fingers. Her eyes snapped open, even though there was nothing to see. Someone was sobbing across a gulf. It was a soft, unmistakably human sound and it bounced everywhere around her, as if the darkness had somehow folded into canyons.

"Girls?"

"Steph-a-nie!"

Her name sounded like it was coming from across a valley. Flea stood up.

"Hello? Who's there?"

It was Zi's voice, just a thimble of sound.

Flea had no problem running now; she ran through wave after wave of vertigo and by some miracle of human biology her inner ear didn't fail and Flea didn't fall; and then she collided with something soft and warm and felt a pair of arms shoot around her. She hooked her arms beneath the coves of the child's armpits in the darkness and drew her up to her chest. A second pair of hands grabbed at her waist.

"Steph it's you it's so dark in here it's the Swimming Hole we found it ourselves and Zi thinks she saw the snakes here, real ones. . . ."

She knelt and folded into the girls' breath and heat, their wet faces. She almost didn't want to believe that she had found them—it would in many ways be easier if she had merely lost her mind. A part of her thought that she was the cause of all this, that this was a private hell she'd fallen into (whenever Flea had been lost heretofore it had been inside her own tiny skull). The relief of not being crazy was tempered by the new problem that lay before her. *This is real,* Flea thought with a little flutter, *we are really trapped.*

"Girls? I can't see your faces." She pushed one of the girls' hair off her cheeks. "I can't see anything at all." She found the child's hand, which surprised her with its talc dryness. For a moment the three of them stood in silence, linking hands and arms as if they were stitching themselves into a formidable new creature.

"You didn't see inside the hole, Steph?" Twif asked, flush against Flea's left side.

"What do you mean? You could see? What did you see?"

When Twif's voice came again she sounded almost shy.

"The snakes."

The girl was turning now, and Flea turned with her. And for just a fraction of a second Flea *did* see them through a crack in the void behind them, hundreds of them, red and yellow and pale green snakes twisting in imbricated circles, falling from the tarry darkness above their heads where a roof should have been. They looked like empty suns, bright red and ochre rings with vacant centers where the air roared. The snakes fell in wheels with their rattlers in their mouths, the shine of their dolls' eyes visible for a moment before they disappeared. She saw scales, tongues. The fire of diamonds. The thought *not real!* went off in Flea's brain like a shrill whistle. The girls were quiet beside her and she was afraid to ask them what they were seeing. Flea resisted an overpowering desire to lie down on her back

and feel the floor press up against her spine. *We'll wait right here,* she heard herself saying in a wild keen, *for your daddy to find us.* But she did not say anything. She didn't sink into her knees or scream or cradle her head between her hands because the girls were here, the girls were taking shallow breaths beside her, and there was no one else to find an exit for them.

"This way," she said firmly. She had just realized what she was covered in, what fragile paper lined the floor of this Quonset: snake skins. Shed skins, thousands and thousands of them covering the floor like the detritus from aeons of autumn. She plucked one from her arm and crumbed it to powder. She thought now that they were in some kind of colossal snakes' burrow. The snakes came here to feed or breed, whatever it was that this dowsing species did underground. They had made a mistake, following the rattling of their wands. The exit, if there was one, would be away from that sound.

"This is the way out?"

"I think so, Twif."

"We'll be safe?"

"Yes."

Flea didn't really think they would be. But this seemed to be the only direction now, away from the thick veil of sound. In the central shadows she could hear a downpour building like the world's last hailstorm, and she steered the children away from it. She thought about how she'd palmed the walls of their motel room, feeling for the light switch. She tried to revive a single picture in her mind, the orange orb burning behind the mountains.

"Think about the sun, Zi. Twif, hold on to your sister."

For once Flea took her own advice. She preached to the children the way a Christian mother might tutor them on the fundamentals of faith: "This is just an ugly steel Quonset," she shouted hoarsely, "this is a building and you are inside it. There is a *sun* outside the Quonset. . . ." She moved the girls forward and tried to will what she now understood to be the holiest geometry into existence, four right angles of light. Her eyes were shut against the hiss of the dowsing snakes, but Flea sketched the outline of the Quonset on her red eyelids. She drew intersecting cracks there and she thought the word *door.*

Back in the trailer, Eolia was telling Jim a story, a legend really, about the westernback rattlers of the Sonoran. Jim took sips of tap water

out of a gold *M*A*S*H* mug and nodded politely. She seemed to have forgotten about the palm reading entirely and was still talking up her own past:

"And they have a kind of a secret locomotion, a devilish trick, these snakes. Every June they come rolling in out of the west with their rattles in their mouths. They come out of hibernation in a great tide and turn their bodies into wheels, can you see it! It's not a myth, it's actual. Some scientists from Cornell University came out to film it one summer but of course they didn't do it *then*, those snakes went flat as rulers again, they were like my own kids, on their best behavior for visitors. . . ."

Jim was no naturalist, but he didn't doubt that this was possible. "I used to get around that way myself, ma'am," he said. "I was a junkie, ma'am, and that pretty much describes how we all traveled." *Your body turns into a wheel of wanting-getting-wanting-getting,* he thought but didn't say, staring at her desert tarot deck. The card she'd turned up was a black-and-corn-colored snake gripping its tail in its mouth.

"What about that reading now?" he asked. He plunked a finger on the corner of the five-dollar bill and twitched it at her. He was glad to buy Flea some time alone with the girls.

"Huh, right," said Eolia. She took his palm and used an orchid purple nail to trace the lines there.

"Oh, what a distance you have left to travel. Terrible, terrible! There's no end to it that I can make out, you're in some great wreck, that woman is with you, those girls are with you, there is thunder, disaster, there is . . . fog now," she added slyly, glancing up at him.

"But we're going to make it though?" He was embarrassed at how anxious he sounded.

"Ah," she sighed, pulling up smoothly as a black sedan to this intersection in the conversation. Jim pictured a window rolling down and a palm extended. Her rheumy eyes swung over his face, waiting to see if he would offer her more money.

"Friend, for five bucks I can't tell you anything definite. . . ."

But Jim didn't move for his wallet, and after a moment Eolia dragged her bottom eyelid down and spat an answer at him, as if begrudging him even the nebulous goodness of this fortune:

"It means your lot *could*. It means you have a long-enough road."

La Tête

Georges-Olivier Châteaureynaud

—Translated from French by Edward Gauvin

PERMIT ME TO REMAIN anonymous; my name would mean nothing to you. My profession, however, is not unrelated to the story I am about to tell. I am a doctor. I've seen many woes in my line of work. Some I've eased, and in other cases forestalled what, without my intervention, wouldn't have been long in coming. Well, you'll say, that's all you can ask of a doctor, and I quite agree: We save those patients of ours whom death vies for distractedly. Should its interest in the game be aroused, all our efforts are in vain, and death reaps another victory. . . . It was fifteen years ago—the summer of 1905, to be exact—while in the exercise of my profession, that I made the acquaintance of a young man who introduced himself to me as Bennett Snapte. He was a stranger to the small seaside town where I had my practice. I knew as much at the first sight of him in my waiting room, crowded that Saturday as any other. After twenty years of being a doctor in a small town, one knows, or can at least place everyone. By all counts a strapping lad, he wasn't one of my regulars nor, I would have sworn, among those of my two competitors. I say "strapping" because I've known few people with his physique. On seeing him, I remember thinking that if the whole town had his constitution, I could've tucked the key under the mat and retired. Twenty years old, with a marble worker's shoulders and a peasant's cheeks, the neck of a glassblower and hands big enough to throttle a horse. He had health to spare; I would have bought some if I could. Still, something was the matter, since there he was in my packed waiting room. I took the time to study him, and in his blue eyes, with their corneal patina of faience, easily identified a brightness and fixity of stare that, in such an irritatingly vital giant, could have but one cause: terror.

What a fickle thing is a man, no matter how settled in his ways. Simply arouse his curiosity, and he forgets his compunction, his

198

seriousness, and soon thereafter even his duties. In my newcomer's eyes, I'd chanced upon an expression that so intrigued me I examined Mrs. Blanc-Dubourg with appalling absentmindedness; the most unsuitable noises might have come from inside her without my so much as batting an eye. One sole question preoccupied me: In this time of peace at home and abroad, what could possibly have so badly frightened a boy of twenty built, for all appearances, to live a hundred more? After seeing Mrs. Blanc-Dubourg all the way to the front steps in apology, I strode into the waiting room with the imperious air of someone about to abuse his power and pointed at the young man.

"You're next!" I said in a tone that brooked no rebuttal.

He rose. From all around came astonished sighs and a rebellious rustling of knees. In all fairness, he shouldn't have made it into my office for another two hours. Sweeping the room with an icy gaze, I silenced any inclination to revolt. Was I not the master of my house?

The party concerned, whose already ruddy cheeks had further reddened, gathered a canvas sack from beneath his seat. He held it close to him and preceded me into the office I'd pointed out with a jerk of my chin.

I never begin an appointment before my patient and I have taken our respective places on opposite sides of my old leather-topped desk. This desk, as my patients are dimly aware—this desk is the gulf that separates sickness from health. I hold my hand out to them across this gulf, and if my patients are obedient enough, and lucky—if I'm lucky—I pull them gently across to my side, to life. . . . But what am I blathering on about? The young man was sitting across from me— that's all that matters. He remained silent, eyes lowered, chest canted forward, arms hanging between his knees, hands fiddling with the drawstrings of his sack. I used my most confident, jovial tone of voice. A doctor's voice is fully half of doctoring.

"Well, well, my boy! What can the matter be?"

He lifted his eyes, then dropped them again almost as quickly, coughed slightly, and spoke at last in the voice of a lost child.

"Aw, Doc, everything was going swell . . ." He stopped, not knowing how to continue.

"You felt the need to see me."

"Yeah. . . ." He fell silent again. Timidity. Shame. Anxiety. Aha! Often as not, shame plus anxiety equals venereal disease! I should have hit on it earlier, I thought; a lad like that surely leaves a trail of

broken hearts in his wake. Broken hearts and everything else too. I laid a clean sheet of Bristol on my blotter and uncapped my pen.

"Let's begin at the beginning. What's your name?"

"Bennett Snapte, Doctor."

"Bennett Snapped? P-E-D? Like a stick?"

"P-T-E. Bennett."

"Date of birth?"

"November 22, 1885, Doctor."

"Why, you're only twenty! It's the springtime of your life! You're enjoying it to the hilt, I gather?"

"Excuse me?"

"I said I gather you're enjoying the springtime of your life to the hilt!"

"Uh, yes . . ."

"Good! So, you've enjoyed yourself so thoroughly that . . ."

I left the end of my sentence hanging. Would the young lion wind up taking the line I'd thrown? He did nothing. He was beginning to irk me. After all, I'd surely upset good and faithful patients to hear him out, and now he threatened to be a waste of time. . . .

"You can tell your doctor everything, my boy. I'll even go so far as to say: You must. This kind of affliction—"

He understood what I was getting at, and at the same moment, I understood, as he slowly shook his head, that I was barking up the wrong tree.

"No, Doc, it's not that—" Suddenly, his voice broke and he burst into tears. My heart is hardened, as it must be in my line of work, but his distress touched me all the more because I couldn't fathom its cause.

"Come, come! Are you a doctor? You're not the one who should decide if this is worth crying over. I'm here to help, but I can't do a thing if you won't tell me where and why it hurts."

"It's not me, Doc, it's him—"

"Him? Who?"

Bennett Snapte kept right on sobbing as he placed his sack on my desk and undid the drawstrings. He reached in and pulled out the most horrifying thing I have ever seen. I leapt back so fast I knocked over my chair.

"Madman! Killer! Go! Get out of here now! Take that thing away!"

I groped about the desktop for the brass bell that would summon Edgar, my nurse-gardener-errand boy. My patient saw my hand, and his voice grew pleading.

"Please, Doc, don't! I'm not a killer or a madman. I just came to get help! For him, Doc! For him! He's alive!"

And in a barely audible whisper, the thing he held aloft with fingers clenched around a lock of black and gleaming hair confirmed his words:

"It's true, Doctor. I'm alive. . . . Have mercy, for the love of Christ, have mercy!"

At the time, I was a robust fifty years of age; should such a scene occur today it would surely kill me. As a student, then an intern, I'd seen far worse than a severed head, but this wasn't the same. In such cases, context is everything. During my studies, anatomy was all parts and pieces. My friends and I examined and handled these in a university setting, under the supervision of our professors, and with their support. Besides, the body parts smelled of formalin, and that powerful, distinctive odor dehumanized them—"thingified" them, if I may. . . . What my patient now thrust into my face was no anatomical part, but well and truly *a man's head*. I would have preferred a hundred times over for it to give off the wholesome odor of formaldehyde rather than a blend of rotting flesh and the cheap cologne it had been sprayed with. But above all—above all! The sliced-off head moved, wept, and spoke. Or rather, it shivered, sniveled, and whispered. The free play of its functions—facial mobility, lachrymal effusions, phonation—was considerably impaired. But the simple fact that these manifested themselves at all flew in the face of what the entire medical establishment took for granted. That said, I am a progressive and an optimist; if it's proven tomorrow that babies will henceforth be born from their mothers' ears, that's where I'll await them. The decapitated head spoke? So be it!

"Who is it?"

"His name's Henri Languille, Doctor."

"Yes—I'm Henri Languille!" whispered the head.

"Languille? Never heard of him! Where did you get it?" I asked the young man.

"You called me a killer—well, he's the killer!" he replied. "As for me, I'm apprenticed—well I was, till recently—to Mr. Deibler, the executioner. Mr. Deibler and me chopped Languille's head off on the twelfth in Orleans."

"The twelfth? It's the twenty-fourth! That's almost two weeks— well, go on. What happened?"

"Dr. Beaurieu in Orleans and my boss agreed to try something out. Even Languille was on board with it. Weren't you, Languille?"

201

"I admit I was, I was," Languille mumbled.

"So it was settled then: Right after the execution, Mr. Deibler would ask the head, 'Can you hear me, Languille?' And if Languille could hear him, he'd blink."

The scientist in me bridled at this simpleminded protocol. "What were you trying to prove? A blink could quite easily be nothing but a reflex! And besides, guillotines cut off heads, not ears!"

"All right, but anyway he blinked . . . and he's still blinking now!"

I had to face facts: Twelve days after his beheading, Languille was still blinking away.

"Fine! The experiment was a success, if you must. Then what?"

"After that, I did something dumb. The whole thing had gotten me all turned around. He could still hear, see, think . . . what was going on in that bodiless head? Do you realize—? Anyway, I was supposed to bury him on my own, Mr. Deibler was already on the train back to Paris, but at the last moment I wanted to try the experiment again, just to see."

Bennett Snapte fell silent. At the end of his fist, the head was silent too. A single mysterious emotion held the two consciousnesses in a single embrace—the hardened killer and the apprentice executioner, so different and yet so close in that instant beyond all guilt and innocence.

"Well?"

"He didn't just blink, he spoke to me again. He said it hurt, that he was frightened. Of me, especially. Of the darkness of the grave. I should've put him back in that raw wood coffin again right away, with his uncomplaining body, and nailed it all up tight and buried him and not given it another thought, but put yourself in my shoes . . . I couldn't. After all, Mr. Deibler and me aren't paid to kill them but once. I felt sorry for Languille, because of how he talked about the dark. I couldn't, and well . . . here we are."

Where had Languille come up with those tears, those heavy tears that trailed down his creased and greenish cheeks?

"How did you make it all the way here? What did you do for those twelve days?" I asked Bennett Snapte.

"I hid him in this bag I usually used for lunch, and took him home with me—I mean, to the room I was renting in Orleans. That night we talked a lot. I reassured him as best I could. He was thirsty, so I gave him some moonshine."

"You gave it a drink?"

"I had to put him in the tub, of course. But it did him good, or so

he said. Just the taste of it made his head spin. And I could keep using the same moonshine over and over. . . ."

That first night, Bennett Snapte had understood that he'd committed a great wrong in the eyes of Mr. Deibler, the administration, and perhaps authorities even higher still. Imagine that night and those that followed. A young soul of twenty interrogating himself on the consequences of an ill-considered act, the crushing responsibility he had undertaken while from the shadows on the table that terrified and terrifying presence, that nightmare curio, clicked its teeth from time to time in the quiet of the night.

The next day, the boy did not return to Paris, where his master Deibler was waiting. He panicked and ran away with his charge. Together, one carrying the other, they wandered the highways and byways at random, sleeping in small inns but also in fields, beneath bridges, on the beach. And always, the head complained—it ached; it was afraid of the night, of the day, of everything! It was fear incarnate, absolute, confined to the tiny chamber of a human skull. And it was beginning to reek. Bennett washed it in the sink when he dared take a room for the night, or in a brook, or the sea. But the saltwater stung. . . . In the villages he passed through, he bought lotions and vials of perfume for it. Nothing did any good. The head was rotting alive. The decomposition manifested itself not only in sight and smell, but also in memory loss, hallucinatory episodes, delirium, and fits of dementia. Several times, the head tried to bite its benefactor. Bennett was afraid of it now. He wanted to have done with it, smash the head against a wall or a rock, free it once and for all—even it had been begging him to do so for several days now—but he dared not, and that was why they were here before me. They'd thought a doctor might know how to do it. It was forbidden, of course, but what exactly was forbidden? Practicing euthanasia on a lopped-off head? What article of the law forbade that?

Dear reader, I don't know what you would have done in my place. I know I couldn't let this child leave again with the contents of his tarred canvas sack swinging against his leg. I calmed him down, then sent him off alone toward an altered fate—for I doubt he ever took up his apprenticeship with Mr. Deibler again. After he left, I hid the head and its stinking sack in a cupboard and rang for Edgar. Pleading

faintness, I bade him announce that I would see no more patients that day. Then, alone in my locked office, I consulted diverse treatises on pharmacology and toxicology while waiting for my angry and disappointed patients to leave. When at last all was quiet once more, I removed Languille from the cupboard. I spoke to him gently. I listened to him at length. And when I was certain of his resolve, I did what must be done.

Bigfoot and the Bodhisattva
James Morrow

AFTER THIRTY YEARS SPENT eating the chilled coral brains of over-achieving amateur climbers who believed they could reach the summit of Mount Everest without dying, a diet from which I derived many insights into the virtues and limitations of Western thought, I decided that my life could use a touch more spirituality, and so I resolved to study Tibetan Buddhism under the tutelage of His Holiness Chögi Gyatso, the fifteenth Dalai Lama.

The problem was not so much that I nourished myself through cerebrophagy, but that I felt so little pity for the unfortunates on whom I fed. Chögi Gyatso, by contrast, was reportedly the reincarnation of Avalokitesvara, the Bodhisattva of Compassion. Evidently he had much to teach me.

As far as I know, I was the first of my race to undertake an explicitly religious quest. Traditionally we yeti are an unchurched species. Our ideological commitments, such as they are, tend along Marxist lines, the natural inclination of any creature with a dialectical metabolism, but we try not to push it too far, lest we lapse into hypocrisy. After all, it's difficult to maintain a robust contempt for the haute bourgeoisie when their neuronal tissues are your preferred source of sustenance.

We live by a code and kill by a canon. Yes, kill: for the raw fact is that, while the typical cyanotic climber who ends up on the yeti menu may be doomed, he is not necessarily dead. We always follow protocol. Happening upon a lost and languishing mountaineer, I shall immediately search the scene for some evidence that he might survive. If I spot a sherpa party on the horizon or a rescue helicopter in the distance, I shall continue on my way. If death appears inevitable, however, I tell the victim of my intention, then perform the venerable act of *nang-duzul,* hedging the frosty skull with all thirty-eight of my teeth, assuming a wide stance for maximum torque, and, finally, snaffling off the cranium in an abrupt yet respectful gesture. The *sha* is traditionally devoured on the spot. It's all very ritualistic, all very *in nomine Patris, et Filii, et Spiritus Sancti,*

to use a phrase I learned from the left cerebral hemisphere of Michael Rafferty, former seminarian, best-selling author of eighteen Father Tertullian detective novels, and failed Everest aspirant.

No matter how scrupulously he observes the norms of *nang-duzul*, the celebrant cannot expect any immediate cognitive gain. He must be patient. This isn't vodka. Two or three hours will elapse before the arrival of the *sha-shespah*, the meat-knowledge, but it's usually worth the wait. Typically the enrichment will linger for over a year, sometimes a decade, occasionally a lifetime. Last week I partook of a tenured comparative literature professor from Princeton, hence the formality of my present diction. I would have preferred a south Jersey Mafioso to a central Jersey postmodernist, the better to tell my story quickly and colorfully, but the mob rarely comes up on the mountain. My benefactor's name was Dexter Sherwood, and he'd remitted $65,000 to an outfit called Karmic Adventures on the promise that they would get him to the summit along with six other well-heeled clients. The corporation fulfilled its half of the contract, planting Dexter Sherwood squarely atop the planet, but during the descent a freak storm arrived, and it became every man for himself. I have nothing good to say about Karmic Adventures and its rivals: Extreme Ascents, Himalayan Challenge, Rappelling to Paradise, Jomolungma or Bust. They litter the slopes with their oxygen tanks, they piss off the sky goddess, and every so often they kill a customer. *My Parents Froze to Death on Everest and All I Got Was This Lousy T-Shirt.*

I shall not deny that a connoisseur of long pork occupies ethically ambiguous ground, so let me offer the following proposition. If you will grant that my race is fully sentient, with all attendant rights and privileges, then we shall admit to being cannibals. True, we are *Candidopithecus tibetus* and you are *Homo sapiens*, but my younger sister Namgyal long ago demonstrated that this taxonomy is no barrier to fertile intercourse between our races, hence my half-breed niece, Tencho, and my mixed-blood nephew, Jurmo. Do we have an understanding, O furless ones? Call us psychopaths and Dahmerists, accuse us of despoiling the dead, but spare us your stinking zoos, your lurid circuses, your ugly sideshows, your atrocious laboratories.

This agreement, of course, is purely academic, for you will never learn that we exist—not, at least, in consequence of the present text. I do not write for your amusement but for my own enlightenment. In setting down this account of my religious education, all the while imagining that my audience is your cryptic kind, I hope to make some sense of the tragedy that befell His Holiness. And when I am

done, you may be sure, I shall drop the manuscript into the deepest, darkest crevasse I can find.

I did not doubt that Chögi Gyatso would agree to instruct me in the dharma. For the past four years my clan and I had faithfully shielded him from the predations of the People's Liberation Army during his thrice-yearly pilgrimages from Sikkim to Tibet. Thanks to me and my cousins, the true Dalai Lama had thus far enjoyed twelve secret audiences with his false counterpart in Lhasa. His Holiness owed me one.

"Why do you wish to study the dharma?" Chögi Gyatso inquired, knitting his considerable brow.

"My eating habits cause me distress," I explained.

"Digestive?"

"Deontological."

"I know all about your eating habits, Taktra Kunga," His Holiness said, soothing me with his soft hazel eyes. He had a moon face, a shaved pate, and prominent ears. Behind his back, we yeti called him Mr. Sacred Potato Head. "You feed on deceased climbers, extracting *sha-shespah* from their brains."

Although our local holy men were aware of yeti culinary practices, they'd never learned all the sordid details, assuming in their innocence that we restrained our appetite until the donor was defunct—an illusion I preferred to keep intact. "Every species has its own epistemology," I noted, offering His Holiness an intensely dental grin.

"For me you are like the carrion birds who assist in our sky burials," Chögi Gyatso said. "Scavenging is an honorable way of life, Taktra Kunga. You have no more need of Buddhism than does a vulture."

"I wish to feel pity for those on whom I prey," I explained.

A seraphic light filled His Holiness's countenance. Now I was speaking his language. "Does it occur to you that, were you to acquire this pity, you might end up forsaking *sha-shespah* altogether?"

"It's a risk I'm willing to take."

"I shall become your teacher under two conditions. First, each lesson must occur at a time and place of my own choosing. Second, you must forgo your usual cheekiness and approach me with an attitude of respectful submission."

"I'm sorry to hear you think I'm cheeky, Your Holiness."

"And I'm sorry if I've insulted you, Your Hairiness. I merely want

207

to clarify that these lessons will be different from the banter we enjoy during our journeys to Lhasa. We shall have fun, but we shall not descend into facetiousness."

"No talk of James Bond," I said, nodding sagely. Like the fourteenth Dalai Lama before him, Chögi Gyatso was an aficionado of Anglo-American cinema. Until I began my study of the dharma, our mutual affection for Agent 007 was the only thing we really had in common.

"Or perhaps *much* talk of James Bond," the monk corrected me, "though surely even more talk of Cham Bön, the dance celebrating the gods."

The motives behind our trips to see the false Dalai Lama were essentially political rather than religious, although in His Holiness's universe the art of the possible and the pursuit of the ineffable often melded together. Having once dined on Laurence Beckwith, a Stanford professor of twentieth-century Asian history, I understood the necessity of these furtive treks. The disaster began in 1950 when the People's Liberation Army crossed the Upper Yangtze and marched on Lhasa with the aim of delivering the Tibetan people from the ravages of their own culture. By 1955 the collectivization process was fully under way, with Mao Tse-tung's troops confiscating whatever property, possessions, and human beings stood in the way of turning this backward feudal society into a brutal socialist paradise. Over the next four years it became clear that China intended to dissolve the Tibetan government altogether and imprison Tenzin Gyatso, the fourteenth Dalai Lama, and so on the evening of March 17, 1959, that regal young man disguised himself as a soldier and fled to Dharamsala in India, where he eventually established a government in exile, got on the radar of the secular West, and won a Nobel Peace Prize.

A mere two months after Tenzin Gyatso passed away, Beijing shamelessly appointed a successor, a bewildered three-year-old from Mükangsar named Shikpo Tsering. On his tenth birthday, Shikpo Tsering was taken from his parents, placed under house arrest in the Potola Palace, and ordained as Güntu Gyatso, the fifteenth Dalai Lama. No Tibetan Buddhist was fooled, and neither were we yeti. Güntu Gyatso is no more the reincarnation of Tenzin Gyatso than I am the reincarnation of King Kong. Among my race he is known as the Phonisattva.

Meanwhile, the monks in Dharamsala set about locating the genuine fifteenth Dalai Lama. When a chubby infant from Zhangmu,

208

Töpa Dogyaltsan, passed all the tests, including the correct identification of the late Tenzin Gyatso's eyeglasses, prayer beads, hand drum, and wristwatch from among dozens of choices, he forthwith became Chögi Gyatso, the latest iteration of the Bodhisattva of Compassion. On Chögi Gyatso's twenty-first birthday, the monks relocated their itinerant theocracy to the austere environs of Gangtok in Sikkim. The Pachen Lama told the outside world that certain benevolent deities, communicating through dreams, had demanded this move. He did not mention that these same gods evidently envisioned His Holiness periodically slipping across the border to advise the false Dalai Lama in matters both pragmatic and cosmic.

And so it happened that, one fine white day in February, my lair became the locus of a royal visit. The unexpected arrival of Chögi Gyatso and his retinue threw my girlfriend, Gawa Samphel, into a tizzy, and I was equally nonplussed. Had we known they were coming, Gawa and I would have tidied up the living room, disposing of the climber skulls strewn everywhere. We were fond of gnawing on them after sex. Death is healthier than cigarettes. To their credit, the monks pretended not to notice the bony clutter.

Gawa served a yeti specialty, pineal-gland tea sweetened with honey. His Holiness drained his mug, cleared his throat, and got to the point. As the leader of "the tall and valiant Antelope Clan"—an accurate assessment, the average yeti height being eight feet and the typical yeti heart being stout—I could perform a great service for the long-suffering Tibetan people. If I and my fellow *Shi-mis* would escort His Holiness through the Lachung Pass to Lhasa three times each year, doing our best to "peacefully and compassionately keep the Chinese patrols at bay," the monks back in Gangtok would send forth eight hundred thousand prayers a week for the continued prosperity of my race. His Holiness promised to compensate us for our trouble, one hundred rupees per yeti per six-day pilgrimage.

"I want to help you out," I said, massaging my scraggly beard, "but I fear that in the course of shielding you from the Mao Maos we shall inadvertently reveal ourselves to the world."

"That is a very logical objection," Chögi Gyatso said, flashing his beautiful white teeth. He had the brightest smile in Asia. "And yet I have faith that these missions will not bring your species to light."

"Your faith, our skin," I said. "I am loath to put either at risk."

"Faith is not something a person can put at risk," His Holiness informed me, wiping the steam from his glasses with the sleeve of

his robe. "Faith is the opposite of a James Bond martini—it may be stirred but not shaken."

To this day I'm not sure why I assented to become His Holiness's paladin. It certainly wasn't the money or the prayers. I think my decision had something to do with my inveterate affection for the perverse—that, and the prospect of discussing secret-agent movies with a young man whose aesthetics differed so radically from my own.

"I had no idea you were a James Bond fan," I said as Chögi Gyatso took leave of our lair. "Now that I think about it, the titles do have a certain Buddhist quality. *The World Is Not Enough. You Only Live Twice. Tomorrow Never Knows. Live and Let Die.* Is that why you like the series?"

"You are quite correct, Taktra Kunga," His Holiness replied. "I derive much food for meditation from the Bond titles. I also enjoy the babes."

Whether by the grace of the Bön gods, the vicissitudes of chance, or the devotion of his yeti protectors, Chögi Gyatso's pilgrimages proved far less perilous than anyone anticipated. Whenever a Chinese patrol threatened to apprehend His Holiness, my six cousins and I would circle silently around the soldiers, then come at them from behind. The Mao Maos never knew what hit them. A sudden whack between the shoulder blades, the blow we apes call *glog,* the lightning flash, and the startled soldier wobbled like a defective prayer wheel, then fell prone in the snow, gasping and groaning. By the time the patrol recovered its collective senses, Chögi Gyatso was far away, off to see the sham wizard on his stolen throne.

Our victories in these skirmishes traced largely to our invisibility. This attribute of *Candidopithecus tibetus* is highly adaptive and entirely natural. Like the skin of a chameleon, our fur transmogrifies until it precisely matches the shade of the immediate snowscape. So complete is this camouflage that we appear to the naive observer as autonomous blazing orbs and disembodied flashing teeth. Set us down anywhere in the Himalayas, and we become eyes without faces, fangs without serpents, grins without cats.

Committed to conveying His Holiness to Lhasa with maximum efficiency, we eventually devised an elaborate relay system using modified climbing gear. Our method comprised a set of six grappling irons outfitted with especially long ropes. By hurling each hook high

into the air and deliberately snagging it on the edge of a crag, Cousin Jowo, the strongest among us, succeeded in stringing a succession of high-altitude Tarzan vines between the gateway to the Lachung Pass and the outskirts of Lhasa. Once these immense pendulums had been hung, it became a simple matter for Cousin Drebung, Cousin Yangdak, Cousin Garap, Cousin Nyima, and me to swing through the canyons in great Newtonian oscillations, gripping our respective ropes with one hand while using the opposite arm to pass His Holiness from ape to ape like a sacramental basketball. Cousin Ngawang brought up the rear, carefully detaching the six hooks and gathering up the ropes, so the Mao Maos would remain oblivious to our conspiracy.

Naturally my clan and I never dared venture into Lhasa proper, and so after depositing Chögi Gyatso at the city gates we always made a wide arc to the east, tromping through the hills until we reached the railroad bridge that spanned the Brahmaputra River like a sleek tiger leaping over a chasm. His Holiness's half brother, Dorje Lingpa, lived by himself in a yurt on the opposite shore. We could get there only by sprinting anxiously along the suspended rails. The passenger train made two scheduled and predictable round-trips per day, but the freight lines and the military transports ran at odd hours, so my cousins and I were always thrilled to reach the far side of the gorge and leap to the safety of the berm.

Dorje Lingpa worked for the Chinese National Railroad, one of four token Tibetans in their employ. Six days a week, he would leave his abode shortly after dawn, walk twenty paces to the siding, climb into his motorized section-gang car, and clatter along the maintenance line, routinely stopping to shovel snow, ice, stones, rubble, and litter off the parallel stretch of gleaming high-speed track running west into Lhasa. Whereas the typical Beijing technocrat had a private driveway and a Subaru, Dorje Lingpa had his own railroad siding and a personal locomotive.

A considerate if quixotic man, His Holiness's half brother always remembered to leave the key under the welcome mat. My clan and I would let ourselves into the yurt, brew some buttered tea, purchase stacks of chips from our host's poker set, and pass the afternoon playing seven-card stud, which Cousin Ngawang had absorbed from a Philadelphia lawyer who'd run short of oxygen on the South Col. Chögi Gyatso and Dorje Lingpa normally returned within an hour of each other—the true Dalai Lama from counseling the Phonisattva, his brother from clearing the Lhasa line. Usually Chögi Gyatso

211

remembered to bring a new set of postcards depicting the changing face of the capital. The Lhasa of my youth was a populous and noisy yet fundamentally congenial world. Thanks to the dubious boon of the railroad, the city now swarmed with franchise restaurants selling yak burgers, flat-screen TVs displaying prayer flags, taxicabs papered with holograms of stupas, and movie theaters running Bollywood musicals dubbed into Chinese.

Our fellowship always spent the night on the premises, Chögi Gyatso and his brother bunking in the yurt, we seven yeti sleeping on the ground in the backyard. Does that image bring a chill to your bones, o naked ones? You should understand that our fur is not simply a kind of cloak. Every pelt is a dwelling, like a turtle's shell. We live and die within the haven of ourselves.

Dorje Lingpa loved his job, but he hated his Mao Mao bosses. Every time he hosted Chögi Gyatso and his yeti entourage, he outlined his latest unrealized scheme for chastising the Han Chinese. As you might imagine, these narratives were among the few phenomena that could dislodge Chögi Gyatso's impacted serenity.

"I've decided to target the Brahmaputra River bridge," Dorje Lingpa told us on the occasion of the bodhisattva's tenth pilgrimage. "At first I thought I'd need plastique, but now I believe dynamite will suffice. There's lots of it lying around from when they built the railroad."

"Dear brother, you are allowing anger to rule your life," Chögi Gyatso said, scowling. "I fear you have strayed far from the path of enlightenment."

"Every night as I fall asleep, I have visions of the collapsing bridge," Dorje Lingpa said, discreetly opening a window to admit fresh air. Though too polite to mention it, he obviously found our amalgamated yeti aroma rather too piquant. "I see a train carrying Chinese troops plunging headlong into the gorge."

"It's not your place to punish our oppressors," His Holiness replied. "Through their ignorance they are sowing the seeds of their own future suffering."

Dorje Lingpa turned to me and said, "During the occupation, tens of thousands of Tibetans were arrested and put in concentration camps, where mass starvation and horrendous torture were the norm. When China suffered a major crop failure in 1959, the army confiscated our entire harvest and shipped it east, causing a terrible famine throughout Tibet."

"I have forgiven the Chinese for what they did to us," Chögi

Gyatso told his brother, "and I expect the same of you."

"I would rather be in a situation where you must forgive me for what I did to the Chinese," Dorje Lingpa replied.

"Beloved brother, you vex me greatly," Chögi Gyatso said. "All during Mönlam Chenmo I want you to meditate from dawn to dusk. You must purge these evil thoughts from your mind. Will you promise me that?"

Dorje Lingpa nodded listlessly.

"Anyone for seven-card stud?" Cousin Yangdak asked.

"Deal me in," Cousin Nyima said.

"At the start of the Cultural Revolution, the Red Guards swarmed into Tibet," Dorje Lingpa told me. "They forced monks and nuns to copulate in public, coerced them into urinating on sacred texts, threw excrement on holy men, scrawled graffiti on temple walls, and prosecuted local leaders in kangaroo courts for so-called crimes against the people."

"Nothing wild, high-low, table stakes," said Cousin Nyima, distributing the cards.

"The Red Guards also went on gang-rape sprees throughout the countryside," Dorje Lingpa continued. "They usually required the victim's husband, parents, children, and neighbors to watch."

"First king bets," Cousin Nyima said.

"Two rupees," Cousin Jowo said.

"Make it three," Cousin Drebung said.

Three days later Chögi Gyatso sent an emissary to my lair—Lopsang Chokden, who eerily resembled the massive Oddjob from *Goldfinger*. He consumed a mug of Gawa's pineal-gland tea, all the while surveying the scattered skulls, which he called "splendid meditation objects," then delivered his message. His Holiness would begin my tutelage on the morning after the two-week New Year's celebration of Mönlam Chenmo, which I knew to be a kind of karmic rodeo combining sporting events, prayers, exorcisms, and public philosophical debates in a manner corresponding to no Western religious festival whatsoever. Chögi Gyatso suggested that I bring a toothbrush, as the first stage of my apprenticeship might easily last forty-eight hours. I should also pack my favorite snacks, provided they contained no Chinese dog meat.

As I prepared for my journey, it occurred to me that the mind I would be presenting to His Holiness was hardly a tabula rasa. My fur

was white, but my slate was not blank. Owing to my ingestion of a dozen California pseudo-Buddhists over the years, I'd grasped much of what the dharma involved, or, rather, did not involve. I had particularly vivid memories of a Santa Monica mystic named Kimberly Weatherwax. Shortly before I stumbled upon this hapless climber, she had fallen from the Lhotse Face, simultaneously losing her oxygen tank and stabbing herself in the back with an ice ax. Her blood oozed through her parka and leaked onto the snow like a Jackson Pollock painting in progress. She had perhaps five minutes to live, an interval she elected to spend telling me about her past lives in ancient Babylon and Akhenaton's Egypt.

"Are you by any chance the Abominable Snowman?" she asked, her brain so bereft of oxygen that she evidently felt no pain.

"My girlfriend thinks I'm insufferable, but I'm not abominable," I replied. "Call me Taktra Kunga, yeti of the *Shi-mi* Clan."

"A yeti? Wow! Really?"

"Really."

"That's so cool," she rasped, her voice decaying to a whisper. "An actual yeti," she mumbled. "This has been the most meaningful experience of my life."

"And now you are dying, which means I must eat your cerebral cortex."

"Heavy."

She wheezed and blacked out. From the subsequent *nang-duzul* I learned that, for tantric dilettantes like Kimberly Weatherwax, Eastern religion promised three big payoffs: solving the death problem through reincarnation, improving one's sex life through deferred gratification, and leaving the mundane realm of false values and failed plans for an axiomatically superior plane of relentless joy and unremitting bliss. Years later, trudging toward Gangtok for my first lesson with His Holiness, I decided that such spiritual avarice was the last thing my teacher would endorse. Obviously the dharma was not simply an exotic road to immortality and orgasms, not simply a gold-plated *Get Out of Samsara Free* card. Clearly there was more to infinity than that.

Dressed in his most sumptuous saffron-and-burgundy robe, Chögi Gyatso stood waiting at the gateway to his private residence, a stately, many-towered palace that the deracinated monks had constructed shortly after the Mao Maos installed the Phonisattva in Lhasa. As His Holiness led me down the central corridor, I began expounding upon the dharma. "I understand that reincarnation is different from

immortality, and I likewise understand that the tantra is not a means of erotic fulfillment. So we can dispense with those issues and get into something meatier right away."

A man of abiding forbearance, Chögi Gyatso listened thoughtfully, then looked me in the eye and unsheathed his epic smile. "What you understand is precisely nothing, Taktra Kunga," he said cheerily. "What you understand is zero, less than zero, zero and zero again, or, to use Mr. Bond's epithet, Double-Oh-Seven, seven being the number of rightful branches that a bodhisattva will pursue while on the radiance level of his emergence, along with thirty additional such disciplines."

We slipped into His Holiness's private bedchamber, where a smiling nun hovered over a tea cart that held a ceramic pot and a *You Only Live Twice* collector's mug, plus a plain white mug presumably intended for me.

"I don't doubt that I am ignorant, Your Holiness," I told Chögi Gyatso. "What are the seven rightful branches?"

"Correct mindfulness, correct discernment, correct effort, correct joy, correct pliancy, correct meditation, and correct equanimity, but don't worry about it, Your Hairiness. Perhaps you have the makings of a bodhisattva, perhaps not, but for now we simply want to increase your compassion quotient. Your education will begin with a simple oath honoring Sakyamuni, his teachings, and the community of monks and nuns he founded."

"Sounds good," I said, inhaling the sweet oily fragrance of the tea.

"Recite the following vow three times. 'I take refuge in the Buddha, I take refuge in the dharma, I take refuge in the samgha.'"

"'I take refuge in the Buddha, I take refuge in the dharma, I take refuge in the samgha.'"

Twice more I repeated the pledge, and then His Holiness gifted me with a *kata*—a white silk scarf—draping it around my neck. The nun filled his mug with buttered tea, handed him the pot, and slipped away. He proceeded to load my mug beyond its capacity, the greasy amber fluid spilling over the rim and cascading across the tray, flooding the spoons and napkins.

"Might I suggest you stop pouring?" I asked.

Chögi Gyatso maintained his posture, so that the tray soon held the entire steaming, roiling, eddying contents of the tea pot. "Like this mug, your mind is filled with useless musings and self-generated afflictions. You will not progress until you shed all such psychic baggage." He pointed toward a huge porcelain bathtub, elevated on four

solid-brass lion paws to accommodate a brazier for heating the water. "And if you are to empty your mind, Taktra Kunga, you must first empty this tub, transferring all twenty gallons to the cistern we use for flushing the toilets. I was planning to take a nice warm bath tonight, but that ambition has now fallen away."

"Where's the bucket?" I asked.

"You will not use a bucket, but rather this implement." Chögi Gyatso reached toward the inundated tea tray and withdrew a dripping silver spoon.

"That's ridiculous," I said.

"Indeed," Chögi Gyatso said. "Completely ridiculous. The cistern is at the end of the corridor, last room on the left."

"What if I refuse?"

"Taktra Kunga, need I remind you that these lessons were your idea? In truth I have better things to do with my time."

"How long will the job take?"

"About seven hours. I suggest you get started right after lunch."

"Do you want me to chant a mantra or anything?"

"You are not yet ready for meditation, but if you insist on chanting something"—His Holiness offered a sly wink—"try the following: 'That's a Smith & Wesson, and you've had your six.'"

"*Dr. No*, right?"

The bodhisattva dipped his head and said, "To become enlightened is to encounter the perfect void, the final naught, the ultimate no. Alternatively, you may wish to ponder the following koan: When a chicken has sex with an egg, which comes first?"

His Holiness laughed uproariously. Under normal circumstances, I might have shared his merriment, but I was too depressed by the thought of the tedious chore that lay before me.

"Evidently it would be best if I did not ponder anything in particular," I said.

"That is the wisest remark you have made all morning," Chögi Gyatso said.

With an aggrieved heart but a curious intellect, I did as my teacher suggested, consuming my lunch, a bowl of noodle soup, then getting to work. While His Holiness sat rigidly in his study, alternately reading Tsong-kha-pa's *The Great Exposition of the Stages of the Path* and Ian Fleming's *The Man with the Golden Gun*, I ferried twenty gallons of bathwater from tub to cistern, one ounce at a time. As Chögi Gyatso predicted, the task took all afternoon and well into the evening. Alas, instead of growing vacant my skull became jammed

to the walls with toxic resentments. I wanted to put thorns in His Holiness's slippers. I wanted to break his drums and shatter his James Bond DVDs.

"The job is done," I told my teacher at nine o'clock.

"Go to your bedchamber, Taktra Kunga, first door on the right. An excellent dinner awaits you, mutton curry with rice. I would suggest that you turn in early. Come morning, the nun will bring you two oranges. After you have savored their sweet juices and exquisite pulp, you should begin your second labor."

"Which is?"

"Replenishing the tub."

"You must be joking."

"That is correct, Taktra Kunga. I am joking. It's a funny idea—isn't it?—filling the big tub you so recently emptied."

"Very funny, yes."

"However, please know that, come tomorrow afternoon, I may wish to bathe."

"I see," I said evenly.

"Do you?"

"Alas, yes. Might I use a bucket this time?"

"No. Sorry. The spoon. You should aim to finish by three o'clock, whereupon the nun will start warming my bath."

I figured I had no choice, and so the next day, right after consuming my two oranges, which were truly delicious, I spent another seven hours wielding my pathetic spoon, transferring the water ounce by dreary ounce. Midway through the ordeal, I realized that my anger at Chögi Gyatso had largely vanished. Here I was, receiving personal instruction in a magnificent religious tradition from the world's most famous holy man. It behooved me to be glad, not to mention grateful. At the very least I must become like a luscious female operative in thrall to Agent 007, surrendering to my teacher with a willing spirit.

"And now let me ask a question," Chögi Gyatso said after I'd finished drawing his bath. "What if I commanded you to empty the tub all over again?"

"I would gnash my teeth," I replied.

"And then?"

"I would growl like a snow lion."

"And then?"

"I would gasp like a dying climber."

"And then?"

"I would empty the tub."

"That is a very good answer, Taktra Kunga. Now go home to your woman and make love to her long into the night."

At the start of the third lunar month, the hulking emissary Lopsang Chokden reappeared in my lair and delivered a new message from His Holiness, but only after once again consuming a mug of pineal-gland tea and sorting contemplatively through our skulls. Chögi Gyatso, I now learned, wanted me to return to Sikkim forthwith and seek him out in the New Ganden Monastery. I should anticipate spending four full weeks with His Holiness—and pack my luggage accordingly.

"Twenty-eight days of celibacy," Gawa sneered. "Really, Taktra Kunga, your guru is asking a lot of you—me—us."

"Abstinence makes the heart grow fonder," I replied.

"Horse manure."

"Please try to understand. I'm not at peace with myself."

We passed the rest of the day alternately quarreling and copulating, and the following morning Gawa sent me off with her resentful blessing. I made my way south through the Lachung Pass, pausing to dine on Robin Balaban, an NYU film studies professor, then crossed the border into Sikkim. Digesting Professor Balaban's thoughts, I came to realize that he'd been troubled by a question that had often haunted me, namely, why has there never been a good movie about a yeti? *Man Beast* is atrocious. *Half Human* is risible. *The Snow Beast* is a snore. Only the Hammer Film called *The Abominable Snowman of the Himalayas* is remotely watchable, although everyone involved, including star Peter Cushing, writer Nigel Kneale, and director Val Guest, went on to make much better thrillers.

"During the first half of your sojourn here, you will experience intimations of the primordial Buddhist vehicle, the Hinayana, keyed to purging mental defilements and achieving personal enlightenment," Chögi Gyatso said as we connected, hand to paw, on the steps of the New Ganden Monastery. "During the second half of your stay, you will taste of the plenary vehicle, the Mahayana, which aims to cultivate a person's compassion for all living beings through the doctrine of *sunyata,* emptiness. In the fullness of time I shall introduce you to the quintessential vehicle, the diamond way, the indestructible Vajrayana."

"*Diamonds Are Forever,*" I said.

"Probably my favorite 007. But let's not delude ourselves, Taktra Kunga. Whether *Homo sapiens* or *Candidopithecus tibetus,* a seeker may need to spend many years, perhaps many lifetimes, pursuing the Hinayana and the Mahayana before he can claim them as his own, and yet without such grounding he is unlikely to attain the eternal wakefulness promised by the Vajrayana."

"Given the immensity of the challenge, let me suggest that we start immediately," I said. "There's no time like the present, right, Your Holiness?"

"No, Taktra Kunga, there's *only* a time like the present," my teacher corrected me. "The past is a tortoise-hair coat. The future is a clam-tooth necklace."

I passed the next seven days in the Tathagata Gallery, contemplating the canvases, four completely white, four completely black. His Holiness's expectations were clear. I must endeavor to fill the featureless spaces with whatever random notions crossed my mind—imperiled mountaineers, tasty yuppie brains, voluptuous yeti barmaids, crummy Abominable Snowman movies—then imagine these projections catching fire and turning to ash, so they would cease to colonize my skull. Despite my initial skepticism, before the long week was out I succeeded in slowing down the rackety engine of my consciousness, the endless *kachung, kachung, kachung* of my thoughts, the ceaseless *haroosh, haroosh, haroosh* of my anxieties, or so it seemed.

"I'm a much calmer person," I told my teacher. "Indeed, I think I've achieved near total equanimity. Does that mean I'm enlightened?"

"Give me a break, Taktra Kunga."

My second week in the New Ganden Monastery confronted me with a different sort of *sunyata,* the bare trees of the Dzogchen Arboretum, their branches bereft of leaves, fruit, and blossoms. This time around, my instructions were to focus my drifting thoughts on the here and now, the luminous, numinous, capacious present. Once again I profited from my meditations. Within twenty-four hours a sublime stillness swelled at the center of my being. I was truly *there,* inhabiting each given instant, second by millisecond by nanosecond.

"I did it," I told His Holiness. "I extinguished the past and annihilated the future. For now there is only today, and for today there is only now. I see nirvana just over the horizon."

"Don't crack walnuts in your ass, Taktra Kunga."

My troubles began during week three, which I spent in the Hall of Empty Mirrors, alternately meditating with closed eyes and

contemplating with a rapt gaze the twenty-one ornately carved frames, each distinctly lacking a looking glass. I was now swimming in the ocean of the Mahayana. It would not do for me simply to still my thoughts and occupy the present. I must also shed my ego, scrutinizing my nonself in the nonglass. Good-bye, Taktra Kunga. You are an idea at best, a phantasm of your atrophied awareness. No person, place, thing, or circumstance boasts a stable, inherent existence. Earthly attachments mean nothing. Nothing means everything. All is illusion. Flux rules. Welcome to the void.

"I don't like the Hall of Empty Mirrors," I told His Holiness at the end of week three, from which I'd lamentably emerged more myself, more Taktra Kungaesque, than ever. "In fact, I detest it."

"You're in good company," Chögi Gyatso said. "When the Buddha first spoke of the quest for *sunyata,* thousands of his followers had heart attacks."

"Then perhaps we should omit emptiness from the curriculum?"

"A person can no more achieve enlightenment without *sunyata* than he can make an omelet without eggs."

"I don't want to have a heart attack."

"To tell you the truth, I never believed that story," Chögi Gyatso said. "Although it's always disturbing to have the rug pulled out, the fall is rarely fatal."

"But if everything is an illusion, then isn't the idea that everything is an illusion *also* an illusion?" I asked petulantly.

"Let's not stoop to sophistry, Taktra Kunga. This is contemporary Gangtok, not ancient Athens."

Having acquitted myself so poorly in the Hall of Empty Mirrors, I anticipated even worse luck in the locus of my fourth and final week, the Chamber of Silence, reminiscent of the padded cells in which Western civilization was once pleased to warehouse its lunatics. My pessimism proved prescient. Much as I enjoyed meditating amid this cacophony of quietude, this mute chorus of one hand clapping, no foot stomping, thirty fish sneezing, forty oysters laughing, and a million dust motes singing, I was no closer to deposing my sovereign self than when I'd first entered the New Ganden Monastery.

"I'm discouraged, Your Holiness."

"That is actually good news," he replied.

"No, I mean I'm *really* discouraged."

"You must have patience. Better the dense glacier of genuine despair than the brittle ice of false hope."

O hairless ones, I give you my teacher, Chögi Gyatso, the Charlie

Chan of the Himalayas, forever dispensing therapeutic aphorisms. And if His Holiness were Chan, did that make me his nonexistent offspring, his favorite illusory child, his Number One Sunyata? Raised by the Antelope Clan, I'd never known my biological parents, who'd died in the Great Khumbu Avalanche six months after my birth. In seeking out His Holiness, was I really just looking for my father? The more I pondered the question, the more mixed my emotions grew—a hodgepodge, a vortex, an incommodious vicus of recirculation, to paraphrase a Joycean scholar I'd once assimilated.

Chögi Gyatso bid me farewell. I left the New Ganden Monastery and headed for the Lachung Pass as fast as my limbs would carry me, sometimes running on all fours, eager for a sensual reunion with Gawa. Midway through my journey I again encountered the corpse of Robin Balaban, the NYU film professor. His gutted cranium taunted me with the void I'd failed to apprehend in the monastery. I averted my eyes and howled with despair.

My indifference to Professor Balaban's fate, I realized to my infinite chagrin, was equaled only by my apathy toward his bereaved loved ones. With crystal clarity I beheld my benighted mind. I would never awaken. Buddhahood was as far away as the summit of some soaring Jomolungma on another planet. And so I howled again, wracked by a self-pity born of my inability to pity anyone but myself, then continued on my way.

While Chögi Gyatso doubtless regarded me as a difficult pupil, perhaps the most exasperating he'd encountered in his present incarnation, the primary menace to his tranquillity in those days remained his bitter, restless, firebrand brother. Although Dorje Lingpa had kept his promise to spend the whole of Mönlam Chenmo in profound meditation, his efforts had proved abortive, and he was now more determined than ever to strike a blow against the Han Chinese. Unenlightened being that I was, I framed Dorje Lingpa's failure in egotistical terms. If His Holiness's blood relatives had difficulty attaining *sunyata*, then I shouldn't feel so bad about the absence of emptiness in my own life.

The intractable condition of Dorje Lingpa's anger became apparent during our next secret pilgrimage to Lhasa. In a tone as devoid of compassion as a brick is devoid of milk, he confessed that he could not shake his mental image of "the Brahmaputra gorge swallowing a troop train like the great god Za feeding a string of sausages to the

mouth embedded in his stomach." He speculated that this vision might be "a sign from heaven," and that Za himself was telling him "to render a divine judgment against the evil ones."

His Holiness began to weep, the subtlest display of anguish I'd ever seen, the tears trickling softly down his face like meltwater in spring, his sobs barely audible above the guttural breathing of the seven hairy apes in the yurt. Dorje Lingpa remained adamant. The People's Liberation Army must pay for its crimes. Changing the subject, or so it seemed at the time, he said that shortly after dawn he would like to take His Holiness on "a brief excursion in my track-inspection vehicle," then turned to his yeti guests and declared that there would be room for one of us. I told him I would like to join the party.

Thus it happened that, shortly after sunrise, Chögi Gyatso, Dorje Lingpa, and I climbed into the open-air section-gang car and began tooling eastward along the maintenance line at a brisk eighty kilometers per hour, enduring a windchill from some frigid equivalent of hell. Dorje Lingpa wore his bomber jacket, His Holiness sat hunched beneath a yak-hide blanket, and I had wrapped myself head to toe in a tarp—not because I minded the cold, but because the surrounding gang car defied my usual white-on-white camouflage. Suddenly the harsh metallic bawl of a diesel horn filled the air, and then the train appeared, zooming toward us along the adjacent high-speed rails in a great sucking rush that whipped our clothing every which way like prayer flags in a gale. Each passenger coach was crammed with Han Chinese, some perhaps bound for a holiday in Lhasa but the majority surely intending to settle permanently, players in the government's plan to marginalize the native population. Five hundred faces flew past, lined up along the windows like an abacus assembled from severed heads. Each wore an expression of nauseated misery—a syndrome probably born of the thin air, though I liked to imagine they were also suffering spasms of regret over their role in the rout of Tibet.

As the morning progressed, Dorje Lingpa's agenda became clear. He meant to give us a guided tour of recent outrages by the Chinese. Periodically he stopped the gang car and passed us his binoculars, so that we could behold yet another exhibit in the Museum of Modern Expediency: the bombed lamaseries, razed temples, trampled shrines, maimed statues—desecrations that the Beijing regime imagined would help stamp out the indigenous cancer of contemplation and replace it with the new state religion, that cruel fusion of normless monopoly capitalism and murderous totalitarianism. Once again

His Holiness's eyes grew damp, and now he wept prolifically, great dollops of saltwater rolling down his cheeks and freezing on his chest, so that he soon wore a necklace of tears.

Knowing of his brother's fascination with James Bond's Aston Martin, Dorje Lingpa asked if he would like to take the throttle during our return trip. For a full minute the grieving monk said nothing, then offered a nod of disengaged corroboration. Dorje Lingpa stopped the inspection vehicle, then threw the motor into reverse. We pivoted in our seats. His Holiness gripped the controls, and we were off, retracing our path westward through the scattered shards of the Tibetan soul. Drawing within view of the gorge, we again heard the blast of a diesel horn, and seconds later we were overtaken by another train from Beijing, bearing still more Han into the sacred city.

We reached the yurt shortly after two o'clock. My cousins had prepared a hot luncheon of steamed dumplings, but I was not hungry, and neither was His Holiness. The meal passed languidly and without conversation. At last Chögi Gyatso broke the silence, his resonant and reassuring voice warming the icy air.

"Beloved brother," he told Dorje Lingpa, "that was a good thing you did, taking us across the plateau. I understand you much better now."

"I am grateful for your praise," the trainman said. "Will you join my war against the People's Liberation Army?"

"What do you think?" Chögi Gyatso asked.

"I think I should not count on your participation."

"That is correct."

"I'm reminded of an old joke," Cousin Ngawang said. "A man went to a priest in the north of Ireland and confessed that he'd blown up six miles of British railroad track. And the priest said, 'For your penance, you must go out and do the stations.'"

"Very amusing," Cousin Jowo said.

"Decidedly droll," Cousin Drebung said.

But no one laughed, most especially me, most conspicuously Chögi Gyatso, and most predictably Dorje Lingpa.

My third tutorial with His Holiness took me to the fabled Bebhaha Temple of Cosmic Desire, the very loins, as it were, of the Gangtok Buddhist Complex, famous throughout Asia for its six thousand masterpieces of erotic art. Despite his celibacy, or perhaps because of it, Chögi Gyatso held a generally approving attitude toward the sex

act, and he believed that, my embarrassing performance in the monastery notwithstanding, the meditation practices pursued in the Bebhaha Temple might occasion my awakening. Moreover, this time around I would be following a regimen drawn from His Holiness's specialty—the tantric path, the diamond discipline, the venerable Vajrayana.

The mystic principle behind the temple was straightforward enough. Tsangyang Gyatso, the sixth Dalai Lama, had put it well: "If one's thoughts toward the dharma were of the same intensity as those toward physical love, one would become a Buddha in this very body, in this very life." And so it was that I spent a week in Gangtok's spiritual red-light district, contemplating hundreds of paintings and sculptures depicting sexual ensembles—couples, trios, quartets, quintets, human, yeti, divine, biologically mixed, taxonomically diverse, ontologically scrambled—engaged in every sort of carnal congress, homoerotic, heteroerotic, autoerotic, even surrealistic: images of copulating trees and randy pocket watches, playfully signed "Salvador Dali Lama." I seethed with lust. I stroked myself to torrential spasms. At one point His Holiness suggested that I take up with the kind of sexual consort known as a karma-mudra, an "action seal," so named because the practice sealed or solidified the seeker's understanding that all phenomena are a union of ecstasy and emptiness. I declined this provocative invitation, feeling that His Holiness's syllabus had already put enough strain on my relationship with Gawa.

Even as I wrapped my hand around my cock, I sought to keep my eye on the ball. The idea was to gather up all this libidinous energy, this tsunami of seed, and, through diligent meditation and focused chanting, channel it toward *sunyata,* detachment, and boundless pity for the suffering of all sentients. From onanism to *Om mani padme hum,* oh, yes, that was the grand truth of the tantra, an ingenious strategy of masturbate-and-switch, and I did my best, O depilated ones, you must believe me, I truly played to win.

"I tried," I told Chögi Gyatso as I stumbled out of the Bebhaha Temple, all passions spent. "I tried, and I failed. Immerse me in the tantra, and my thoughts turn to wanking, not awakening. Let's face it, Your Holiness. I was not made for the Vajrayana, nor the Mahayana either, nor even the Hinayana."

"You're probably right. But I must also say this, Taktra Kunga. Your attitude sucks."

"So do half your deities."

"Might we try one final tantric lesson? At the start of the tenth lunar month, come to the Antarabhava Charnel Ground on the slopes of Mount Jelep La, eight kilometers to the northeast. You will know it by the vultures wheeling overhead."

I shrugged and said, "I suppose I have nothing to lose."

"No, Taktra Kunga, you have *everything* to lose," His Holiness reproached me. "That is the whole point. Lose your illusions, lose your goals, lose your ego, lose the world, and only *then* will you come to know the wonder of it all."

O smooth ones, you might think that an ape whose lair was appointed with skulls would revel in the ambience of the Antarabhava Charnel Ground, but in fact I found it a completely ghastly place, a seething soup of shucked bones, strewn teeth, rotting flesh, disembodied hair, fluttering shrouds, buzzing flies, busy worms, industrious crows, and enraptured vultures. By Chögi Gyatso's account, two geographical circumstances accounted for this macabre ecology. Because wood was scarce in Tibet, cremation had never become the norm, and—thanks to the rocky and often frozen soil—interment was equally uncommon. Instead Tibetans had resorted to the colorful custom of sky burial, dismembering the corpse and leaving the components in a high, open place to be consumed by jackals and carrion birds.

"Death, decay, and transmigration: the three fundamental facts of existence," His Holiness said.

"I want to go home," I said, my eyes watering and my brain reeling from the foulness of it all. The stench was itself a kind of raptor, pecking at my sinuses, nibbling at the lining of my throat.

"The sorrowful cycle of samsara," Chögi Gyatso persisted. "The wretched wheel of life, turning and turning in the widening gyre, but there is no rough beast, Taktra Kunga, no Bethlehem, only more turning, more suffering, more turning, more suffering. Sean Connery is reborn as George Lazenby, who is reborn as Roger Moore, who is reborn as Timothy Dalton, who is reborn as Pierce Brosnan, who is reborn as Daniel Craig, who is reborn as Brian Flaherty. It can be much worse, of course. A person might spend his life deliberately harming other sentient beings. Owing to this bad karma, he will come back as an invertebrate, a miserable crawling thing, or else a hungry ghost, or maybe even a hell being. Agent 007, if he truly existed, would probably be a dung beetle now. So it goes, Taktra

Kunga. You can't win, you can't break even—but you *can* get out of the game."

"*You* didn't get out of the game," I noted, staring at my feet. "You keep opting for reincarnation."

"That doesn't mean I like it."

"If your brother sends a troop train into the gorge, how many lifetimes will he need to discharge his karmic debt? A hundred? A thousand? A million?"

"I don't want to talk about my brother," Chögi Gyatso said, placing his open palm beneath my shaggy simian chin and directing my gaze toward the open-air ossuary. "Behold."

Bearing a narrow palanquin on which lay a robe-wrapped corpse, a solemn procession shuffled into view: monks, mourners, tub haulers, and a team of specialists that His Holiness identified as *rogyapas,* body cutters. Expectant vultures arrived from all points of the compass. After finding a relatively uncluttered space, the palanquin bearers set down their burden, whereupon the *rogyapas* secured the corpse with ropes and pegs, "lest the birds claim it too soon," His Holiness explained. Availing themselves of the tub, the monks next washed the body in a solution scented with saffron and camphor, "thereby making the flesh more pleasing to the nostrils of its feathered beneficiaries."

"Your religion is good with details," I noted.

"In giving his body to scavengers, the deceased is performing an act of great charity," Chögi Gyatso explained. "Even as we speak, that person's hovering consciousness negotiates the *bardo,* the gap between his present life and his next incarnation. He is presently confronting a multitude of confusing sights, sounds, smells, textures, and tastes, as well as hordes of tantric deities, some peaceful, others wrathful, each spawned by his mind. It's all in the *Bardo Thodol.*"

"Maybe we should try selling it to the movies."

"Taktra Kunga, shut up."

After drawing out their sharp, gleaming knives, the body cutters went to work, opening up the corpse's chest, removing the internal organs, and slicing the flesh from the skeleton. The *rogyapas* mashed up the bones with stone hammers, then mixed the particles with barley flour, a proven vulture delicacy.

"What are we doing here?" I moaned, seizing His Holiness by the shoulders.

"We are here to relieve the suffering of other sentient beings.

Haven't you been paying attention?"

"No, I mean what are we doing *here?* Why are we in this demented alfresco cemetery?"

"We are here to meditate on *tathata*—suchness—the true nature of reality."

Only after a large quantity of flesh and bone had been prepared were the vultures allowed into the ceremony, a precaution that kept them from fighting among themselves. The *rogyapas* carried the offerings to a large slab of rock decorated with a geometric representation of the universe, then systematically pitched the portions, one by one, toward the center of the circle. Meanwhile, one particularly athletic *rogyapa* swung a large rope across the inscribed outcropping, discouraging the raptors from entering the mandala before the proper time.

"Take me away!" I wailed. "I can't stand this place! Class dismissed!"

"Is that truly your wish?" His Holiness asked.

"Yes! It's over! *Allons-y!* I'm the worst student you ever had!"

"That would appear to be the case."

The rope swinger stilled his cord and stepped aside. Fluttering, shrieking, squawking, and—for all I knew—chanting praises to their patrons, the appreciative vultures descended.

"I don't want to be enlightened!" I cried. "I want Gawa! I want my cousins! I want onion bagels and pineal-gland tea and Prokofiev and Fred Astaire and the Marx Brothers! I want all my stupid, worthless, impermanent toys!"

The bodhisattva shrugged and, taking my paw in his hand, began leading me toward Gangtok. "Taktra Kunga, I am disappointed in you."

"I don't doubt it."

"Let me offer a word of counsel," His Holiness said. "When lying on your deathbed, strive mightily to release these negative energies of yours. You won't be reborn a buddha, but you won't come back an insect either. Speaking personally, I hope you remain a giant ape. You do that very well."

The earth turned, the wheel of life revolved, and, exactly one year after hearing Dorje Lingpa declare his intention to wreck a Mao Mao troop train, my cousins and I once again found ourselves huddled drowsily behind his yurt on the eve of Mönlam Chenmo. We did not

expect to get much sleep. Chögi Gyatso and his half brother had stayed up late arguing over the necessity of destroying the Brahmaputra bridge. They had found no points of accord. Bad karma suffused the gorge like the stench of a charnel ground.

I awoke shortly after sunrise, tired, bleary, and miserable, then stumbled into the yurt. My cousins occupied the dining table, playing seven-card stud. His Holiness and Dorje Lingpa sat in the breakfast nook, eating oranges and drinking buttered tea.

"A flush," said Cousin Jowo, displaying five hearts.

"Beats my straight," said Cousin Nyima, disclosing his hand.

The plaintive moan of a diesel horn fissured the frosty air.

"A troop transport," Dorje Lingpa noted. "Over the years I've come to know each train by its call, like a hunter identifying different species of geese by their honks."

A second mournful wail arose, rattling the circular roof.

"The train is exactly nine miles away," Dorje Lingpa said. "It will be here in six and a half minutes."

"Dear brother, your mind is crammed with useless knowledge," Chögi Gyatso said.

"That horn is a death knell," Dorje Lingpa continued. "Listen carefully, brother. The train is pealing its own doom."

"What are you talking about?" I asked.

A long, malevolent, Za-like grin bisected Dorje Lingpa's melon face. "I'm talking about a bridge bristling with sticks of dynamite. I'm talking about a detonator attached to the high-speed track. I'm talking about headlines in tomorrow's *Beijing Times* and the next day's *Washington Post.*" He brushed his brother's shaved head. "And there's absolutely nothing you can do about it."

Nothing. His Holiness's favorite concept. Long live Double-Oh-Seven. You can imagine my surprise, therefore, when Chögi Gyatso leapt up, fled the yurt, and dashed toward the railroad siding.

"Bad idea!" I yelled, giving chase.

"I think not," His Holiness replied.

I drew abreast of Chögi Gyatso, surpassed him, depositing my furry bulk in his path. He circumnavigated me and lurched toward the rusting turnout connecting the maintenance track to the Lhasa line.

"*Om mani padme hum,*" he chanted, seizing the steel lever and throwing the switch.

"What are you doing?" I demanded.

Actually it was quite obvious what he was doing. He was contriving to reconfigure the rails, so that he might drive the gang car west

228

along the high-speed line, hit the bridge, and trip the detonator.

"Pacifism is not passivity," he noted, then headed for the gang car. "The explosion will warn the engineer to stop the train."

"No! That's crazy! Don't!"

Now Dorje Lingpa appeared on the scene, grabbing His Holiness around the waist with the evident intention of hauling him to the ground.

The diesel horn bellowed, louder than ever.

I was there, O shiny ones. I saw the whole amazing incident. For the first time in seven hundred years, a Dalai Lama decked somebody with a roundhouse right—in this case, his own bewildered brother. James Bond swinging his fists or a yeti delivering a *glog* punch could not have felled Dorje Lingpa more skillfully.

As the trainman lay in the snow, stunned and supine, my clan arrived, grappling hooks in hand, climbing ropes slung over their shoulders like huge epaulets. Cousin Ngawang placed a large hairy foot on Dorje Lingpa's chest.

"Your brother is a brave man," the ape declared.

The diesel horn screamed across the valley.

His Holiness climbed into the inspection vehicle and assumed the controls. "After I've passed over the turnout, kindly throw the switch to its former position," he instructed me. "We don't want to save the train from my brother's vengeance only to derail it through negligence."

"You don't understand!" I cried. "All is illusion! That train isn't real! The soldiers aren't real! There is no suchness except what exists in your mind!"

"Don't be silly," His Holiness said, putting the motor in gear. "I love you, Taktra Kunga," he added, and he was off.

The gang car rattled out of the yard, frogged onto the Lhasa line, and raced away at full throttle. I planted myself squarely on the maintenance track, the better to see Chögi Gyatso depart his present incarnation. An instant later the car reached the bridge and continued across, a caterpillar crawling along a hissing firecracker. The wheel flanges hit the detonator, and there came forth a deafening explosion that catapulted the car and its passenger a hundred meters into the air. A plume of fire and ash billowed upward from the shattered span. Flames licked the sheer blue sky. The vehicle succumbed to gravity. My former teacher hung briefly in the swirling smoke, as if suspended on the breath of a thousand thwarted demons, a miracle truly befitting the bardo of a bodhisattva, and then he fell.

*

I am pleased to report that His Holiness's scenario played out large-ly as he'd imagined, with the troop train's engineer slamming on the pneumatic brakes the instant the ka-boom of the dynamite reached his ears. The wheels locked, flanges squealing against the icy rails, leaving five hundred Mao Mao soldiers at the mercy of the fickle fric-tion. The gargantuan locomotive skated crazily, dragging its fourteen coaches toward the abyss.

By this time my cousins, no strangers to the laws of physics, had arrayed themselves along both sides of the tracks, gear in hand, wait-ing for the train. I threw the switch as His Holiness had requested, then climbed a snowy knoll, from which vantage I beheld my worthy clan improvise a grand act of salvation.

"Hurry!" I shouted superfluously.

Moving in perfect synchronicity, the apes hurled the six grappling irons toward the rolling coaches, smashing the windows and secur-ing the hooks solidly within the frames.

"Such lovely beasts!" I cried.

Having successfully harpooned the passing train, my cousins allowed the ropes to pay out briefly, then tightened their grips. Still skidding, the locomotive towed the six yeti along the roadbed like an outboard motorboat pulling multiple water skiers, spumes of ice and snow spewing upward from their padded heels. In a matter of seconds the momentum shifted in compassion's favor. The train slowed—and slowed—and slowed. I shouted for joy. The Bön gods smiled.

"*Tiao!*" my clan cried in a single voice. "*Tiao!* Jump! *Tiao!* Jump! *Tiao! Tiao! Tiao!*"

The soldiers rushed toward the coach doors in a tumult of brown uniforms, gleaming rifles, and wide-eyed faces. They jumped, spill-ing pell-mell from the decelerating train like Norway rats abandon-ing a sinking steamer. My cousins, satisfied, released the ropes and headed for the hills, determined that this would not be the day of their unmasking. Sprawled in the roadbed, the perplexed but grateful Mao Maos gasped and sputtered. The engineer abandoned his post none too soon, leaping from the cab barely thirty seconds before the coasting locomotive and its vacant coaches glided majestically across the burning bridge, reached the rift, and hurtled off the tracks. Seconds later the train hit the river, the thunderous crash echoing up and down the gorge.

Before the eventful morning ended, my clan and I, along with Dorje Lingpa, managed to sneak within view of the Brahmaputra and observe the twisted consequences of His Holiness's courage. Having shattered the river's normal sheet of ice, the hot locomotive and its strewn coaches clogged the current like vast carrots floating in an immense stew. I scanned the steaming wreckage. The corpse of Chögi Gyatso was easy to spot. His saffron-and-burgundy robe rose vividly against the bright white floe that was his bier.

"Forgive me, brother," Dorje Lingpa said.

"Goodbye, Your Holiness," Cousin Ngawang said.

"Farewell, beloved monk," Cousin Jowo said.

"I hope you've gone to heaven," Cousin Drebung said.

"Do lamas believe in heaven?" Cousin Yangdak asked.

"Rebirth," Cousin Garap explained.

"Then I hope you've been reborn," Cousin Drebung said.

"Though they don't come any better than you," Cousin Nyima noted.

I attempted to speak, but my tongue had gone numb, my throat was clamped shut, and my lungs were filled with stones.

The clan and I bore Chögi Gyatso's dead body far down the frozen river and secured it behind a boulder, lest the People's Liberation Army come upon it while investigating the loss of their train. As I knelt before the dead bodhisattva and began to partake of his brain, I decided that this *nang-duzul* would mark a new phase in my life. No, I did not forswear meat-knowledge, to which I was addicted and always would be. But from now on, I promised myself, I would cease to kill my prey. I would instead become like the charnel-ground raptors, leaving my nourishment to the whims of chance, consuming only such human flesh as my karma merited.

Yes, O glossy ones, eventually I realized that I should not simply demur from devouring a stranded climber—I should also summon a rescue party. So far I haven't endeavored to save anyone's life, even though such altruism would hardly compromise my species' security, for the sherpas already know we exist, and they would never dream of betraying us to either a Mao Mao patrol or an Everest entrepreneur. But old habits die hard. Give me a little time.

I wish I could say that some political good came of His Holiness's deliverance of the Mao Mao soldiers. In fact the ugly status quo persists, with Tibetan culture still withering under the iron boot of the

231

People's Liberation Army, may they rot in hell. As for Dorje Lingpa, he was never officially fired from his job with the National Railroad. Instead he was arrested, tortured with a cattle prod, imprisoned for five years, tortured again, and hung. The moral of his sorry life is simple. If you want to be a successful insurgent, don't practice on Chinese Communists.

When I told the Pachen Lama where to find Chögi Gyatso's body, he did not at first believe me, but then I began laying out evidence—a grappling iron, the *Beijing Times* headline, His Holiness's white silk scarf—and the monks dispatched a recovery team to the Brahmaputra River gorge. No sky burial, of course, for Chögi Gyatso. No vultures for His Holiness. The monks cremated him on the grounds of the New Ganden Monastery, then set about searching for his reincarnation. At last report they'd located a promising three-year-old in the village of Gyanzge.

So what is it like to be enlightened? What rarefied phenomena does a bodhisattva perceive? I regret to say that the gift was largely wasted on me. To be sure, shortly after eating Chögi Gyatso's cerebrum I found myself praying compulsively, chanting incessantly, and meditating obsessively, much to Gawa's consternation. For a few incandescent days I saw the world as he had, lambent and fair and full of woe, abrim with beings who, without exception, every one, each and all, deserved my unqualified kindness.

But my wisdom did not endure. It faded like the westering sun, and what I recall of ecstatic emptiness cannot be framed in any language, human or simian.

I suppose this loss was to be expected. As these pages attest, I was always a lousy candidate for wakefulness. In my heart I'm a child of that other enlightenment, the one personified by such cheeky contrarians as Voltaire, Thomas Paine, and Benjamin Franklin. At the end of the day I'm a *carpe diem* creature, a rationalist, really, the sort of primate who can't help wondering whether a compassion born of emptiness might not be an empty compassion indeed. I love my life. I treasure my attachments. That is not about to change. True, this ape may eventually evolve, in the Darwinian sense, but for now I shall leave transcendence to the professionals.

That said, I am endlessly honored to have been his student. My gestures of remembrance are small but constant. Every night, after making love to Gawa, I stare into the blackness of our lair and give voice to the lovely words he taught me, saying, "I take refuge in the Buddha, I take refuge in the dharma, I take refuge in the samgha."

And then, relaxing, drifting, I lay my head on the yak-hair pillow. Gawa snores beside me. The dying embers crackle. I close my eyes, quiet my mind, and dream of my friend, His Holiness, the fifteenth Dalai Lama.

The Spirit of a Lark
Theodore Enslin

I HAD LEFT MY NATIVE village in sadness and disgust. I was not old at that time, but the handful of friends I'd had—people with interests similar to mine—had all died or moved away. I was living alone on the outskirts of town. Except for running necessary errands, I rarely went into the village itself. I was not exactly shunned but most of the inhabitants, young and old, considered me odd, and in some cases a downright nuisance. It was certain that our interests were dramatically opposed. Somehow it seemed possible for me to continue in an unfriendly environment, in many cases grubbing my living from the land. I foraged for food and fuel. I had never held any sort of permanent job, and that catchphrase "the commute to work," made me cringe. That cringing was often evident to others who had chosen a different path. I am sure many people were jealous of my apparent leisure, with no visible means of support, and it had been whispered among the usual gossips that I was probably engaged in some sort of criminal activity. I had never married or had a long-term engagement or relationship. My house was substandard by local notions of what it should have been like. I rarely took part in local celebrations. In earlier times these oddities would have been tolerated, if the oddball had not interfered with more ordinary lives, but now anything that was out of lockstep with the crowd was suspect. Worse still, I had no affiliation with a religious organization—a man to be avoided.

So. Exit from exurbia. That was easy in itself. I decided to travel light and put a few provisions in my knapsack, leaving most of my belongings behind, even half a cup of warm coffee on the table where I had finished breakfast. I took the usual route of my earlier excursions—off my left wrist. But this time it was as if I were half asleep, barely aware of a long journey that seemed to include bus travel, and then a walk with several companions who were not particularly pleasant. One man, a giant, directed us through a dense forest. He

234

carried what seemed to be an ancient pikestaff with which he pointed the way.

When we cleared the woods, my fellow travelers disappeared, and I was in familiar country—marshes and meadows where my friend Roy Basileus had his duck blind. I reached it, passing a cottage I didn't remember. Roy came out from his adjacent house and greeted me warmly: "Ah, so you have finally come." He explained that he had built the cottage and now lived here full-time. The duck hunting was good, and he had few other interests. He invited me in for a roast duck dinner. I have always been very fond of wild duck, and these were excellently done—a far cry from commercial "ducklings," which were mostly bone and grease.

Roy invited me to stay over and perhaps to go with him to the blind in the morning. He advised me *not* to go up the rise to the windmills. Most of them were not in operation, and were abandoned. "And Zerlina is not here." He chuckled for a moment. So he knew the details of my former visit. I said I would have to leave early the next day.

"Then I would advise you to take the beaten path across the marshes," he said. "You may find something to your liking there."

I stayed that night after Roy's repeated urging and departed in the morning. A land mist soon burned off, and I was aware that I was crossing a gently rising grassland that seemed limitless. Here and there I saw the remains of isolated farmhouses. There was no sign of life. The sun was hot, and I was glad I had taken the canteen Roy had given me. What was inside was good and slaked my thirst, but it was not water. The meadows had gradually risen to a rocky terrain. Here and there solitary trees dotted the landscape. In the distance I saw a steeper rise and what might be a forest. When I reached it I was confronted by an escarpment. There seemed to be no way up, and yet I was certain that I must get beyond it. A small stream flowed along the base with pools in the shade of the forbidding rocks. I took advantage of one of them and went in for a swim. Very pleasant.

Refreshed, I started looking for some sort of path that would lead me to the top. Eventually I found a fault in the ledge where there was a natural staircase. I tried it and found there were few difficulties. Steps, but nothing more dangerous. When I had reached the top I was in deep woods, but there was a well-defined path that soon led me

out of the trees to another vast meadow. This time it seemed almost subalpine. The grasses were more sparingly scattered—a tougher breed than those below. The ground was arid—no intervening marshes as there had been in Roy's country. A clearer air. But the path continued. I followed it for what seemed many days and nights. Did I eat or sleep along the way? Who knows? This was a place that did not answer to ordinary timing.

Eventually I reached a large river. The remains of a bridge spanned it, and I crossed it warily. On the far side there were a few abandoned cellar holes and several wells that had evidently served some sort of settlement. But the more or less level grassland apparently ended a bit farther on—dropping off as abruptly as it had risen when I first entered the high grassland.

Not far from this dramatic change in the landscape, there was a slight descent and a separate meadow that seemed as limitless as the others. It was different from the various other levels of terrain through which I had passed. It appeared to have been recently culti- vated—the grass grew as lush as in the lowlands—and artificially built, a vast oval shape that indicated husbandry. There were two dilapidated farmhouses at one end of this grassland, most likely deserted. I went up to the first one, which was barely standing. The floors sagged under my weight. The whole structure looked ready to collapse so I beat a hasty retreat.

I found the second house in better condition, despite its swayback roof and broken windows. I went in across a great slab of granite. The door stood ajar but was intact. I went through a short hallway to a large square room, which was partly furnished with a table and a number of chairs. What shocked me most was a neat stack of boxes that seemed familiar. Indeed they were. Many of the belongings I had left at home were inside, virtually unchanged. On the table was a cup of coffee—the same one I had left behind. It was still warm. At the end of the room was an area set up as a farm kitchen. There were cupboards and a few counters and an old cast-iron cookstove, as well as a soapstone sink and a hand pump. I tried the handle and a stream of water came out of the spout. It was surprisingly fresh, as if it had been used recently. Evidently someone had primed the pump and cleared the water shortly before my arrival. Behind the stove was a pile of wood as well as kindling.

I was not disturbed by any of this. It seemed that I had made this journey and that it was mine in ways that might not have been the same for others who had suddenly found the circumstances of their

lives changed. Apparently I was in the place where I should be. At any rate, I was *here*.

I went farther into the house through a door that stood ajar into another room at the back of the kitchen. My old couch was there and a small table at which I had worked. An alcove led to another room. A spare bed of mine was there, freshly made and much more neatly than it might have been after my hit-or-miss attempt at it. Suddenly I became very tired, almost as if I had been drugged. It was growing dark outside, or it might have been merely that I was half asleep. I scarcely remember undressing and climbing into the bed, which was a bit higher than more modern ones.

I woke in what I suppose was morning. Timing, even natural timing, had changed so much that I couldn't keep track of it as I once had. The room was bright, and my dingy belongings looked cleaner than they ever had in my former home. They would have to be put in some sort of order before the inevitable clutter of daily living re-arranged them into a semblance of something that could be called my own. Perhaps another room would do better for some of it.

I went back into the kitchen. The stove was warm, and there were biscuits on the warming shelves. Coffee was bubbling in a percolator. I sat down to eat and drink a better breakfast than I had had in a long time. Finishing it, I went to the sink. A large basin of hot water was already there. I washed the few dishes and arranged them in a strainer. Then I decided to look over the rest of the house. There was a stair-case off the main room, and I went up to the second floor. There was another large room there, and one a bit smaller, fitted out as the true bedroom. Three sides of the larger room had bookshelves floor to ceiling, and my books were in labeled boxes waiting to be distributed.

I went down again and found a back door to an outside cellar and from it, a bulkhead up another short flight to the outside. As I ascended, a door above me opened, and a young girl, little more than a child, greeted me with a laugh.

"Call me Lark, if you like." Yes, she had prepared breakfast, know-ing that I was still asleep, and when the "porters" had brought my belongings, she had had them put in what she hoped were appropri-ate places, knowing that I would be coming soon and would need some of them. She apologized for the broken windows and various other signs of disrepair, and said that everything would be set to

rights. She wanted me to see the place as it was, to decide whether I was willing to move in. I was speechless. I think I thanked Lark, but she was gone.

I spent the morning upstairs, arranging my belongings. I thought I heard various sounds, hammering and other noises, perhaps the creaking of old beams common to older houses. Outside there were innumerable birdcalls, perhaps the "zeek" of insects, crickets, or cicadas. I realized I was hungry and went downstairs to try to find things for lunch. There was no need. The table was set, and again, a finer meal than those I was used to was ready for me. It was so good that I thought I would like more. Even as I thought this, another bowl of chowder appeared. I was no longer particularly surprised at any of this. Perhaps Lark was responsible, but she was nowhere in sight. The dishes vanished as soon as I had finished, and I looked around me. The sagging floors were straight. The front door had been rehung, and now opened and closed easily. The broken windowpanes had been replaced. So this was how it was to be. The door opened and Lark reappeared. This was not the little girl of our earlier encounter, however, but a young woman. She asked if I had found things satisfactory, including lunch. I certainly had.

"You are Lark?"

"Of course." She advised me to stay downstairs for the afternoon, perhaps go for a walk. And again she was gone.

I decided to take a walk across the grasslands, in a direction I had not taken before. I seemed to go a great distance for many hours. It was beginning to get dark by the time I reached the house. But I had already noticed that the ordinary (arbitrary) divisions of measurement meant little in this country. I had been struck by the fact that when I was rearranging my former belongings, the few clocks I had owned were missing and I no longer had the watch I had worn in my former life. That did seem a bit odd, but I had already learned not to question such differences, and I had entered off-the-wrist country. During the return to "my" house I had become hungry once more. It would be very pleasant to have lobster for dinner. Formerly, I had been quite fond of it. When I came into the dining room I found a large platter with a pair of them. I consumed them, along with several glasses of the brandy, similar to what Roy Basileus had given me. After I finished, Lark appeared once more, a striking middle-aged grande dame, dressed as if for a party. She asked after my walk. Had I found it pleasant? Was the dinner to my liking? After my enthusiastic replies, she suggested we go upstairs. Everything was as I had

left it the previous morning, except that the rooms were spotless—
better housekeeping than that to which I had been accustomed, and
these windows and doors had been repaired as they had been below.
Nothing of mine had been disturbed. Lark asked me if it had been
done as I might have wanted it. Again I was enthusiastic, but sug-
gested there might be more light on what I took to be the north wall
of my bedroom. She simply answered "Ah," and disappeared.

I woke after what I supposed to have been a full night's sleep. It
was just beginning to turn light, much of it coming through two
large windows where there had been none a day before. Going down-
stairs, breakfast was ready as I had thought it might be. When I fin-
ished and the debris had vanished, the little-girl Lark appeared once
more. She seemed in a playful mood and skipped around the room.
Finally she asked me if I had slept well and if I liked the new win-
dows in my bedroom. Then she asked me more about yesterday's
walk. Did I miss anything? I assured her that it had been a very pleas-
ant saunter, but in all this prairie-like expanse, I did miss woods, and
perhaps a stream. She laughed and said that I need only follow my
wrist in *this* direction—and she pointed to what I took to be north.
"I think you might find something that you will like."

As soon as she disappeared I set out. It did not seem far. I could see
a line of trees, and eventually reached them, and indeed it was a
splendid woods. The trees were a vast assortment of the many kinds
I'd had in my former home, but there were many others I had never
seen before. There were several well-defined paths, and I followed
one of them until I reached a small stream, which was extremely
clear, with occasional deep pools. I stopped at one of these, stripped,
and went in. The water was refreshingly cool but not frigid. When I
came out I discovered a tray with various picnic foods and a bottle of
the brandy that I had grown to like. Obviously I had not been for-
gotten. I dressed and ate my lunch. Going farther, I discovered open
patches in the woods and many kinds of berries, which were all in
fruit at the same time. I picked a quantity as dessert. Farther on, I dis-
covered a slight depression where there were palms and other tropi-
cal growth. Nothing had been forgotten. There were many different
kinds of birds, and at one point I saw a large group of deer who
seemed not at all disturbed by my presence. I walked on for several
more hours, if time could be reckoned that way. Finally I decided to
go back. I reversed the process along my left wrist, and was soon back
in the familiar grassland. Before going directly to the house, I went
to the edge of the ravine. It was as dark and forbidding as when I had

first discovered it, yet it interested me, and I wondered if it would be possible to explore it on another walk. But there was growing darkness, and I decided to go home.

I went in half expecting to find the evening meal waiting for me, but there was nothing. However, in a few minutes there was a knock at the door, and Roy Basileus appeared with the usual offering of a pair of ducks. I was very glad to see him. The one thing that disturbed me in all of this was the lack of any companionship, except for the daily visits from Lark. Roy suggested that we prepare the dinner ourselves, and as I have always enjoyed cooking, we did—roasting the birds in the cookstove oven, which I hadn't used before. It was a splendid meal, washed down with the usual brandy. Roy settled back in his chair and asked me how I had been faring. Did I enjoy life here? Then he laughed a bit, and said, "Of course you don't have Zerlina."

I assured him that that was not troubling me. That brief encounter had posed many problems, more than I had needed.

"Yes, there are advantages to a solitary life, particularly if the daily living is assured without much effort." He added that so long as I paid attention to the left wrist and did not attempt to go in other directions, the various "fingers" would answer all of my needs.

I was about to ask him what he meant by the various fingers when Lark appeared, this time as an old woman, striking but a dowager. She and Roy obviously knew each other. He laughed. "Oh, I do prefer an elder to a young girl," and she smiled and kissed her hand to him. The conversation became general, and Roy took his leave shortly thereafter, urging me to visit him soon, either at the blind or the house. Lark then asked me if I had enjoyed my visit to the forest.

I assured her it had been splendid, and that I would visit it again, if such was permissible.

"Of course. Spend as much time there as suits you. Is there anything else you would like to do?" I asked her if it would be all right to go down into the ravine.

There was an immediate change in her attitude. After a brief pause she shook her finger and said, "That is forbidden. If you insist, I cannot prevent you, but you will have lost the use of your wrist, and you will not be able to return here." I could see that she was serious, and certainly there was no real reason why I should go there, particularly into such forbidding country. So I said that I would respect her wishes.

"A wise choice." And she was gone once more.

My life continued as it had begun since I arrived. Anything I needed was immediately available. I spent much time in the newly discovered forest. I began to do more things for myself, such as cooking and the various household chores, but whenever I didn't do them, through forgetfulness or the desire to do something else, they were done for me as before. Occasionally I visited Roy Basileus, following the "finger" that he had indicated when he had pointed out the route to follow. Although I sometimes went to the edge of the ravine, looked down and across to the far mountains, I did not go any farther, even though there were moments of temptation. Lark showed up almost daily in one or another of her various guises. At one of her visits I did say that I missed a few things, such as music, which had been important to me in my former life. She told me to look on a table upstairs in the library, which had become extensive, since any book I had asked for appeared. I found what looked like a very large book, perhaps a dictionary. I opened it and found that it was a catalog of all the music I had ever known and cherished, as well as much that I had never known. In the margin before each entry there was what appeared to be a small black button. I pressed one of them and immediately the piece began, surrounding me, filling the room as if I were in a concert hall. I had never heard or understood the music so clearly. This was to become one of the greatest gifts in my new condition. Looking at what had been a blank wall earlier, I could see the musicians as if I were at an actual performance—not unpleasant but rather strange. Over the next few hours I pressed a number of the buttons with the same result. Music again became an important part of my life.

I experimented with the various "fingers" from my wrist and found it possible to go to numerous places beyond the grasslands. There was a large pond, almost a lake, to the left of the forest. There were hills. When I climbed them there were views that went as far as Roy Basileus's house and the duck blind. I could see the farther hills where I had spent time among the windmills. But all of the horizons appeared to end with a clearly defined drop-off—the ravine. Lark continued to appear with her inevitable questions as to what I might want or need and, for a while at least, I let her know I was quite happy with things as they were.

I listened to much music, including stage performances of a number of operas. One night, as I was a spectator at a performance of *Don Giovanni*, I noticed Zerlina, *my* Zerlina. For a moment I wanted to go to her. I noticed the scars on my left wrist. There was

a momentary ache of nostalgia. No, I had no desire to return to that episode, but from then on I did have a persistent longing for some sort of companionship, not necessarily an erotic involvement—simply more than the occasional visits of Lark or Roy.

The seasons gradually changed. Eventually winter came, but it was gentle—a few moderate snows that soon vanished. There was always heat in the house, whether or not I attended the fires. I have always liked wood fires and attending to them, but if I forgot or was asleep, what was necessary continued, and there was always a supply of fuel behind the kitchen stove and the larger one that heated the upstairs.

But my feelings of loneliness increased. At times I felt that I was in a gilded prison. Finally one evening when Lark appeared as the middle-aged matron, dressed as if for a festive occasion, I told her of my restless loneliness. Would it be possible for me to have some sort of compatible companion, not necessarily a woman, merely someone with whom I could talk and share my pleasures?

She was quiet for a moment. "Yes, that is possible, but you will forfeit everything else you have here. Eventually you will have to return to your former home, and you will never be able to return. You will have lost the power of your left wrist. Think carefully before you ask this. Take time."

It was as if I had been struck by a blinding light. No, I had no wish to return to what had been a very unpleasant situation. For a number of days I was nearly as unhappy as I had been in that other life, although outwardly nothing had changed. I spent a period of time half asleep. I took no pleasure in any of my advantages.

Eventually I seemed to wake up. Yes, everything was as it had been. My breakfast was waiting as usual. I ate and attempted to view the situation in a different way.

I have both the seen and the unseen presence of Lark, and the occasional visits from Roy Basileus, as well as my even fewer visits to him. I suppose all of this should be enough, even though I have to admit that despite all my advantages, occasionally, I, Benjamin, am lonely, not necessarily for companionship, but for those few things (some would say that they were many) I cannot have and continue here. Therefore I will not ask for company, more than what I have. Nor an entrance to the ravine.

Ah! But I am lonely.

The Golden Rule;
Or, I Am Trying to Do the Right Thing
Edie Meidav

THEY LIKED HIM BECAUSE he made jokes, singing old war songs whenever they had to do something embarrassing like clean his soiled rear, cleaning just as if he were a baby getting whatever mama might have failed to give him. He let them keep their dignity, they let him keep his magic hands: This became the basic bargain, especially after the first nurse started to fly.

Because he told them, they know that some seventy-six years earlier his mother had asked him to lie in a cold Hungarian bed to warm bedsheets for her, that much he remembers, but there are a heap of other sentences into which he springs with a young man's joy only to end up tangled, sentences tying him into lexical knots and an aspirated gargle of politeness as if they were the ones who need parsing, as if they had gotten confused. You were saying—?

The person they are less sure what to do with is the wife, a tiny, pert woman in a cherry tracksuit with a mostly upright derriere, all screaming her determination to cling to life and the forget-me-not possibility of dreamboats, her efficiency bespeaking all the anxiety she has laid to rest like folded bat wings in a closet before coming to check on how they're treating her spouse. To the home she comes riding in her energy-efficient touch-sensitive car, herself equipped with demands, one of those women whose life of self-privation means she is doomed to present the outside world with an impenetrable front that friendlier acquaintances call glow and enemies call selfishness.

Inside, the wife may have had some secret holy purpose, starving deep into the hollows of her cheekbones so she could be hungrier for exigencies, to be a readier soldier when it came to fluttering in, indignant, a hummingbird voice and imperious manners ready to rally against all slights, imagined or not.

Whatever the case—here they borrow the husband's favorite phrase—they can't tell. They do know the wife has a habit of raising her voice, as if all nurses were, upon receipt of the N after R, deaf;

243

and her main talent during her visits seems not tenderness but rather the asking of certain pointed questions about how well her husband's chart is being kept.

One nurse saw that on the application the wife, in her former occupation, served as coordinator of the county's social services. A couple of them guessed they had on their hands a lady who had not quite achieved the status she had imagined would be hers. Maybe on an unfrilled childhood bed she had twisted hair around fingers dreaming of winning elections, breaking important stories, the first to break free of some suppressive immigrant family. Maybe she had waltzed across a living room balancing books on her head. Maybe some of this could explain why she had to enunciate so clearly. You could never tell with families of patients. Could be that none of the rest of her family had attended a lick of college until long after the kids were grown. Maybe she had some sisters back home—wherever home was, forgotten, kept alive only by the umbilicus of the occasional birthday phone call—who had become nurses, women who made her feel guilty for having fled the calling of service, and because of this, the woman, whom someone started calling the Hummingbird, the moniker catching on right away, could never show respect to nurses, could never treat them as anything but detritus from a planet over which she would hover but never set foot.

It could also be that the Hummingbird had gotten weighed down by degrees—you had to have a master's, at least, to head social services, right?—and maybe her knack for having been a good student, notating telephone conversations and keeping pen cartridges well organized in drawers with little hole reinforcements and everything one needs in the pursuit of truth, having had others act as if she was important for long enough, had nonetheless made her feel she had entered her own crypt: You could take her pert little requests as last gasps. Perhaps she had felt stuck as any of the rest of them, caught in a niche, whether you called it nursing, grant writing, or public administration, a life of private calibrations and collective holidays, because who can tell where a life goes?

Or maybe after each visit to the husband, Hummingbird had to sneak into the wheelchair bathroom to relieve herself of the terrible sexual ache her husband had never been able to fulfill because she had never been able to quit her darned habit of moving so quickly.

Whatever the case, they knew the facts. Hummingbird had been quick to admit their patient to the home. I am trying to do the right thing, she kept saying. She and her grown children had worn the

grave, important masks people could magically find, old witch-doctor masks hanging in a psychic backroom, useful whenever some-one had to do the equivalent of sticking a family member into what the nurses called, if never around a patient, the Crypt. When the truth was that the home was less crypt and more just one more place governed by the logic of thoughtful care, financial realities, bedpans, germ control, efficiency.

Of course there had been the golden era, back in the seventies, when nursing care had been clocked as the great cash cow, the gray-ing of the population meaning the greening of pockets, when people with big ideas had checked in, boom years for nurses and speed degrees, for senior developments all over. And in certain counties the homes grew fast as prisons after an election: To such homes you could lure people via tribal affiliations, Seventh-Day Adventist or Zionist, Anglophilic or Pastoral Ecological, or you could also offer them one-size-fits-all, because what did people really need in the end of their days beyond pleasant activities such as you'd find in any smart-minded Montessori classroom, along with counseling, titrated meds, and the company of others actively monitored for vital signs?

That golden age had passed. No longer was it the time when niches grew and quality slacked. Now in these dire times homes had been forced to return to doldrum basics, old-time measures, ammonia and morphine, palliatives and hygiene, and even with that, the home the husband had been brought to stayed famous for its Pleasant Activities, for its undrool factor, as the wife explained to her un-smiling grown children, known for the inventive depth and reach of its activities, not just the usual macramé and bingo, the small-motor-skill development of basket weaving but also—she flapped the brochure on which were listed wheelchair folk music nights and gambling parties based on thumb cockfights and even vessel games-manship, which was really, as one of the nurses had explained, a PR euphemism for bedpan croquet.

A home was what it was called; no one could help the irony. If we were all cavemen, the wife asked her children, trying to make the question rhetorical, what would we do?

In the ninth century, in remote parts of the world, children were told to eat parents who had outlived their usefulness, the geographer son with his undiagnosed Asperger's said, and then, sensing a faux pas, immediately fell silent.

This particular home happened to lure members of the husband's tribe because it boasted reps on certain holidays and the possibility

of having a roommate who shared not just snore space but also one's faith. Quickly, because the wife's constitution prevented slowness, she talked it over with the somber children, each with a thick relation to the father. Though the father had clearly outwitted all actuarial odds imagined for himself, though already ten years past the age of his own father who had died of an unjust dosage of anesthetic during a minor operation in the era before litigation, as the nurses would be told many times, their father was actually not so old.

To the children the Hummingbird listed the reasons she could not have him in her home anymore. First he had transgressed against her, but no one talked of that, though the children had received hints, either catching them or spinning them off into forgetful ether.

Secondly: The father had squandered money she in her public job had accrued, despite her attempts to squirrel it away year after year. He'd had one unsuccessful business venture after another, his gambler optimism and lofty-minded ideals no match for anyone's checkbook. No one talked directly of this either; instead, she said she had to hold on to what was legitimately hers, especially as she was no spring chicken, she said, straightening her spine to look more like one.

Thirdly, you had to consider Maria.

For many years, the wife had enlisted the services of a maid named Maria, a woman unhappy with the lot she had found herself in life, given that her dreams would have had her be a Mexican film star living in a salmon pink house with a curved grand staircase and children conveniently stowed in various corners, brought out clean faced and docile to wear fancy white fluffy dresses for their *quinceañeras,* offspring accruing compliments as evidence of fertility, their elite comportment and looks thrown into the bargain. Instead, because of Maria's own buxom form, because the shadow of the bottle had crossed her household too often, because of her quick-thinking canniness, Maria had managed to find herself in a state in the Estados Unidos where her English was workable and she got to clean rich people's houses for a living, sometimes able to bring her outwardly sullen, secretly joyous Indian-faced daughter to a house, her daughter compliant about being stuck in front of television shows in which young white girls shook juju hair while dancing out the life the mother should have known and that the daughter would, long after diabetes felled Maria at the age of fifty, seek as a barmaid in a country-themed interstate watering hole called Día de los Muertos.

Before that moment, Maria's rebellion against her current life took

many subtle forms, rebellion a trickster coyote. In every room she cleaned, she turned on a radio blasting reggaetón, its rhythms bespeaking the life mislaid by someone for her, the one she should have known, in which tall pale men whispered constant entreaties. Sometimes she also liked listening to the lubricious wheeze of the Spanish-language talk shows with the booming echo of their station IDs: el premio lo mas famoso en todo el mundo! On Sunday mornings, she lay in bed with her daughter, watching telenovelas from her country, and when tears arose, as they did at the plight of all these tristes, her daughter would send her mother a covert glance, hungering for the depths of her mother's secret life.

Yet for her daughter, whom Maria had named Syphilis because it sounded pretty, pronounced See-phyllis, only a joke on the first day of school and then forgotten later until the daughter reached junior high, when it became an unfortunate destiny, Sísí for short, Maria kept it together. If Maria had made a few bad choices—her daughter's father being an alcoholic all too similar to her own father whose fists she had escaped—she would set things on a better course. She saw where the rich people sent their kids to school and so advocated with workable English, talking to a Board of Ed secretary who seemed to think it acceptable to wear curlers and slippers to work, that her daughter get to attend such a school like the estadounidenses who were so privileged without having earned it.

And then one day a magical gift from God fell into Maria's lap, quite literally, on a crowded bus, the gift being a gem of a man with a soft voice and a round face, a man who seemed to come from a higher class, given his embarrassment in rising from her lap, all of which she found touching, a man with the useful vulnerability of riskier immigration status, and while she introduced him at first to her employers as her cousin, it soon became clear to all that Javier was her new beau, that one day they would marry so as to change his green-card status, and that he even liked playing father to Sísí, as he had lost his own son to cerebral palsy years ago back in Oaxaca: in short, a good man, unafraid to cry entreaties to her when she wished to turn cold toward him, a man who appreciated what a hard worker she was, much in contrast to the lagabouts for whom he had fallen before. When Javier wasn't washing tall high-rise windows, his hobby consisted of reading popular self-help books: Their favorite postcoital moments involved his coaching her about the most direct way to achieve her dreams.

While what Maria loved more than anything was arranging items

of different sizes on a shelf, an act that gave her a sense of control so far elusive in the general business of life, not to mention the raising of a daughter whom she tried to keep safe from the roaming hands of the daughter's older half brothers, with whom she had tried to sever contact.

And the wife appreciated this above all in Maria, her instinct toward order, so that both women, going up and down stairs in the tall house, had, on good days, a sense of lubricating a vast machine, sharing the workings of the house. Perfume bottles in a row, dishes stacked neatly, books arranged by height. To the woman who liked learning, one time at the home, that she had been named the Hummingbird—she even started to think of herself as the Hummingbird, as if she had been born trilling, an Edith Piaf—Maria was indispensable, if the Hummingbird also chose not to know too much about the details of Maria's past or imagined future.

And because Maria had been cleaning for years when the husband started going backward, first losing the ability to walk, slowly losing the ability to use the bathroom without someone else, going backward even as his grandchildren were learning to walk and go potty, and even as his throat was thickening, soon to strip him of the ability to speak, it was much easier to ask Maria to take on the act of giving care to his body.

And because there were also those unmentionable, dearly held wrongs this same body had committed, ones the Hummingbird would forgive him for only on her own deathbed, when it was too late, when a feeding sac was attached to her stomach as if she had been transmogrified into a pregnant termite queen, Maria was a good stopgap measure, despite her lack of training as a caregiver: Stout and voluptuous, she could hold the husband as he first started to forget how to walk well, up and down the seventy steps to their house, perched on a dreamy hill facing the boats of the great river that led down to the greater city into which Maria had first crossed the border.

It soon became logical enough that Maria and her amiable smart man friend—whom she would marry soon as they could execute a real wedding—would take up residence in the basement, available now that the kids were gone. The pair stayed on call day and night for the husband, if at a hefty price, because Maria knew the power of negotiation and also that the Hummingbird had money pocketed

away here and there; no way would Maria take over so many of the husband's leaky bodily functions without also having some funds hemorrhage her way, without being compensated in the way that she thought most linked to her own future movie starness, knowing herself destined for more than the mere watching of telenovelas, her future gilded with glamour, the life of a successful neighbor, the one unburdened with problems, on a telenovela.

As such, she and the Hummingbird entered a course of détente in which Maria brought the Hummingbird coffee each morning, one packet of artificial sugar, and one sloop of skim milk. Good at keeping the house going while mostly ignoring the Post-it notes left her in scrawled loopy script—MARIA, PLEASE MAKE SALAD FOR LUNCH, THANKS—Maria showed brilliance by keeping the Hummingbird satisfied, and, when alone with the husband, was not above holding his black-socked foot with affection, or, when toweling him off after his bath, slicking his hair back so he became a giant pink baby. In moments of tenderness she liked calling him her big pink doll.

What Maria didn't like was incontinence in the bed, and, given her lack of training, kept her dislike overt; every morning she thought it fair to castigate her patient for his soiled sheets, every night chastising him as she placed his frail hips into a double diaper. All other parts of the job she could handle with smirking equanimity and competence, her heart softening so that when he cried like a baby, she would say, Don't worry, señor, and even made a big poster her patient could look at, saying IF YOU NEED SOMETHING, CALL MARIA, as reassuring to him as a map of Greenland would be to an armchair explorer.

Until the early dawn when, in a fit of paranoid dementia, her patient, not in his clean pink-baby state but in his soiled dawn, at his most anxious and self-pitying, confused about which house he was in, if not which gender, propositioned her, saying point-blank that if Maria refused to make love with him he would fire her. He took on the air of the boss he used to be. It probably had been years since he'd had congress with anyone.

Make love, he shouted, and then whimpered, make love. As if she could even entertain the concept!

She would not. She ran downstairs crying, her dam finally broken, telling every detail to her smart boyfriend and adding a few details from the telenovelas.

*

249

Later Maria's calm, when explaining that unless her salary was upped by twenty-five percent, she would not continue, inspired awe; it stole the Hummingbird's breath, made her heartbeat rapid in her throat.

Once Maria's tale finished, the wife knew it was over: She would no longer keep the body and wandering spirit of this husband in a house she had started to think of as hers. After all, was it not? Who else was responsible for its operations, its lights during the day, its heat at night, the way it breathed, what it needed, its bill paying and hedge cutting, the minutest adjustments keeping their home that of their early marriage? It was their home that could not be lost to this new development, this loss of dignity, strangulated calls in the early morning booming on the baby monitor next to where Maria slept in the basement apartment, the mentholated scent wafting through the house with its sick-joke potpourri, the ammonia bottles stacked ready in the closet, the poop stains on Persian carpets.

That afternoon the Hummingbird called the children to her house in order to make the plan. This time, unlike the way she had tried excising him totally from her heart, it would be no failed rocket launch à la 1960 in Cape Canaveral, a rocket combusting in midair before leaving the earth's atmosphere; this would be total eject.

Someone had once told the Hummingbird, back in the early days of marriage, right after she had met her disapproving in-laws, that eccentricities get more pronounced as people age. She had used this maxim often, if unsuccessfully, to try to forgive certain people, but in the hours that stretched between Maria's story of the proposition and the Hummingbird's announcement of the husband's ejection, she could not forgive.

This was not senior dementia, it was the natural consequence of his mind and hands that had wandered during the years of their marriage.

Maybe, the Hummingbird considered, heaven and hell really exist, except they exist before a person dies: You end up in exactly the living hell you have created. Each person has his own hell.

On entering the home, the husband immediately did his best to charm all the nurses, successful with everyone but old Berta, always canny at recognizing the loose-fingered ones. He's a groper, that guy, he'll put hands on you, Berta said right off, and since she had close to

a hundred percent record in her initial assessments, most of the nurses did what they could to avoid being assigned his room.

Still, when they saw the new nurse, Letty or Letitia from Guatemala, who'd gotten stuck with the assignment, flying down the hall, there started to be a movement in reverse.

Don't tell the doctors, it was agreed, let's keep it among us.

He ask me lean close. Then he kiss and grab, said Letty. What I do? I get quick out of room. Then I fly, you say float?

Float?

Their faces quizzed her.

My dream, whispered Letty, a rapture stealing over her face. When I small girl, I say one day I fly. You think he give other dreams, I let him do anything.

You sure the two things are related? Berta asked, feeling the knot of cause versus correlation in her gut, unable to say it, hooking pointer fingers together to show her meaning. She would not let the new girl get one over them so quickly.

I tell you, I fly. Trust! said Letty, with the deep Catholic throatiness of someone who twice has had the Virgin wink back at her from a cloth diaper. I know.

And no one waited to hear what she had to say next, because even if skeptics disbelieved, already the quarreling was on. Letty could be easily bumped but who would get to serve the Groper next?

Because he couldn't have ten nurses tending to him, they had to take turns, and because he was unable to keep up with the rotating parade of faces, faces popping in to change his diaper or guide him to the toilet or roll him back and forth to prevent bedsores, unaware of the havoc his ministry had caused on the floor, he just started calling all of his attendants Nurse, as in Nurse, may I please have, or Nurse, could you please—and would welcome whatever new face would pop in to diagnose, soothe, or attend to the demands of his body.

Over that first month, old Berta was happy to have her back pain healed, Mindy overjoyed to have her husband give up the drink and check in, finally, to rehab, and Sherrie pleased to lose her clumsiness. Inez lost her limp, Gloria had her workman's comp claim go through, and Rosa's son paid a visit with her new grandson. At this point, some of the more mercenary on the staff were tempted to sell outsiders a grope with the geezer—imagine how it would look on the

Web! it could be a subscription service!—but calmer voices pre-
vailed, especially since some of the nurses had risen from their own
shady-lady past, and knew a secret kept within the ranks was worth
two in the bush.

Still, nurses from other floors, getting wind, asked to sub the night
shift, just so they could serve the Groper, the secret healer of Ward
77 in the skilled nursing facility, because, even if there were no sci-
ence to the healing, even if it worked like astrology or aromatherapy,
since you could not predict, fully, how or if or when it would work,
all it really seemed to take was just letting yourself lean close for one
of his kisses.

They did find that whoever let herself be groped immediately fol-
lowing one of the wife's visits would *not* have her wish fulfilled, or
if it was, the wish would be fulfilled in a tweaked way.

Applying scientific method, the frustrated ones started keeping a
logbook so as to better study the pattern, and it became clear that it
was wisest to avoid a grope post-Hummingbird: You just had to peek
at the obvious links. For example, Elsa's daughter announced, after a
grope the day of the Hummingbird's visit, that, not content with just
graduating school, she wanted to move away. When Joanne's new car
came, it was a lemon that left her stranded by a depressing country-
ish watering hole on the interstate. Susie from two hours away had
her bank account filled, by mistake, with someone else's massive
deposit, equal to an entire year's salary, and after she bought them all
lunchtime burgers and said she would leave to study tango in Buenos
Aires, the bank fees the following week left her poorer than before,
though she didn't let it faze her, back to her usual resourceful self,
clicking heels down the halls.

Of course, they kept the Groper's skills a secret from the Humming-
bird. And the Hummingbird read her husband's moniker completely
wrong: After the Hummingbird overheard someone calling him the
Groper, if with an affectionate lilt, she could not help but gloat. Such
a sting of happiness to the idea that her husband was rotting away in
a hell of his own devising. After all the Hummingbird had endured,
he was being joked about. Being called the Groper! He had lost po-
tency, he had basically lost his male organ, he was forever married to
a catheter. You could not have dreamt of greater recompense.

She did not think farther to ask what would be her hell. She had
new age ideas about people creating their sickness, even if she

wished to evade such beliefs, as they were worrisome, and could encompass gossiping friends who would lose their vocal cords, or her worrywart son—a contrast to the geographer Asperger's one—who would sprout cancers.

She decided to confide this idea that her husband had created his own hell to her neighbor Donna, a hearty platinum-haired Italian married to a high school sweetheart, Donna who had always let neighborhood kids run amok in her house.

New age hogwash, Donna said, just as the Hummingbird had feared: Already she wished to back away from the fence between their driveways. Donna kept on: You don't have to believe in some higher power, but you think everyone creates their own realities? What about tsunami victims? Holocausts? War refugees? There's so much beyond our control.

I wasn't raised Catholic, said the Hummingbird.

You don't have to be Catholic. We have no control over our hells, she said, pressing a sack of ginger cookies into the Hummingbird's hand before returning to what she was doing, which was carrying in supplies for her beloved scrapbook making.

A relationship is built from memory, the Hummingbird had once told her husband, after he had made incursions upon her idea of loyalty.

Now that, on each visit, he had less and less memory, he proved her bitterly right.

How are you? she would ask, giving him a quick peck, trying to avoid inhaling his moldy odor.

She would see herself in his bifocals, swimming into focus. I have important theories on the flagellation of Christ, he would say. In my spare time, I'm redesigning the early aqueduct system of Budapest. A few times he was especially jolly in seeing her: Hello, Nurse! he would say brightly, as if expecting her to fly off happy at being misrecognized.

Every week, nonetheless, she visited at least twice. As she rose in the elevator with other visitors, each visitor coming out of love, curiosity, duty, or bearing the ostentatious flag of nobility, she would consider the place her unfaithful husband had ended up in, the Groper stuck in bed, laughed at by nurses. The Groper!

At some point in the visit, it would reach an end. Again she would purse her beaklike face and lean down, giving that bony forehead a dry kiss and inhaling his odor, happy that in two minutes she would descend in the elevator and five minutes later could be out inhaling fresh air in greedy gulps.

Some three months into his stay at the home, one of the rare doctors anyone had ever sighted on the floor stopped by to breezily invite her to come to his office, a kind of closet next to the women's bathroom, behind where they usually kept the rolling mop cart. He was a big, bearish man, the kind she had fancied in the years when her husband had first started wandering, but she was too old, she was foolish, the doctor had no eyes for her. He pretended to engage in deep study of her husband's chart and then took off his glasses, an act that he must have done lots of times with lots of different wives. He said, with professional pacing, offering an illusion of largesse and compassion, that the patient probably only had a few weeks left of life.

How can you know such things?

I'm not God, but there are signs. Small ones. Nurses say he tugs at bedclothes. I just stepped in to see him. His eyes are glassy. His vital signs are OK, but when he sleeps, his breath stops for up to forty-five seconds. You of course have seen the rot creeping up his fingers?

She said nothing, knowing this rot to be the outward disease of her husband's groping soul, while also believing the doctor's death sentence. Nothing could be deferred.

You know, said the doctor, as if in consolation, he seems popular enough on the ward.

She felt her own heart stop, even as she said goodbye to the doctor, whose last name she immediately forgot, though it rhymed with the place where she had long ago enjoyed a laughing honeymoon by the sea. Rimini.

Immediately, and though she'd been looking forward to the descent in the elevator, she had to perform an act of restitution. Feeling not at all birdlike, rather more like a hooked fish, she reeled back to her husband's room, where she waited for a nurse to finish mopping up the path between bed and bathroom with ammonia. Once alone with the man into whose sparkling green eyes she had gazed, across a short path, in the moment before betrothal, his eyes so bright as if a crystal into which, if she peered long enough, she could discern all future cheer, she sat in the chair next to the bed—usually she sat at

the one next to his feet, but now she felt required to whisper—and waited before voicing her first sincere apology in their more than forty years of marriage: I've been cold.

He gasped back, rather fishlike himself. Had he not been able to make a coherent sentence only twenty minutes earlier, before she had met with the doctor? Maybe the pill he took to dry up the fluid that insisted on flooding his lungs wasn't working, maybe dosages had to be upped, or maybe he was deep into a vision, this the term she preferred to hallucination, as that much she continued to do for the husband's pride, never once having called him demented.

Perhaps he gasped something like: I love you too. She did not know. All she knew was that she had to lean close to hear him, as if he wished to tug her, small bones and all, into the grave. All she knew was that she inhaled death.

His muttering had turned to some unseen arena of private, attentive angels huddled close to his mouth.

Then he opened his eyes and looked straight at her, managing to speak more loudly, intelligibly enough that she could understand: Thank you for bringing me to this palace.

For a second, she looked for irony. Finding none, she knew how well she had consigned him to a hell he hadn't recognized, one he seemed to call heaven.

He looked up at her with a childish glee. Here they call me the Groper! he said.

I know, she murmured, using a tone she hadn't used with him for years, soft as tissue. Outside the door, for a second, she thought she saw a nurse float by, but surely this was a function of tears filling her vision. Just after, there arose in her head the wish—perhaps the clearest in a life strewn with wishes—that she could have again the husband who should have been hers, a husband faithful and brave against all incursions.

They fight to serve me! he went on.

She lied: Good, because I was not sure about bringing you here—(this, when it had been one of the most resolute decisions of her life).

Then he voiced, loudly enough that she could hear, the three sweetest words in the English language: You were right.

And just after that they began what may as well have been their very first conversation.

Disappearance and
Stephen O'Connor

THE CORMORANT, it is said, can foretell the hour of your death.

The first thing Tim noticed was the hiss of feather against feather, and a certain salt mustiness. It was a cormorant. Its feet were still wet and left beaded tracks in the middle of the plastic tablecloth. Cormorants always look affronted, their beak tips higher than their heads, their inflated feather-and-bone breasts, the way they look at you with only one beetle green eye. This bird was no different.

Brown glint on skull top. Tick of talon accidentally hooked through plastic cloth, extracted.

What surprised Tim was her voice; there was nothing hinge-squeaky about it, no rasp of rounded stone against rounded stone, nothing remotely aquatic. If an oak had a voice, it would be her voice: pale of hue, frank, and efficient, the voice of endurance without shame.

The whole while the cormorant spoke, Tim had been looking down into his coffee cup.

"Got that?" she said when she had finished.

How was one to respond?

"If anything doesn't make sense, just ask. That's what I'm here for."

He wished she wouldn't move her head that way: first one eye and then the other—fast as a blink. That beak always pointing at the ceiling. The way the bend slid up and down her neck, like an arc on an oscilloscope.

"That's OK," he said.

He felt that he had let her down.

256

"The only rule is that you can't tell anyone," she said.

"Why not?"

"Because then they would know." The bird seemed to think this was self-explanatory.

"Oh," he said.

"Right, then," said the cormorant, duck-footing it to the table edge. "If you would be so kind."

Tim opened the kitchen door onto a morning like other mornings: Dew on the fiddleheads twinkling copper and aquamarine. Sun puddles the size of dinner plates spotlighting the birch trunks and trembling beech leaves. That faint mist like a variety of not seeing very well.

"Thanks," said the bird at his feet.

"Don't mention it."

First there was a considerable expansion of wing and a sound like nylon on nylon. After that there was a buffeting of his bare knees, shins, and feet by wads of air. Then the cormorant was only a bird in the blue. A tiny, horizontal wiggling. A trembling dot. Nothing.

His wife was the one who should know what the cormorant had said. But if he told her now, she would only think she was dreaming. He put her cup of coffee on the night table. "Morning," he said.

His wife's name was Ava. Once she and Tim had been sproingy, like bent twigs, like gymnasts; now they were resilient, in the manner of moss on the forest floor, in the manner of water muscle flexing against brook stone. It was a natural development.

Polly and Chanticleer were huddled in their quilts on their bedroom floor. They made small peeping noises as Tim shook their shoulders; they covered their faces with their forearms. His children were so light. If you threw them into the air, they would drift slowly to the ground, rocking like snowflakes, like dust motes.

"Rise and shine!" he called out as he yanked up their blinds. "Rise and shine!"

"God, Dad!" said Polly. "You sound like a cereal ad!"

"Shut up, Polly!" said Chanticleer.

"Breakfast is on the table!" said Tim.

"Barf me out!" said Polly.

"Jeeze, Poll," said Chanticleer.

*

"What's that smell?" Ava asked, eating a piece of toast over the sink, already in her stewardess uniform, her carry-on against her knee.

"What smell?" asked Tim.

He had decided not to tell her. What difference would it make? What could she possibly do?

"Like a tide pool," she said. "Like duck breath."

He nodded at her carry-on. "Where to today?"

"Abu Dhabi," she said. "Boring. Don't wait up."

Eleven fifty-six p.m., he thought.

The children were off to school: Polly with her backpack that stank of cigarettes, Chanticleer lugging his briefcase on a trolley. They reminded Tim of bubbles as they rose toward the hillcrest—aimless, multicolored, unrestrained. They called out to one another. They shouted insults. Then, at the hill's crest, they seemed simultaneously to leap off the earth's edge. All that lingered afterward was the subsiding echo of Polly's laugh.

As a child Tim had learned to tell the difference between disappearance and loss. Disappearance is best defined as the occasion for reappearance; loss is the diminishment of life. The problem was that Tim had only learned this lesson in a way; in another way he hadn't learned it at all, and so, during all of his days and years, even his most joyful hours had contained minutes of sorrow.

It was a short walk through the woods to the ornithology lab. Where the path got boggy, he could leap from stone to stone. Even the trees sported lichen. Spiders drifted on yards-long strands. Philosophers tell us that the clearest measures of our mind-loneliness are a pair of infinities: the first between the photons for green and the color, and the second between the color and the word by which it is known. That is all well and good, but Tim was grateful, nevertheless, for the coincidence of light and leaves that morning, and for the leaf-fluttering wind, and for the heat of a May sun on the bed of pine needles,

for their sweet musk. It was in such isolation that he constructed himself, and as he walked into the meadow that was what he did, and he did it again as he walked through the thick glass doors of the ornithology lab, and so on and so on . . . I live in the constant unfolding of a miracle, he reminded himself.

Loss and loss and loss.

"Doctor?" said the volunteer, whose teeth had begun to push her lips apart.

"Hunh?" said Tim.

And then he said, "Sorry."

He replaced his wrinkle of disconcertment with the frown of authority. He made a note on his clipboard: *Bill-bite. Unfortunate but expected, treatable.*

"I'm sending you to orthodontia," he declared.

"Thank you," she said.

He gestured at her collar with his pen.

She unbuttoned her shirt enough for Tim to see the cirrus of down that covered her chest.

"Nice," he said. "Beautiful."

Then she rolled up her sleeves so that he could examine her nascent pinfeathers: auburn, soft—like infant hair, oiled and combed.

"Perfect!" said Tim. "How are the flying lessons?"

"I haven't started yet."

Tim made a note on his pad.

Susurrus and jay-clink. Olive brown, slug yellow, and robin's-breast red. The head-cleansing scent of ants.

Tim filled paper cups so that he could watch the bubbles rise like jellyfish in the watercooler by the staff lounge. Twelve full cups in a crowd at his feet. Fourteen. Eighteen. Twenty-seven.

Tim?

Tim?

Everything OK?

Loss and loss and loss.

People were talking in Celia's presence, so she decided to go see for herself. Celia was a woman whose entire life revolved around one monumental fact. She was transparent, poor Celia; she was naked in public. The whole world could see that inside Celia's mind there was a shrine, and on the throne in that shrine sat a medium-sized man with sandy brown hair, fog gray eyes, and an unimpressive chin: This was Tim.

And thus it was that Tim had been having a degrading effect upon her marriage for years.

She dreamed of him nightly: They shared a gondola in Venice, but then the canal caught fire. She held his penis in her hand, but between her legs she had gone blank as a Barbie. They were astronauts together, in a glass globe floating toward the moon, and the moon was exactly the same as their globe but opaque and alight, and when they collided with the moon, either the moon or their globe would crack—but maybe not; maybe she and Tim would drift right past the moon, and then just drift and drift and drift.

Tim had trouble remembering Celia's name. At various points he had called her Cynthia, Cecelia, Cecily, and Jane.

"Everything OK?" she asked. Tim stood alone on the observation deck, his pants legs flapping, his hair perpendicular to the left side of his head.

"What?" said Tim.

"Windy day," she shouted.

The air beyond the railings was dizzy with swoops, barrel rolls, knife-winged hoverings and dives.

Tim pointed.

"I was just remembering," he said, "that I first got interested in

ornithology because I wanted to become a barn swallow. If free will had ever been more than a myth, I would be out there right now weaving flight paths with my buddies, cheeping in joy at my incomparable skill."

Celia, who well understood what it was to have been born into the wrong life, touched Tim at his elbow and asked, "Everything OK?"

"I am trying not to feel pathetic," he said.

Celia wanted to kiss him. She knew that if she could just summon the strength, she could save him—and save herself—with her limitless love.

"Me too," she said.

"Suppose you had been told by a reliable authority the exact minute of your death," said Tim. "What would you do?"

"This," said Celia, leaning forward and kissing him on the lips.

But that was not, in fact, what she did.

What she did was say nothing, look choked, shrug her shoulders, and wince.

"I've been thinking about that all day," Tim said. "And I've been thinking that the only thing I would do would be to keep on living the life I've lived."

Celia gulped. Her head twitched. Her eyes went shiny and red.

"It's not as easy as you would think," said Tim.

The cormorant duplicates its upper half in the lake. When the cormorant merges with its own reflection, both cease to exist. Where once swam the cormorant swirls a dimple in the sky. Beak first emerges the snake-headed, snake-necked, night-colored bird. Perky. Superior. Dumb as a post. The cormorant dives again to return with a carp—long as a flip-flop and twice as thick—clutched in its slender, hook-tipped beak. Wait a second—what's that the cormorant is doing? Note how the fish head and fish tail jerk violently with every shake. Note the sharpness of the beak hook. All self-replicating beings of cellulose or flesh must one day surrender that essence distinguishing them from stone, air, and empty space. The fish is metallic orange, and then, as it flips toward the sun: flashing gold. In fact, the jaw dislocates. "Welcome, my darling," says the expanding darkness. Now watch carefully: Note how the bird's throat is roughly three times the thickness of its head. Note how that thickness

descends until it merges with the bird's sleek body. Well done! Well done! You've earned your rest, Mrs. Cormorant. Cork bobbing; beak under wing.

"At exactly 11:56 p.m.," the cormorant said. "Double one, five-six."

"Lucile?" said Tim. Then a moment later: "Oh God! I am *so* sorry."

Tim's days had been pickles in a barrel. Had been ninety-nine point nine-nine-nine-nine-nine percent interatomic space. They moved with the slowness of thunder lizards petrifying on a red plain. *Fssst!* Have you ever seen a shooting star? Like that, from birth to this instant. A succession of windows onto impossible landscapes. Like grape after grape tossed into the air, mostly bouncing off the teeth, nose, and chin to roll in the dust. Like having to masquerade as a eunuch in a harem. Barn swallows snatch microbites of clear-winged protein with every swoop, twist, and free fall. They are always hungry. Why, then, should we be different? All of Tim's days could be measured on the scale of desire. What Tim could never figure out was why there had to be, around every corner, this big guy with callused knuckles and an unsavory disposition. The hoot of a great horned owl multiplying in the leafy wood.

"I have always spoken with the owls," Tim said. "They are so cold. They have known such sublime sorrow."

Chanticleer's bathing habits were verging on the repulsive. Already the world had shown Polly manifold discourtesies, and her brother had to cart her home on his trolley. Pizza or blood sausage? "Jesus, Dad, have you no sense of proportion!" And that was how they did it: The mechanism was mostly attitude, solidified with a sort of paste made by masticating sassafras root, vole's blood, and a gray-green mold commonly found on the stem scars of blueberries. Ignorance helped. Pass the juice. The gray arcs beneath his finger-nails, and a certain pong that would waft across the table. What they were, really, was a sort of mechanical fog that, directed by randomly

generated algorithms, could assume an infinite variety of shapes.
More pizza? Homework? Bedtime? They made their mistakes, but
their bodies were so soft, miracles of pertness. And, oh, what a dream
it had once been to place his lips upon their warm infant heads! And,
oh, what a dream simply to breathe those molecules in!

"Bedtime!" said Tim. He chased his children from the table with a
broom. "Bedtime!" He batted them aloft, and they reversed mid-
flight like badminton birdies as they arced through the air to their
quilts.

Each bridge became the foundation for the next, but none ever
reached the other side. The other side was, in fact, only one postu-
late among many. Bedtime, I said. Now I was the coyote. Now I was
the redtail stationary in the wind. And Tim's dead father, drunk
again, was rolling in the grass outside the basement door—and Tim
was there too, as bat wings carved the darkness overhead, and the
night was so very gentle, if needled occasionally by mosquitoes.
There were worse things, Tim reflected, than to be lying on a picnic
table on this first summer night of spring. He had done this so many
times before. He should have been afraid, and he was, but he had
lived his whole life at the edge of winking out. You know that
instant just as the dark dwarf beside the road is becoming the bush
in the headlight, but hasn't yet? It was just like that. All of it.

Double one, five-six.

If truth was only a variety of falsehood, that left Tim to choose
between faith and fear. . . . No—sorry!—I mean between the cor-
morant and the cormorant's articulation.

Eleven fifty, said Tim's watch.

"There you are," said Ava. She lay down beside him on the picnic
table. Night was over them, a sort of canopy—aeons across, and
constantly expanding.

"You're home early," Tim said.

"No headwinds."

"Ah."

She had taken his hand. From the coolness of her fingers and palm, from their suppleness and weight, he could deduce her entirety: this body so known to him. Its every fragrance and split. Her habit of coughing as she entered a room. Long ago she had climbed the steps into his attic and leaned a ski pole against the wall. It was still there.

The sky in which the stars hung grew ever larger, ever larger. They became brighter, lonelier, chromatically rectified; there were more of them every time, and there was more and more room for the breezes. If a woman could be a season, Ava would be late summer, after the orioles have gone, when the robins are getting restless, and the geese.

"It's nice out," said Ava.

"Yes," said Tim.

"But chilly."

"A little."

"I'm going back inside for my sweater."

"Don't," he said.

There it was again: the owl's solitude in the mouse-filled night.

Eleven fifty-five.

It was a practiced move: the letting go of hands, the simultaneous head lifting and backward rotation of arm. And it ended, as it nearly always had, with her head on his shoulder and his breathing the warm air riding close to her skull. And all that while, the night sky had continued to hurtle away from the earth, making more room for stars. There were new ones every instant, thousands of them, and each was a pin-prick gem, an incandescent speck, a microscopic leap of light. Star after star after star. This couldn't keep happening. If it did, the whole night sky would soon be white.

*

Eleven fifty-seven.

Eleven fifty-eight.

Tim began to snore. Ava's elbow between his ribs. "What?" said Tim. There it was again: that long, cool cry.

Eleven fifty-nine.

Predecessor
Jeff VanderMeer

THE GREAT MAN'S HOME lay within thick woods, beyond a churning river crossed only by a bridge that looked like it had been falling apart for many years. The woods were dark and loamy and took the sound of our transport like a wolf taking a rabbit. The leaves passed above us in patterns of deep green shot through with glints of old light. There was the smell of something rich yet suspect in the chilled air.

The house rose out of the forest like a cathedral out of a city: unmistakable. It had an antique feel. Two levels, although the second story was gutted and unusable to us, with an off-white color stained with the amber and green dustings of pollen and pine needles. A steeple of a roof that contained nothing but rotted timbers, descending to a screened-in porch, beyond which (we knew from our maps) lay the horseshoe construction of the interior passageways. The house might have been a hundred years old. It might have been two hundred years old. It might have always been there.

Our tread on the gravel driveway startled me; it was the first true sound I'd heard for many miles.

The screen door was broken—someone had slashed through it, and the two pieces had curled back. We walked onto the porch and found there beside two large wicker chairs like decaying thrones the mummified remains of two animals the size of dogs but with skulls more like apes. They looked as if they'd fallen asleep attempting to embrace. They looked, in the way their paws had crossed, as if they had been attempting to cross the divide between animal and human.

My partner looked at them with revulsion.

"Corruption," she said.

"Peace," I said.

In answer she took out her keys and moved toward the door that led into the house.

The door had been hacked at with some kind of axe or other crude weapon. The gouges and cuts had turned black against the weathered

white. The knob dangled from the door as if it belonged somewhere else.

"Nothing did that," I said. "Nothing that lives here now. Remember that."

"I'll remember," she said, and turned the key in the lock. It made a sound like metal scraping, but also of something released.

She glanced at me before she opened the door. "We don't know what he left."

The iron gray of her eyes wanted something from me, but all I had was: "The power's gone from it. He hasn't slept for a long time."

I had no weapon. She had no weapon.

Beyond the door, a long, straight corridor waited for us, badly lit by glimmering lamps set into walls that seemed to both jut outward and recede into shadow. It was like the throat of a beast, except at the far end we could see where it curved to enter into the second half of the U. Where it came out, we didn't know. There had been no other door on the porch.

From where we stood, the corridor clearly changed as it progressed. What was near to us had a weathered opulence—rosewood panels and graying chandeliers long since gone dark. The burgundy carpet lay flat under our feet, and something had been dragged so violently down its length that the fibers had flattened in a swerving pattern. But farther down we could see plants or little trees, and there came from the far end a suggestion of an underlying funk, the smell of unnatural decay. There came also a throaty murmur, as of a fading congregation.

"Vestiges," I said.

"Of what?"

"Of the man himself."

I walked forward. Her boots scuffed the carpet behind me as if she was compelled to follow against her will.

Nothing happened for several minutes. We did not investigate the rooms we passed, which lay behind closed doors. We did not stop to look at the paintings. Side tables, lamps, and the like did not interest us. Instead, it was as if we followed the swerving pattern in the carpet to see where it led. I began to think of it now less as the imprint of a body being pulled and more as the trail of something that had no legs, like a giant slug. There was a suggestion at the edges of the swerve of a curious mixture of a deeper red and an amber resin.

We had no specific brief. She knew this, and still she asked, "What are we looking for?"

"Everything," I said, and it was true. Nothing angered him more than the wrong focus. But she was nervous. I could tell.

The corridor seemed to collapse into forest, even though I knew this could not be true. It was simply the overgrowth of potted plants and trees run amok, aided by the bulge of a domed skylight mottled dark green with debris. The trees were almost bony, but tall, and their leaves spread out like emerald daggers. What once were regimented bushes had become feral explosions of branches. Between them lichen and vine had taken hold in cracks in the floor where the carpet had been cut away. The trail of the thing without legs led over the underbrush. Recent.

"What's that? In there—beneath?" she asked. I felt rather than heard a tremor in her voice.

"Something dead," I said. It did not seem important to say more.

"Spectacularly dead," she said, and I thought perhaps I had not felt a tremor after all.

We moved on, farther into the great man's house. Now there were glass cages set into the inner wall and no doors at all, but the cages held only mold and things that had died a long time ago. Some of them lay close to the glass as if trying to burrow through it. Others had died with their forearms banging against it. We did not examine them closely.

Then we began to encounter the living. The inner wall pulled into itself and left room for more than just glass cages. A muttering rose from the displays that had been left there, behind a torn, bloodied, sometimes shredded, cross-hatching wire. What lay behind was squirming flesh mottled with fur, an eye or two glancing out from the mess with an odd acknowledgment of fate. A spasming claw. A quivering snout. There was no great seriousness or order to this exhibit. These creatures, neglected and left without food or water, had half devoured each other, and by their nervous natures had consigned themselves to an ever-contracting existence. They would not leave the ledge on which they'd lived their lives to that point. Now they were deranged, and lay on the border between life and death without knowing the difference.

"Survivors," she said.

"No," I said. "Not yet."

We walked farther. By now, we were almost two-thirds of the way to the curve of the U. The stain trail on the carpet had resumed, seemed again to lead us.

Now came the parrotlike birds that had the mange and stumbled across the floor, too weak to fly. Now came cats and dogs that had been combined in peculiar ways and left to stagger, something wrong with their brains that made them lose their balance. Now came the fish tanks full of slop and mewling and naked, shivering tissue. Now came things living inside of other things, gone so completely wild that they were innocent of us.

The vines had crawled up the sides of the walls.

The vines were hiding tiny creatures that peered out at us. Or had they become part of the vines?

She was looking around as if for a weapon, but we had decided against weapons.

"It will be over soon," I said. "For some, it is already over."

She nodded. I knew she trusted me. We were not without weapons now that we had abandoned them.

What had looked like ornamentation ahead, at the join of the U, was actually a row of faces jutting out of the wall, set slightly above what appeared to be a long love seat with thin crimson cushions. These faces—twenty or thirty of them—ranged from that of a boar to that of a kind of thick lizard to a thing very much like a woman. They were all undergoing a slow transmutation of expressions, as if sedated. None looked peaceful. None could speak, and where you could see their throats it was clear some surgery had been required of them. This was to be expected. But what were they supposed to be looking at?

My partner knelt and stared into the face of the woman-thing. There was not so much distance between them. Not really.

"These cushions were once white," she said, staring into the open, gray eyes of the woman-thing. Its lank hair fell straight. It gave off a smell of corruption.

"There has been spillage," I said.

"Can we free them?"

She, like me, had understood that these were not just faces. The bodies behind them must descend in living coffins behind the love seat. Did their feet touch the edge of some surface? Or did they hang, torsos held in harnesses? And if so, what lay beneath them?

I dared not put my hand on her shoulder. When you let some things in, you never get them out.

"Don't you see that they are already free?" I said.

It was in the eyes. While the muscles in their cheeks, their jowls, their snouts, their muzzles, winced and pulled back in soundless rage or sadness, those eyes stared straight ahead, as dead as anything dead we'd yet seen.

"This is the work of a great man," she said, but I could hear the question.

"We should continue," I said.

For the row of faces led to a doorway, and the doorway led to the second corridor—the one that should lead back even though there had only been one entrance on the porch.

She rose, and on a whim peered back down the corridor we had just traveled through. "The lights are out," she said. "The lights are going out."

And they were. One by one, each lamp, each dim-glowing chandelier, was blinking out, leaving more and more shadow. More and more darkness. Into that space shapes moved where no shapes had been.

Was the shiver I felt one of anticipation? I don't know. Soon there would be an ending.

"We should continue," I repeated. Perhaps there was a tremor in my voice this time. I do not know.

Beyond the doorway lay the second corridor. Gone the rosewood. Gone the carpet. Gone the paintings on the wall. The walls were as off-white as the outside of the house. The stench of blood came from everywhere, and the lights here were bare bulbs and flickering fluorescent strips. The floor was linoleum and the stain of whatever had come through formed a long snarl of red disappearing into the distance. Now, though, it trailed up the walls, onto the ceiling, not just the floor. Spun crazily. Did not take a straight line.

We could not see the end of the corridor. We could see no trees or bushes. Now the lights went out one by one as we passed, and when I looked back there appeared to be a long shadow with one arm against the doorway staring at us. Then it was gone.

"Is he here?" she said.

"Yes," I said.

She took a step, then another, and I followed for a time and let her lead.

We came to a place where the wall gave way to a huge glass cage

that held a wet, flickering, shifting mass of blackish brown broken only by shimmers of blood.

"What is it?" This time I asked.

She was quiet for a moment. "Starlings. So many starlings, so close together that they cannot move, held up by each other's bodies."

Now I could see the wings and beaks and feathered heads. The eyes bright, feverish, anguished.

"What purpose could this serve to him?" I asked.

She only laughed harshly, took my arm, tried to pull me away. I would not go.

"What purpose could this serve to him?" I asked again, and still she had no answer.

There was a way into the cage. A small chamber at the bottom that would allow a man to crawl in, shut the door, and then open another translucent door into the space with the birds. The red trail led inside and then back out again.

She saw me looking at it. "What purpose would it serve to go in?" she asked.

"Then I would know *why*," I said.

"You might know why, or you might not. But you would come out mad."

"Am I not already mad?"

There was no way in which I could look at an individual starling within that glass cage. They had become something else.

"Trap," I said, wrenching my gaze away.

She led me forward. We had no weapons.

I had said no weapons.

Was I right?

The lights, they went out behind us. Now the few windows showed us not forest but darkness. Night had come, and had kept coming while we walked down the corridor. I kept thinking about the starlings. I kept thinking about the soundless scream that must be rising within them.

We came to a massive enclave hollowed out from the inner wall. I did not think that there could be such a space within the house, until I remembered the second floor and the way the steepled roof had looked like a chapel.

Within this enclave lay a giant human body composed of many other bodies. And within its belly, which had been ripped open, there

lay the bodies of animals too various to describe. And these bodies too had been torn apart and remade to create still stranger creatures. And those creatures had their own as well. The scene seemed to recede from us as we watched it, as if my mind wanted to put as much distance there as possible. The face of the giant human body was various—a patchwork of so many different possibilities. *Flesh is only flesh, skin only skin, muscle only muscle. It can all change and be changed.* There was a desperation to it, as of someone frustrated, thwarted, looking for a solution that never came.

The stain across the walls, across the ceiling, across the floor, had smashed through the glass divide between us and that tableau. The stain ended here even if the corridor did not. Somehow this change in logic unnerved me more than the box of starlings—more even than the body within bodies laid out before us.

"What is the meaning of us?" she whispered.

I know she meant "What is the meaning of this?" but that is not what she said.

"Keep moving," I said. "We are almost at the end now."

"What kind of end can that be?"

"The great man is nearby, I can tell."

"But we have no weapons."

"That is our weapon."

"I expected . . ."

"Stop."

At first, the corridor seemed to end in a blank wall—as disconcerting as following an arm with one's gaze only to have it end in a nub. But no: It curved once again, and beyond the curve was the office of the great man. A sparse desk. A windowless existence. Parts of things all over the floor, red and various. No chair. It was not needed.

In the light from the lamp on the desk, we could see that a giant raven stood there. It had a beak huge and ominous, which had the look of steel but the riddled-through consistency of driftwood, riven with wormholes and fissures. A clacking black tongue within the beak. A head like a battering ram. A body the size of a mastiff. Instead of legs and claws it had thick human forearms and hands. The fingernails were long, curved, and yellowing.

The raven inclined its head and turned one giant, bottomless eye toward us—an almond of pure black with just a hint of light reflecting from it.

"It didn't take them long," the raven said, in a deep, refined voice. "It didn't take them long at all."

At the sound of that voice, my partner began to cry: a soft weeping that I echoed from somewhere deep inside.

But I had a mission. *We* had a mission. Now, when it didn't matter, I took her limp, cold hand in mine and held it tight.

"We have a message to deliver," I said.

"Oh?" the raven said, considering me coldly. I saw now that all across his razor beak there were the signs of dried blood. "And what message is that? I'm busy here."

"You are to stop. You are to *stop*," I said.

"Stop what?" Bemusement beneath the dark feathers.

"*Out there*, they want you dead."

A soft, chuffing laugh that a bird should not be able to make. "There is no *out there*. Anymore."

"No," I admitted. "We didn't find much. But every time you change something, it changes there."

"Someday it may be enough," he said.

My partner made a sound, as if to speak.

"Don't you recognize her?" I asked.

"Her?" he said. "Her?" Peering.

"Don't you recognize me?" she said. "I recognize you."

The raven with the human hands turned back to his desk. Beyond that desk was a formless darkness. "That was a long time ago. That wasn't here. That wasn't this."

"It could be," she said, and took a hesitant step forward. And then another. I saw the courage that took, although I don't believe in courage.

The raven's head whipped around, and it said, almost with a snarl, "Stay back."

She stopped.

I heard a lurching sound now, coming from down the corridor. Every light behind us was dark. We existed only in the round glow of the lights in the office.

"We are here to make you stop," I said.

"I know," he said.

"Don't you remember?" she said, as the dead talk to the dead. But she was staring into the darkness beyond.

I was close enough now. I lunged across at him, in the motion I had practiced a thousand times at his behest. My arm around the surprisingly delicate neck. A quick, wrenching twist. The raven's eyes

273

rolled up. It dropped to the floor. Dead.

I stood there, staring. Was it to be that easy? It was not.

The darkness moved, came out into the light. It was him. Again. Much larger, but the same. The eye regarding me from above was not without love.

"I couldn't let you after all," he said. "The work is too important."

"Don't you remember?" she said again. My partner now seemed caught in a loop. I could not help her.

The lurching came nearer.

"Your predecessor is almost here," the raven said. "I cannot stop, and you cannot stop me."

"Someday you will be convinced," I said. "And you will let me."

"Someday I will finally sleep," came the rumbling voice.

There was a wetness behind me, and a soft guttural sound as of a throat that has been cut and yet the flesh lives.

"Don't you remember."

A sadness entered the eyes of the great man. "I remember enough to let you decide."

It was useless, but I tried. I lunged up at him, but my predecessor had caught up to me. A hand that was not a hand on my arm. A kind of intensity of motion that sucked its way into my skin, all of my skin. Tore it off. Tore it all off. All of it.

Brought me struggling to the box of starlings. Shoved me in. Left me there. Waiting for the moments when the great man and his new-old queen walk by. Waiting to sense them from the way the wings ripple differently across my face, the way the beaks and heads and claws suppurate and wriggle and try to escape, and keep trying to escape. Breathing in the spaces between.

One day, he will let me go, with or without her. He will release the starlings up through the ruined second story, through the chimney, to explode out into the sky, over the old woods. They will no longer know they are birds, as I no longer remember what I was before. But we will be flying and falling, falling and flying, and against that beating of atrophied wings, against that sharp blue, I will see the gravel path and the bridge beneath us. Returning. Remembering.

While my predecessor feeds upon me.

Flat Daddy
Shelley Jackson

—*New York Times*, New England Edition, 9/30/06

TO MY READERS: I mince my words. Cheese has holes and so does this page. My mouth is a hole, troubled with messages. I am a hole troubled with messages. Milk messages run through me, my ABCs are thick and white. I will spit cheese, eventually.

Mistakenly, I was. No reason given.

I have a father—that is science. It does not implicate me in a family.

When I was twelve, a Warm Loving Family advisory found that my father lacked authority. He was sharply criticized, with an umbrella, and banned from any public show of family. He became a small white father, a milk father, no big cheese. Now he lives in the Zone, gently wears an apron.

A Flat Daddy, faxed to me by WLF, took his place. "Way to trade up," said my Flat Daddy, "*son*. Let's turn this thing around."

My Flat Daddy is running for president of the United States of Overly Friendly. "I have had the privilege to represent all the—men, women—corn—the good stuff. Milk, my God. Family. I'm a big—huge. I am deeply—now and then." He is smiling through the holes in a slice of Wisconsin cheese. "I'm reversible. Just turn me around! Broadcast my backside, same as my front!"

I was not flat, but I was not solid. I was foggy—a smell, a chance of rain. I beamed messages to Asclepius, god of healing and medicine: Make me thick. Make me solid chocolate, no space inside.

Cheese has turned out to be a formidable player in the elections. Both candidates wear a cheese crown and rub themselves daily in Muenster. Of course, this is cow cheese. The controversy over human cheese produced in prison is hurting the United States' claim to the title of Dairyland of the World. "Cheese is yellow afternoon sunshine, free air and space," said the Flat Daddy. "Cheese is not jail. Catchphrase, son, catchphrase!"

The afternoon, explicit: dry air carrying the smell of paper, a few high clouds. The land, geographic: a map of a place, not a place. My Flat Daddy flat on his backside. No shadow. Only the hedge stands up.

The hedge divided our land from the Milk Zone. WLF policy bars schoolchildren from passage through the "demoralizing growth," but there was a hole through which an enemy green showed. I crept closer. Beyond the hedge, a portrait of a guard in a photograph of a building was watching some arugula for criminal conduct. I considered the arugula with suspicion. It was not unusually florid.

Miles away, a yellow river toils through green fields. Serious cows stand on their shadows.

Shadows!

Talking points: The Flat Daddy is good to women and schoolchildren. The Flat Daddy can be used as a paddle, in case of high water, or disobedience. In sunshine, a fan.

The Flat Daddy is not a bas-relief, he is flat. He has square feet. However, the Flat Daddy should not be misidentified as a letter, a page of a book, a photo, a billboard, or an obscure federal agriculture publication—also flat. He is alive, updated, and cool, Pops! He likes cowboys and the rapper Madness, though not the British ska band of the same name. The Flat Daddy is Web savvy.

The Flat Daddy grows a beard. A flat beard. "I'm pretending to be a Canadian nun," he says. "I'm pretending to be Hungarian ballet dancers!"

Sometimes holes are cut in a paddle to make the beating more painful. I am talking to my corporal father through the hedge. He stands in the arugula. His apron has plums and lemons on it. My Flat Daddy is watching, smiling.

"He's underage—better not get any closer," says my Flat Daddy. "Sorry, Pops!"

My corporal father said, "Does he think you're—"

"Game forfeited," said my Flat Daddy. "Player go home. Son, to me."

Sometimes the Flat Daddy calls himself The Lawmaker, The Charity Cheese, The Unaffected, The Supersonic Cowboy, Men Not in Aprons, The Special Event, Nemesis Technologies, or The Quotation. He is old, cold, dry, and smiling. "What ya wearing?" the Flat Daddy asked his team. Mink, said Hippocrates. Shearling, said Asclepius. Full leather, said Donald H. Rumsfeld gently.

My Flat Daddy is smiling down from campaign billboards across the United States of Overly Friendly. He is wearing mink with an *I Heart Flat Daddy* design.

The Flat Daddy wants to plan an attack inside the Zone, against milk and mouths, fat and goop. "My God, it's gross," said Flat Daddy. "Find your Interior Knucklehead, by God, and grow a damn beard, or it's aprons."

"Pops?" I said. I was "pretexting," or getting information by pretending to be someone else—a son of a father.

"The Flat Daddy welcomes comments and suggestions," he says, "or complaints about errors that warrant correction."

"What if I can't grow a beard?"

My Flat Daddy does not answer. Instead he puts up a private billboard. "Do the Right Thing," it says. "Be a Man."

Mistakenly hopeful, I longed to "do the right thing," decided to "resolve the matter." I locked myself in the bathroom and disciplined myself with the umbrella.

Then I disciplined myself with my hand.

Then I disciplined myself with my mouth.

I tucked in, sexually. Boy, I took action against myself. "I will stunt my beard," I said, troubled, but I am a rogue relative. I disciplined myself again.

"Where's the beard?" Rumsfeld asks.

"He's ardent, but gradual," says my Flat Daddy. But "By God," he says in private, "have some kidney. You look like a shearling. Where's the fur trim, man-child?"

"Pending," I say, and begin rolling up my father for the night.

"Mr. Not Yet." My Flat Daddy spits. On his own backside.

I smell warm milk when I go to the bathroom, and Muenster under my arms. Locked in the bathroom, I make investigations, find sensitive information—blood on the TP.

"Pops," I said, "I am not a boy."

"POV, son," he said.

"No boy, no beard," I said.

"Don't let me down, son," he said. "You don't want to let me down."

Reader, I let him down.

"You are in violation of WLF law," said my Flat Daddy. "It allows me to identify enemies, imprison them indefinitely in my bathroom, and discipline them with a father smell."

"You have no father smell," I said. "You are a cutout."

"I might have to curtail you," said the Flat Daddy. "I might have to commit gastronomy against your behind. Do the right thing, cowboy."

I did not do the right thing.

My Flat Daddy curtailed me.

"My God," I said.

Asclepius, the god of healing and medicine, said, "What a revoltin' development."

"I am deeply sorry," said my Flat Daddy playfully, and curtailed me again.

I am in the bathroom, finding a new spot the umbrella can reach. I am deeply—deeply sorry—

Information is awakening. Difficult. Delicate. Gross. Free.

"I smell cheese," said my Flat Daddy, when I come out.

There are lies within reach. I don't reach.

"I will not have a son who is a milk sympathizer."

"You will not have a son," I said.

"Out of the mouths of underage criminal defendants," he said, and sent me to Beard Camp. There, I was bound, hung by the arms, and beaten on my fat mouth.

They had parental consent. They made that clear.

I was blistering with messages, each lesion a letter home:
Dear Daddy,
Wish you were.
Readers, there is a worrisome hole in that sentence. Look through it—I did. I saw edges, shadows. Scattered articles: a Concorde, a carry-on. An elegant letter T, relic of an ancient ABC. Cowboys, cows, and a ska band. I saw men stand guard over vats of human cheese. I saw a jail of blocks and columns, like a newspaper. I saw a hedge 5,723 miles long. I saw a boy smiling at his Flat Daddy, a man with a thick wooden paddle, a woman in a land where the milk comes by train.

This sentence was like a kaleidoscope: A few turns could mince a human life, or a country.

I turn it. Chips dance. I see a giant beard grow in the White House.

I turn it. I see the ship of state strike a block of cheese, and sink.

I turn it. I see my Flat Daddy rolled like a newspaper, swatting at weather.

I turn it. I see a mouth running with milk. I see a sentence like a canal, I see e-mail and instant messages running through a dry land. I see a page like a slice of cheese, intimate and culinary; I see a block of cheese called a book feed three hundred thousand schoolchildren. I see a hedge with a hole in it.

I go through the hole in the hedge in the hole in the sentence I wrote.

It is difficult. It is nearly impossible, but I fit.

I run through miles of arugula. I run through shadows. Shadows! By moonlight, I cross the river.

Readers, you might object that this page is also flat. These words— "milk," "rain boots," "goop," even "I": print on paper. My Flat Daddy and I lie edge to edge in this sentence, only an "and" between us. I might be accused of being the very kind of thing I have denounced: the billboard calling the bas-relief flat. I have tried to

dismiss the evidence that I am a figure study, portrait of the artist as a young cheese. That my delivery was at the hands of a paper boy. But it may be that this page is the only place I have known my Flat Daddy, or the one I call corporal. It may be that "blistering" is the only blistering I have ever known, that I am not deeply sorry or deeply anything—deeply flat?; that I have no parents, only an editor. There is no goop, only a florid sentence on a dry page.

Flat is as flat does, you say—you solid ones, you between the sunshine and your shadows. But if the only Milk Zone is the one I make with sentences, then I will farm this page, safeguard it with a yellow river of journalism, build a home out of columns of print. If there are no redemptions but "redemptions" no spell but spelling no god of healing but the name Asclepius, then I will believe in names and take action in 2D.

If my Flat Daddy is written then he can be edited.

I am writing this from a cottage in the Zone. Outside, children paddle in the yellow river. My father is doing the crossword. He has misspelled Mississippi, and milk is running from his paper heart.

I write, To my readers:

I am your missing child!
I am citizen justice!
I fight in the name of Asclepius!
I fight in the name of the Milk Zone!
I disclose the heart of the news!
The foggy, foggy heart!
I fight with cheese!
I fight with goop!
Formidable cheese!
Intrepid goop!
Flat Daddy, I edit your beard!
Flat country, I edit your news!
I am your nemesis!
BIG CHEESE NEMESIS!

Catchphrase, Pops, catchphrase!

The Next Country
Michael J. Lee

ONE SPRING AFTERNOON, I rose from my bed of needles in the backyard and took in my surroundings. A few squirrels were playing games in the tree above me, some ants were swarming over a Popsicle stick I had dropped some days earlier, and a train was hurtling through the bad parts of Balltank, my town, blowing its whistle and warning all the children and the mentally ill playing on the tracks to get out of the way or risk losing their lives, which are, no matter what the cynics say, full of promise.

The reason I was able to sleep late during a workweek is because I had recently been let go from my job, where I was paid to shake hands for a living. I was never fond of my job in the first place, though, and was secretly praying all along that they would get rid of me, even though I was earnestly shaking every hand that was put before me up until my very last day. My employers didn't specify the reason they let me go, but I knew that they probably had a decent reason for doing it, even if it did create a financial hardship for me. People generally have perfectly good reasons for doing the things they do, even if the things they do are sometimes downright ghastly. But all in all, my employers and I parted on good terms, which is the most anyone could hope for, I think, when waving goodbye.

One positive aspect to being let go from my job was that I suddenly had much more time on my hands. However, having no spending money had a few unexpected effects on me. For one, I couldn't pay any of my bills, including my rent, so my landlord evicted me and locked my house, and as a result, I had to spend my days out of the house, in the backyard, hidden behind some shrubs. I didn't want to meet my landlord, because if there was ever a person bound for Hell, it was him, and I hadn't yet had the displeasure of meeting him when I wasn't fully paid up on my rent. You might think that I was taking a terrible risk by sleeping illegally in my backyard, and you would certainly not be wrong, but at the same time, Balltank had a zero tolerance policy against homelessness, and the last thing I wanted was to be incarcerated. The second thing that happened to me because I

was let go from my job was that I had to stop my substance abuse, which had become a little extreme, and if anyone ever asks me what the experience of quitting the substances I was abusing was like, I would compare it to trying to wrench a wedding ring off a dead person's hand.

I wasn't in a bad mood that afternoon, but I was feeling a little out of sorts. Besides my having to rough it and my lack of substances, I didn't really have a plan for the future, which was kind of frustrating. To make matters worse, hunting for a job in Balltank was almost out of the question, given the dismal state of the nation's economy. Also, sobriety was not giving me the warm feeling I had hoped it would. I had about twelve dollars to my name and was strongly considering walking down to the convenience store around the corner and spending the last of my money on some substances, because I knew that being under the influence would at least give me the temporary clarity I needed to make a decision about what to do with my future. I was just about to head inside my house through the bathroom window I had wisely left open and root around for some pants (so I could at least appear decent for the convenience-store clerk), when The Man Upstairs decided to give me a sign. I'm not sure if He suddenly made the squirrel less agile or if maybe He sent a wind over the earth that caused the branch to sway just out of reach of the squirrel's claws, but either way, the squirrel didn't quite make the branch he had set out for, and he fell from the tree and landed on his back in the grass. He was all right, if a little lame, and after collecting himself, he kind of limped back up the tree to find his companion.

It always relieved me when The Man Upstairs decided to send me signs that didn't require the death of other living things, which He'd sadly been known to do before. If the squirrel had, say, landed on my concrete patio near my barbecue, he would have broken his little brain on the concrete, and I would have had to solemnly bury him or her, and I would have been so preoccupied and distraught by the gore and the burial process that I wouldn't have been able to devote the proper time to thinking about His sign. But even though He spared the squirrel that afternoon, I still wasn't sure what the sign was supposed to mean. This happened to me too often, I admit: I could always identify that certain moments were important, and could therefore be identified as signs, but I could never say exactly what I was supposed to take away from them. But in the end I reasoned it this way: The tree is alive, the grass is alive, and the squirrel is alive,

just like I am alive. However, the grass is a plant, just as the tree is a plant, and the squirrel is an animal, just as I am an animal, so I decided that the squirrel was symbolic of me, because squirrels are alive and animals, and that the tree was symbolic of my longed-for substances, because substances are certainly not animals. With this knowledge, I decided that if I had left for the convenience store to get my substances, something bad would have happened to me. Right or wrong, that's what I felt, and I knew I had the symbols to back it up.

I sat down on the concrete, next to my barbecue, and without even realizing I was doing it, I pulled my phone from my shirt pocket and dialed my Sweetheart's number. We hadn't spoken in several months, since the day I called her and asked her nicely to move to Balltank and have my baby. She hadn't accepted my offer, unfortunately, because she couldn't afford a ticket to Balltank, and because she didn't want to scale down her luxurious lifestyle in order to raise the money for one. Even though I was still a little sore at my Sweetheart for not capitulating, she was still my Sweetheart and, besides, a very talented conversationalist, and always knew how to force me to think about my life in a thought-provoking way.

Also, please don't ask me who was paying for my cellular phone. I signed up for a plan back when I was still employed and making a moderate living, but for some reason the bill never came home, and yet my phone continued to work. I wasn't so green as to assume that The Man Upstairs had anything to do with it; I knew full well that there was probably some father or mother somewhere just blindly paying the family phone bill, not noticing that they had adopted an extra child without knowing it. I felt bad about this, but people really need to learn to read the fine print if they are going to get ready for Heaven.

"Hello?" a woman said.

"Hello," I said. "How are you, Sweetheart?"

"This isn't your Sweetheart," she said.

"Always a joker," I said. "How are you?"

"This is her roommate," she said. "This is not your Sweetheart."

"You sound an awful lot like her," I said. She really did. The vocal resemblance was striking.

"Pure coincidence," she said.

"I'm sorry," I said. "I thought this was her phone number."

"It is," she said. "But this is not your Sweetheart."

"Is she around?" I said. "It's really important that I talk to her."

The woman sighed. "I'm sorry to inform you that your Sweetheart

has died. And if I have to say that awful line one more time, I'm just going to throw her phone in the trash."

I wasn't sure whether my Sweetheart was putting me on or whether I should begin the grieving process. "What is my favorite thing?" I said, knowing that only my Sweetheart knew the answer to that question.

"Frankness," she said.

"No," I said, though she was in the ballpark. "Try again."

"Openheartedness," she said.

"You're getting closer," I said. "One last try."

"Emotional baldness," she said.

I decided that if it really were my Sweetheart on the other line, she would have known that my favorite thing in the world was Heaven. Now, a close second was honesty, which she seemed to be getting at, but I felt that I could have dragged the questioning out into eternity, and she would have only gotten fractionally closer each time. "Is my Sweetheart really dead?" I said.

"If she isn't," she said, "someone raised her without telling me."

I knew that the only person in the universe who could raise the dead was The Man Upstairs, and that He was careful only to raise those who were Believers. "The Sweetheart I knew wasn't a Believer," I said. "Did she see the light in the end?"

"No," she said. "There's really no way your Sweetheart was raised."

At that moment, I felt a little confused, and I knew that it wouldn't be long before my tears began flowing uncontrollably. I had always hoped that my Sweetheart would see the light in the end. "Who are you?" I said.

"I'm her roommate," she said. "I hope I won't have to repeat that again."

"Do you have a name?" I said.

"It's very generic," she said. "It's not worth remembering at all."

"Well, what is it?" I said.

"My name is Teethpart."

"Oh," I said. "Is that ethnic?"

"Not in the least," she said. "What is your name?"

"I was never officially given one," I said, which was true. "I've been called a lot of things in my life, but nothing really sticks."

"How do you fill out an employment application then?" she said.

"I just make up any old thing," I said. "Can you tell me a little about how my Sweetheart died?"

"I suppose," she said. "Who are you, anyway?"

"I was your roommate's Sweetheart," I said.

"She spoke to me about you," she said.

"What did she say?"

"Oh, tender things. She regretted not having your baby, that's for sure."

"Really?"

"She thought, in the end, that it would have been a worthwhile investment."

I wiped a little tear from the corner of my eye. "It really wouldn't have worked out anyway," I said.

"Why is that?"

"Because I was let go from my job," I said, "and wouldn't have been able to provide for the two of us, let alone my baby."

"What did you do for a living?" she said.

"It's not important now," I said. "What's important is that I'm not exactly certain what to do with my future."

"Do you have a plan?" she said. "Plans are often good coping mechanisms."

"No," I said. "That's why I was calling my Sweetheart, so she could straighten me out a little bit."

"Describe your situation," she said. "Otherwise, I'll be of no assistance."

"Well," I said, "I was let go from my job, and as a result, I've been unable to pay my bills and been forced to give up the substances I depend on for my clarity. I've been sleeping in my backyard because my landlord has evicted me and because Balltank, as a whole, frowns on vagrancy. I have about twelve dollars left and desperately want to spend it on some substances, because they give me a feeling of clarity, but at the same time, I have reason to believe that going to the convenience store would result in some sort of bodily harm for me. On top of all that, it seems that my Sweetheart has just died, and I'll now have to factor in bereavement with everything else I just said."

"Why don't you spend those twelve dollars on a good meal?" she said. "A solid meal from a chain restaurant seems to make the most sense."

"Why a chain restaurant?" I said.

"Because you are almost certain to know what you are getting," she said.

"I have plenty of food," I said. "Meals are just about the least of my worries."

"How can you afford it?"

"I left the bathroom window open a crack, so I can go into my pantry anytime I want and eat the canned goods I've been stockpiling."

"That seems rather apocalyptic of you."

"Not at all," I said. If I was anything at the time, I was certainly not apocalyptic. "I used to eat out a lot when I was abusing substances, and then I'd feel so guilty for doing this that I'd make myself go to the store once a month and buy canned goods so I would eat healthier and spend more time at home."

"I see," she said. "What about water? Human beings need water to survive."

"Some of the canned goods have a good bit of juice in them, so I drink that."

"How long can you survive on what you have?"

"A few more days," I said. "But right now the twelve dollars is burning a hole in my pocket."

"I don't envy you," she said, "but I do pity you."

"Don't do that," I said.

"Why?"

"Because pity is the most heinous sin. It beats out cursing any day of the week."

"How would you rather I feel about you?"

"I don't know," I said. "But I do know that I'd rather you feel revulsion for me than pity."

"Revulsion it is then."

"Maybe you could find something in between," I said.

"How about feeling nothing at all?" she said.

"I guess," I said. "I don't really know you that well anyway." I then realized that we had stopped talking about my Sweetheart entirely, and this made me think of her in her afterlife, wherever that was, shaking her fist scornfully at me because I could so easily be distracted from talking about her. "What did you mean when you said that you never wanted to say that line about my Sweetheart's death again?" I said.

"What do you mean?"

"Surely you haven't referred to her as Sweetheart to every person who's called," I said.

"She had many Sweethearts," she said. "I even counted myself as one of them."

"She told me I was her only one," I said. I was hurt.

"I'm sorry to say that you weren't," she said.

At that moment, I didn't know what I felt worse about—my Sweetheart no longer being on the earth or the fact that she had many other Sweethearts. "But I'll bet I was the only one who wanted to have a baby with her," I said.

"No," she said. "She had offers from all directions."

"She didn't take any of those other Sweethearts up on their offers, did she?" I was letting envy overtake me, I admit.

"No," she said, "her baby was miraculously conceived."

"She has a baby?" I said. "Is it alive?"

"It's right here," she said. "Do you want to say hello?"

"Yes," I said. "Does it look like my Sweetheart?"

"Oh yes," she said. "Here, say hello." I heard the reception crackle.

"Hello," I said. "Hello, baby." There was silence, and then the reception crackled again.

"It couldn't hear you," Teethpart said.

"Why?" I said.

"It was sleeping," she said.

"Well, when it wakes up, tell it hello for me." I then realized that I still didn't know anything about my Sweetheart's death, beyond the fact that she had given birth to a miracle baby before she passed on. "How did my Sweetheart die?" I said.

"It was complicated," she said. "Very complicated."

"I have plenty of time," I said.

"To make a long story short," she said, "Sweetheart made a bad investment."

"How bad?" I said.

"Simply ruinous," she said. "Can you hold for a moment?"

"I guess," I said.

"Someone else is calling," she said. "I'll try and make it brief."

"Try not to take too long," I said, "or I might start my journey to the convenience store."

"That's your decision to make," she said.

If there is one thing I find truly disrespectful in this world, it is being put on hold, because it strands you in a nasty little space in between two realities. Half of me was there on the phone, just waiting for Teethpart's return, and the other half was trying to take in my surroundings in the yard, and I didn't seem to be giving either the full attention it deserved. After a few minutes, I grew very impatient and decided to commit myself more fully to my surroundings in the yard. I rose from the concrete and did a quick jog. Then I started

stretching, which I would have continued, except that I saw my landlord coming around the corner of my house with a ladder, and I quickly ran back to my bed of needles behind the shrubs and lay down. Then I tried, in vain, to grieve properly for my Sweetheart. I just couldn't believe that she was gone. She didn't deserve it one bit; she was my age, and was full of promise. The Man Upstairs obviously has his reasons for doing things, and they aren't for us to know, but that doesn't mean we still can't be bewildered once in a while by his apparent lack of humanity. Over the shrubs, I heard my landlord begin to hum something ugly to himself, something about the pleasures of preying on human weakness, and just as I thought I was going to be driven mentally ill by the song, I heard Teethpart breathing on the line.

"Hello?" I whispered into the phone.

"Hello," she said. "Thank you for your patience."

"I have to be quiet," I said. "I'm not where I'm supposed to be."

"I'll listen more loudly," she said.

"Who was that calling?" I said.

"Another Sweetheart," she said. "And he was more emotional than the rest."

"Sweetheart tended to make people emotional," I said.

"That was her special gift," she said. "You should have tried living with her. She broke me down so thoroughly that I was never sure who I was."

"That's not such a bad thing," I said, but I didn't even know what I was talking about.

"Oh yes," she said, "I agree. Complacency rots the soul."

"I can understand how people would grow attached to her," I said. "She was so headstrong."

"She was the most important person in my life," she said.

"Mine too," I said, though I really placed myself above others, even though my Sweetheart was a close second. "How are you coping? Did you have to quit your job to be able to grieve?"

"No," she said. "Sweetheart's parents paid for me to quit my job, so I could answer her phone full-time and deliver the tragic news."

"So you have money?" I said.

"Too much money," she said. "And between answering the phone and caring for her baby, I have no time to spend it."

"I could care for the baby part-time, if you needed a little time off."

"But you couldn't provide for it," she said.

288

"No, but I could care for it," I said. I felt a little seep of pride in saying it.

"I'll think about it," she said.

"How did my Sweetheart die?" I said. "I'm really, really curious."

"I thought I told you," she said.

"We were interrupted by that other Sweetheart," I said.

"Like I said, it was very complicated."

"I hope it wasn't painful," I said, and I really meant it, though I was still a little angry at my Sweetheart for her infidelity.

"I don't think so," she said. "I think that when someone decides to end their own life, they have already gone to a place beyond pain."

"She committed suicide?" I said. "That doesn't seem at all like the Sweetheart I knew."

"What Sweetheart did you know?" she said.

"The Sweetheart I knew was pretty good at not letting the world get her down," I said.

"Well, it finally got her down," she said. "Your Sweetheart is living in Heaven now."

"How can you be sure she's living in Heaven?" I said.

"That's what her note said, so I'm inclined to believe her."

"Heaven is my favorite thing," I said. "You almost guessed it earlier."

"It's so lovely to dream," she said.

"Heaven's no dream," I said. "It's as real as you and me."

"Terrific," she said, though she didn't sound as if she meant it.

"But the thing about Heaven is, you can't go if you commit suicide."

"Who says?" she said.

"Well," I said, "that's just not how it works. Suicide isn't the shortcut it appears to be."

"Why not?" she said.

"Because," I said, but then I trailed off, because I wasn't so sure. Sometimes my knowledge just fails me. It's something I have to work on.

"Perhaps," she said. "I did think that Sweetheart might have been a little hasty in her decision to leave the world."

"What are your plans for the future?"

"None," she said. "My plan was to answer Sweetheart's phone until the day it stopped ringing, and then I was going to follow her to Heaven."

289

"That doesn't sound like any kind of plan," I said. "What about the baby?"

"Her baby loves the idea of Heaven. I was going to bring it with me."

"Babies don't know anything about Heaven," I whispered more loudly. "It takes a very mature mind to start thinking about the afterlife."

"So what?" she said.

"You should never end a life," I said, "because lives are full of promise, no matter what anyone tells you." I had never felt more strongly about anything in my life.

"That's a sweet thought," she said. "But I really don't give—"

Unfortunately, I couldn't hear the rest of what she said because another train came hurtling through the bad parts of Balltank, screaming its whistle.

"Was that a train I heard?" she said after the whistling had died off.

"Right on time," I said. "What did you say just as the train came through?"

"Nothing of importance," she said. "Does the train go north?"

"I don't see how it could go any further south," I said. "What did you say?"

"Get on that train," she said.

"Why?" I said.

"Get on that train," she said.

"Twelve dollars won't even buy me a dinner in the dining car," I said.

"Get on that train," she said. "Slip into a boxcar."

"It's as easy as that?"

"It's as easy as that," she said. "I'll meet you at the border."

"Why?" I said.

"I have something for you," she said.

"Are you going to give me our Sweetheart's baby?" I said.

"If not the baby, something of equal value."

"Like money or substances?" I said.

"You'll find out at the border," she said.

"What border?" I said.

"The border to the next country," she said.

"Is life noticeably better in the next country?"

"No," she said. "But their economy is strong."

"But I'll arrive with no money," I said. "Will they take care of me there?"

"I don't know," she said. "What other options do you have?"

I had to admit that she had a point. "How will I know you?" I said.

"I will bear a striking resemblance to Sweetheart."

"I never saw her in person," I said. "We had a strictly long-distance relationship."

"You will know me," she said.

"But how?" I said. "You pass so many people on the train."

"You will know me," she said.

"Can you put a flower in your hair or something?"

"There are no flowers at the border," she said, "and I have no hair."

"I guess I will know you then," I said.

"Good luck on your journey," she said.

"Good luck on yours," I said.

"I won't be making any journey," she said. "Your Sweetheart and I lived at the border."

"Well, enjoy your short walk then," I said.

"I will," she said. "Call her phone when you are close."

Then I suddenly became nakedly sentimental. "Come live with me and our Sweetheart's baby across the border until we grow old enough to earn a place in Heaven," I said.

"We'll see," she said. "Goodbye."

Then she hung up on me, though I couldn't blame her for abruptness, because we had pretty much reached the end of the conversation. I jumped up from my bed of needles and jogged to the bathroom window. My landlord called the name I had given him on the rental application, but I had already dived inside and didn't answer. I groped around in the dark until I found a suitable pair of pants and a plastic garbage bag. I emptied my cupboard, throwing all my canned goods and a can opener into the bag, then I jogged to the front door, unlocked it, and went out into the world, which was still unusually still. I passed the convenience store, which I cursed under my breath for its convenience, and because the twelve dollars were still burning a hole in my pocket, even though, in my hurry to leave the house, I had managed to misplace them. I made it to the railroad tracks and was surprised to find them surrounded by police and sympathetic onlookers. Unfortunately, this time, The Man Upstairs had decided to give me a sign that did require someone else to be put in harm's way, and He had thrown someone in front of the tracks just as the train was hurtling through Balltank, so I would have time to climb aboard. It was either a child or someone mentally ill, but I

really didn't want to find out which; the symbolic nature of the sign felt about as important as a stubbed toe right then. The Man Upstairs wanted me to leave Balltank, I was pretty sure. I slipped into a box-car, which thankfully was empty, and listened to the sirens, trying not to think about anything at all. A few hours later, the train started moving, heading north. On my journey, I ate canned goods when I needed the nourishment, and watched the country I was leaving roll by. I wasn't in a bad mood, nor would I call it a good one. It was just a little different from what I was used to. When I neared the border, I called my Sweetheart, but all I got was her answering machine. I couldn't bring myself to leave a message, and when I reached the border, the train stopped, and I squinted, but there was no one who fit her description. No Teethpart, no baby, and certainly no Sweet-heart. In looking hard for them, though, I must have stuck my head too far out of the boxcar, because the conductor spotted me and jogged toward me, carrying a railroad spike. He dragged me out of the boxcar, and asked me my name, and when I told him I had none, he beat me and beat me until I could only invent one, and I said my name was Sweetheart, and he told me to say it again, and I yelled that my name was Sweetheart, and he told me to say it again, and I cried that my name was Sweetheart, and then he picked me up with his pink and pitiless hands and threw me over the border, into the land of promise.

Dr. Eric

Rob Walsh

1.

DR. ERIC MARKED A FIGURE of high complexity and purpose onto Cathy's stomach and asked if she knew of the plan?

Dr. Eric did not want a son, and he reemphasized this point to Cathy, but, all the same, the doctor had come to feel strongly that Cathy should have a son and he was prepared to make certain personal sacrifices toward her accomplishing this.

His small instrument was made of steel, Dr. Eric said. He allowed it to drift closer to her face so that there could be no mistaking this. Cathy noticed then, beyond the blurry, ever-closer object that had cleaved her perspective in two, the figure of the nurse, idly swilling instruments in a sinkful of red water; Cathy noticed also a pile of clothes, which had the habit of leaving her body and reappearing in folded stacks.

Presently Dr. Eric measured a fist's worth of Cathy's hair and examined the strands that jutted between his fingers.

Cathy was in an unresolved state. Directly overhead, a strip light passed a lingering, unfair notion of her skin, and Cathy rearranged herself to present a better case to the doctor. His hand approached her shoulder.

Since she was able to have a son, the doctor said, and others, such as this nurse, were not, Dr. Eric said while removing from the scabbard at his hip another small instrument and pointing it at the nurse, then Cathy shouldn't let her son go to waste.

The doctor continued, for appearance's sake, to lengthen and make several new incisions on Cathy, but he had already saved her life some time ago.

2.

Dr. Eric removed an oblong black section of Cathy and asked if she would like to keep it?

Cathy shook her head. The nurse had been assisting with the

293

procedure and she too shook her head at this question, though it had not been directed to her.

Dr. Eric made a noise in his throat and the nurse half stamped, half ran to the chair he was pointing at.

She couldn't hear them anymore, Dr. Eric said; not if they talked like this, he said under his breath to Cathy. He indicated with a nod the nurse, who was now sitting far in the corner and picking knits off her uniform and dropping them on the floor. She was a strong, thriving nurse, Dr. Eric said; though, he added, she had a willful streak that could overcomplicate certain procedures.

Still, Dr. Eric said, as he tugged at the cleft of his chin, the nurse would not be having a son.

Which was fine by him, Dr. Eric added in a louder, faster voice that Cathy did not find plausible.

The doctor moved his head ponderously from side to side. Long ago, he had taken an even larger, darker quantity of the nurse and she had elected to keep it in a jar, he told Cathy. Progressing from this fact, he assigned each of Cathy's hairs, her head, torso, and limbs a numerical value, then averaged these figures to give Cathy his precise opinion of her. She was not used to thinking of herself in these terms and was surprised not only by the lofty sum, but that it should come from someone of the doctor's stature. Was Cathy's husband at home now? Dr. Eric asked.

He was not, Dr. Eric said; they both knew very well that Cathy was unmarried. The doctor stared at Cathy.

He leaned closer and put both his hands around Cathy's neck for a moment, then begged her pardon for it and left to consult the nurse.

3.

Dr. Eric replaced the cap on the jar of ink and asked if Cathy understood what she had put her signature to?

That day, Dr. Eric did not screw the cap on securely, so that when he stood up, in the same motion reaching down to pluck the jar of ink from his desk, the cap toppled and, perhaps intentionally, a blob of ink spilled onto his shirt.

For a while Dr. Eric did not acknowledge it.

For quite a while, actually. He stared at Cathy, waiting to see if she would acknowledge it.

During this period the ink spread nonconcentrically into a shape that seemed, at least to Cathy's mind, vaguely familiar.

If not an identical match, it occurred to her, then the shape at least shared something with the ambiguously blotted cards that the doctor often used to access Cathy's hidden feelings. And she did not much like those stained, irregular squares of paper he quickly flashed, nor did she appreciate the groans of disapproval that always seemed to flow from Dr. Eric no matter what angle of response she chose to give.

The doctor unbuttoned his shirt and hung it over a steel rack in the corner of the room. He returned to review the form Cathy had signed. She looked away, then she looked at the space between them, then with guilty, roving eyes she took in all of Dr. Eric's shirtless body.

4.

Dr. Eric had a slide in his step and he asked if Cathy was as restrained as he was on this fine day?

If Cathy was pregnant, or if she was not pregnant, it didn't make the least bit of difference to Dr. Eric, Dr. Eric told Cathy. While she did not find comfort in this, there was something tranquilizing about the doctor's conduct, the long, rolling movements of his eyes, and the lightness of his touch, as it coasted along her arm and from one fine hair to the next without touching the skin. Dr. Eric put his hand over Cathy's face. He pulled, alternately pressing, with a steady progression of force, until he had milked an expression of calm from her.

The nurse walked up to Dr. Eric and whispered something in his ear.

It seemed that Cathy's husband was still in the picture, Dr. Eric said, his voice bottoming out.

The doctor swiftly retracted his hand and put a checkmark in a small box.

Or was he? Dr. Eric said with another reversal of mood; he put his hand back over Cathy's face. This time, she felt a tremor pass through him, which she mistook, at first, for a vulnerability, perhaps a signal from the doctor's inmost self, the side he had not yet shown, but which quickly grew into a type of shock therapy that rattled Cathy back and forth.

5.

Dr. Eric's brows knit to indicate his confusion at the pants Cathy still had on and he asked if there was some kind of problem?

Impatiently Dr. Eric gestured to the nurse, as if to say, Get rid of it, and he turned his back as she wrangled Cathy's pants off and put them in a bag.

The doctor gestured to the nurse as if to say, Now you, and again turned his back in courtesy.

Presently the nurse and Cathy sat side by side on the plastic table. A field of perfume surrounded the nurse. Cathy scooted—imperceptibly, she hoped—toward its perimeter.

Dr. Eric, in the meantime, breathing heavily through his mouth, strapped sphygmomanometers to both of their arms.

He removed the inflatable cuffs and recorded their blood pressures on his chart, and proceeding from this step, took their body temperatures, respiratory rates, pulses, then hurt each of them a little, and asked them to classify it on a pain scale of zero to ten, then observed their pupils' reactivity to light while recording all of this onto the chart.

The doctor put his hands under Cathy's armpits. With a groan of exertion he lifted her high, near to the lights in the ceiling. In the same manner, he went on to lift the nurse up, as close again to the strip of fluorescent lights, to look her over appraisingly.

6.

Dr. Eric put on a pair of overlarge, irregular glasses and asked if Cathy believed such spectacles allowed him to see past the clothes she was wearing?

Dr. Eric let them fall to the ledge of his nose; he looked at Cathy very seriously. They were nothing more than a child's toy, the doctor said. He put them back in his desk and told Cathy that he would hear no more on the subject.

Still, whatever relief Cathy felt in the storage of this device was fleeting, and surcharged with regret, as, consequently, the doctor turned all of his attention from her and invested it in the paperwork before him. Here, in the absence of Dr. Eric's steady glare, was where she felt most exposed. For when Dr. Eric was studying Cathy, her place was assured. The unexamined life, Dr. Eric had once told her, was not worth living, and upon this word of advice he had wadded

up a paper towel and squeezed the fluid it had just absorbed into a glass container.

The nurse wandered in and the small room proceeded to fill with the scent the nurse wore.

Dr. Eric closed one file, opened another. His eyes puckered as he read something that did not agree with him and he shook his head quickly, as if to break free of it.

Cathy sat up on the plastic table.

She recalled, that day, not only her husband but his exact posture and the hat he always wore, but Dr. Eric said that these statements were inadmissible and he began to take apart, then loudly put back together, a steel mechanism, the clink and clatter drowning the remainder of what Cathy had to say.

7.

Dr. Eric was busy at that moment and he asked if Cathy would lie back down and not say another word?

Perhaps it was the jag of bone, having slipped from the confinement of Cathy's skin, that excited her that day, leading her to violate certain conditions of her stay, such as not displeasing him.

In these situations Cathy, where possible, kept her eyes shut, where impossible looked in all directions while blinking rapidly, and soon she had balled up both her hands.

All the while Dr. Eric had been staring at the nurse. In fact, he had been absorbing her for the duration of that day, head to shoes, which were orthopedic, standard issue, but made to seem extravagant by the thick, bulging glances he lavished over them. He turned his eyes up and down the nurse one last time, then side to side, as he unstoppered a small phial and downed the contents. Cathy's body could learn a lot from the nurse's body, Dr. Eric said. It was an independent, disciplined vessel, Dr. Eric said, entirely self-contained, and nobody would ever wake up one morning to find that it had multiplied. Also, it says here, Dr. Eric said as he whirled in his chair and held up Cathy's file, that Cathy is unlicensed, decidedly unmarried, and afraid of dogs with green collars.

With that Dr. Eric returned to his paperwork. He studied the contents of several thick files, signing his name to numerous pages of each. He put his pens in their holders, then his pencils. He flattened his hands one on top of the other. Soon this stack of fingers traveled down the grain and along the eaves of his desk. Then Dr. Eric, as if

absently, pulled on the lobe of his ear.

But this was just the signal the nurse had been waiting for and she jumped out of her chair and smeared Cathy's face with a glutinous substance.

8.

Dr. Eric asked if Cathy had an inkling of this man?

The picture was obviously of her husband. Cathy said as much and immediately the picture disappeared into her file, which then disappeared into the rest of the files.

That night, Dr. Eric again posed this question to Cathy. The picture had changed only by the darkness of the small room, lit indirectly by a hallway strip light, and the placement of Dr. Eric's hand, slantwise over the subject of the photograph so as to almost completely obscure it. Yet she offered the same identification and Dr. Eric started to speak, before she had finished speaking, and told Cathy to be cautious of what she said to him!

Dr. Eric would never examine a married woman, he told Cathy, his tone half shocked, half wounded. Cathy felt her heart flinch in involuntary regret for what she had implied, or had begun to imply, and she glanced at this organ with surprise.

Dr. Eric examined a strand of Cathy's hair. He shook his head. Her clothes also would need to go, Dr. Eric said.

As if just remembering something, the doctor produced a scalpel, which he allowed her to hold, then an older, encrusted scalpel, whose provenance he explained to her in detail. Children were loud, Dr. Eric said, as if having just remembered this, too; and for another thing, all wrinkled when you first got them; though, he admitted, in this aspect there was often room for improvement.

Time for Cathy's pill, Dr. Eric said. The doctor marked this determination not by an instrument of time but by a flash of nurse in the hallway; he proceeded after her at a businesslike trot.

9.

Dr. Eric adjusted the spread of photographs of one who had recently undergone the procedure and asked if Cathy was looking forward to it?

Cathy turned away, glancing around the room with extraordinary focus, it seemed, on everything but the indecent pictures laid before her.

Having little time to spare, the doctor warned her with a double-quick, sputtering groan, then tried to intercept her line of sight with a picture of a gloomy bald woman, when the nurse barged in.

The nurse announced that there had been a mix-up. Cheerfully, the nurse removed the initial set of pictures, which she told Cathy were so outdated as to be primitive, in their place arranging a new set of pictures.

Dr. Eric winced. He followed the nurse with his eyes. First one plastic glove, then the other slipped from his limp hands and drifted away, each toward a different square of tile.

Presently the doctor withdrew to stand in silence by a lathe in the corner of the room. From time to time, he laid his arm upon it gently, in what could be seen as an imparting of condolences.

10.

Dr. Eric explained that it was nearly impossible to concentrate when Cathy was wearing that particular outfit, or any outfit for that matter, and he paused, then asked if she was still married?

Dr. Eric went into the corner while she was changing. Over his shoulder, the doctor offered a few words to relieve the formality and put Cathy at ease, some small information about himself, as doctors will do, such as the temperature he preferred, where he shopped for clothes, and where he did not, under any circumstances, shop for clothes, and how little he wanted a son, then the doctor returned to Cathy's side and uplifted the paper gown she had put on.

When Dr. Eric, ungloved, touched her like this, Cathy, shut eyed, felt as if all her pores had been suddenly deobstructed.

Patiently he searched out a vein that was to his liking, for, as Cathy's veins had begun to scar and narrow, it required him to ply through most of her body until he found one that, in the doctor's words, was just the ticket. He hooked an IV line into it and she lost consciousness.

If Cathy ever had a child, she would probably want to name it Bernard. And not just because that had been the name of Dr. Eric's grandfather, he told Cathy's body, while the nurse, her posture thrust at an odd angle, appeared to be trying very hard not to look at him.

11.

Dr. Eric, as a rule, always ate in private and did not permit others to watch him swallow even the smallest morsel of food, but held the opposite position with drink, often taking long draughts as he treated Cathy or brooded over her file, and that day he asked if she wanted some?

It was milk, perhaps; it was sort of white and Cathy had watched the doctor pour it from a carton. But at this stage, it no longer looked like milk, as what remained in his glass was diluted by saliva, here and there flecked with black dregs that had migrated from the doctor's mouth.

Accordingly, Cathy said that she was not thirsty. But her answer seemed to quite startle the doctor and he took one and another short step backward.

Presently he returned to his desk, where he appended Cathy's response to her file.

Drink it, Dr. Eric said, not to Cathy but to the nurse, though he did not look or speak in the nurse's direction, just held the glass at arm's length as he said those words, and the nurse came over and downed it.

A memory broke. The first of that day, in clear rays over a tract of Cathy that had been languishing and she sprang upright and reported that, contrary to other memories, her husband was not in jail.

To this, Dr. Eric groaned and doubled the speed he had been writing in her file.

When the nurse wasn't looking, Dr. Eric folded a note and passed it to Cathy.

Later, also when the nurse wasn't looking, Cathy unfolded the note and tried to make sense of the sprawling equation, chains of infinitesimals, and various-sided shapes.

12.

Dr. Eric shifted his eyebrows to indicate a certain crate and he asked if Cathy was eager to know what was inside?

Cathy was a little curious at least, Dr. Eric said, as he began to smooth his hands along the slatted wood in gentle, polishing motions. Dr. Eric closed one eye suggestively.

When none of this stimulated Cathy's interest he began to rub his hands together very quickly while staring at the crate.

But Cathy had a more immediate concern. She remained hunched, silent on the plastic table, her blanket self-knotted and pulled tight around her leg.

At last Dr. Eric shuffled reluctantly back to Cathy. A small bone protruded from her. The doctor eyed it wearily as half his gaze seemed to remain committed to the corner of the room and the unopened crate. Dr. Eric's vision drifted, toward and away from Cathy in sluggish ripples, as if lost on a film of glutinous, standing liquid that has been agitated ever so slightly by a wisp of air or by the legs of water bugs that skim across the surface, in the intuitive yet senseless pattern of creatures who are aware only of the fact that they will die in a week, and Cathy noticed that the doctor's pupils had grown very large.

If, at some point, by some horrible coincidence, Cathy and Dr. Eric ended up with the same son, Dr. Eric said, she could expect a reasonable level of support from him.

From the doorway, the nurse's penciled eyebrows knit together as she took in this statement.

Dr. Eric got up and stood midway between Cathy and the crate. After a moment, he leaped onto the crate and in a flurry of gyrations attempted one last time to involve her in the item and the secret within, when Cathy blacked out.

13.

Dr. Eric was intolerant of delay and he asked if Cathy had decided?

His fingers unfurled in all directions, each straightening toward a different surgical instrument, a collection of the doctor's finest, arranged for Cathy's survey across a long white towel.

Dr. Eric trailed behind, looking over Cathy's shoulder as she paced slowly up and down the line. She gave each instrument her careful evaluation but was left unmoved. It was unlikely that any instrument, no matter how keenly edged or how gleaming with polish, no matter how pure the composition of steel, would entice her to be operated on, and Cathy shook her head.

To this the puzzled doctor shook his own head and pointed with renewed emphasis at the tools.

He had been thinking a lot, lately, of the likelihood of her child, Bernard, Dr. Eric said.

Cathy noticed that the doctor's longest finger was trembling and seemed to be urging her toward one in particular, of a thin, toothed

design, enhanced in its purpose by a spring mechanism.

Unexpectedly the nurse appeared in the doorway.

That day, the nurse was wearing a hat.

This fact would not escape Dr. Eric. He proceeded to blink rapidly, in the custom of one who cannot believe his own eyes. He made a quick, unintelligible noise, crowded to the limit with surprise, amusement, and fury.

14.

Dr. Eric asked if Cathy was satisfied with that look?

He put a sharp eye to the sweater Cathy had on, dismissed it, then ran the same eye over the rest of her clothes, dismissed them, and consolingly laid his hand on Cathy's shoulder. It was the doctor's conclusion that she wore these old-fashioned garments like an encasement.

He fled the small room with Cathy's clothing, her last connection to the material realm she understood and felt comfortable in, wadded under his arm.

Before long the nurse entered and dressed Cathy in the fashion that Dr. Eric was partial to: a simple, modern paper gown.

She laid her hand on Cathy's shoulder like the doctor had done. But, along with these sentiments, the nurse plunged in a needle that filled Cathy to the brim with a combination of powerful analgesics.

Later, when Cathy awoke and glanced around the small room in confusion, she observed that the doctor and the nurse were engaged in playful, then less playful sparring with short-handled, two-pronged utensils. But Cathy's consciousness would not go undiscovered for long and the nurse hustled over and injected her.

Still later, a soft voice woke Cathy. A whisper, close enough to thrill even the most slender, most delicate hairs along the ridge of her ear.

15.

Dr. Eric flared open his hand to showcase the item on display and he asked if Cathy had any idea what an instrument like that went for?

Cathy did not know, but the nurse, who had participated in this contest before, did, and she whispered the answer in Cathy's ear.

At the nurse's indiscretion Dr. Eric's jaw dropped so rapidly it appeared to dislocate. Had the nurse really just violated one of the

basic regulations of this game? Had she flouted the rule directly in front of him? Her small feet kicked then twitched as the doctor raised her off the ground and asked her several further variations on this question.

It was ruined now, Dr. Eric said.

All of it, he said, with an expansive gesture of his arm.

Dr. Eric's bottom lip was standing fully erect as he proceeded that day to pout with such an intensity that Cathy found it increasingly painful to look at him, and several of her organs flinched involuntarily.

A son would look and dress like him, down to the last particular, Dr. Eric snarled at the nurse. She began to inspect her makeup in a small mirror, which she flipped open emphatically. Perhaps, Dr. Eric said, he would also speak with the same inflections but less refined, less sophisticated than Dr. Eric, to a charming effect. Dr. Eric told the nurse to measure Cathy's heart and respiratory rates, then blindfold Cathy, then get out.

The nurse did three of those things. Dr. Eric had been playing chess by correspondence with a colleague from overseas and he swept the pieces onto the floor when the nurse did not obey.

16.

Dr. Eric reentered the small room and asked if Cathy knew who took the sample left on his desk while he was away, having mistakenly thought, Dr. Eric said, his tone wrung and bitter stressed, that in his absence Cathy was faithful enough to watch over the sample of urine?

Cathy could tell Dr. Eric, Dr. Eric said, his voice sweetening. He closed one eye reassuringly.

Moments ago, Cathy had in fact witnessed the nurse appear at the threshold, glide into the room, and tip that particular phial down the large front pocket of her nurse's uniform, in a false show of dusting. But Cathy did not report this to the doctor. She felt not allegiance to the nurse, not respect, not even goodwill, but a powerful awareness of the nurse's suffering, which, in some aspects, was indistinguishable from her own.

After Dr. Eric looked inside of Cathy and out, he sulked from the room with his arms crossed tightly against his chest.

Cathy, now as before, was the small room's only occupant. But each time she tentatively rose, Dr. Eric's head immediately poked

303

through the doorway and frowned her back onto the plastic table.

On the wall across: a poster of the heart, clarifying the operations of this most bloody, pumplike of organs, its severed ventricles spouting in every direction. The nurse's head poked in. She gave Cathy a crooked smile, playful at one corner and spiteful at the other, followed by a quick shake of the phial. The nurse covered her mouth to suppress a small laugh as her head poked out, closing one eye as it withdrew.

17.

Dr. Eric groaned for some while in a low, from time to time surging tone that seemed to question Cathy?

Just as resolutely as her lips parted to answer in each instance, they closed shut. Torn between her desire to submit and the grip of her dignity, Cathy's mouth continued to open and close in this manner, without intelligible remark.

Abruptly the doctor snapped his fingers and his attention veered toward a tower of boxes stacked high in a corner of the room.

The doctor would need to stand on a stool in order to reach the highest boxes of the stack, the nurse said in a hushed, fast voice that Cathy could not quite designate as a whisper or a hiss.

Dr. Eric proceeded to use a stool in exactly the manner she had predicted.

Next, the nurse said, if the doctor was interested in the topmost box, and it was likely that no other would satisfy him, this would mean straining upward on the tips of his toes, the nurse said, as her nails dug small plots into Cathy's shoulder, and suddenly, perhaps intentionally, Dr. Eric fell to the floor and struck his head against the tile.

He got up quickly. Dr. Eric's face was split by a wall of blood.

The nurse ran for the door but instantly hardened, remaining motionless as the doctor leveled his eyes on her. At the same time, Cathy tried to straighten but found that her posture would go no further.

Cathy, Dr. Eric, and the nurse were each located at different points in the room, equidistant from each other; this was not by accident. Casting quick glances between them, Dr. Eric utilized the fall from the stool to charge this symmetry with massive amounts of tension, blame, and imminent retaliation, and the doctor did not move from his spot for some while, nor did he allow anyone else to move from theirs.

18.

Dr. Eric did not feel nor had he ever felt anything stir inside him when he looked at Cathy and he asked if she, by chance, felt something stir when she looked at him?

Good, Dr. Eric said before Cathy had an opening to speak.

Now that that was out the way, Dr. Eric said, they could continue with the examination, and he skated his nails slowly up, then slowly down Cathy, until her back was ruled by five red lines. Suddenly Dr. Eric twisted his wristwatch into view.

With a cry of recollection the doctor shot from the small room.

Just as the doctor was striding clear of the threshold, however, something fell from his white coat.

After waiting what to her mind was an adequate amount of time for the doctor to return, Cathy put her paper gown back on, looked both ways, then walked carefully, from one toe to the next, toward the object that had fallen.

An envelope. Cathy flipped it over.

She jumped back. *Cathy* was written on it.

Her first instinct was to drop the envelope, then retrace her steps with rapidity. Then she glanced around, deciding to bury it under something. Finally she clutched it to her chest and climbed back onto the plastic table, where, a short while later, her medication kicked in and Cathy fell asleep, the letter centered perfectly on her breast.

The nurse entered. That day the nurse was eating a diet bar, and she looked closely at Cathy's sleeping face, then peeled back the wrapper and took another bite of the diet bar.

Gently the nurse untwined Cathy's fingers and lifted the envelope, at the same time exchanging—gradually, to an extent that counterpoised the object she was removing so that Cathy's slumber would not be disturbed by an increase or decrease in weight—the crumpled wrapper.

19.

Dr. Eric's eyes were closing as he rested his head in the crook of his arm, and in an overencumbered, creaking voice, he asked if Cathy would see that he was not dormant for long?

Dr. Eric was asleep.

An instant later Cathy was on her toes, as without a sound she

crept toward the doctor's desk. Cathy stood very close to him. For a period of several soft breaths she remained still, watchful of the prostrate doctor. Then she reached out to touch his face.

Reflexively Dr. Eric's hand sprang out to catch her wrist. To all other appearances, he remained asleep.

Held fast, as much by the bind of the doctor's grip as by the thrill of it, Cathy awaited her release. And when it became clear that such a thing was not forthcoming any time soon, she sighed but indulgently, as Cathy knew that being restrained by the doctor was not without its advantages.

Eventually, one by one, the sleeping doctor's fingers unwound, and with a luxurious groan he shifted positions on his desk so as to bury his head deeper into the crook of his arm.

Cathy massaged her wrists. She wondered then if the chafes would fade entirely or leave a scarred token for her to remember this incident by. Cathy investigated the corner of the small room but was able to uncover nothing of interest beyond a few spider corpses, which she covered with a paper towel.

Bernard! Dr. Eric suddenly cried, and he looked wildly around the room as if just waking from a terrible dream.

The Familiars
Micaela Morrissette

THE BOY AND HIS MOTHER wake late in the swampy summer mornings and sit on the edge of the porch drinking their first glass of water and spooning out their wedges of melon and picking the dead heads off poppies with their toes. They brush their teeth side by side at the kitchen sink and sometimes the mother lathers the boy's cheeks with almond soap and pretends to shave him with a butter knife, chattering in an arch accent that aspires to Cockney. They fill the wheelbarrow with the boy's stuffed animals and matchbox cars and his wand for blowing bubbles and his kazoo and tambourine and truck down to the pond where the boy lies in the hammock, holding his toys in the air and swooping them up and down and crooning to them, and the mother reads paperbacks in the deep, low wicker rocker, pushing the hammock gently back and forth with her foot.

For lunch there is French bread spread with soft cheese and served with purple pickled eggs and Jordan almonds. They picnic under the sycamore on one of the boy's old bed sheets, patterned with smiling clouds and pastel rainbows, too childish for him now, and suck the candy shells from the nuts, and see who can flick an ant the farthest. The sheet smells as the boy used to—hot, heavy cream, slightly soured, and powdered sugar, and cough syrup, black cherry.

They put on their cleanest clothes and drift through the heat down the dirt road to town, the mother pale beneath a black umbrella and the boy's head swimming in a man-sized baseball cap. They check at the post office for their bills and catalogs and postcards of the town, which the mother has sent to the boy on the sly, and they buy a wheel of licorice or a birch beer or a small wooden crate of sour clementines. They also buy a backpack, or some tennis shoes, or a lunch box, for the boy's first day of school, which is nearly upon them. With two pennies they wish in the fountain, and they walk home, carefully matching their steps to the footprints they made on the first leg of their journey.

They plant mason jars in the garden to steep their sun tea, and they blow trumpeting squeals on blades of grass. They play a game

that is both tic-tac-toe and hopscotch with chalk and stones on the cement walkway, and the mother turns the hose on the boy and washes off the chalk and dust and sweat while he shrills and capers. For dinner there are drumsticks, sticky and burnt, off the old gas grill, or hot dogs charred on sticks at the fire pit. Then cold red wine with seltzer water for the mother, and warm milk with vanilla and sugar for the boy, in the swooning, exhausted armchairs of the living room, with the white gauze curtains swelling at every breath of breeze.

The mother reads to the boy in bed, adventure stories about islands or magic pools or noble lovers or gallant orphans, or the boy tells ghost stories to the mother, in which crushed faces press against the glass of windows, or trees grown over graves sigh and weep and rustle their leaves. The mother sleeps on one side of an enormous mattress, under an avalanche of pillows, and in another room the boy sleeps in a red wooden bed and his legs and arms tumble over the sides.

It's dawn and the boy has woken early when the friend appears. It unfurls from under the bed. Its features have not quite coalesced. Its skin rises up like a blush. The mouth, full of rapid shadows, comes painfully. As the boy watches, its teeth emerge and its eyes take on their hues. It's both gawky and graceful and the boy is touched by the tentativeness of its existence. Its limbs fold out with small tremblings. The boy moves over in the bed and the friend huddles gratefully into the warm depression he leaves. The boy knows not to touch the friend as it is born. Shyly, the boy indicates that the friend is welcome.

The friend begins right away to tell secrets. Some of them are astounding, and the boy giggles in nervous exhilaration. Some of them the boy already knew without knowing it. The wonderful thing is that the boy has secrets too, and the friend is fascinated, and they whisper under the covers until the mother pokes her head around the door, stirring honey into the first glass of their new batch of sun tea for the boy's good morning. The friend is under the bed so quickly that the boy has no time to feel alarm. But when the mother asks was he talking to himself, the boy responds without hesitation that he was talking to his invisible friend. His mother smiles and asks what's his friend's name, and since the boy doesn't know, he says it's a secret.

His mother smiles and looks proud in a forlorn sort of way and

brushes back his hair with her fingers and he feels the happy little pokes and tickles of his friend through the mattress, approving him, and all three are happy, and he drinks his sun tea with the honey not quite dissolved, coating his tongue and staying sweet there for some minutes. The damp smell that attends the friend, a stain of its birth, is clogging the air of the room, but the mother says nothing and the boy thinks that perhaps the friend is invisible after all.

That day it rains and the boy and his friend play in the attic. There is a trunk full of clothes and dust and the boy's friend dresses up as the princess and the boy as the minstrel without any money, or the boy dresses up as a monster of the air and the friend as a monster of the deep, or the boy dresses up as a man of the future and the friend holds over his face a helmet that carries the boy through time and space. The rain assaults the roof of the attic. They have stores of crackers and dried fruit and they plant flashlights all over the floor, the beams gaping up at the rafters. There is a box of paper houses that unfold: castles, a Hindu temple, a Victorian country home. They set these up and populate the rooms with colored plastic figurines from sets of jungle beasts, dinosaurs, and the Wild West.

The Christmas tree is stored in the attic, still tangled in its lights. The boy and his friend creep in under the lowest fronds, curling themselves around the base, and turn the beams of their flashlights out through the strings of dead bulbs to make them glow.

Between the panes of the windows are cemeteries of moth wings and wasp heads and fly legs. The attic swells into the rain.

They find a punch bowl roped in cobwebs and fill it with water and stare in to see the silk awake. They turn off all the flashlights and haunt each other in the dark with sobs and screeches. They roast marshmallows with a butane lighter. The boy recites the alphabet backwards. The friend dances.

By nightfall the sky has cleared and the mother takes the boy out onto the slanting roof of the house and they lie on their backs on the shingles and she shows him the constellations. The dippers, the hunter, the seven sisters, the two bears. The mother tells the boy how the stars are immense balls of flame millions of miles away, and how many of them may already have been dead for hundreds of thousands of years.

Hidden behind the stack of the chimney, the friend laughs in derision and reaches out its hand and rubs the pattern off the sky. Then it draws new figures: the claw, the widow, the thief, the cocoon. The planet shudders and rocks and the boy loses his grip and skids down the plane of the roof until the mother catches his hand and pulls him to safety. She bundles him into her arms and totes him down the attic stair, soothing and scolding and breathless, while he cranes his neck to peer behind him at the lights scattering across the dark like startled starlings.

The boy and his friend play in the garden, under the sun. They play in the garden, which is on the edge of the wood, and the trees shade it, many games. They play pick-up sticks, checkers, hide-and-go-seek, and things, and the sun enacts changes in their skin and hair and eyes. They play in the garden, and smile. They smile and smile and smile and smile and smile.

The boy's mother puts an extra cookie on the plate for the friend, but the boy says the friend doesn't eat. She brings an extra pillow for the bed, but the boy says the friend doesn't sleep. What does it do all night then, she asks the boy. Doesn't it get bored? Plays in my dreams, the boy tells her.

The boy and his friend make shadow puppets in the afternoon. The boy curtains the windows and holds his hands in front of the lamp and does a bird, a rabbit, a hunchback, a spider. The friend opens the curtains and crouches on the windowsill, a black silhouette against the sun. The sun pulses and shivers in the sky and the outline of the friend flickers and wavers at the edges. Its body makes an ocean wave, a spouting volcano, a hurricane, a shape-changing cloud: giraffe, dragon, whale. The boy crows and claps his hands. The friend grows huge in the window and blots out the light, making the night sky. It spreads its limbs so no sliver of sunlight peeks through and it makes the bottomless well.

The boy's mother sits on the edge of the tub and the steam clings to her; she is composed of droplets. At bath time the friend disappears,

the boy says; it hates water. The mother runs the hot when the boy complains that the bath is cooling. She shampoos the boy's golden hair with the tips of her fingers. She rubs the puffs and cracks of deep pruning on his hands. When he announces that the bath is over, she starts a splashing war to make him forget.

The boy has a duck for the bath, and to play with the duck, an inflatable bear, and to amuse the bear, little pills that pop open into sponges, and to collect the sponges, a net with butterfly shapes sewn into the webbing, and to transport the net, a battleship that sprays water through its nose, and to fight the battleship, a tin rocket that rusts in the water, and the mother cuts her hand on the crumbling metal and the blood makes a blossom in the bath. The boy leaps up and shouts out that his friend is calling and he runs shivering and half drowned out of the bathroom.

The mother stays behind and bandages her hand into an enormous white paw. When she tucks the boy in that night, she brandishes the paw and growls and tickles his stomach. But he says the friend can smell the rusty blood and he insists that she leave, and she does and wonders if the boy is weary of her or protecting her from his imaginary friend, and she sits for an hour in the window seat in her bedroom, watching trees and clouds move across the reflection of her face in the pane.

The boy and his friend camp out in the treehouse. They make believe there's a siege and they're starving to death. They make believe there's a war and they're hidden in a priest's hole. They make believe it's a nuclear winter and they're trapped in a fallout shelter. They make believe they're princes locked in a dungeon by the king's wicked councillor. They make believe they're hermits fasting in a mountain cave. They make believe they're stowaways in the hold of a galleon. They make believe they're magicians tied up in a chest. They make believe they're scientists in a sunken bathysphere. They make believe they've been swallowed by a giant and explore the vast cavern of his stomach. They make believe they're in a spaceship warping through black holes. They make believe they're shrunken to the size of tiny bugs, stuck in a raindrop falling to earth. Sometimes they climb through the trapdoor out into the treetop and sit astride the sturdy limbs and pretend they're galloping on white stallions in a thundering herd of wild black horses.

Sometimes they close their eyes and pretend to be blind and they

311

feel each other's faces and the boy is careful not to hurt the friend. Sometimes the friend grooms the boy, picking the bark and sap from his hair and licking the pollen dust from his face. Sometimes the boy curls up in the lap of the friend and the friend asks him questions. What animal would you like to be? What food would you eat if you could only eat one? How would you choose to die? What is your greatest fear? What superpower would be the best? If you could save the world by sacrificing one life, would you do it? What was your first word? What is your earliest memory?

The mother calls the boy into her bedroom and shows him the photographs she has spilled out over the white froth of tumbled linens. The scent of the soap washed into the sheets has always reminded the boy of snow, but tonight it stings his cringing nose, astringent.

She shows the boy pictures in dull umbers and maroons, long-ago film, of the boy's parents before he was born. This is his mother, distracted in an itchy sweater, in a cabin on her honeymoon, lamplight the color of cooking oil shining and blurring on her face. Her hair is shorter and it looks rough and blunt and prickly. Her smile is unfamiliar. Here is his father, forehead buried in a dark navy watchman's cap, chin and nose smothered in a charcoal turtleneck, marking off a pale strip of skin out of which black eyes gape, the inverse of the bandit's eye mask.

Now pictures of the boy as a baby, with a fat, lolling neck and a glazed expression, bulbous and gaping in a matted blue towel, or seemingly deserted in a flat field on a gray day. The photos get glossier and brighter as they go on. Last year on the ferry, noses and eyelids smashed flat by the wind. This past winter, roasting potatoes in foil in the fireplace here, the lighting off, their hands red and their faces smeared across the exposure. The boy and the mother on the boy's birthday at the zoo. A leather-chested gorilla with blood in its eyes stands behind them as they pose, the spit spray of its roar fouling the glass wall of the enclosure. The boy squirms on the bed, bored and truculent.

In the night the boy and the friend sneak back into the mother's bedroom and steal the box of photographs. They draw the friend into the pictures: sometimes a black zigzag of shadow at the corner of the frame behind the mother, sometimes a silvery trail the friend makes with the point of a needle, a shape hovering between the boy and the lens. With crayons, the boy draws the friend's scales and the stripes

of its fur onto the face of his father, and the friend shades its own eyes within the eyes of the gorilla.

When the mother finds the pictures in the morning she cries and screams at the boy, and he takes off, kicking the ground, the corners of his mouth wrenching down despite himself, and runs to the wood, and begs the friend to take him inside, behind the tree line, and the friend does, and comforts him.

The boy and the mother make up and on Sunday they bake cookies for breakfast. They have a collection of cookie cutters and they bake pigs and crescent moons and hearts and maple leaves, royal crowns and saxophones and lighthouses and bumblebees. They sprinkle jimmies on the tops, or push in currants with their thumbs. Shivery with sugar, they bustle into town and the mother, rapid and excitable, buys suspenders and striped shoelaces for the boy's first day of school, and a set of stencils, and stickers that smell of chocolate, bubble gum, peanut butter, and green apple. On the way home she asks casually how the friend will keep busy when the boy is at school all day. It will come with me, says the boy, startled, and the mother, kind and vague, shakes her head with her eyes set on the distance.

When they reach the house, the boy tears through the rooms, but the friend is nowhere to be found. At last the boy discovers it in the basement, huddled beneath the stairs, tearing apart a daddy longlegs. I won't go! promises the boy, and any other supplication he can think of. By and by, he's able to coax the friend upstairs, where it scuttles into the boy's bedroom and under his bed. It stays there through the evening and all night, and in the morning the mother sees the boy's face is puffed and flushed as if he's been stung, and his eyes have a queer translucence.

The mother invites the boy and the friend to dance. She pushes the armchairs and ottomans to the outskirts of the living room and sweeps the floor, making an odd pile of broken dried leaves, frayed and twisted threads of gold and purple, small slivers of glass, dust clumps woven in spheres like tumbleweeds, and wasps, curled in on themselves like fetuses, their antennae shattered.

The mother wears an ivory slip and black opera gloves and, on a long chain, a cameo that chills her through the thin silk of her slip. The boy comes down in his small black suit, which still fits him

313

perfectly. He hasn't grown. The mother rummages in the spare room for a man's dove gray fedora, which engulfs the boy's ears and slips backward, the brim chafing his neck. Baby's breath is wedged in the band.

The boy informs the mother solemnly that the friend has sent its regrets. The mother, stymied, asks if he and she might go together to press the invitation, but the boy fuddles the needle onto the record and extends his hand without answering. The boy and the mother waltz awkwardly. Where did you learn to dance? says the mother. I thought I would have to teach you. My friend taught me, says the boy, are you jealous? The mother stares at him. No, she says, that's not it. The needle staggers into a gouge in the record. Oh dear, the mother says, what a shame. My friend loves this song, says the boy.

He puts his arms up trustingly, as if to be carried, high above his head, and his fingers curl around where the shoulders of the friend might be. They sweep about the room, the friend a confident lead, the boy swooning gracefully in its embrace. The mother forms an encouraging smile. I'll get some refreshments, she says, champagne with ginger ale, and lemon ices. Switch off the lights when you go, says the boy, still revolving. The mother hesitates, flicks the switch, and mounts the stairs. Sometime in the night the music skids to a halt.

She knows it's beautiful. She knows what kind of skin it has—blue veined, with a thick translucence like shellfish, bruising easily in a kind of panic. She knows because it's obvious.

She knows, because her son has told her, in a voice with a reverential, primal hush, like the silence of dim morning air at ease on still water, that his friend has a wonderful facility of climbing in the trees and running in the tallest, most whipping, stinging grass. She knows that a heartbeat will slow to the rhythm of its voice. She knows its eyes are colors from another spectrum. She knows the fine golden down that covers its limbs; she just knows.

She knows the ravishable tenderness of its throat. She knows the coils of its ears can provoke a dangerous hypnosis if regarded too long. She knows the razor sharpness of its elbows and the woozy perfume of its breath.

She knows that the rays of the sun are addicted to its body and that it drinks in the moonlight with upturned mouth. She's never seen it,

but she knows. She doesn't know the secrets it shares, the memories it hides, the fears it cherishes, or why it is vying for her son.

Past the tree line, just within the wood, is the skeleton of a burned-down barn, and brambles of blackberries and bushes of lady's slippers have gentled the ruins. Past the barn, a deer trail leads through a claustrophobia of clawing saplings and lashing briars, until the wood opens, and the floor is a miniature forest of tiny trees of climacium moss. Long gray vines sway from the canopy; the branches over which they're looped are lost in leaves and in the clouds of spores and insects that laze overhead. The boy grabs a vine and swings. He whoops once, then swoops silently between the trunks on the endless arc of his pendulum. The friend tugs the vine to a halt and brushes the boy's face in apology. Hurry, it says.

They trudge out of the forest of moss and down a short bank graceful with ferns and irises and ending in a stream that cuts through the wood. Water fleas flash in the current and the boy sees the velvety puffs of silt where crawfish have shot back under rocks from fear of him. Before the water, the friend pants in terror, so the boy tucks it in his pocket and hops carefully across the rocks to the opposite bank. The leaves of the wood rustle and sunshine shakes down in a brief warm, muddy rain.

Beyond the stream is the dank overhang of the cliff, under which round stones mark out a ring in the mud. There are some curls of burned metal, mildewed spent shells from a shotgun, and bones chewed by an animal. The friend breathes deeply here, and traces its hand against the soot smoked on the rock ceiling, and a silver skin oozes down to blind its eye. Up the back of the cliff they go, grabbing at tree trunks and clawing the dirt to ascend the incline. Then suddenly they've plunged to the top and the summer has fallen away.

The ground is covered with black and brown leaves, and the wind has shaken the treetops gray. There's a gravestone, white with chips of mica, with a carving of an arum lily garbled and shallowed by weather, and violets growing all around. All already ready, says the friend. The boy sighs. Let's run away, he says. The friend is silent. I'm hungry, says the boy. You're never hungry now, says the friend, and that's true. The boy shrugs. The friend ruminates, and chews a sprig of poison ivy. Suddenly its hot hiss snakes out and its tongue is in the boy's ear. Poisoned you! cries the friend. The boy screams his

laughter and he's running through the wood yelling, I'll find the anti-dote, and the friend strolls after him, smiling.

The boy and the mother sit Indian style on the boy's bed and play cat's cradle. The boy threads his fingers through the string to make the cradle. The mother slips her hands into the maze. Pinching the taut cord, she whisks the boy's fingers free, and makes the soldier's bed. The boy snatches at the intersections, and pulls them through themselves, and the candles shine in his hands. The mother reaches over awkwardly and twists the string. Its bite tightens around the boy, and his skin swells and reddens. With a wrench of her wrist, she constructs the manger between them. The boy's tiny fingers go dart-ing among the knots. Before she knows it, he's imprisoned in dia-monds. We won! exults the mother. The boy smiles at her. His eyes are prisms for the day's light. She sees that there's something he holds in his mouth, gleaming dark and wet. A candy, a tongue, a morsel of mercury.

The mother reaches slowly for the bowl of water that stands by her son's painting set on the night table, dips her hand in it, and with a panicked lunge, she flicks the liquid on the boy. It wrenches back on the bed with a jolt and a high-pitched moan. Her hand flies to her throat. She squeezes her eyes closed. Hey! protests the boy. What are you doing? Then he lurches for the bowl and begins to flick her back, in messy, muddy splashes. The mother quavers and laughs in great gulps. The paint water soaks into the blankets, patterning her legs and hands with blurred designs, mottled markings, scaly smudges in brownish red and brownish blue and brownish green.

She lets the boy spill out the whole bowl, and although she changes the linens and blots the bed with towels to soak up the moisture, he still makes her flip the whole mattress before bedtime, so that the friend can nest there with no fear of the wet.

The boy discovers the friend hidden away in the fortress that sprawls across the living room, layer upon layer of sheets and wool blankets and towels and clothes slung between armchairs. The friend is prone, half sunk into the floor, disappearing into the wood like a ship slow-ly submerging below the skin of the sea. The boy throws his arms about the friend and covers it with chafing kisses. The friend coughs faintly but its eyes flash into brightness, burning the boy where the

friend's gaze falls on him. What's wrong? the boy whispers fiercely. What's happened? You haven't gone, croaks the friend, you're here. I'm here, says the boy, of course I'm here.

The friend and the boy stand up and spin themselves in circles. Even when the dizziness has passed, the boy can't remember what's where in the room outside the fortress. The French doors, the fireplace, the grandfather clock have all lost their places. The friend draws three doors for the boy. Where do they lead? says the friend.

The boy thinks hard. The first door, he says, a garden full of delicious fruit that feels pain when you bite it. Your turn. The friend considers. It says, the second door: a world in the center of the earth where you're turned inside out. You walk backward, talk backward, and see backward. Third door? The boy imagines. Third door, he says, somebody else. You can live in their body, but they control all your movements and your thoughts. The friend laughs. Pick a door, it says. The boy spins and spins until he doesn't remember which door is which. He opens one and falls out into darkness.

In the yard, in her bathing suit and sunglasses, the mother sits rigid in the blare of the sun. Little worms of perspiration nose their way out of her skin and trail across her upper lip. Beside her is a glass of ice water; she picks it up to watch the blades of grass, pale with the cold of the glass, rise shakily from their crushing. Glossy crows settle over the lawn. She lies down but finds she can't endure the crawling of the grass across the back of her neck. A dragonfly comes crashing toward her face and she gasps. A gnat executes stiff seizures in the cold of the ice water. Her fingernails ache from the dirt packed beneath them. She puffs at a dying dandelion to make a wish, and the seeds blow back and stick to her lips and tongue. She plucks at the petals of a daisy, then beheads the whole thing summarily with a jerk of her thumb. *Mama had a baby and its head popped off!* she sings.

The boy is staring at the lion and he doesn't dare to move. The boy is in the big blue armchair in the living room, with the lamp in the shape of a dancing lady spilling light from the table beside him, but the lion, only a few feet away, is in darkness, a darkness that grows thicker and thinner, so the boy keeps losing sight of the lion, though neither of them is moving.

Into the boy's dream comes the friend, and the boy feels relief like

317

the sudden release of a waterfall that's been dammed up, and with his eyes he signals the presence of the lion to the friend. The friend stays very still, and the darkness blows like wind over its face, and the boy loses and finds the friend's features for hours. At last the boy comes to wonder, in a rush of urgency, why the friend doesn't slay the lion. Kill it! whispers the boy. Please, kill it! The friend makes a sign and the boy sees that he himself is holding a long dagger. Me? I can't, pleads the boy. Please, kill it. The friend gestures to the boy to make use of the dagger. The boy stares aghast at the lion. Its eyes are mournful like the eyes of the boy's dog that had died, but there's a low growl coming from it like the moans of the tomcats that fight in the yard at night. The boy doesn't move. The lion climbs painfully to its feet and pads over to the boy and lies down beside him. Wondering and trembling, the boy places his hand on the lion's head. The friend spins around, claps its hands, and screams, and the lion's jaws hurtle open and its roar is pounding the boy like blows, and his terror is gagging his throat.

He comes awake with the friend beside him in bed, laughing and fanning the boy's face. That was a close one! says the friend, twinkling. What were you thinking? You almost got us killed, it giggles, and cuddles. The boy falls back into sleep, with his eyes screwed tight shut against dreams, and his skin smelling sour with a dried crust of sweat.

The mother goes in the gloaming to the grave in the wood. She sits. Moths smack against her flashlight and are snarled in her hair. After some time, she climbs back down the cliff and wades into the stream, flinching at the bite of the water on her skin. She drops a ring, a small plastic figurine, and a gray fedora into the water. She makes three wishes. With her toe she buries the ring and the toy in the mud, and she watches the floating fedora tear against some bracken on the bank and be devoured by shadows. On the way home she bats in a fury against the thorns that snag her clothes and beat her legs.

She sits on the porch. The screaming of the mosquitoes, an incessant and furious anguish, is overwhelming; it seems to the mother that all the darkness of the lawn might be a black cloud of suffering insects; but nothing bites her. There's a damp smell and she feels her skin crawling, flinching away from her bones. Behind her, the screen door slaps against the jamb in the windless, ponderous night, and the

mother stays very still, only slightly stiffening her back.

Before dawn she goes into the boy's room and lifts his body from the bed. She bears him cautiously out of the house to the car, and tucks him into the backseat. His clothes are already folded on the passenger seat. In the minute between the starting of the car and rolling out of their driveway, the mother's alarm grows so fierce that her vision is blurred. Once they gain the public road, it's vanished, and she's calm and deadened. She drives to the school and she parks.

When the sun comes up and the doors groan open and the flag struggles into the pale air above her, she's ready. By the time the buses come marching in disciplined formation down the drive, he's awake. He doesn't seem alarmed by his abduction, just sleepy and bewildered and quiescent. They get his overalls on and his Velcro firmly strapped. He observes the patterns described by the hundreds of small milling bodies with grave interest. She holds on to his hand as far as the classroom door. For some time she sits in the car and watches, but nothing comes or goes until she does.

Alone in the house, the friend trickles from room to room, carried by a draft that floats past the curtains, through the walls, and around the doors. The molecules of the air bruise the friend's body and it suffers this.

In her car, driving, the mother thinks of the friend with shaken pity, and in his classroom the boy draws a picture with a blank face and long arms like tangled ropes and a sky full of dashes like rain falling like arrows or like shooting stars.

The friend drifts into a cobweb and clings there till its weight rends the strands and it resumes its meandering course. Where it drags along the floor, dust gathers on its skin, smothering the pores. The eyes of the friend empty and its mouth consumes itself. At last, with a sigh, it disperses.

At the end of the day, the mother watches to see that the boy files out with the others, and then in her car she shoots out ahead of the schoolbus to be ready to greet him when he jumps down the steps to disembark at the end of their drive. He's glowing like a new penny and he navigates the yard in a series of bounds. He has a collage for the fridge of black horses pasted on a picture of a coral reef, and he has a caterpillar made of pipe cleaners. The mother and the boy

nestle the caterpillar in the grass at the base of the sycamore to protect the treehouse.

There are mimeographed lists from the teacher, of Things to Buy and Things to Do, and the boy has won a ribbon for thinking of the most words beginning with A. At lunchtime the other children had raised an outcry over the boy's purple pickled egg, and the mother promises that tomorrow he will have a white-bread sandwich cut in triangles and an apple with a leaf still on the stem. For recess they learned to jump rope while singing songs and afterward the teacher read a story that the boy had never heard, about a child who flies on the back of the wind. The boy runs about the house, visiting the attic and the basement and the bathroom, as if to see how different they've become. He told a girl in his class about the pond and the girl didn't believe that he has one and the mother says that the girl can come and see for herself, with some other of the boy's classmates, if he would like.

During dinner the boy bounces up and down, upsetting the jar of cucumber salad. He runs out twice to make sure that he has everything in his backpack that he'll need at school the next day, and three times to check that the caterpillar is still in place, guarding the treehouse. He doesn't mention the friend, and his eyes are the color that the mother remembers.

By bedtime the boy is exhausted and the mother tucks him in and sings, *Mairzy doats and dozy doats and liddle lamzy divey* and he accompanies her in a contented blur of humming that spins around the edge of the tune. When she turns out the light and clicks closed the door he's already quite asleep.

He wakes not because of the volume of the breathing in the room or because of its horrible wet crackling and sucking, but because of the heat the breath gives off, a heat like an anvil, which crushes him into the bed. The windows are fogged over and the moon leaks through the droplets on the glass in weak smears of sickly light, like the ghosts of murdered stars.

He knows his waking has been noticed, for whatever it is is now holding its breath. He can hear the interminable, deliberate creak of the floorboards where something is shifting its weight under the bed with infinite caution and cunning. Then a terrible quiet. The boy

quakes and his spasmodic gasp is like a slap cracking across the silent face of the darkness. The longest pause. At last the bed begins to joggle teasingly and then to rock violently so he can barely keep from sliding off. Every time his hand or foot slips over the side of the mattress he sobs with terror and feels the humid wind where something has just missed its snatch at him. The earthquake in the bed is because the thing is shaking with laughter. Whatever is under the bed is laughing.

Then the laughter stops, and the smell comes up, dank and congealed, and he can feel the putrefying odor worming inside his pajamas and bloating his skin with its stink, and the monster stretches itself. The room tilts as the monster ripples its spine, voluptuous, and the flayed leather of its body rustles and sucks as it moves, and it unfurls from under the bed, he sees its arm creep out, as if on a thousand little millipedal feet, right there before him, in the same air that's burning and lashing against his own starting eyeballs, and the nails of the thing shred whatever faint moonlight has crept through the steam in the room, and the boy knows, he knows, its head is coming out next, and he hears the cut and the thrust and the singing of its teeth as they emerge, smiling and smiling and smiling.

A Man of Vision
Patrick Crerand

—For Richard Connell

LATE IN THE AFTERNOON, THE donors and their children toured the old abandoned zoo pavilion. Their guide, a man dressed in khaki, walked at the front of the group, noting points of interest along the dirt path before finally stopping near a railing that stood above an enormous gravel lot deep inside the maze of moribund paddocks and halls. The lot itself held no animals, only the odd plastic bag and Styrofoam cup. A sharp smell of decay festered in the air heated by the last rays of that day's sun. They were relieved to stop, but the man in khaki did not seem to be sweating. He wore a set of field glasses around his neck and carried a rifle by its fluted end like a walking stick. He pointed at the lot behind them and spoke of the dismal status of the zoo's predators. Though his tone had been dour for most of the tour, the donors appreciated the affected spirit of his accessories, which he wore especially, in their opinion, for the sake of the children. Several times during his tour, he had crouched down to their level and pointed out the tracks of animals preserved in cement on the zoo walls or allowed them to use his field glasses to spy a stray bird scavenging the bare floor of an old paddock. He was a good sport, this man in khaki, they all agreed.

"Imagine," the man in khaki said, gathering the children near him, "the dangerous rivulets of the Serengeti meeting the treacherous sloughs of a Brazilian rain forest *and* the forbidden tundra of the Arctic. Imagine lions, hyenas, tigers, jaguars, anacondas, and polar bears, all in one space, all in *this* space. The greatest predators of the world lurking around every inch of dirt, mud, and ice for your viewing pleasure. It's all possible with just a few donations."

Some of the donors jockeyed with the children for better views of the empty gravel lot in the low light of the afternoon, pushing the man in khaki closer to the railing so that the fluted end of the rifle barrel clanged against the steel bars like the chimes of some distant clock.

"Below us," the man in khaki continued, "picture a watering hole

322

complete with sandstone rocks and a swaying palm tree or two. The stream will be fed by a larger pool, fifty feet deep. Next to it, a frozen tundra where we can ship in mounds of snow and ice completely refrigerated. To the right, brown vines and creepers will hang below and tangle with giant milk tree leaves of the Amazonian jungle. We'll have rain sprinklers, real lava slides, a snow machine running every day."

The donors beamed and pressed closer to the bars. As they listened, they inched the children out of the way, apart from a few bolder preteens who had climbed up the fences and sat on the top railing.

"Of course," the man in khaki continued, "all of this will be written down on several large bronze plaques to explain how these predators have no other place to go and how the world is bent on their extinction, et cetera, et cetera." He pointed to the black steel bars of the railing and with his other hand outlined the rectangular shape and size of the plaques, much to the donors' delight. "And then," he continued, "a bas-relief of the face of the greatest donor emblazoned here on a separate plaque. It will read, 'Our eternal gratitude to that most generous benefactor who manufactured a habitat out of the goodwill of his or her heart.' Again the wording is open to negotiation."

The donors could almost see their names in bronze, and the group broke into applause. The man in khaki stood and held the rifle over his head like a T to gain their attention. "But before this vision can be realized, we need your help. There can be no mission without money. Shall we open the bidding for the first plaque at five thousand?"

"Five thousand," a man in a navy blazer shouted.

"Seven," another screamed.

"Seven five," still yet another man yelled.

The man in khaki strained to keep up with the figures being shouted, but then his voice settled into the low, bumpy tone of an auctioneer. He sold the first plaque in ten seconds, slamming his fist into the palm of his other hand to complete the sale. The largest plaque with the bas-relief took longer, but the man in khaki pointed each bidder out clearly, stabbing his finger in the air to each man, woman, or child who spoke.

During the exclamation of bids, it was apparent two separate groups had formed. With each shout and mad gesture of the first group, the members of the second moved to the back, allowing the

most fervent to form a semicircle around the man in khaki. The women of this closest group shrieked and elbowed, flashing their diamond brooches and gaudy baubles as their husbands, in new tuxedos, postured and rolled up their sleeves, digging in for a fight. But the man in khaki, it seemed, never lost sight of the second group behind the loudest bidders.

This group was made up of more reserved members, and they bided their time in the back, knowing well that such noise was the behavior of junior executives, the men and women who worked on the floor of the exchange rather than those who ran it from private office suites up above. Among this second group of bidders was a large woman who wore a black dress patterned with white and yellow orchids that lolled obscenely around her rotund figure. Somehow the small child in her arms remained asleep amidst all the shouting. The boy wore a gleaming white suit with gold piping around the hem and looked like a midget admiral.

While the first group exhausted themselves haggling over the wording of the plaque, the man in khaki stepped away and walked forward up the path to a brick ledge overlooking a piece of empty grassland two football fields wide. The area was surrounded by an enormous fiberglass rock wall and below the wall, a moss-filled moat. A few lines of thick wild bushes grew greenly in the middle. The rotund woman walked to the front of this second group and nodded at the man in khaki upon her arrival. He returned her nod with a cavalier wink that seemed to convey a hidden predatory knowledge of the business world. The man in khaki gathered the second group by the ledge.

"Pray tell, sir," the woman asked, peering over the bricks, "what plans do you have for this space here?"

The group of junior executives gestured for order, clearing their throats in authoritative fashion, but the man in khaki turned his attention to the large woman and her cadre.

"Madame," the man in khaki said, "you have quite an eye. My compliments. You have found my favorite paddock of the old zoo. It is one of the few exhibits that we maintained while the others went abandoned."

The man in khaki stood up on the ledge and leaned over, pointing his gun toward the dense brush in the lower right corner of the grassland, just above the low moat that ran along the bottom edge of the property. The area he spoke of fell nearly behind them, so close to the ledge they stood upon that the group could see only the tips of

the green shoots and barbs stretching out over the moat. The man in khaki invited them all up on the ledge to get a closer view. The first group had brushed off the indignity of the man in khaki's absence like pocket lint and now crammed in tighter around the ledge with the others so as not to miss an opportunity to compare their lot with the paddock below them.

"Somewhere deep in that brush," the man in khaki said, "rests one of the greatest predators ever to stalk the earth, the giant seven-toed sloth."

A baronet in a navy blazer from the first group coughed out a crude laugh. "A sloth?" he asked. "I see an empty field," the baronet shouted. The baronet's blazer had a crest embroidered on his breast pocket in garish reds and blues that perhaps represented his last thread of nobility, but the bald man's leathery face seemed more fit for attending a yacht than owning one. The first group, hoping to impress him, broke into a curious laughter, but the people on the ledge leaned closer to catch a view.

The man in khaki remained stony eyed. "The giant seven-toed sloth is one of the few predators on earth to survive throughout the previous five eras of extinction, sir. I shouldn't have to tell you, sir, that its lone defense all this time has been its impressive camouflage. I shouldn't have to tell you, sir, that a cursory glance into the brush wouldn't be sufficient to see it. I should think, sir, you should expect more from such a predaceous beast than to reveal itself on the whim of some mortal," he hesitated. "Baronet, is it?"

The baronet looked down at his oxblood loafers and scuffed the ground. "Please continue," he said. "I humbly apologize."

The man in khaki resumed his position facing the group on the ledge, holding the barrel of his rifle against his leg. "As I was saying, the sloth has survived ice ages, catastrophic meteorite impacts, volcanic eruptions, super typhoons, tsunamis, and earthquakes immeasurable on the Richter scale. Its reign stretches from the era of the dinosaurs to modern times. It has lived on every continent and on top of every food chain. From the earliest days of this present era, men have burned it, speared it, clubbed it, shot it, hanged it, and recently attempted to obliterate it with weapons of mass destruction. Its metabolism is so slow, its will so relentless, however, that nothing can kill it."

"Nothing?" the baronet asked.

The man in khaki turned to eye the first group behind him. "Oh, I *could* pump it full of lead, as the saying goes, but it would still take

an aeon to die, and before it did, the giant seven-toed sloth would eventually hunt me down and eat me. You see, it not only survived the five eras of extinction but this seven-toed species is responsible for the extinctions of most of the mammals, birds, and insects that have vanished from the planet thus far. Even our dear director, after he found this one in a South American rain forest, had to give his own life to keep it in this zoo."

The man in khaki stepped up onto the ledge and gathered some of the children around him. "As you can see, this paddock requires a sizable endowment and a terrific commitment to maintain and preserve this most dangerous of species. Who among you can help contain its poisonous musk from leaking out into the megacities and infecting hundreds of millions? Who can sate its need for the millions of blood tulips it requires not to grow wearisome during its captivity? Who will pay for the tarantula webbing flecked with gold dust above its fountains of mercury that it has come to appreciate? Can we put a price on the enjoyment of future generations of such a treasure as this sloth? Surely you don't expect me to come up with a bid?"

The man in khaki paused and listened to the members of the first group protest for, at the least, a guiding value. But the man in khaki stepped down among them and turned his back to face the group on the ledge. The rotund woman quickly silenced their meek bickering.

"Three million dollars," the rotund woman said. She set her son down on the ledge next to her and shot a fierce look down the line at the remaining bidders standing on the ledge with her. She eyed each man and woman carefully and one by one they stepped down until only the rotund woman, her child, and a man with a black eye patch stood.

"Three million five," the one-eyed man said.

"Four," the rotund woman countered. "And I want my name in gilded letters on a wrought-iron archway above the whole pavilion."

"Five million!" the one-eyed man countered.

"Six!" the rotund woman said.

The bidding rose steadily. The man in khaki never spoke but stabbed wildly in the air like a conductor at a symphony. The rotund woman was savvy, though. After the last bid she curled her finger and called the man in khaki over to her, resting her ample bosom on his shoulder. "How much for the whole shebang?"

The man in khaki whispered in her ear and the woman licked her lips and threw up her hands with joy.

"I'm in for it all!" she shouted. Before the man with the eye patch could speak, the man in khaki slammed the butt of the rifle against the ground.

"Sold!" he said.

The rotund woman was elated. The flowers on her dress writhed as she danced on the ledge, lost in the joy of owning what even the most privileged could not own, but in her excitement she forgot that her son was next to her and, with one careless jolt of her hips, she knocked the boy off balance. He teetered on the corner of the bricks for a moment, waving his arms and smiling, before falling awkwardly off the ledge. The donors gasped as the boy flipped several times and landed with a splash thirty feet below them in the green water of the moat. The rotund woman screamed. From their vantage, the crowd could see the boy's pained expression tighten his eyes into slits. But before he could let out a wet cry, his mother pointed at the grass and let loose a terrific yelp: "God in heaven, the sloth, child! Run for the rocks."

"No!" the man in khaki screamed. "Stop where you are, boy!"

At first the child looked stupidly and blankly at the crowd, but his mother had screamed so loudly that he had no choice but to ignore the unfamiliar yell of the man in khaki and run. The donors followed the boy as he dashed out of the water and up into the field.

"Stop running!" the man in khaki shouted again. "It's the worst thing you can do! Stop! Stop!"

This time the boy listened. He stood wide eyed on the grass.

"We're coming," the rotund woman said. She looked at the crowd below her and the man in khaki. "Save him," the rotund woman pleaded. "Please save my boy!"

"I'm afraid I cannot," the man in khaki said.

"Nonsense," the baronet said. He stripped off his jacket and rolled up his pant legs. "Surely there's a ladder. It can't be more than twenty feet. I'll jump down and the boy can climb up with me."

"No," the man in khaki said. "Once the sloth has smelled the boy, it's only a matter of time." He peered through the field glasses and pursed his lips, and then looked at his watch. In the western horizon, the sun was a wavering globule of orange light.

The baronet put his oxblood loafer on the angled edge and knocked a dusting of mortar off with the sole as if to prepare to jump the gap, but the man in khaki pulled him back with the butt of his rifle. He pointed the gun at the baronet and corralled him into the larger group of donors.

"You don't know what you're dealing with," the man in khaki said. He wrapped the strap of his rifle around his forearm to steady his aim.

"It's a damned sloth!" the baronet said.

"No one is moving an inch," the man in khaki said.

The boy continued to cry out for his mother below them. A sickly patch of yellow stained the front of his white trousers. Still the man in khaki did not lower the barrel of his rifle from the middle of the group.

"You can't shoot us all," the baronet said.

"No," the man in khaki said, "but if I did, it would be a more civilized death than what would happen should you end up down there with that sloth. It hunts at night. Its movements are slow, but it never stops. Humans need sleep and rest, but the sloth never does. It lives on one meal every 280 years if necessary. Once it smells you, it can move faster, but death for the victim is inevitable and quite slow. It has no incisors, only rough molars, so it can't cut through you as much as it has to gnaw. There are reports of one eating a man for ten long years. Think of it, ten years of being chewed on. Of gaining strength to run more, only to fall again and be chewed on more, until the day when you can't run any longer. This sloth here sniffed our own dear departed director as an infant in Peru. He and his parents were disembarking from a ship on the coast. Thirty years later, it finally began eating when he passed out in an alley in Montevideo. It tracked him all the way across two continents, where it finished the job not far from where the boy stands now."

The rotund woman screamed again and this time stepped down from the ledge limply and then collapsed onto the dusty ground with a hard thump. A few of the sturdier men laid her out. The baronet rolled his navy blazer into a pillow. He stood over her and smacked her face until she returned to consciousness. A splotchy rash marked the places where the boy had grabbed her arms just minutes earlier.

The rotund woman came to. She still had the boy's white cap in her hand and she clutched it as she staggered to her feet. "Blessed mother, run to the rocks, son!"

The boy ran in a long curve away from the bushes and the ledge, as if one leg were shorter than the other.

"He'll only make himself look more like prey," the man in khaki said. "Stop!"

"Zig, now zag," the man with one eye offered.

The man in khaki swore and raised the rifle and fired a single shot

into the air. It echoed above the pavilion and out into the pink light of the western sky.

"The sloth abhors confrontation, boy!" the man in khaki said. "Your only chance for survival is to stand your ground."

The small white figure stopped in his tracks as if he had been shot. The sun had dipped low, nearly behind the wall now. The grass was coated in jagged shadows. After a long pause, the rotund woman spoke.

"How long must he stand there?" she asked.

"I'm afraid," the man in khaki said, "for the rest of his life."

"Let me go in," she pleaded, inching nearer to the man in khaki. "Let me take his place. Give me the gun. I'll shoot it dead."

"If you shoot it," the man in khaki replied, "you'll only make it madder. It's been on the earth for millennia. Think of the rage it has stored up over that period of time."

"Surely one body is as good as another, though. Let me go in."

"It's too late now," the man in khaki replied. "The sloth has already smelled him. If you went down now, he would eat both of you eventually."

"Shoot it, you coward," the baronet shouted.

"And waste a perfectly good sloth?" the man in khaki said. "My dear baronet, you reveal your true self. Why kill the sloth? After all, isn't it just doing its job? Isn't this why people come to a zoo: to see a predator in its natural element? As a zoo conservationist, I don't think I need to explain to you about the endangered status of these sloths or how hard they are to come by. No, as long as the boy stays in the paddock, the sloth will not harm him or any of us. It will be fed and survive for future generations to enjoy."

In the paddock, the boy stared at the line of bushes and then turned to face the crowd. He cried out to his mother. He was no bigger than a thumb now, a white blob far away from all of them, indistinguishable from the plastic bags or the Styrofoam cups.

"Please," she cried. "The boy can climb out himself. He could have a fruitful life before it found him. I'd put him far away at sea or in a rocket orbiting the earth. The sloth could never find him there. I'll pay you any amount of money. Whatever you want, it's yours. Just give me back my boy. He could still have a fruitful life. Please! I beg of you."

The man in khaki paused and fingered the nipple of his gun. The line of his mouth tilted diagonally. "It's possible the boy could outrun the sloth, but it's very doubtful. This sloth will surely outlive

every last one of us gathered here. But my concern is what would the boy's life be like if he climbed out of the paddock?"

"It could still be good," the mother said. "I'd make sure of it."

"No," the man in khaki said. "I think it would be dreadful. For the rest of his life, every moment, every great accomplishment, and every great joy would be tempered by the unbearable pain of knowing the horrible death that awaited him. As a humane man, I couldn't free the boy and live with myself afterward knowing that that would be his future. It may be hard to realize, but this is for the best."

The woman stared at the man in khaki and her face loosened for a moment as if she recognized him from some dinner party held long ago. Behind him in the grass, she could see the last spots of sun touch the brush. The boy cried out still.

"Think of how much less you'll worry," the man in khaki said. "You'll never have to wonder, is my boy in danger or will he come back from school today. All those sleepless nights wondering if he'll be a genius or a dunce, if he'll be a failure or fall just short of the success you've attained. It's all settled here and now."

The man in khaki lowered his rifle and led the crowd back to the front entrance of the zoo, leaving the mother alone on the brick ledge. In the parking lot, they waited for the valets to bring their vehicles and made small talk to cover the noise of the boy's screams. The baronet put a hand on the man in khaki's shoulder and nodded. Before each of them drove off, it seemed, every one of the donors had touched him on the shoulder or taken his hand in theirs and spoken of the kindness and the rigid constitution such a situation dictated, all except the mother, who remained on the ledge, staring down at the boy until the darkness came fully and neither could see the other.

The Logic of the World
Robert Kelly

EASTER WAS LONG PAST. It was the quiet time of year when nothing
was happening but the slow dawning of grain and fruit, the green
shoots thickening to stems, stems beginning to round out toward
what, months later, in the quietest time, would be ripe for harvest.
Deep earth was asleep. Only her skin was lively, the powers and
forms she had been dreaming all winter long were off on their own
now, and she could sleep.

So that even here, where there was no sowing and no reaping,
reigned the incessant uprising of tree and fern and toadstool, the
ever-upward life of the forest itself, in the quiet heat of afternoon.
The lilies rosy speckled like swift river fish had faded now, but the
Pentecost roses were getting ready to blossom.

The knight cared about such things, though he didn't know much
about their names. He noticed, though, and cared about the thicken-
ing, the coming of color into the plant, lifting some pale or vivid hue
magically right out of the green, how did it happen, how could the
brown twig and green leaf suddenly start to yield scarlet, yellow, or
the rare of blue? Where do colors come from? He remembered,
though he couldn't see it right now, the way sometimes the moisture
caught in his eyelashes caught the sun so that tiny rainbows formed
and scattered. What are colors?

He let himself think about such things. It was good to have a keen
eye, to keep his vision whetted by noticing the slight difference be-
tween today and tomorrow, as the plant shows it, so subtly but so
clearly, by its changes. Keep vision whetted by noticing the patterns
that insects make in the air, or how certain tamped-down foliage
means a deer has slept here with her fawn. He was good at watching.

And on the old track through the dark woods there was much to
watch, evidence of people before him come and gone, and others
whose presence, neither friendly nor hostile, he could feel nearby,
unseen, ever present. They were people who did not concern them-
selves with travelers: a knight like himself, a monk or two, or even
a company of pilgrims, they just amounted to weather in the woods,

passing, not really there.

The knight felt almost comforted by their presence, at peace with their indifference. Just as he felt indifferent but alert to the trees and herbs he passed by, or slept beneath, or nibbled in the morning, when he knew this leaf was safe, to wake his breath and shape the waking air.

It was still morning as he rode, and he was beginning to feel the first stirrings of hunger. He had plenty of bread in his saddlebag, and sweet water in his leather bottle, but he was a well-reared young man, and knew that one should not eat while doing some other thing, in this case riding, watching, understanding the world he passed through. Eating takes the soul inside, to survey the food's journey to the center—that is how he had been taught. And taught too that doing things while eating sapped the nourishment from the food, and also drained the soul from the other thing he might be doing. He had seen other people, some of them knights or priests even, munching while they walked or worked wood or read in a book—he shook his head to think of such folly, that people should live on the earth and not understand the simplest things about their bodies' relations with the place they lived in.

The track he followed was narrow but clear. He rode cautiously, frequently having to duck beneath a heavy branch, or gently lift a younger one aside—do not break the tree that shelters the path, that was another thing he knew.

Just ahead now he could see, in something of a clearing where more sun came through, another traveler on the path. He was seated on a fallen log, it seemed, and the knight could see a big bag slumped beside the man. As the knight drew closer, he saw that the seated man was a leper, his walking staff with rattle top lying beside him, his shabby old tunic still showing clear enough the huge rough heart shape painted on it in rust. The leper was eating, but dropped his loaf and went to pick up the staff and rattle it, to warn the knight.

"Good morning, Sir Leper," the knight called out in a friendly way. The leper let the staff fall, and smiled up. His face was mostly still there, and the smile was easy enough to look at.

"Good morning, Lord Knight," the leper replied, each man courteously elevating the social status of the other. Perhaps the leper had been a man of better station once upon a time.

There was not much to say. But the knight lingered, of a mind to share and inquire.

"Have you food enough, Sir Leper? I have a bit in my satchel."

"Thank you kindly, my lord, but I have some meat in mine too. And there is good water in a spring a little way beyond; you'll pass it in five minutes, if you need. It breaks out of a single rock upright among cool ferns. I like the place, but do not linger there, because I am as you see me."

The knight knew no easy way to respond to that, and turned his words aside.

"What is this place we're in? Whose forest is this?"

"I don't know its name, or it may not have one, and I have lived near at hand most of my life, apart from the years I wandered in the Holy Land that taught me to wear such clothes as these," said the leper, sweeping one hand down along his tunic, which was blazoned with the Heart of Pity, as they called it, that all lepers in this land must wear. "They say the woods are owned by the Abbey of Saint Ulfric, but no one lives in that abbey any longer, and the last abbot died when I was a child. Whoever may own the land, there is no doubt who controls it. For this whole forest is in the clutches of a dragon who lives in a gorge only a mile or a mile and a half, depending on what path you take to reach it, from where we are sitting."

"A dragon!" exclaimed the knight. "Does he do great mischief in the woods?"

"Not to the trees, but you will have noticed, perhaps, that no animals have crossed your path, and few are the birds that flew over you."

"I had not noticed. Why is that?"

"Most have been consumed by the dragon," said the leper. "My uncleanness must spoil his appetite, since he has never bothered me, though I have seen him half a dozen times, and I am sure he's seen me more often than that, since little does he miss in what goes forward."

"What does he look like, when you see him, this dragon?"

"Much as you suppose. Vast and sinuous and mostly green, with flakes of bony stuff atop his spine that would slice a man in half. Wings he has as well, of a pale bluish color, translucent like the wings of a bat, and very long. His face is an interesting one: He has the fangs you'd expect, but set in a muzzle of some nobility, more lion than snake, more eagle than lion. Hard to be sure, since his face seems to change its bones with his mood."

"That is very odd," said the knight. He was silent for a while, thinking of what he had heard. Then asked: "If the dragon has eaten

up all the deer and boars and hares in these woods, what does he live on, do you think?"

"I know the answer to that," said the leper. "He leaves the woods and raids the towns and granges all about, on the far side of the forest, away from the side from which you came. He is a plague and a bother to them, but strange to say, though he breathes fire like any dragon, he never burns down a house or croft or mill. Mostly he'll seize cattle or sheep, a goat or a dog, and that will sate him. But sometimes he has been known to snatch a maiden, wrap her in his coils, and fly away with her to his gorge. At least that is what people think. The bones of the girls are never found."

"That is a sad and shameful thing, that a young woman be carried off at all, let alone by such a beast."

"Beast he may be, though I'm not sure of that, since I have heard him talk."

"Talk!"

"Yes, and not the way crows talk, for example, where you have to hold your heart and mind a certain way to understand what they're saying. No, this dragon talks as you and I are talking now, using words, most of which I recognize."

"Have you spoken with him then?" asked the knight, a little doubtful all at once of the character of this leper.

"Never, but I have heard him speaking. Whether to himself or to another I could not tell. Out of fear I kept my distance. Damaged and distressed as it is, this body is still precious to me, and I would fain keep it a while longer."

"What does he say, this dragon? What is there for him to speak about, I wonder."

The leper closed his eye and thought a bit before he answered.

"You know, lord, I am not sure. While he was speaking, I understood perfectly what he said and what he meant. But afterward, and now, all I can do is remember understanding. But what I understood, that I can't remember."

"It seems to me," said the knight, "that I should go and see what this dragon has to say for himself. And if he does not give a good account, I suppose I must seek with God's help to slay him, and rid the forest and the farms of his harm. This seems then to be an adventure that has come to me. Thank you, Sir Leper."

"That is gracious of you, Lord Knight, but better to thank me later, when you see whether or not this is a good thing you undertake."

"How could it, with God's help, fail to be good?"

334

"I could not say, Lord Knight, but the dragon may not be of a mind to be slain. Or he may speak with such wiles as to dissuade you. Or even win you to his cause, whatever that might be."

"Speaking of that, you speak well, Sir Leper, if I may say so. Your words are intelligent and suave and well chosen, dare I say it, and much wittier than mine. You remind me of certain clerics who had the kindness to instruct me when I was very young."

"Yes, Lord Knight, I was a priest once upon a time, and went with the Jerusalem Farers on their crusades, to give them counsel and keep them honest along the way, much good it did."

A leper priest is a scary thing indeed, the young knight thought, but wasn't sure why it should be so. Why scarier than a leper farmer or a leper soldier? Yet it was, almost as if it meant that something was wrong in the way the world was made. That a priest should give up women and begetting and owning and amassing, and yet be subject to this degrading disease. And all a priest's learning went for naught. Not naught, though, since here he was being instructed by this wise priest.

"I grieve for your distress," said the knight, and the other knew he meant not just the leprosy but also his sadness at the human condition, where rutting soldiers would not listen to their priests, and stole and spoiled and ravened.

"Bless you for your understanding," said the leper, and said no more.

The knight sat a while longer and thought about what he had learned. Now it is a knight's business to balance the iniquity in the moral world and the imperfections in the natural order with his own virtue and prowess and that special quality of responsible loving-kindness called honesty. It would appear, and so it seemed to him, that the activities of the dragon, as reported, constituted an imperfection in this forest in particular, and the scheme of things in general, one that should be mended. And the code of Holy Adventure, by which knights have always lived, and still do live, calls for the knight who discovers the flaw in the pattern to be the one who heals it.

The leper was sitting quietly, and the knight supposed the man wanted to get on with his meal—the sun was straight overhead now. But the leper made no gesture one way or another, just sat.

"Sir Leper," asked the knight, "could you show me the way to the dragon's gorge?"

The leper smiled, and gently thrust his rear leg forward. Only now

did the knight see that there was scarcely a foot at the end of the leg, just a mass of clotted cloths tied round a stump that did not bear thinking about.

"My lord will see that I am not skilled at walking these days, and will forgive me for not keeping him company. I walk little as I can, and on the softest places, where the pine needles let fall the soft, safe road that is my bed as well. I will tell you, though, how to meet your dragon."

How strange, the knight thought, that the priest had already made the dragon the knight's own.

"From this place keep onward as you were going. As I said before, you will soon come to a spring among the ferns—it will be on your right side as you go. Pause and drink—the water is healthy and bracing. Just past the spring you will see, on the same side, a thickety place, all rustling aspen leaves and shadow. In the thicket you will soon find, God willing, a little path, evident, wide enough for your horse, I think. Take this and follow it. It rises slowly through trees to a bare hill, climbs the hill—it is no more than a mile from the spring—and from the top, you will look down into the gorge of the one of whom we have spoken. God be with you, Lord Knight."

"And with you, Sir Priest, and thank you."

The knight made a civil gesture, which was returned. Then he urged his horse onward. In a few minutes man and rider came to the rock among ferns. The knight dismounted and drank, and drank again. And felt again the hunger he'd been feeling before the leper. Why not eat his midday meal here?

He did so. And as he chewed on the good grainy bread, he thought a little about priest and dragon, maiden and duty, then drew his mind back to the bread. Because thinking about things while eating is no better than riding or plowing a field while eating. Eat while eating, ride while riding, sleep while sleeping. But thinking has a way of creeping in, the way dream creeps into blameless sleep and tells its incoherent stories. Not easy not to think. Best to think about bread, his jaws chewing, his body dark with waiting.

When he swallowed as much of his bread as he'd let himself eat this summery day with supper far away, he packed up his things, drank again from the spring, and remounted. Soon enough he spied a little track off through the aspens, and veered that way, hoping it was the right one. A dark way indeed, and the leaves on their slender

branches had a way of being mobile, moving before him, beside him, behind him, as if they were opening the curtain of themselves and leading him further in.

Now that the leper had alerted him to the absence of beast and fowl, the knight kept an ear open for any bird cry he might hear. It was true, the forest was quiet, very quiet, apart from the noises he made brushing through the trees. A few times there did come the clear call of a crow from up ahead, a sound he liked hearing. It made him easier about his choice of path. He trusted crows, and any place where they gathered.

A mile or so, the leper priest had said. Ambling though the horse was, and the leaves thick around them, he expected he'd find himself at the hill in no great while, and indeed the ground was gradually, perceptibly rising before him. Soon the aspens gave way to a treeless slope close covered with heather, and he spurred his horse up. Again the crows called ahead of him, more than one—three, he guessed, from the timbre of their cries. At the top of what seemed not a hill but a ridge, the knight looked down into the gorge he expected to see.

Deep it was, and running arrow-straight from south to north (it seemed) through the forest. Seventy or eighty feet down, a feeble stream winked along the narrow valley. On the far side of the gorge, tall pines stood, and two or three crows seemed tossed from branch to branch, but no longer did they cry. He had come, he thought, to where he was supposed to be, so no more directions were needed. Here it is. The steep slopes of the gorge fell away—walking back and forth along the rim, he could spy no trail, and it was too steep for any horse. Where was the dragon?

The slope in front of him was densely matted with juniper and cedar and heather, while the slope on the far side seemed crusted with a low, thick ground cover, a row of spiky bushes running along it halfway down. What he saw was quiet, and gave him no sense of awe or fear. As a good and honest knight, he knew fear, knew it well, and knew how to deal with it most times. Without fear there could be no courage—his teachers had taught him that. Without fear there can only be a creeping uneasiness, a draining, enervating malaise. Fear is brilliant, though, and summons even cowards to be brave. These were good thoughts to be having, he thought, when looking for dragons. But where was the dragon? No smell, no sound, no glimpse of his presence. Or of what he might have done. In earlier encounters with dragons he had heard about, the knight had always

found near the caverns scattered bones, garments stripped from poor travelers devoured, bracelets, pieces of gold even, though most of those were buried deep within some cave or burrow. The knight looked for such evidence now, and found nothing. Was this the right place? He wondered about the leper, whether a man like that, however well spoken and kindly acting, might not have, in his own despair, come to take pleasure in leading other men astray, as once he had tried vainly to lead them toward the good. Where was the dragon?

The knight slipped off his horse, tethered the creature to a sturdy, thick old juniper bush, and plucked off a few of those cloudy blue berries. He mashed them in his fingers, inhaled the heady smell of them—they smelled like a rain shower on a hot, sunny day. He dropped the seedy pulp but licked his fingers. The taste was nothing at all like the smell. That is how things are. The knight sat down cross-legged, and waited, staring into the ravine.

It was pleasant being where he was. The horse found nourishment in deep, unvisited grasses among the shrubs. A quiet wind was moving, and it dawned on the knight that it was because the wind was coming from over his shoulder that he smelled none of the stench people had told him to expect anywhere that dragons had stayed a while.

He wondered what manner of dragon this might be. The description the priest had given could, depending on just how faithful a describer he had been, suit several sorts of dragon: the Cloud Worm (and the blue wings suggested it) , who nests in earth but spends most of his day aloft; or the Diggon Nail, who burrows straight down in the earth and (it seems an evil miracle) turns himself inside out to shoot out again, arrow swift, from the earth to seize its prey; or the Riverlord, who lived mostly in streams and lakes to keep his fires banked against the moment of need. But the nobility the priest had noted in the dragon's face, "more lion than snake, more eagle than lion," did not match any of those three kinds. None of the other dragons he knew about had wings at all, or tall scales on their backbones. So he would await the encounter, and learn.

As he sat there, reviewing his knowledge of such matters as might be useful to recall in the next while, he grew sleepy. He knew well enough that sleep is not to be fought off—only enemies are to be fought, but not to be indulged either; only bad friends need to be indulged. No, sleep was a good friend, and should be met candidly, and only when the time was right. The time seemed right, nothing

asked itself of him, he let his eyelids close, and let himself drift toward sleep.

A breath of air tickled along his neck, and his eyes opened. And before he let them close again he noticed, or thought he noticed, that there was some subtle difference in the slope on the far side of the ravine. It had changed, its contour was not what it had been, but the knight could not tell just how. He decided to experiment: He closed his eyes, drifted almost away, then quickly opened them. Yes, there was a change; the curve of the bushes was different.

Then, as he watched, eyes wide, the change happened—a ripple ran through the shrubs and grasses over there, and then a stronger one. He could feel no wind to account for it, or for the next, even heftier, ripple. Then the whole hillside lifted up and looked at him.

For it was the dragon himself, stretched out and likely asleep, that he had been watching all this while, the tough green scales and hairy interweaves of the great body now clearly discernible, the huge head (he had thought it a distant tree) now reared halfway up the sky turned round to gaze at the knight, who felt awe and fear, states of feeling he had been trained to turn into thinking. He thought, calmly and quickly, taking and holding and releasing his breaths in the rhythm he had been taught by a monk when he was still in the hands of his master.

The dragon's head swung nearer, balancing gently halfway across the gorge. The eyes of this dragon, which was in fact the first of any kind that the knight had seen with his own eyes, these eyes that looked at him were many colored. They did not glitter like the eyes of a snake or glisten like those of a frog. They were more catlike, he thought, in that they seemed to go very deep into themselves and open up in there onto some other space. The hall in an ancient castle they all are coming from, he thought.

Smoke drifted out of the dragon's nostrils. Watching the smoke curl away into emptiness made him feel strange, so he concentrated on his breathing, and on letting his eyes do their work with the eyes of the animal.

Though it didn't much look like an animal.

"Can you with all your seeing see who I am?" asked the dragon. The voice was smaller than you'd imagine, deep enough, but seeming to come from nowhere. In fact, the knight looked around to see if someone else had spoken.

"No," said the dragon, "it is I who spoke. Do you feel fit to answer my question? Can you see who I am?"

"Truth to tell, I can't. I have been looking, maybe even staring, forgive me, I know that isn't polite, but somehow I imagined an animal would not mind being stared at. I mean, animals—cats, for instance, or deer, or owls—are always staring."

"That is logical, Sir Parsival. But animals do mind being stared at as if they were not worth any other mode of discourse. Seeing can be very distancing. The object you look at so intently can be rendered into a mere thing by your beholding. Instead, you should try to use all of your senses, mental senses at least, to observe."

"How do you know my name?"

"I know all the names, Sir Parsival. And I know which name belongs to whom, and what everybody's real name is."

But Parsival doubted suddenly. In his mind's eye he could see the leper hobbling through the aspen grove, hurrying along a shortcut to the dragon's lair, and whispering to the dragon the name of his soon-to-be assailant. And once the knight started thinking that way, he soon imagined that the leper had deliberately lured him, for no decent reason, into this encounter with the dragon. The leper was some sort of agent or tool of the dragon. No wonder he stank and had scaly skin. The knight didn't blurt out all that, of course, but only said, suspiciously enough: "I think the leper came secretly to you and told you my name."

And even as he said so, he realized that he had not told the leper his name.

"Not so, Sir Parsival, I would not need a priest to tell me what I can read from your heart."

"How did you know the leper was a priest? He wears no sign of his former glory."

"I know what everybody is, and everybody was, and some part of what everybody will be—but not all," explained the dragon, "so do not ask much about what is to come. What is to come is written in what has been. You think I am a monster (you haven't said so, but I can tell), whereas I think I myself am nothing but the logic of the world."

The dragon paused, more as if to reflect than to give the knight a chance to speak, then went on: "And the logic of the world is frightening enough, God knows."

"You dare to speak of God!"

"Everybody talks about God. Be closer!"

340

At that command, abruptly spoken, Parsival drew back, and his hand began to coax his sword out of its scabbard. Yet suddenly he was closer, much closer, right in front of the dragon's face, but he had not moved. The great head had swung further toward him. He could feel the warmth of the dragon's breath on his face. He had been holding his breath, for fear of the evil smell of that breath, and perhaps a righteous fear of inhaling evil itself into his innocent body. But he had to breathe, and snatched a quick inhalation. To his surprise, the smell was far from unpleasant. It reminded him of many things— the skin beside his mother's earlobe when he had kissed her goodbye, a birch-bark box he had once opened and found full of old rose petals, most of their color gone but still a rosy scent left for him.

"See," said the dragon, "you are beginning to stare with other senses now."

Bravely, the knight inhaled deeply. And now he found other fragrances mingling too, more enigmatic—sun on hot slate, a cucumber stung by a wasp and turned a little brown around the bite, a door slammed by the wind and the dust on the threshold whirled up by its motion, tickle in the nostrils, could moonlight have a smell? And wasn't that the smell of the place in the woods where he'd seen a stag rubbing itself against a beech tree? He sneezed.

Instantly the huge membranous wings of the dragon whirled and came to rest a few feet above the knight's head.

"Why? What?" gasped the knight.

"I am shielding you from the noontime; the sun is greedy for the part of a man's soul that flies out when he sneezes and looks around and soon comes back unless it's snatched by some power. I shield you from that power."

"Thank you," said the knight, still a little breathless from his big sneeze.

"That is the first word or sign of courtesy you have shown me, Sir Parsival. Thank you for it, though someday you'll grasp that it does you more good than it does me. Now tell me, why have you come to slay me?"

"Not easy to explain, now that you ask me. At this moment, I don't feel very much like killing you. Or anything else."

"Those words are good to hear. (Even better that you speak them.) But before this very moment on the porches of my house, in pleasant sunlight, and no birds shouting, why did you think to come slay me?"

"I suppose I didn't 'think to' slay you. I really didn't think at all. I

have been raised in a tradition that tells me that virtue lies in smiting or slaying the enemy. The same tradition recognizes enemies of all kinds—wolves and bears, snakes and spiders, foreigners and bandits, demons, bad neighbors, dragons, monsters, devils, and the Devil himself. All of them are against us, and we must be quick to flee them or slay them, whichever is in our power. And many of the great older brethren in my company have distinguished themselves by slaying dragons. Or so it is said. I have never seen it done. To be truthful, you are the first dragon I have ever seen."

The dragon's head drew even closer, and turned slowly from side to side as if to give the knight a chance to see him whole. Poised now a foot or two above, the dragon spoke.

"Do I seem to you to belong to the class of enemies you have listed? Is it enough just for me to be a dragon to make you slay me, or must I first be guilty of bad behavior? And if so, what wrong have I done you?"

The knight edged back a little to get some distance from that all-too-observant face, the broad nostrils carved in the shapely muzzle, the all-color eyes resting, always resting, calmly on him.

"No wrong, Sir Dragon. But the leper told me of your depredations on the farmlands and houses outside the woods, and the maidens you have carried off. It seemed from what he said that you were behaving exactly as dragons are said to behave. Therefore it fell to me to remedy the evil—the one who learns about it must do something about it, that is the rule."

"A good rule," said the dragon. "But what it means to 'do something,' ah, that's another matter. We should one day have a talk about that."

"Do you deny that you have raided and ravened in the plains round about?"

"Come into my house deeper, sir, and you will find no plunder. There are no maidens here."

"Did the leper lie?"

"Perhaps the priest in him made him do it. They are creatures of books and ceremonies, priests. He, like you, has learned how dragons make nuisances of themselves, and, like you, assumes that since I am a dragon, I have done what the dragons in his books are said to do."

"So I should not be afraid of you?"

"You have done very well so far in hiding your fear, or perhaps distracting us both from it. But on the contrary, you should be very

afraid of me. I told you that I am logical. Now I tell you that I am wise. The two flanks of the mind are deployed, and there is no room for stupidity or hatred or indifference. And not much room for love— just enough to keep the world at work."

"But how can I slay wisdom?"

The dragon looked very sad a moment, unless the knight deceived himself by interpreting a certain wetness of the eye.

"Slay wisdom? The priests do it all day long, and what they leave still breathing the schoolmasters and the merchants soon make away with. Wisdom, being eternal, is the easiest thing to slay."

"That's too deep for me," said the knight. And he stood up, tugging the sword loose at last from the sheath. The dragon did not move.

"O little one, o little knight, my little son! Don't you know you have already slain me? Don't you know that you'll come back tomorrow morning and there will be no dragon here, just an empty gorge, with a trickle of reddish water in it, rusty from the iron sills in this old rock. No dragon, no hoard, no maiden. But your mind will be different. You will listen to me in your head again. You will realize that, just like the cowardly creature your traditions claim I am, I have rushed into hiding. You will slowly realize that I have hidden myself in the snuggest cavern of all, deep inside your mind, and that you will never altogether silence me. Because once you have slain someone or something, you take into yourself everything they are and know and do."

Parsival did not raise his sword, but let it fall. He began to cry. Wisdom is so cruel, so tender, what can he do but cry? He is young, after all, not yet seventeen, and his mother is dead.

He blinks tears out of his eyes and says, "I'm sorry, I'm sorry, I meant no harm."

"And none was done," said the voice of the dragon.

"What shall I do?"

"Do what you have done. Be quick to listen, slow to lift the sword. Learn from everything you see and everyone you meet. Even lepers. Even priests. Even me."

Then there was no dragon. The air was just the same, the gorge was as it had been before; perhaps the far slope was a little more barren, perhaps not. Memory is not reliable.

The knight stowed away his sword, untethered his horse, mounted, and went back down the way he had come. He wiped his eyes on his

sleeve. Perhaps he should seek out the leper and disabuse him of his false ideas about the dragon. And yet, he thought, it was those wrong ideas that had brought him to this meeting. The meeting seemed important, very important, but Sir Parsival could not exactly say how or why. He left it to work itself out in his mind, the way things do. No need to bother the poor leper, let him think as he pleased.

Then Parsival attended to his path, the calm demeanor of his horse. Strange, now he thought about it, that his horse had not shied from the dragon, had not even whinnied or shifted. All through the conversation, the horse had gone on browsing. He began to think about the horse, what it must have felt. What an animal must know.

NOTES ON CONTRIBUTORS

JEDEDIAH BERRY's first novel, *The Manual of Detection*, was published earlier this year by Penguin Press. He is an assistant editor at Small Beer Press.

JONATHAN CARROLL's most recent novel, *The Ghost in Love*, was published by Farrar, Straus and Giroux. His Web site address is: www.jonathancarroll.com.

Widely known in his native France, fabulist GEORGES-OLIVIER CHÂTEAUREY-NAUD has been translated into fourteen languages and honored with the Prix Renaudot, the Prix Giono, and the Bourse Goncourt de la nouvelle. He is a founding member of the contemporary movement La Nouvelle Fiction (NeoFiction). "La Tête" is from his collection *The Pavilion and the Linden* (*Le kiosque et le tilleul*, Julliard).

PATRICK CRERAND's stories have appeared in *Ninth Letter, New Orleans Review*, and *Indiana Review*, among other journals. He teaches at Saint Leo University in Florida.

JULIA ELLIOTT's fiction has appeared in *Tin House, The Georgia Review, Puerto Del Sol, The Mississippi Review, Black Warrior Review, New Delta Review*, the anthology *Best American Fantasy 2007*, and previous issues of *Conjunctions*.

JON ENFIELD's work has appeared in *Xavier Review, Poetry Ireland Review*, and *Underground Voices*, among other journals. He teaches writing at the University of Southern California and is working on a novel.

The first of THEODORE ENSLIN's "Benjamin Stories," *One Summer's Day Dream*, was published by Granite Press in the United Kingdom. His collection of sequences, *NINE*, was published by the National Poetry Foundation.

EDWARD GAUVIN has received a fellowship from the American Literary Translators Association and a residency from the Banff International Literary Translation Centre, where he was able to pursue work on a Georges-Olivier Châteaureynaud reader, forthcoming from Small Beer Press. He translates graphic novels for Tokyopop, First Second Books, and Archaia Studios Press.

SCOTT GEIGER's story "The Frank Orison," originally published in *Conjunctions: 45*, was awarded a Pushcart Prize. His conversation with structural engineer Guy Nordenson is forthcoming in *The Believer*.

ELIZABETH HAND is the author of ten novels and three collections of short fiction. *Wonderwall*, a young-adult novel about Arthur Rimbaud, is forthcoming this fall from Viking. She is currently at work on a new novel, *Available Dark*, set in Reykjavik.

SHELLEY JACKSON is the author of *Half Life* (HarperCollins), *The Melancholy of Anatomy* (Anchor Books), and hypertexts including *Patchwork Girl* (Eastgate Systems). "Flat Daddy" is composed of words found on the first page (front and back sides) of *The New York Times*/New England Edition, 9/30/06. One word has been added.

ROBERT KELLY's many books include *The Book from the Sky* (North Atlantic) and *Fire Exit* (forthcoming from Black Widow Press). "The Logic of the World" is from a new collection of fiction forthcoming from McPherson & Company.

MICHAEL J. LEE's fiction has appeared in *Denver Quarterly, New Orleans Review,* and *Santa Monica Review.*

STEPHEN MARCHE is the author of *Raymond and Hannah* (Harcourt) and *Shining at the Bottom of the Sea* (Riverhead). He lives in Toronto.

BEN MARCUS's recent stories have appeared in *Harper's* and *Conjunctions*. He is a recipient of the Morton Dauwen Zabel Award from the American Academy of Letters and a fellowship from the Creative Capital foundation. He lives in New York.

J. W. McCORMACK is a senior editor at *Conjunctions.*

EDIE MEIDAV is the author of *The Far Field: A Novel of Ceylon* (Houghton Mifflin), *Crawl Space,* and the forthcoming *Highway 5* (both Farrar, Straus and Giroux). She received a Lannan Fellowship and is a visiting professor at Bard College.

CHINA MIÉVILLE is *The New York Times* best-selling author of several novels, including *The City & the City* (Del Rey). He has won the Arthur C. Clarke Award and British Fantasy Award twice each. His nonfiction includes *Between Equal Rights* (Brill), a study of international law. He is associate professor of creative writing at Warwick University, and an honorary research fellow at Birkbeck School of Law.

MICAELA MORRISSETTE is a senior editor of *Conjunctions*. Her stories have appeared in this journal, as well as in *Best American Fantasy 2008* (Prime Books), Heide Hatry's *Heads & Tales* (Charta Art Books), *Weird Tales,* and *Paul Revere's Horse.* The recipient of a 2009 Pushcart Prize for her story "Ave Maria," published in *Conjunctions:49,* she lives in Brooklyn, New York.

JAMES MORROW's most recent novels include *The Last Witchfinder, The Philosopher's Apprentice* (both William Morrow), and *Shambling Towards Hiroshima* (Tachyon Publications), all of which are currently available in trade

paperback editions. He lives in State College, Pennsylvania, with his wife, Kathy, son, Chris, two dogs, and a garden yeti.

JOYCE CAROL OATES is the author, most recently, of the novel *My Sister, My Love: The Intimate Story of Skyler Rampike* and the story collection *Dear Husband,* (both Ecco) the title story of which appeared in *Conjunctions:51* and has been selected for *The Best American Mystery Stories 2009.* She lives in Princeton, New Jersey, where she is professor of humanities and creative arts at Princeton University.

STEPHEN O'CONNOR is the author of *Rescue* (Harmony), *Will My Name Be Shouted Out?* (Simon & Schuster/Touchstone), and *Orphan Trains* (Houghton Mifflin/University of Chicago). He teaches in the MFA programs of Columbia and Sarah Lawrence.

KAREN RUSSELL is the author of the short-story collection *St. Lucy's Home for Girls Raised by Wolves* (Knopf), and is currently at work on her first novel.

KENNY SCHARF is a pop-surrealist artist whose work is the subject of numerous solo and group exhibitions. His diversified oeuvre includes a mélange of paintings, sculpture, installations, consumer products, and an animated special. He lives and works in his native Los Angeles.

JEFF VANDERMEER grew up in the Fiji Islands and has had fiction published in over twenty countries. His books include the best-selling *City of Saints & Madmen* (Bantam). Current projects include *Booklife: Strategies and Survival Tips for Twenty-First-Century Writers* (Tachyon Publications) and the noir fantasy novel *Finch* (Underland Press). He lives in Tallahassee, Florida.

ROB WALSH's work has appeared in *NOON, American Letters & Commentary, Columbia, Mississippi Review,* and elsewhere. He lives in Providence, Rhode Island.

STEPHEN WRIGHT's latest novel is *The Amalgamation Polka* (Knopf).

NEW DIRECTIONS BOOKS

Spring 2009
April through June

ROBERTO BOLAÑO
Nazi Literature in the Americas. Translated by Chris Andrews. "A wicked invented encyclopedia of imaginary fascist writers" —*NY Times Bk Rev.* $13.95 pbk.

LAWRENCE FERLINGHETTI
Poetry As Insurgent Art. A great radical primer in prose of what poetry is, could be, and should be by America's poetic "National Treasure." $12.95 cl.

DUNYA MIKHAIL
Diary of a Wave Outside the Sea. Trans. by Winslow & Mikhail. The Iraqi writer's poetic memoir. "Spellbinding" —*Al-Ahram. Bilingual.* $16.95 pbk. original

KENNETH REXROTH
Songs of Love, Moon, & Wind: Poems from the Chinese and **Written on the Sky: Poems from the Japanese.** Both books edited by Eliot Weinberger. Two exquisite little gift editions of classic poetry. $12.95 each.

GUILLERMO ROSALES
The Halfway House. Trans. by Anna Kushner. A heart-breaking classic of modern Cuban literature about a home for indigents in Miami, Florida. $14.95 pbk. orig.

YOKO TAWADA
The Naked Eye. Trans. by Susan Bernofsky. Fantasies of Catherine Denueve sustain a lost girl's sanity in this suspenseful novel of abduction. $13.95 pbk. orig.

ROBERT WALSER
The Tanners. Trans. by Susan Bernofsky, Intro. by W. G. Sebald. Walser's last major novel available in English. "A clairvoyant of the small" —Sebald. $15.95 pbk.

ELIOT WEINBERGER
Oranges and Peanuts for Sale. Weinberger continues his astonishing explorations of the essay. "A brilliant scholar in a dark age" —*Rain Taxi.* $16.95 pbk. orig.

NATHANAEL WEST
Miss Lonelyhearts & The Day of the Locust. *NEW* Intro. by Jonathan Letham. Two great works in one volume. "Brilliant" —Dorothy Parker. $11.95 pbk.

TENNESSEE WILLIAMS
New Selected Essays: Where I Live. *NEW* Foreword by John Lahr. Ed. by John S. Bak. A much expanded volume of witty and elegant essays. $18.95 pbk.

WILLIAM ERIC WILLIAMS
William Carlos William — An American Dad. With "A Letter to My Father" by Paul Herman Williams. Text/Photos ed. by E. Mitchell Wallace. $19.95 pbk. orig.

 NEW DIRECTIONS 80 Eighth Avenue, New York, NY 10011
www.ndpublishing.com

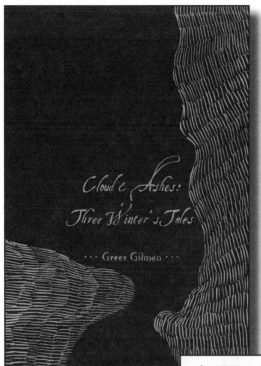

Cloud & Ashes is a slow whirlwind of language, a button box of words, a mythic Joycean fable that will invite immersion, study, revisitation, and delight. Inventive, playful, and erudite, Gilman is an archeolexicologist rewriting language itself in these long-awaited tales.

"Gilman writes like no one else. To read her is to travel back, well back, in time."—Margo Lanagan (*Tender Morsels*)

9781931520553
May · cloth · $26

It's difficult to keep up with the daily tasks (besides making tea, playing solitaire, checking e-mail, and—oh yeah, writing!) that complicate a writer's life: tracking submissions, finding markets, planning projects, researching funding. . . . *A Working Writer's Daily Planner* makes it easy for writers to keep track of the practical, business end so that they can pay more attention to the real work of writing.

9781931520584
pb · $13.95

A Working Writer's Daily Planner 2010
Your Year in Writing

"I am ticking off the days until I can get my *Working Writer's Daily Planner.* All work is at a complete stop until its arrival."
—Karen Joy Fowler, author of *The Jane Austen Book Club*

master of fine arts in writing

FACULTY

Rae Armantrout

Sarah Shun-lien Bynum

Michael Davidson

Cristina Rivera-Garza

Anna Joy Springer

Wai-Lim Yip

Eileen Myles, Emeritus

RECENT VISITING FACULTY

Ben Doller

Fanny Howe

Stanya Kahn

Chris Kraus

Ali Liebegott

Sawako Nakayasu

Lisa Robertson

UCSanDiego

(619) 534-8849

mfawriting@ucsd.edu

literature.ucsd.edu/grad/mfawriting/

German for
Travelers: A Novel
in 95 Lessons

Norah Labiner

— NOVEL —

All Fall Down

Mary Caponegro

— STORIES —

Fugue State

Brian Evenson
with art
by Zak Sally

— STORIES —

The Hebrew Tutor
of Bel Air

Allan Appel

— NOVEL —

Beats at Naropa

Edited by
Anne Waldman and
Laura Wright

— ANTHOLOGY —

Portrait and Dream:
New and Selected
Poems

Bill Berkson

— POETRY —

Coal Mountain
Elementary

Mark Nowak
with photographs
by Ian Teh

— POETRY —

A Toast in the
House of Friends

Akilah Oliver

— POETRY —

The Spoils

Ted Mathys

— POETRY —

Good books are brewing at www.coffeehousepress.org

DELILLO FIEDLER GASS PYNCHON
University of Delaware Press
Collections on Contemporary Masters

UNDERWORDS
Perspectives on Don
DeLillo's *Underworld*

**Edited by Joseph Dewey, Steven
G. Kellman, and Irving Malin**

Essays by Jackson R. Bryer, David
Cowart, Kathleen Fitzpatrick,
Joanne Gass, Paul Gleason, Donald
J. Greiner, Robert McMinn,
Thomas Myers, Ira Nadel, Carl
Ostrowski, Timothy L. Parrish,
Marc Singer, and David Yetter

$39.50

INTO *THE TUNNEL*
Readings of Gass's
Novel

**Edited by Steven G. Kellman
and Irving Malin**

Essays by Rebecca Goldstein,
Donald J. Greiner, Brooke Horvath,
Marcus Klein, Jerome Klinkowitz,
Paul Maliszewski, James McCourt,
Arthur Saltzman, Susan Stewart,
and Heide Ziegler

$35.00

LESLIE FIEDLER
AND AMERICAN
CULTURE

**Edited by Steven G. Kellman
and Irving Malin**

Essays by John Barth, Robert
Boyers, James M. Cox, Joseph
Dewey, R.H.W. Dillard, Geoffrey
Green, Irving Feldman, Leslie
Fiedler, Susan Gubar, Jay L. Halio,
Brooke Horvath, David Ketterer,
R.W.B. Lewis, Sanford Pinsker,
Harold Schechter, Daniel Schwarz,
David R. Slavitt, Daniel Walden,
and Mark Royden Winchell

$36.50

PYNCHON AND
MASON & DIXON

**Edited by Brooke Horvath and
Irving Malin**

Essays by Jeff Baker, Joseph
Dewey, Bernard Duyfhuizen, David
Foreman, Donald J. Greiner, Brian
McHale, Clifford S. Mead, Arthur
Saltzman, Thomas H. Schaub,
David Seed, and Victor Strandberg

$39.50

ORDER FROM ASSOCIATED UNIVERSITY PRESSES
2010 Eastpark Blvd., Cranbury, New Jersey 08512
PH 609-655-4770 FAX 609-655-8366 E-mail AUP440@ aol.com

THIS IS NOON'S TENTH ANNIVERSARY!

NOON

A LITERARY ANNUAL

1324 LEXINGTON AVENUE PMB 298 NEW YORK NEW YORK 10128

EDITION PRICE $12 DOMESTIC $17 FOREIGN

Since 1981 our summer-based MFA degree program in upstate New York has offered a non-traditional approach to the creative arts. Intensive eight-week summer sessions, emphasizing individual conferencing with faculty and school-wide interdisciplinary group conversation/critique, combine with ten-month independent study periods to both challenge the student and allow space for artistic exploration.

Our Writing discipline emphasizes awareness of a variety of verbal, aural, and textual structures, and students develop an individual process of composition as well as a critical understanding of their field. Forms such as innovative poetry, short fiction, sound, and mixed-media writing are particularly well-suited to the structure and nature of the Bard MFA program.

2009 Writing faculty include:

Anselm Berrigan, co-chair	Paul La Farge
Robert Fitterman	Ann Lauterbach, co-chair
Renee Gladman	Anna Moschovakis
Carla Harryman	David Levi Strauss
Laird Hunt	Matvei Yankelevich

Call or email us to schedule a campus visit, or check *www.bard.edu/mfa* for a list of upcoming information sessions.

MFA
BARD COLLEGE

845-758-7481 • mfa@bard.edu • www.bard.edu/mfa